Images of Penance, Images of Mercy

Southwestern *Santos* in the Late Nineteenth Century

Images of Penance
Images of Mercy

Southwestern *Santos* in the
Late Nineteenth Century

by

William Wroth

With an Introduction to Part 2 by Marta Weigle

Published
for
Taylor Museum for Southwestern Studies
Colorado Springs Fine Arts Center
by
University of Oklahoma Press : Norman and London

By William Wroth

(ed.) *Hispanic Crafts of the Southwest* (Colorado Springs, 1977)
The Chapel of Our Lady of Talpa (Colorado Springs, 1979)
Christian Images in Hispanic New Mexico (Colorado Springs, 1982)
(ed.) *Furniture from the Hispanic Southwest: Authentic Designs* (Santa Fe, 1984)
(ed.) *Weaving and Colcha from the Hispanic Southwest: Authentic Designs* (Santa Fe, 1985)
(ed.) *Russell Lee's FSA Photographs of Chamisal and Peñasco, New Mexico* (Santa Fe, 1985)
Images of Penance, Images of Mercy: Southwestern Santos *in the Late Nineteenth Century* (Norman, 1991)

Unless noted otherwise, all plates are photographed by Gary Hall.

Library of Congress Cataloging-in-Publication Data

Wroth, William
 Images of penance, images of mercy: southwestern santos in the late nineteenth century / by William Wroth; with an introduction to part 2 by Marta Weigle.—1st ed.
 p. cm.
 Includes bibliographical references and index.
 1. Santos (Art)—Southwest, New—History—19th century. 2. Santos (Art)—Southwest, New—Catalogs. I. Taylor Museum. II. Title.
 N7908.6w76 1991
 70.9'482—dc20 90-50701
 ISBN 0-8061-2325-7 (cloth)
 ISBN 0-8061-2326-5 (paper)

Inquiries regarding rights and permissions should be directed to the publisher.

Published by the University of Oklahoma Press, Publishing Division of the University of Oklahoma, 1005 Asp Avenue, Norman, OK 73019-0445.

2 3 4 5 6 7 8 9 10 11 12 13 14 15 16 17 18 19 20 21 22

Contents

Illustrations

PLATES

Foreword

Images of Penance, Images of Mercy: Southwestern Santos *in the Late Nineteenth Century* is a Taylor Museum for Southwestern Studies project which examines Hispanic religious images in New Mexico and Colorado. The Taylor Museum for Southwestern Studies is a department of the Colorado Springs Fine Arts Center. Other departments include the Fine Arts Center's art museum, art school, theater, and library. The extraordinary collections, programs, publications, and personnel of the Taylor Museum for Southwestern Studies have given it a sort of "meta" persona, the stuff of which legends are made. The Taylor Museum for Southwestern Studies, or "TM" as it is affectionately referred to by Fine Arts Center staff, is an ethnographic museum which specializes in the Hispanic and Native American material culture of the Southwest United States and the folk art of Mexico and Central and South America. Established in 1935, it contains today some 15,000 artifacts. The rich legacy of the Taylor Museum is documented in the Colorado Springs Fine Arts Center's fiftieth anniversary publication, *Colorado Springs Fine Arts Center: A History and Selections from the Permanent Collections* (1986).

One purpose of the Taylor Museum for Southwestern Studies is to preserve and exhibit important objects from the past. Another is to construe meaning from these objects. *Images of Penance, Images of Mercy* consists of two components—a national touring exhibition of objects from the Taylor Museum and the present publication. Within these pages are 144 color and black-and-white illustrations, including over 100 examples from the Taylor Museum collection, many of which are part of the exhibition, plus an interpretive text by William Wroth, former Taylor Museum curator. It is hoped that this book and exhibition will make the Taylor Museum collection better known and understood throughout this country and abroad. They are the first large-scale scholarly publication and interpretive exhibition on the late nineteenth-century *santos* and the penitential Brotherhood of Our Father Jesus Nazarene. Together, the publication and exhibition embody the fundamental purposes of the Taylor Museum.

From the start, founding Taylor Museum patroness Alice Bemis Taylor and curator (and later director) Mitchell A. Wilder sought to collect, exhibit, and pub-lish the indigenous folk arts of the American Southwest. As one in an ongoing series of Taylor Museum projects, *Images of Penance, Images of Mercy* builds upon the tradition of folk studies scholarship at the Colorado Springs Fine Arts Center begun some fifty-five years ago. During these years, more than 130 Taylor Museum exhibitions have been mounted. Of its thirty-plus books and catalogues, Taylor Museum publication highlights include:

> George Kubler, *The Religious Architecture of New Mexico in the Colonial Period and Since the American Occupation* (1940)
> Mitchell Wilder and Edgar Breitenbach, *Santos: The Religious Folk Art of New Mexico* (1943)
> George Mills, *Navajo Art and Culture* (1959)
> Leland C. Wyman, *Navajo Sandpainting: The Huckel Collection* (1960)
> Leland C. Wyman, *The Windways of the Navajo* (1962)
> George Mills, *The People of the Saints* (1967)
> Robert L. Shalkop, *Arroyo Hondo: The Folk Art of a New Mexican Village* (1969)
> William Wroth, ed. *Hispanic Crafts of the Southwest* (1977)
> William Wroth, *Christian Images in Hispanic New Mexico* (1982)
> Christine Conte, *Maya Culture and Costume* (1984)
> Jonathan Batkin, *Pottery of the Pueblos of New Mexico, 1700–1940* (1987)

This tradition has been a source of great pride for Hispanic and Native American people of the Southwest, regional scholars, and the community of Colorado Springs. In the spirit of this tradition, it is hoped that *Images of Penance, Images of Mercy* will contribute appreciably to Southwest studies by comprehensively documenting for the first time the rare Taylor Museum collection of late nineteenth-century *santos*, most of which are previously unpublished.

While the individuals and organizations who have generously contributed to make this enterprise possible have been identified in the acknowledgments section of this publication, I would like to single out a handful among them for special recognition. These include William Wroth, guest curator, for his expert scholarship, discerning connoisseurship, compelling writing, and skilled grantsmanship; Jonathan Batkin, former Taylor Museum curator, for launching this project with his initial National Endowment for the Humanities grant application; and Cathy Wright, cur-

rent Taylor Museum for Southwestern Studies curator and director of collections and exhibitions for the Colorado Springs Fine Arts Center, for capably managing all organizational aspects of *Images of Penance, Images of Mercy.*

I would also like to thank Dennis O'Rourke for convincing members of the Fine Arts Center's Taylor Society to contribute funds in the form of venture capital to underwrite initial fundraising efforts for this project; the Taylor Society members; the Board of Trustees of the Colorado Springs Fine Arts Center for its enduring support; and the National Endowment for the Humanities, which for all practical purposes made this project possible with a planning grant in 1984 and an ample implementation grant in 1989. We are also indebted to the Colorado Springs office of Holme Roberts & Owen for lending its legal expertise to various aspects of the project. Finally, thanks are due to colleagues at museums participating in the national *Images of Penance, Images of Mercy* exhibition tour, and also to the William H. Donner Foundation for their additional support of the tour, and to all others who dedicated themselves to *Images of Penance, Images of Mercy: Southwestern Santos in the Late Nine-*

teenth Century. Your spirit now permanently resides with the Taylor Museum for Southwestern Studies.

The exhibition, *Images of Penance, Images of Mercy,* will be shown at the Colorado Springs Fine Arts Center March 9–July 14, 1991. After that, it will travel to the following institutions:

The Walters Art Gallery
Baltimore, Maryland August 25–October 20, 1991

The University of Oklahoma Museum of Art
Norman, Oklahoma January 17–March 15, 1992

Behring/Hoffman Educational Institute, Inc.
(University of California, Berkeley)
Danville, California April 11–June 7, 1992

McMichael Canadian Art Collection
Kleinburg, Ontario, Canada September 20–
November 22, 1992

Additional support for the tour of *Images of Penance, Images of Mercy* was provided by the William H. Donner Foundation.

DAVID J. WAGNER
EXECUTIVE DIRECTOR
COLORADO SPRINGS FINE ARTS CENTER

Acknowledgments

THROUGH THE KINDNESS of Apolinar Sandoval during Lent of 1971, while living in Truchas, New Mexico, I was able to attend prayer services at the village *morada*. This was not only a moving experience, but also the beginning of a longstanding interest in the spirituality and activities of the penitential Brotherhood of Our Father Jesus Nazarene in New Mexico and Colorado. The present publication was first conceived in 1977 as part of a plan to catalogue the extensive Taylor Museum collection of Southwestern *santos*. The first part, published in 1982 as *Christian Images in Hispanic New Mexico*, brought the study of New Mexican *santos* to 1860; the present work focusses upon the pieces after 1860, made primarily for use by the Brotherhood.

Support for this project has come from three successive directors of the Colorado Springs Fine Arts Center: Arne Hansen, Paul Piazza, and David J. Wagner. Jonathan Batkin, curator of the Taylor Museum from 1983 to 1988, served as the project director of the National Endowment for the Humanities planning grant in 1984 and 1985 that supported my research and writing for this publication and the initial planning for the concurrent Taylor Museum exhibition. His successor, Cathy L. Wright, has served as in-house coordinator for the project's implementation phase, also made possible by generous support from the National Endowment for the Humanities. I am grateful to the Taylor Society, led by Dennis O'Rourke, and to the Hulbert Center for Southwestern Studies at Colorado College, directed by Joseph Gordon; these organizations provided the initial funds for the implementation phase. Many other staff members of the Fine Arts Center have aided in this project, in particular, Judith Polus, acting director 1989–1990; Diane Stevens, registrar; and Judy Burdick, museum assistant.

My research into the origins of the Brotherhood of Our Father Jesus Nazarene was enriched by visits to several institutions around the country. In Providence, Rhode Island, I was kindly assisted by Norman Fiering and his staff at the John Carter Brown Library. In Texas, Ann Harkness and other staff members at the Latin American Collection of the University of Texas-Austin made their remarkable collections available to me, and Cesar Caballero at the University of Texas-El Paso did the same, later sending me microfilm copies of Mexican archives. I am also indebted to William Cagle and his staff at the Lilly Library, Indiana University, where I have spent many happy hours consulting materials in their important Mendel collection. In New Mexico, Austin Hoover of the Rio Grande Historical Collections at New Mexico State University and Richard Salazar at the State of New Mexico Records Center and Archives have been very helpful with archival inquiries. In 1984 director Yvonne Lange and curator Christine Mather at the Museum of International Folk Art first made their files and collections available to me for this project, and in 1987–1989 my duties as guest curator of the Museum's Hispanic Heritage Wing made possible a more careful study of their collections. In this I was ably assisted by curators Donna Pierce and Robin Farwell Gavin, librarian Judy Sellars, and director Charlene Cerny.

Many other friends and colleagues have provided important help in this project. Mary Taylor not only made the fruits of her own research on New Mexico and northern Mexico available during a most pleasant visit to Mesilla, but also sent me a copy of the important Martínez-Zubiría correspondence. In pursuit of the elusive painter and sculptor José de Gracia Gonzales, Mark L. Gardner spent many hours searching archival records for me in Trinidad and interviewed several of Gonzales's descendants, among them, his granddaughters Adeline Aragon, Belinda Gomez, and Juanita Martinez, who provided not only information but also photographs of their grandfather. Gonzales's granddaughter Mercy Valerio, his daughter-in-law Rufinita Gonzales, and his great-grandchildren Margaret Apodaca and Joseph de Gracia Gonzales also assisted us.

Daniel Tyler and Father Charles L. Polzer provided suggestions for research avenues in Mexico, and in the city of Durango, historian José I. Gallegos gave me information about the religious history of that region, as did Fray Elias Rodriguez, resident friar at the Church of San Francisco in Sombrerete, Zacatecas. Father Thomas J. Steele and Rowena Rivera kindly sent me the manuscript of their *Penitente Self-Government* prior to its publication, as well as unpublished Brotherhood documents.

Charles Carrillo, Floyd Trujillo, and Horacio Valdez, among others, have given me information about religious practices and the ceremonial use of *santos* and other objects in New Mexico. John Ben Manzanares, Mike Tafoya, and Florence Valdez have helped with questions concerning the Brotherhood in Colorado, and thanks to Mrs. Valdez, in 1977 I was able to attend Holy Week ceremonies in a southern Colorado *morada*.

The text of this publication has been improved immeasurably by the comments and suggestions of colleagues who have read portions of the manuscript. William A. Christian, Jr., Bernard Fontana, and Marta Weigle all read the first draft of Part 1, and many improvements are thanks to their comments. Jonathan Batkin made a careful reading of the first draft of the entire manuscript, providing many useful suggestions. I am also grateful to Rama P. Coomaraswamy for reading chapter 1, Father Thomas J. Steele for reading chapter 4, and Marianne L. Stoller for reading chapter 9.

I wish to thank Marta Weigle for her stage-setting introduction to Part 2, and Gary Hall for his excellent photographs of the Taylor Museum objects reproduced here. The enthusiastic response of John Drayton and Sarah Nestor at the University of Oklahoma Press and the design work of Bill Cason have added a great deal to the pleasure and excitement of bringing this book to publication.

The exhibition accompanying this publication has also been made possible by the generous support of the National Endowment for the Humanities. Many people have helped to bring it to fruition. In particular I would like to thank Fine Arts Center staff members Cathy L. Wright and Diane Stevens; designer Berkeley Blashfield; and consultants Richard Ahlborn, Charles Carrillo, Enrique Lamadrid, Jack Loeffler, Father Jerome Martinez, Father Thomas J. Steele, Marianne L. Stoller, Floyd Trujillo, Kay Turner, and Marta Weigle.

WILLIAM WROTH

Preface

THIS WORK is a study of the religious images known as *santos* made in New Mexico and Colorado in the late nineteenth and early twentieth centuries. It is based upon the comprehensive collection of the Taylor Museum of the Colorado Springs Fine Arts Center, which among its more than 750 Southwestern *santos* includes approximately 125 from the period 1860 to 1910. Although the collection has examples of virtually every style and type of *santo* from this period, it has in the past been little studied; until now there has not been a systematic study of these late nineteenth-century *santos* and their cultural and historic roots.

The present work is a companion volume to *Christian Images in Hispanic New Mexico*, in which we described the progression of styles and periods of image-making in New Mexico from the early 1700s to circa 1860, cataloging and illustrating 191 pieces, mostly from the Taylor Museum collection. In that work we attempted to portray the important role played by these images in the lives of New Mexicans, documenting their sources in the tradition of Christian art. *Christian Images* was intended as a general introduction to the religious folk art of the Southwest to 1860. The present work is intended to complete the cataloging of the Taylor Museum collection of Southwestern *santos*, including painting, sculpture, and other artifacts, from 1860 until the traditional pieces ceased being made about 1910.

In studying this body of work, one is immediately struck by the preponderance of images associated with the passion and crucifixion of Christ. While this was an important theme in the earlier *santos*, now it is the predominant theme, with the vast majority of pieces devoted to different aspects of the subject. The reason for this preponderance of passion imagery may be traced to the existence and growing importance of an organization known today as the Brotherhood of Our Father Jesus Nazarene (La Hermandad de Nuestro Padre Jesús Nazareno, known popularly as the Penitentes). The Brotherhood is a Catholic lay confraternity (*cofradía*), whose members are dedicated to living a pious Christian life through fervent devotion to the suffering and crucifixion of Christ. Their devotional activities include prayer and the singing of

hymns (*alabados*) during Lent and throughout the year, penitential processions during Holy Week to reenact the suffering and crucifixion, and various forms of self-mortification such as flagellation and the carrying of heavy wooden crosses.

The preponderance of images in the late nineteenth century relating to Christ's passion corresponds directly to the social and political situation in New Mexico at that time and to the growing importance of the penitential Brotherhood. After the American Occupation of 1846 it was the Brotherhood which most strongly resisted the modernizing effects of Americanization by conscientiously preserving the core values of their Hispanic Catholic faith. The most important ceremonial elements in the popular practice of Catholicism since the late Middle Ages had been the annual reenactment of Christ's passion during Holy Week. This complex of ceremony and ritual drama, so tenaciously preserved by the Brotherhood, served the vital purpose of annually renewing the bonds of faith and the communal bonds which linked together all the members of the community.

The Brotherhood in the late nineteenth century constituted the spiritual core of Hispanic society. To understand the striking images associated with Christ's passion made for the Brotherhood in this period, one must understand the origins of the Brotherhood and the significance of their ceremonies and other activities in the context of Hispanic Catholicism.

In the first part of this study the notion of penance in Christian thought and its place in the early Christian era are discussed. The new personalism of medieval worship and an emphasis upon Christ's humanity resulted in the increasing importance of penitential practices in Western Europe. The forms such practices took in Spain and their transmission to New Spain (Mexico) in the early 1500s are next considered, followed by a discussion of the development of penitentialism in northern New Spain through the colonial era. Finally, in Part 1, the origins of the New Mexico Brotherhood, which came to prominence in the nineteenth century, are discussed, demonstrating its continuity in thought and practice with the Mexican and Spanish traditions. The spiritual value placed

upon individual penance in the early Christian era still inspired the religious life of Hispanic New Mexicans and Coloradans in the nineteenth and twentieth centuries.

The second part of this study is devoted more specifically to the activities and images of the Brotherhood in the late nineteenth century. In her introduction to Part 2, Marta Weigle describes the wide range of Brotherhood rituals and social functions, dealing with the relationship between the Brotherhood and the Hispanic community at large and with Brotherhood charitable activities in isolated communities. The rest of Part 2 constitutes a catalog of the major Taylor Museum images of the late nineteenth century, giving information about the different styles of work and the artists who made them, and including discussions of the sources and iconography of the images and their use in Brotherhood ceremonies.

The religious images produced in New Mexico and Colorado after 1860 differ in several significant ways from those of the earlier period. These differences reflect the rapid changes that took place in the territory after the American Occupation of 1846. We can view these profound changes at two levels. At the ideological level, traditional religious and cultural values were under attack from the modernism and Protestantism of the incoming Anglo-Americans. At the material and economic level, the traditional artisanal and farming-based economy began to give way to American commerce and capitalism.

The American Occupation brought to issue the confrontation of two diametrically opposed social orders. In the traditional Hispanic Catholic world view, religious values were dominant and pervaded all aspects of life. The goal of human life was not earthly reward, but heavenly salvation. A strong faith in God coupled with the desire for salvation produced a social environment in which conformation to God's will was at the kernel of every action. In spite of inevitable human imperfection, there was a highly stable and long-established social order in which ideally each individual cooperated for the good of all and for fulfillment of obligation to heaven.

In contrast, the world view of the incoming Americans valued above all mastery of the material realm and the earthly rewards resulting therefrom. Drawing its roots from humanistic tendencies that had developed in northern Europe since the Renaissance, it was a highly dynamic view based on notions of human rights (as opposed to obligations), economic freedom, and an evolutionary social progress. This view was characterized by a horizontal satisfaction with the things of this world (materialism), in contrast to the traditional spiritual view characterized by a vertical attraction to the next world, an overwhelming desire for transcendence of the world and of materiality. The humanistic view was closely tied to liberal Protestantism, which was the predominant religion of the westward-moving Americans. The Americans viewed the cohesion and harmony of Hispanic Catholic New Mexico in decidedly negative terms: they saw these qualities as signs of a static society that was out of touch with modern life and greatly in need of reforms on many fronts.

In the realm of religion, penitential and other practices were seen by the Americans as the epitome of a whole complex of cultural expressions which were considered out-of-date, unprogressive, and even socially harmful. *Santos* and other objects which for many centuries in Europe and Latin America had been standard and widely recognized symbols of piety were seen by the newcomers as exotic relics of an antiquated cult. The survival of these objects and practices reveals the dramatically different degree of modernization between Hispanic and American society, for they had been unknown in Anglo-American culture for several centuries.

While attacking these cultural values the Americans were simultaneously taking control of New Mexican sovereignty and economy and were introducing modern means of transportation, trade, and production to the formerly isolated territory. The traditional self-sufficient economy of Hispanic and Indian New Mexico had been based upon handwork: nearly the full range of daily necessities from food to clothing, shelter, furnishings, and tools was produced by hand from local materials, as were the equally essential religious images. In some cases gradually, in some quite quickly, nearly all of these hand products were replaced by modern factory-made goods or by modern means of production.

Commercial images quickly came to replace the widespread locally made *santos* of New Mexico. Chromolithographs and cast plaster statues of saints were imported in large quantities by the new merchants of New Mexico from the eastern states and Europe. The art of panel painting was the first to succumb to change, because local artists could not compete with the ubiquitous and inexpensive chromolithographs.

Ideological changes played a part in the demise of locally made altar screens. The new American Catholic clergy, primarily of French origin, was unsympathetic to local religious art and introduced dramatic changes in church decoration. Few painted altar screens were commissioned locally after 1860; the priests often replaced those needing renovation with severe architectural assemblages in the prevailing neoclassic style. These were often constructed by incoming American or immigrant carpenters using more sophisticated tools and newly available milled lumber. The new neoclassic altars were seldom decorated with painted images, but had niches built into them to incorporate the aesthetically compatible commercial plaster statues.

In this ideological attack, which affected even the very sanctuary of the churches, the Brotherhood of the Sangre de Cristo (known today as the Brother-

hood of Our Father Jesus Nazarene) became the protector of core religious values of the Hispanic New Mexicans. The *moradas* (meeting houses) of the Brotherhood became the refuges of traditional Catholicism; the Brothers kept alive the essential values of penance and mercy and the ceremonies of Holy Week, which expressed these values. Many other Catholic devotions died out during this period due not only to the American presence but also to the lack of support from the new clergy, who wanted to modernize New Mexican modes of worship. The fabric of community life in New Mexico began to weaken: some villagers converted to Protestantism; others left to find wage labor far from home; and the new economy sapped the former self-sufficiency of the villages. However, through adherence to traditional values such as mutual aid and communal public observances, the members of the Brotherhood sought to preserve the cohesiveness of their communities and the essentials of their religion.

The Brotherhood created a demand for locally made sculpture which therefore did not die out as quickly as painting and church decoration. The Brothers preferred locally made images for several reasons. One no doubt was economic: local pieces were cheaper and could often be obtained through barter. However, the Brotherhood also preferred the stark, expressive qualities of locally made statues over the saccharine sentimentality of commercial ones. The commercial images did not meet their needs, for the advocations of Jesús Nazareno, Cristo Entierro, and Nuestra Señora de la Soledad were primarily Spanish and Spanish-American devotions, and expressive commercial plaster statues of these holy personages could not easily be obtained. Even if available, the cast plaster statues lacked an essential feature required for Brotherhood ceremonies—the arms and other members were not articulated so they could not easily be dressed, nor could they be used in the *emprendimiento* (seizure) of Christ, the *encuentro* (encounter) of Mary and Jesus, the Descent from the Cross, and other Holy Week ceremonies.

Thus in the late nineteenth century the Brotherhood continued to require locally made statues for Holy Week. This accounts for the preponderance of images of Jesus Nazarene, Our Lady of Solitude, Christ Crucified, and Christ in the Holy Sepulchre among the statues (*bultos*) surviving from this period.

In New Mexico, as everywhere in Latin America, Holy Week ceremonies—in which for the faithful the three stages of penance, love, and union were annually reenacted—formed the core of religious life. American authorities frowned upon large public observances of this type, causing them to die out in the larger towns, but the Brotherhood kept them alive in more isolated villages. They performed these and other traditional ceremonies, as Marta Weigle demonstrates in her introduction to Part 2, with the same penitential fervor that had been the keynote of Hispanic Catholicism since the late Middle Ages.[1]

The second part of this study begins with Marta Weigle's vivid description of Brotherhood ceremonies and other activities, drawn from the most reliable firsthand accounts from the 1890s through the 1930s, many previously unpublished. Following this, the catalog of images in the Taylor Museum from late nineteenth-century New Mexico and Colorado begins in Chapter 6 with the work of José Benito Ortega, a man whose prolific output of sculpture supplied the New Mexican communities east of the Sangre de Cristo range until the first decade of the twentieth century. Also discussed are the School of Ortega, paintings (*retablos*) attributed to this artist, and other paintings by unknown artists of the period. Not all painters of the late nineteenth century were native-born; about 1860 José de Gracia Gonzales, an itinerant artist born in Chihuahua, migrated to northern New Mexico and later moved to southern Colorado. His work is discussed in Chapter 7. Chapter 8 is devoted to the work of five artists who specialized in large passion figures for the *moradas* of Taos and Rio Arriba counties: the Taos County Santero; the Abiquiú Santero and his anonymous follower; Miguel Herrera of Arroyo Hondo; and Juan Ramón Velázquez of Canjilón. Chapter 9 begins with a discussion of Velázquez's influence in the San Luis Valley of Colorado and concludes with other southern Colorado styles. The famous death figures used by the Brotherhood are considered in Chapter 10. Chapter 11 concludes the book with a discussion of the *tenebrario* and other paraphernalia used in the Tinieblas ceremony, musical instruments, heavy *maderos* (crosses) carried by penitents, and other items.

PART 1

Penance and Mercy in the Christian Tradition

The Place of Penance in Early Christian Thought and Practice

THE IDEA of suffering as a means of purification is an integral part of every world religion. The goal of religion is the transformation of the individual from a limited earthly existence to an unlimited heavenly state. In the Catholic tradition this state is the Beatific Vision obtained by the just through salvation; in Hinduism it is *moksa*, that is, release from the conditions of the world; in Buddhism this state is known as *nirvana*. The immortal soul must be separated from the mortal conditions in which it exists on earth. This separation normally takes place through some form of purification: the soul must be purified of all that chains it to the world and to the narrow individuality of the ego.

Purification may take many forms, but in essence it implies a privation, a sacrifice, a suffering, for the individual is inevitably attached to his ego and to the world. Before the soul can be released there must be a renunciation of these attachments; it is a suffering, a spiritual death undergone for the sake of obtaining salvation. By divine grace and through an effort of the will, there is a turning away of the soul from the world towards God.[1]

Purification is often viewed as the first stage in a threefold process.[2] First the soul is purified through the fear of God and the effort of the will and is made ready to receive divine grace.[3] Then, through love of God the soul is sanctified; it is "full of grace" and ready to approach union with God. Finally, the purified and thus sanctified soul may achieve the final goal of divine union, a state which implies no distinction between the immortal soul and God. It is in this sense that the soul dies to the world and to the ego, is reborn in love with "a new heart and a new spirit" (Ezekiel 18:31), and finally is extinguished in union.

In Christian thought and practice the question of purification assumes special importance, for in the Christian view, human beings since the fall of Adam are no longer born in a deified state; they are born in original sin. The state of original sin requires the action of purification to return to grace. This purpose is served by the sacrament of baptism; the blessed water of baptism washes away sin and places the newborn in a state of grace.

THE SACRAMENTS OF BAPTISM AND PENANCE

In the sacrament of baptism, the Christian is placed in a sinless state and is fully prepared for salvation. In practice, however, human imperfection since the fall of Adam means that few individuals are able to resist sin—attachment to the world, to desire, and to the ego—throughout their lives. There is frequently a fall from this sinless state: the soul turns from God back to the world. For this reason, the sacrament of penance serves as a formal means of returning the soul to the original state of grace obtained through baptism.

Baptism is conferred upon the new Christian by means of water and through the grace of the Holy Spirit; it is the infusion of the Spirit into the newborn soul. The sacrament of penance, on the other hand, absolves the sins of the Christian through the grace of Christ: "As the man whom the priest baptizes is enlightened by the grace of the Holy Spirit, so does he who in penance confesses his sins, receive through the priest forgiveness in virtue of the grace of Christ."[4] For it is Christ who is the Redeemer; for the Christian, He and only He provides the way to salvation: "no man can come to the Father but by me."

The act of penance may be seen as having four stages. First the Christian must recognize his sin for what it is and must hate it, as an affront to God. Second, he must confess it—not to anyone, such as a revered relative or advisor, but only to a priest. Third, the priest prescribes some means of penance for satisfaction of his sin. Finally, the priest absolves the sinner; this absolution fully takes effect only after the penance is effectively performed, at which time the sinner is returned to the state of grace. It is the priest alone, acting in Christ's name, who has the power of absolution, for Christ conferred upon the Church, through Saint Peter, the power "to bind and to loose" sins, that is, to prescribe penance and to absolve.

In the first centuries of the Christian era and continuing in gradually diminishing usage through the 1700s, the clergy very often prescribed public actions of penance for more serious sins. Such penance could take many different forms, from simply a required

recitation of a certain number of prayers to periodic fasts or long periods of limited diet and other forms of abstinence and self-mortification to public forms of humiliation, all with the purpose of proving the sincerity of the sinner's repentance, sincerity being the measure of the purification of the soul from sin.

According to Tertullian (ca. A.D. 160–230), the public penance imposed by the early Church was a discipline

> which obliges a man to prostrate and humiliate himself and to adopt a manner of life which will draw down mercy. . . . it prescribes that he shall lie in sackcloth and ashes, clothe his body in rags, plunge his soul in sorrow, correct his faults by harsh treatment of himself . . . usually he shall nourish prayer by fasting, whole days and nights together shall he moan and weep and wail to the Lord his God, cast himself at the feet of the priests . . . and beseech them to plead in his behalf.[5]

In the public penances imposed by the early Greek Church, there were four classes of penitents. The severity of the penitents' sins or lack of true repentance determined their class, and thus their actual, physical distance from the altar and the sacraments, that is from grace and the means to salvation. The first class were the *consistentes*, who were allowed to hear the whole mass but were denied Holy Communion; that is they were denied the direct confirmation of grace through this holy sacrament that was conferred only upon the purified souls. The second group were the *substrati* (prostrate ones) or *genuflectentes* (kneelers), who were allowed to hear the sermon and receive the hand or blessing of the priest or bishop but could not stay even to witness the Communion. The third group were the *audientes* (hearers), who were allowed to hear the sermon from the position of the narthex (vestibule) of the church; they were not allowed into the nave. Finally, the last group were the *fluentes* (weepers), who remained outside the church doors. Excluded entirely from the mass, the *fluentes* could only beseech intercession from the faithful as they passed through the doors.[6]

Public penance traditionally was begun on Ash Wednesday at the beginning of Lent and continued until Maundy (Holy) Thursday during Holy Week, when the bishop would absolve those worthy of absolution just in time to take part in the all-important masses of Good Friday and Easter Sunday. For other penitents whose sins were more serious, their public penance might go on for many years or even, in some cases, their entire life.

INFORMAL PENANCE

In addition to the formally instituted sacrament of penance, from the early days of the Christian era a wide variety of informal mortifications was performed by lay people, monks, and clergy as a means to expiate sin, detach oneself from the world, and purify the soul. The dogma of the Christian Church made this a natural development: man since the fall from Paradise has been born in the state of original sin, inherited from Adam. Christ, the Son of God, came to save man from this deplorable state; to redeem the world Christ sacrificed Himself, gave His human life in the crucifixion. In the traditional Christian perspective, it was not enough merely to accept the validity of Christ's message. A more active role for the Christian was expected: to attain salvation it was necessary not only to abstain from sin but also to make an active renunciation of the world and the passions of the soul. The ultimate earthly goal of the Christian became the imitation of Christ's human life, in particular His suffering, as the best means to obtain heavenly grace. This goal of course had scriptural support, for in *The New Testament* are many exhortations to imitate Christ's example of suffering: "Whosoever will come after me, let him deny himself, and take up his cross, and follow me" (Mark 8:34), and, "For as the sufferings of Christ abound in us, so our consolation also aboundeth in Christ" (2 Corinthians 1:5).

In its early years, the Church was persecuted by the Romans and other non-Christians. At this time for a Christian to suffer and die as a martyr was the supreme form of renunciation and imitation of Christ. Once the persecutions ended and the Church became stronger and more settled, other forms of penance began to take precedence. The early Desert Fathers of the first centuries were the leading exponents of the ideal ascetic life, and their example was highly regarded and emulated among lay people. These virtuous monks resorted to the desert of North Africa in renunciation of the pleasures and comforts of the world, and there they led a simple and severe life of privation, undergoing fasts, physical hardships, and self-imposed mortifications.

The rigorous asceticism of the Desert Fathers was not an end in itself but rather a means to a higher end. The monks employed a systematic method of self-discipline in order to purify themselves of passional, worldly attachments that prevented their making progress upon the spiritual path toward union with God. Thus self-discipline was not simply a means of assuaging guilt or repenting for sin, but it was a means of reaching the essential goal that Christ promised His followers of "life eternal that they might know thee, the only true God and Jesus Christ whom thou hast sent" (John 17:3).

Ascetic practices were of no value in themselves; they were nothing without the grace given the practitioner by God's mercy. Rather, these practices provided the beginning, the first stage in the three-part progress of the soul toward God. The Desert Fathers, according to Evagrius, would explain to the neophyte monk this progress of the soul in the following terms:

> The fear of God strengthens faith, my son, and continence in turn strengthens this fear. Patience and hope make this latter virtue solid beyond all shaking and they also give birth to *apatheia* [impassivity]. Now this *apatheia*

has a child called *agape* [love] who keeps the door to deep knowledge of the created universe. Finally, to this knowledge succeed theology [knowledge of God] and the supreme beatitude.[7]

The love of God which provides the essential basis of divine knowledge and union is only truly meaningful and operative when it is based upon a rigorous control of the passions. This dispassionate state is achieved in its turn through ascetic practices, accompanied by patience and hope (that is, faith). Thus the ascetic practices of the early Desert Fathers and their followers were the basis of the path to achieving heavenly salvation, "the supreme beatitude."

In the early Christian era ascetic practices were not limited to those of the Desert Fathers and other monks but were widespread among the lay community, and they were conceived in the same terms as were those of the monks, though perhaps without as much subtlety or as much rigor and structured discipline. In the early Church there was much less distinction between the religious and lay communities in their spiritual values and practices than in later centuries. The Church constituted the "body of Christ," and the real distinction was between Christians and the rest of the world, in particular the pagan societies of late antiquity. The "world" that the good Christian sought to renounce was the worldliness and paganism of the non-Christian communities.[8]

As we have seen from the above discussion of the four levels of penance, full membership in the Church was only open to "the faithful"—those individuals in a state of grace, for the sacrament of Holy Communion—the essential link between divine and human—was closed to all who had deviated from the norm. It was also closed to the catechumens, who were the unbaptized neophytes not yet deemed worthy to take part in this sacred mystery.

The early Church, then, closely resembled a monastic order with rules pertaining to the requisites and obligations of membership: Christians were deemed to be "in the world but not of the world." Ascetic practices among the members were proportioned to the goal for which they were utilized: they opened the soul to the love and knowledge of God, which were the major goals of Christian worship. Thus all the members of the faith formed a more-or-less coherent whole and the laity shared the same ultimate desire as the monks, to reign eternally with Christ in His heaven.

It was the divine aspects of Christ which commanded the worshippers' attention, not His human life as such, and all efforts were focused upon His divinity. This is evident in the preeminent position given to images of Christ in Majesty over the sanctuaries of the early churches. Christ is seen enthroned in heaven; often He holds a book which is inscribed: "Ego Sum Lux Mundi" ("I am the light of the world," John 9:5).

This emphasis upon the divine majesty meant that for the worshipper his earthly sorrow or suffering was viewed not as an end in itself but as a necessary means to obtain his heavenly reward. Renunciation of the world and the passions was more than compensated by the love of God that it brought about and that in its turn led to salvation.

HOLY WEEK: THE FEAST OF FEASTS

The progress of the faithful toward salvation mirrored the crucial last events of Christ's life as they were annually reenacted during Holy Week. The passion, sacrifice, and resurrection of Christ provided a paradigm for the Christian to follow in his spiritual life, reflecting the three stages of fear, love, and union. The events of Holy Week constituted the essential message of Christianity, and therefore it was the most important festival of the ceremonial year. It was known as the Major Week (Latin, *Hebdomada Major*) and the Feast of Feasts (*Festum Festorum*).

While all Christians in the early Church took part in these crucial events, they were of particular significance for the penitents seeking absolution and the catechumens seeking baptism. For these two groups the process began with a period of strictly observed penance during Lent, the forty-day period preceding Easter Sunday. The modern ceremonies of Ash Wednesday, at the opening of Lent, derive from rites originally observed for penitents alone. Ashes—the purified residue of burnt matter—were an appropriate and obvious symbol of the purification required of the penitent. As Tertullian noted in the passage quoted earlier, the penitent was required to "lie in sackcloth and ashes."[9] Ashes also signify the evanescent, impermanent quality of the material world and thus of human life, and this idea is incorporated into the ceremony of Ash Wednesday. While the priest marks with ashes the sign of the cross upon the forehead of the worshipper, he says: "Remember man that thou are dust and unto dust thou shalt return." This saying prefigures the death of the worldly, external man that is to take place during Holy Week. It is a strong theme through later Christian thought.

The opening of Lent in the early Church concluded with the hanging of a veil before the sanctuary and the veiling of all holy images (in recent centuries on Passion Sunday, two weeks before Easter), which signified exclusion of the faithful as well as the penitent from the sacred mysteries during this period of penance.

During Lent both the penitents and the catechumens undertook a rigorous schedule of prayer and physical penance, including fasting (observed also by the faithful) and other forms of self-mortification. The catechumens were required to undergo a series of examinations known as the "scrutinies" in which their state of preparation for baptism was tested, and they were taught the prayers and rituals at that time still reserved for the faithful, including the Gospels, the Apostles' Creed, and the Lord's Prayer.

For the penitents and catechumens Holy Week itself marked a transitional period between two states, comparable to the transition on the spiritual path between the states of fear and love. In the first days of the week, their penances were increased in commemoration of the suffering of Christ, and more severe fasting and mortifications were enjoined upon all. Finally, on Holy Thursday, in addition to the sorrowful expressions of the day, a series of joyful ceremonies took place in which the love of Christ was made manifest. The penitents were absolved of their sins, thus returned to a state of grace, and the institution of the Holy Eucharist was commemorated.

The Holy Eucharist derives from the Last Supper before the crucifixion, in which Christ revealed to His disciples this saving sacrament: "Whoso eateth my flesh and drinketh my blood, hath eternal life; and I will raise him up at the last day" (John 6:54). Through the identification of bread and wine with Christ's body and blood, a means was provided for the faithful to take part in this most sacred mystery. The sacrifice of Christ—the shedding of His blood in His suffering and crucifixion—was the means of redemption, as Christ explained at the Last Supper: "And he took the cup and gave thanks and gave it to them, saying, Drink ye all of it; for this is my blood of the New Testament, which is shed for many for the remission of sins" (Matthew 26:27–28).

Finally, on Holy or Maundy Thursday, was the rite known as the *mandatum* (from which "maundy" derives), in which the bishop reenacted the washing of the disciples' feet by Christ (John 13:4–16). This ceremony manifested Christ's ideal of humility and selfless love: "If I then, your Lord and Master, have washed your feet; ye also ought to wash one another's feet. For I have given you an example that you should do as I have done to you. . . . A new commandment I give unto you (*mandatum*) that ye love one another; as I have loved you, that ye also love one another" (John 13:14–15, 34).

Christ's final and supreme act of love was commemorated on Good Friday. The death of Christ was both the epitome of sorrow and distress and the epitome of love, for His sacrifice made divine life possible for the faithful. The ceremonies of this day reflected both aspects of His sacrifice: it was the point of transition from sorrow to joy, from fear to love, from His earthly life to His divine life. The aspect of sorrow was served through the bare presentation of the interior of the church: the altar had been stripped of its ornaments, the images were all covered over, and the priests wore black vestments. The Tenebrae (darkness) ceremony (later performed on Wednesday and Thursday nights) had the aspect of a funeral dirge in which sorrowful lamentations were sung while fourteen candles were one by one extinguished. The fifteenth candle, at the top of the triangular candelabra (Spanish, *tenebrario*), represented Jesus Christ. It remained lit but was hidden behind the altar, plunging the church into darkness. At this moment loud, raucous noises were made; the rattling of chains, whirling of cog rattles, and other unearthly sounds symbolized the moment of chaos at the death of Christ (see plates 102 and 103).

In contrast, the Adoration of the Cross, also on Good Friday, represented the aspect of love. Just as Good Friday was the moment of transition from sorrow to joy, so the cross was the supreme symbol of that transition, for it represented both the instrument of the death of Christ and the instrument of man's divine regeneration. The cross, shrouded with all the other images in the church, was gradually unveiled while the priest chanted the anthem, "Behold the wood of the cross on which hung the salvation of the world," and the worshippers responded, while kneeling, "Come, let us adore."[10]

In the early Christian era the Tenebrae was performed on the night of Good Friday, leaving the church dark on Holy Saturday, and so it remained until late in the evening when the paschal candle was ceremoniously lit, ending the vigil and signifying the approaching Day of Resurrection. At this time the catechumens finally received their baptism, in preparation for taking part in their first Holy Communion, which was usually held at midnight of Easter morning. The resurrection of Christ symbolized the triumph of the eternal over the ephemeral, of eternal life over the inevitable limitations of the human state. In terms of the spiritual progress of the soul, the Day of Resurrection represented the firm establishment of the love of God. The earlier state of fear of God had been transcended, or more precisely its conditions so surely mastered that they no longer had hold of the individual. The *apatheia* (impassivity) spoken of by Evagrius had now been born, as well as the love that springs from it.

The Feast of the Ascension of Christ to heaven "to sit on the right hand of the Father" symbolized salvation for the faithful, the ultimate goal of divine union. The date of the Ascension exactly forty days after Easter provided a perfectly symmetrical sequel to the Lenten cycle:

<div align="center">

Ash Wednesday (Penance)
Forty days of Lent
Easter (Love)
Forty days of Easter cycle
Ascension (Union)

</div>

Paschal Tide, the period from Easter to Pentecost, was considered a joyous time, a continuous feast in which penance no longer had a place. There was no fasting in this period and prayers were said standing instead of kneeling. As Adolphe Tanqueray has noted, "The Feast of the Resurrection and the season of Easter recall to us Christ's glorious risen life, the model of the unitive way. This life is heavenly rather than earthly. . . . This is the model for souls in the unitive way, henceforth seeking solitude in order to converse

intimately with God. . . . The Ascension symbolizes a still higher degree of union with God."[11]

In the early Church the entire cycle from Ash Wednesday through Ascension Day was viewed as a coherent whole. In it the mystery of Christ's dual nature, both divine and human, was revealed, as well as the meaning of His sacrifice for man. For the faithful the essential aspect of this cycle was the transformation of the worldly man into the deified man. This was of course of special significance for the catechumens, who had to die to the world and the past and be reborn as new men and women. Thus for them, as for all the faithful, the death of Christ was transformed from a sorrowful to a joyful event. It was the death of the "old man" tied to the impermanent, finite world and the birth of the new man born in the spirit to participate in eternal life:

> Know ye not, that so many of us as were baptized in Jesus Christ were baptized into his death?
> Therefore we are buried with him by baptism into death: that like as Christ was raised up from the dead by the glory of the Father, even so we also should walk in the newness of life. . . .
> Knowing this that our old man is crucified with him, that the body of sin might be destroyed, that henceforth we should not serve sin. . . .
> For the wages of sin is death; but the gift of God is eternal life through Jesus Christ our Lord (Romans 6:3, 4, 6, 23).

The crucifixion is a sad event from the point of view of the world and the ego, for it represents the departure of Christ from this world, "And as long as I am in this world, I am the light of the world" (John 9:5). But from the point of view of the spirit and man's ultimate ends, the crucifixion is a joyful event, for it represents the death of the passions and of the sins resulting therefrom, which tie man to the world and cut him off from salvation.

In its original sense in the early Church the rite of baptism, which followed the death of the "old man," was not lightly or casually bestowed upon the catechumen. It was quite literally a rite of passage or initiation from the state of penance to the state of love, and thus corresponded directly to the level of spiritual development of the neophyte. The scrutinies performed during Lent tested not only the catechumen's seriousness of intention and his formal preparation but more importantly his spiritual preparation: the extent to which through penance and abstention he had mastered his passions, practiced the virtues, and truly understood the inner significance of the dogma and sacraments. Following Greek practice, the rite of baptism was considered to be an enlightenment (fotismos): to be a Christian was to comprehend the divine light which was Christ. Divine light signifies life in the spirit, eternal life, knowledge of God: "In him [Christ] was life; and the life was the light of men" (John 1:4). Due to the clouded and sinful condition of humanity at the time of Christ, there were few who understood the significance of divine light and hence the purpose of human life: "And the light shineth in the darkness; and the darkness comprehended it not" (John 1:5).

Thus for Christians baptism was an enlightening, a dispelling of the darkness caused by sin and the denying of God's will. During the ceremony of baptism the miracle of the blind man receiving sight from Christ (John 9) was recited, a fitting parable for the enlightening of the catechumens. The lighting of the paschal candle on Easter Eve coincided with the performance of the rite of baptism for the catechumens, who received the "true light" of Christ "which lighteth every man that cometh into the world" (John 1:9).

The equating of baptism with enlightenment finds scriptural support in the teaching of St. Paul (Hebrews 6:4, 10:32), but more importantly, following the Johannine symbolism, it demonstrates the emphasis in the early centuries of Christianity upon the spiritual states of love and knowledge. The purpose of life was enlightenment—that is, knowledge of God—which ultimately is union with God. This enlightenment had to be based upon justice and love. Justice corresponds to penance; it is the rigorous example of Christ in which all wrongs are righted, all errors corrected, and all sins repented. Love in its broadest sense draws upon the merciful example of Christ, in whom all the virtues are present. Only through practice of the greatest of the virtues, which is charity (love manifested as selfless generosity), can enlightenment—knowledge of God—be reached:

> And though I have the gift of prophecy, and understand all mysteries, and all knowledge; and though I have all faith, so that I could remove all mountains, and have not charity, I am nothing. . . .
> And though I bestow all my goods to feed the poor, and though I give my body to be burned, and have not charity, it profiteth me nothing. . . . For now we see through a glass darkly; but then [on the Day of Judgment] face to face: now I know in part; but then shall I know even as also I am known (I Corinthians 13:2, 3, 12).[12]

In the Catholic Church the practice of penance has never been an end in itself, or a separate way to salvation (a way of action), for it was realized that man could not be saved by works alone. Penance rather was the necessary first stage through which the soul must pass in its journey towards God. Although from the earliest days of the Church all forms of penance and renunciation of the world played an important part, they were always compensated by the love of God for which they prepared the soul. In actual practice the Church institutionalized means to enhance the progress of the soul toward salvation; these means were in particular the sacraments of baptism, penance, and communion. Since salvation was dependent upon following the example and precepts of Christ, the ceremonial cycle of Easter provided an annual performance of rituals in which all participated in the three states of fear, love, and union.

Penitential Practices in Medieval Europe and Spain Through the Eighteenth Century

PENANCE IN THE MIDDLE AGES

IN THE MIDDLE AGES major changes in the Catholic Church and European society produced a thorough-going reorientation of Christian worship. Beginning in the eleventh century, critical ecclesiastical and social conditions led to a series of papal and monastic reforms and to the emergence of popular religious movements of great import for the Church. In tracing the origins of these developments one has to look back to the fourth century, when there began a gradual but steady series of changes in both theology and liturgical practice as well as an increasing complexity in the structure of the Church and the modes of European secular life.

In the early Christian period, as we have seen, the rite of baptism initiated the individual into active participation in the mysteries of the religion. The baptized faithful took full part in the essential sacrament of the Holy Eucharist, co-celebrating it with the bishop and clergy. The Church at this time was a unified corporate body, the organic "body of Christ" in which all its members in principle were sanctified. After the fourth century a gradual eroding of the part played by the laity took place. Increasingly, the saving sacrament of the Eucharist was performed by the clergy alone, for the benefit of the faithful, who became a passive audience, no longer co-celebrating the rite. The organic wholeness of the Church as the body of Christ gradually weakened; the laity became separated and distant from the Church hierarchy and the sanctifying means of grace. As baptism lost its meaning as the rite of passage to full participation in the spiritual life, so too the faithful lost the means for this participation. More and more, the living of a fully meaningful spiritual life was only possible for the clergy and for members of monastic institutions.

At the same time, theological changes that reflected these liturgical changes were taking place in the Western Church. The early Church had emphasized Christ's divinity, that is, His divine nature and His eternal reign upon the right hand of the Father. In this transcendent view, the focus had been upon the necessity and the means for Christians to reach the heavenly plane, to transcend the earthly plane of corruption and death.

In the Middle Ages there arose in the Catholic Church a definitive change from emphasis upon Christ's divinity to His humanity, in particular His suffering and crucifixion. This new perspective was one which in practical terms engaged the human will, for it emphasized above all else the need for penance: the need, through an act of the will, to imitate Christ's human life and to conform one's will to the divine will. By the faithful of the medieval Church, divine union was now seen simply as this conformation of human to divine will. In contrast, the earlier transcendent view, which continued in the Eastern Orthodox Church, stressed the intellect. In this view union is not merely a conformation of the human with the divine will (although this is a necessary basis), but it is the more essential uniting of the intellect—the heart—of man with the divine Intellect. Thus it is union in its deepest sense: the divine which is immanent within man becomes one with the divine which transcends man. Ultimately, then, the individual will has little place in this earlier view, for the individuality in its limitative sense ceases to exist.

Emphasis upon Christ's human life found theological expression as early as the sixth century, when the Second Council of Constantinople in A.D. 553 declared that both the Incarnate Word of God (Christ's divinity) and His flesh (Christ's humanity) were worthy of adoration.[1] This provided justification for the much later devotion to Christ's suffering and other aspects of His human life. The Roman Church gradually began to take up this new emphasis and to move away from the transcendent position still maintained in the East. In the empire of Charlemagne (A.D. 742–814) these new trends began to emerge, including the rejection of the transcendent role of holy images and the beginning of active devotion to Christ's suffering humanity.[2]

These tendencies culminated in the mid-eleventh century, when in 1054 the break occurred between the Western and Eastern Churches. The schism was symptomatic of the direction in which the Church of Rome was going, and it opened a new period for this Church in which its particular characteristics first became fully manifest, characteristics which were to dominate Catholic life and thought for the next 900 years.

The major theological cause of the schism in 1054 was an issue which today may hardly seem important enough to produce such an effect, but at the time was crucial and expressive of the differing perspectives of the two Churches. The Roman Church for several hundred years had insisted upon adding to the Apostles' Creed (the wording of which was supposed to be inviolable) the idea that the Holy Spirit proceeded both from God the Father "and from the son" (filioque). The Eastern Church held to the traditionally accepted idea that the Spirit proceeded only from the Father. They thus continued to emphasize the oneness and transcendence of the Godhead, which was "beyond being" and upon which both the Second and the Third persons of the Trinity must necessarily depend. This was the transcendent view; in contrast, the Church of Rome held a Christ-centered view that in practice determined its new direction.

Two other ecclesiastical issues divided the two Churches: the question of holy images and the marriage of the clergy. The Eastern Church, as we have discussed at length elsewhere,[3] advocated the transcendent view of the role of religious images: they were seen as bridges between the divine and human and thus as a means to help the soul ascend to divine union. Hence they were sacred objects worthy of veneration. The West since the days of Charlemagne advocated a much more circumscribed view of images: they were justifiable primarily as didactic aids and also as objects of intercession and devotion.

With regard to the long-standing question of clerical marriage, in the eleventh century Rome forbade priests to marry, while in the Eastern Church this practice continued. The roots of this issue are complex, but one of the major factors—and the one most relevant to the present discussion—was the fact that celibacy had been a long-accepted form of penance, a way of renouncing the world, and an aid to prayer and contemplation. Thus from the eleventh century the Roman Catholic clergy was marked above all by its renunciation of this most precious of worldly blessings, the conjugal state. This helped to set a penitential example within the Church, but it also led to many problems.

In the eleventh century the new emphasis upon Christ's suffering humanity engendered the urgent need for the faithful to imitate Him and to devote their own lives to penance and expiation of sins. What were the more immediate causes of the new attitude?

This period in Western Europe was marked by a pervasive sense of the corruption and impending doom of both Church and society. Christians were becoming worldly and secularized: they were falling away from the spiritual ideals of Christ and the early Church. Many were convinced that the long-awaited Day of Judgment was finally at hand, and they felt the vital need for thoroughgoing and immediate reform, both of institutions and of individual lives.

The early Church had had its strength in the desert, in isolated monastic communities devoted to a life of prayer. The Christians who did live in cities had formed an unworldly and often persecuted minority, out of touch with secular affairs. By the eleventh and twelfth centuries this situation had changed completely. The population in Western Europe, previously quite stable, tripled during this period, and thriving cities and towns became the centers of newly developing economic activities: "Merchants emerged to take a dominant place in the new urban society, along with such new professionals as bankers, notaries, lawyers, doctors, and schoolmasters. Most pervasive of all was the greatly expanded quantity and use of money, the lifeblood of the market economy."[4]

Thus the faithful had become secularized and increasingly devoted to the things of this world, in opposition to traditional Christian teaching and practices concerning the virtues of poverty and unworldliness. Neither the Church hierarchy nor the monasteries were able to deal adequately with the problem. Rome was concerned more than ever with international questions, political intrigues, and ecclesiastical abuses needing correction. The monastic institutions had become lax in observance of their originally strict rule, and often they no longer provided an outstanding example of Christian piety for the laity to emulate. Many concerned individuals saw in these conditions signs that the end of the world was imminent, and they set about the task, in preparation for the coming Judgment, of regenerating the original apostolic spirit of Christianity.

A series of reforms, with penance as their keynote, began in the eleventh century; they affected all aspects of religious and secular life. Monastic reformers, such as Saint Romuald of Ravenna (ca. 950–1027) and Saint Peter Damian (1007–1072), attacked the spiritual laxity of the monasteries in northern Italy—in particular their wealth and commercial dealings—because they saw this worldliness to be incompatible with Christian ideals:

> How, o monk, do you mean to lay Christ up in your cell? First, cast out money, for Christ and money do not go well together in one place; if you shut them both up at the same time, you will find yourself the possessor of one without the other. The richer you may be in the poor lucre of this world, the more miserably lacking you are in true riches . . . let terrestrial wealth give way where celestial treasure is admitted![5]

The founding of new monasteries and the reforming of older ones continued to spread throughout Western Europe in the eleventh and twelfth centuries. Of particular importance were the congregations of canons regular (known as the Augustinian canons), whose most noted spokesmen were Hugh and Richard of St. Victor in Paris and the Cistercian order founded by Saint Robert of Molesme in 1098.

The Cistercians, and in particular their renowned

Saint Bernard of Clairvaux (1090–1153), were to a great degree responsible for the spread of devotion to Christ's humanity throughout Western Christendom in the twelfth century. They advocated a new form of spiritual practice that was particularly centered upon Christ's suffering and upon the life and merciful role of the Virgin Mary.

Saint Bernard and the Cistercians set an example for the laity with their rigorous practices, but they did not directly address the problems of the secular realm—the moral laxity, materialism, and apathy that had arisen in the new mercantile urban society—for they continued to practice a hermetic withdrawal from the world. These severe social problems were to be met in the early thirteenth century by a new kind of clerical order.

The new mendicant orders, in particular the Order of Friars Minor (Franciscans) established by Saint Francis of Assisi (1181–1226) and the Order of Preachers (Dominicans) established by Saint Dominic (1170–1221), were devoted to living an active life in the world. Their members not only lived the strict personal life of ascetic monks, but they also committed themselves to spreading the spirit of moral reform among the laity. The mendicant friars sought a far-reaching regeneration of Christian fervor, in the belief that lay people, as well as monks and clergy, should lead a meaningful and serious spiritual life.

To reach the hearts of the people, the friars, after rigorous training in the convent, plunged themselves into the world. They undertook the preaching of penance to the laity, particularly in cities and large towns, where the greatest problems existed. The constitution of the Dominican Order of Preachers explicitly stated that "our order was instituted principally for preaching and for the salvation of souls."[6] The Franciscans also were dedicated to preaching and salvation, and they stressed above all else the ideal of poverty. Owning no property as individuals and dedicating themselves completely to God, they set an example in the practice of renunciation and virtue for the faithful to follow.

Through the preaching of a new devotional form of spirituality based upon penance and the imitation of Christ, the friars sought to end the alienation of the laity from the Church and to provide anew the means for personal sanctification. In this they were remarkably successful. The Dominicans and Franciscans, as well as the two other great mendicant orders, the Carmelites and the Augustinian canons, worked an immediate and far-reaching spiritual renovation in Europe in the thirteenth and fourteenth centuries, a time when spiritual conditions were at a low ebb. The faith and fervor we today associate with the late Middle Ages to a great degree arose from their efforts, and their influence continued to be strong for the next 500 years. Not content to limit their efforts to Western Europe, the mendicant orders sent missionaries all over the known world and played an essen-

tial part in the settlement and Christianization of the Americas.

The saints produced by these orders continued to inspire the faithful for centuries. Among them were many who would still be revered in New Spain (Mexico) in the eighteenth and nineteenth centuries, including Dominicans such as Saint Dominic, Saint Thomas Aquinas, Saint Vincent Ferrer, Saint Rose of Lima, and Saint Catharine of Siena, the last two being members of the Dominican lay Third Order. Among the Franciscans following Saint Francis of Assisi were Saint Anthony of Padua, Saint Bonaventure, Saint Bernardino of Siena, and Saint John Capistran, all of whom were renowned preachers, and there arose from the Franciscan Third Order other revered saints such as Saint Louis, King of France; Saint Ferdinand, King of Leon and Castile; Saint Rosa of Viterbo; and Saint Margaret of Cortona.

LAY ORDERS, CONFRATERNITIES, AND THE PRACTICE OF SELF-MORTIFICATION

In thirteenth-century Europe the preaching of penance by the friars began to awaken faith in thousands of individuals, many of whom flocked around the friaries seeking to live a purer and more regulated spiritual life. This led to the founding of lay orders by both the Franciscans and the Dominicans, known as the Third Orders of Penance, as well as similar groups under the aegis of the Carmelites and Augustinians.

The members of the Third Orders were chosen for their religious zeal and evidence of a pure life. The rule by which they lived included simplicity in dress; daily recitations of the Lord's Prayer and the Ave Maria; confession and communion at least three times a year; fasting during Lent, weekly on Fridays, and at other times during the year; aid to the infirm and other charitable work; obligatory attendance at any member's funeral; and monthly meetings in the Church for a special mass, sermon, and moral instruction.

The Third Orders gave the opportunity for lay people, who were married and had to earn a living, to live like friars as far as that was possible given their secular obligations. Thus membership in a Third Order provided a means for personal sanctification. Lay people began again to participate in the stages of the spiritual life, marked first by penance, then by love and union. The rise of the Third Orders in the thirteenth century formed part of the Church's renewed efforts to minister to the needs of the people and to involve them more directly in religious life, and the Third Orders helped to channel and control the great spiritual enthusiasm and awakening of faith, which the parent mendicant orders had to a great degree instigated.

Lay confraternities similar to the Third Orders also began to assume greater importance in the thirteenth century. Many of them arose under the sponsorship of the Franciscan and Dominican friars, but they dif-

fered from the Third Orders in that they were not formally incorporated into the parent mendicant order. Many arose spontaneously through the fervor of the laity and later received (in some but not all cases) the approval and guidance of the Church. Unlike the Third Orders, they usually had a quite specific purpose for their existence: devotion to a particular aspect of Christ or the Virgin Mary, to a particular liturgical observance, or to the accomplishment of certain charitable works. The prime motive for joining either a confraternity or a Third Order was the desire for a more meaningful spiritual life, and both organizations included many of the same features, such as daily prayers, communion, confession and self-mortifications, charitable works, and monthly meetings under the guidance of a friar or priest.

The first stage in leading a serious spiritual life was the practice of penance for the remission of one's sins, and in both the confraternities and Third Orders various forms of mortifications were practiced on a regular basis. Chief among them was self-flagellation.

Flagellation had long been an accepted practice in the Church, utilized by the early Desert Fathers as part of their discipline, and it had continued to be practiced in the monasteries into the Middle Ages. It had a scriptural basis in the scourging of Christ before the crucifixion (Matthew 27:26; Mark 15:15; John 19:1) and thus formed a part of the devout imitation of Christ's suffering, a widespread practice since the eleventh century. Also, flagellation was a common civil and ecclesiastical punishment and was used by the Church as a form of public penance for the remission of sins. The severe penance prescribed by Saint Peter Damian and other eleventh-century monastic reformers included the regular practice of self-flagellation, and Saint Peter wrote extensively upon the purifying effect of bodily discipline upon the soul.

The Franciscan and Dominican friars practiced flagellation as part of their rigorous discipline of self-abnegation. They instituted this and other forms of self-mortification in the Third Orders and in the confraternities which flowered under their sponsorship. In the early thirteenth century confraternities devoted to flagellation began to gain prominence, inspired not only by the friars but also by the earlier practices of the Cistercian and the Camaldolese monks, such as Saint Peter Damian. As early as 1233 the Dominicans began to promote penitential processions, which included self-flagellation.

In the year 1260, the sense of the impending Day of Judgment was heightened by the devastating plague of the previous year and the chaotic political conditions then prevailing in Italy. In response, at Perugia, groups of flagellants took to the streets to perform public penance in the hopes of expiating the sins of Christendom and appeasing divine wrath. The year 1260 was a prophetic moment, for the millennialist followers of Joachim de Fiore (ca. 1132–1202) had predicted that the cataclysmic end of the decadent age would occur that year. It was to be followed by the new Age of the Holy Spirit, in which, guided by reformist friars, the original spiritual purity of the early Christians would again prevail.[7]

The flagellant movement of Perugia quickly spread, and soon penitential processions of as many as 10,000 people passed through the cities of Italy and elsewhere in Europe. Often they were led by friars and priests carrying cross-staffs and banners, while the flagellants followed them, stripped to the waist, with faces covered or masked. As they marched they scourged themselves, while singing devotional hymns of Christ's suffering.

In 1261 Pope Alexander IV prohibited flagellant processions, and for a period of time these extreme mass observances died out, but the practice of flagellation within the orders and confraternities continued. In Italy many more groups sprang up, calling themselves *battuti* (whippers) and *disciplinati* (flagellants). In Siena, Bologna, and elsewhere they established their own centers known as *Casas di Dio* (Houses of God), where they met for their penitential exercises and other devotions. These houses also served the simultaneous purpose of providing aid to the infirm and the poor.

The onset of the terrible plague in 1347 known as the Black Death and subsequent earthquakes in Italy, as well as ecclesiastical and political chaos, evoked another spontaneous outburst of penitential fervor, for again it was thought that the Day of Judgment was approaching. By 1349 flagellant confraternities and their huge processions had spread all over Western Europe, with the goal of expiating the sins of all mankind. At first the Church lent support to this movement; Pope Clement VI actually instituted flagellant processions at Avignon, France, early in 1349, but in October of that year he condemned the flagellants, declaring them heretics and forbidding their processions. Again the movement quickly died out. There were, however, occasional isolated outbreaks for the next 200 years, and self-flagellation as a private practice continued for many centuries.[8]

That the Church at first lent support to these flagellant processions may seem strange, but it is explained in part by the remarkable beneficial effects they had in the beginning. The powerful outpouring of penitential fervor brought people to their moral senses; it reminded them of their sins and tended to melt the hardness of their hearts that separated them from each other. At the beginnings of these penitential outbursts long-standing enmities were resolved, debts paid, and prisoners released, as suddenly the faithful were all of one heart again.

However, in both 1260 and 1349 these movements quickly became uncontrollable popular enthusiasms. Leaders of the flagellant groups, particularly in northern Europe, soon began to promote flagellation as a direct road to salvation. They advocated a religion entirely of penance, a cult of suffering in which only

physical penance could bring man close to God. They even denied the necessity of the holy sacraments of the Church, thus denying the sanctifying role of grace received by man through the sacraments. This extreme ego-centered attitude was an inversion of the hierarchy of the divine and human worlds, for it suggested that salvation could be achieved by man's efforts alone.

The norm for Christian practice in the late Middle Ages was for penance in general, and in particular flagellation, to be but one aspect—albeit an important one—of the spiritual life. It was the necessary aspect of self-denial, practiced in an active physical form by virtually all Christians. In most confraternities, however, even in those founded upon self-mortification, flagellation was maintained within bounds, regulated by their constitutions and their spiritual advisors. Thus the fourteenth-century penitential confraternity at Bologna, founded under the Dominicans, although they were named "the Flagellants of Saint Dominic," "aimed just as much at mutual support in trouble, their ordinances display not so much divine retribution as divine love, and they aimed to hear Mass daily, to confess and communicate four times a year. As for discipline [self-scourging], it is clearly only one form of devotion not the norm."[9]

PENITENTIAL PILGRIMAGES

In addition to flagellation, penance in the Middle Ages took many other forms, for Christians felt a pressing need to expiate their sins and reform their lives in preparation for the coming Apocalypse. Of great importance in this regard were the Crusades and the pilgrimages to holy shrines, which assumed an almost sacramental quality. The first great Crusade against the Saracens in 1095 and a series of successive Crusades were undertaken as acts of penance, with great sacrifices made by those taking part. The pilgrimages to Jerusalem, Rome, Santiago de Compostela, and other holy shrines were also undertaken as acts of penitential devotion.

In the Middle Ages, Christian life was seen as one long pilgrimage, a trail of hardship and penance towards the divine goal. The actual pilgrimage was then a mirror of life itself, an encapsulation of all the sufferings and concomitant joys of the devout life. Through taking part in it, the pilgrims sought to redeem themselves and be reborn in the life of the spirit.

A pilgrimage, unlike a secular journey, was not undertaken lightly or with great concern for creature comfort. Rather it required, in order to be valid and efficacious, a series of penitential acts in its preparation and throughout its duration. Pilgrims were expected to perform expiations before embarking, making amends for previous sins and faults. They often gave away large sums of money as an act of voluntary poverty prior to making their journey. The pilgrimage itself was intended to break down the walls of indi-

viduality that the holding of wealth and property erected between Christians, to achieve the goal of selfless love advocated by Christ:

> The way to Santiago [de Compostela] is fine but narrow, as narrow as the path of salvation itself. That path is the shunning of vice, the mortification of the flesh, and the increasing of virtue. . . . The pilgrim may bring with him no money at all, except perhaps to distribute to the poor on the road. Those who sell their property before leaving must give every penny of it to the poor. . . . In times past the faithful had but one heart and one soul, and they held all property in common, owning nothing of their own; just so, the pilgrims of today must hold everything in common and travel together with one heart and one soul.[10]

The pilgrim traveled on foot, sometimes barefooted, in simple clothing, enduring many physical hardships on a journey that often took years to complete. The holy shrine at the end of the journey symbolized salvation, the Heavenly Jerusalem. By the time he arrived, a sincere pilgrim had emptied his soul of sin and was thereby prepared to receive the blessings of the holy place and the holy image within the sanctuary, the means through which divine grace was transmitted. Thus the successful pilgrimage was in a sense a second baptism, a rebirth into the life of the spirit achieved through the crowning of personal effort by divine grace. Many of the faithful followed their pilgrimages by becoming monks or nuns, for the event marked a profound change in their lives.

LOVE AND UNION IN THE MIDDLE AGES

It must be stressed that the norm in the Middle Ages was not that penance be practiced as a path in itself but rather that it be incorporated into a balanced and fulfilling spiritual life. It is not surprising then that the rigorous aspects of Christian worship had tender and merciful counterparts. The severity of a Saint Bernard, a Saint Francis, or a Saint Dominic was balanced by their merciful tendencies and devotion to the love of God. Saint Bernard, who preached a strict adherence to the imitation of Christ's suffering, also was known for his exaltation of the merciful qualities of the Blessed Virgin. Saint Francis advocated a strict imitation of Christ and received the stigmata in evidence of his personal devotion to His suffering. However, Saint Francis's tender side included devotion to Christ's childhood, advocation of the Blessed Virgin, and a great love of nature as evidence of God's mercy. Saint Dominic is credited among other practices with the popularization of the saying of the Holy Rosary, which became an essential means to grace in later centuries.

The devotion to Christ's human life, which became so important in the Middle Ages, included not only His suffering but also His tender and merciful aspects. Interest in His holy childhood found expression in many ways. New attention was given to the Nativity, fostered by, among others, Saint Francis, who is credited with popularizing the Christmas

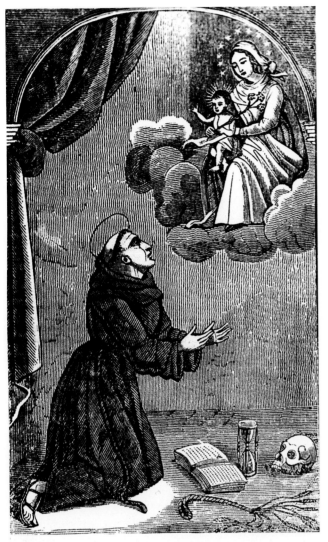

Fig.2.1. Saint Francis of Assisi, founder of the Franciscan order. This nineteenth-century engraving simultaneously depicts the penitential and merciful aspects of Saint Francis. Through his rigorous ascetical practices, symbolized by the flail, and his consciousness of the evanescence of human life, symbolized by the skull and the hourglass, he has received a merciful vision of the Holy Virgin and Christ Child. The book may be taken to represent both his faith and devotion and his wisdom. (From José Arlegui, *Crónica de la Provincia de N.S.P. Francisco de Zacatecas*, Mexico, 1851.)

créche scene. Devotion to the Holy Family of Jesus, Mary, and Joseph as exemplars of the human family gained popularity in the late Middle Ages. Of equal importance were the growing cults of the Holy Virgin and the human saints, who became intercessors with heaven for divine mercy. Shrines to the Virgin and to many of the saints sprang up all over Europe. Through the intermediacy of images and relics, these holy personages were credited with miracles, cures, and the saving of souls.

In the cult of the Virgin Mary, in particular, the aspect of love was developed. Seen from the point of view of love, the Visitation and the Incarnation were paradigms for human salvation, for the Blessed Virgin was the perfect human soul, pure and self-less, the most fitting receptacle for the word of God. The Immaculate Conception of Mary—promoted especially by the Franciscans—later became an important Church doctrine. It stated that Mary too must have been born without taint of original sin, thus placing her in a special, elevated status above the rest of humanity. In devotion to Mary there flowered the varied richness and beauty of Catholic life, belying the notion that the Middle Ages were merely a grim and penitential time. Music and poetry dedicated to the Blessed Virgin were expressions of faith and love found in every country but most especially in the Mediterranean regions. The *laudes*—hymns of praise for both Christ and Mary—were an integral part of Christian worship, promoted especially by the mendicant orders and the confraternities. In Italy, particularly in Tuscany in the thirteenth century, the members of guilds and confraternities "had an ancient custom of assembling at the hour of the Ave Maria, after their day's work was done, either in their chapels or at the street corners before the images of the Madonna, to pray and sing hymns of praise, called Lauds. A company of Laud-singers (Laudesi) was formed in Florence at the end of the twelfth century."[11]

The angelus—the ringing of the church bells three times daily in honor of Mary—was an institution of the Franciscans that soon spread all over Christendom. It was a public way of remembering the Blessed Virgin on a regular, daily basis. The complement to the angelus in private devotion was the daily recitation of the rosary, a personal remembrance and prayer to the Virgin.

In the Middle Ages the spiritual path still had its traditional goal of union with God. The flowering of mysticism at this time bespeaks the serious desire for union, and mystical writers such as Saint Bernard, Saint Catharine of Siena, Meister Eckhart, Johann Tauler, Heinrich Suso, and many others (often members of the mendicant orders) expounded upon the surpassing love that leads to divine union. The pursuit of this elevated goal was not limited to clerics and friars but had a popular basis. There were lay confraternities such as the Brothers and Sisters of the Common Life, which became the Windescheim congregation of Augustinians in the late fourteenth century. For these devotionalists, as they were known, the inner life was of first importance: "through assiduous application, meditation and the removal of worldly distractions, they sought to infuse [the externals of religion] for the individual practitioner with a rich interior significance—one hinging characteristically on the life and example of Christ and designed to foster a tender piety toward his humanity."[12] One of the outstanding contributions of the devotionalists was the work of Saint Thomas a Kempis, *The Imitation of Christ*. This perceptive, easily accessible mystical treatise, which summarized the means and ultimate goal

of the religious life, had a tremendous influence upon lay spirituality all over Western Europe.

In their instruction and public preaching, the mendicant friars introduced spiritual methods to the laity, methods that were formerly practiced only by monks, nuns, friars, and clerics. The use of the rosary, and in particular the Ave Maria prayer within it, was an effective traditional method, for in saying it the practitioner invoked the divine name of Jesus and prayed for salvation through the intermediary of the Blessed Virgin: "Hail Mary full of grace, the Lord is with thee; blessed art thou among women and blessed is the fruit of thy womb, Jesus. Holy Mary, Mother of God, pray for us sinners now and at the hour of our death, amen."

The use of the rosary was complemented by an even simpler and equally efficacious recitation of the divine name of Jesus, popularized by, among others, Saint Bernardino of Siena. In his public preaching the Franciscan Bernardino would hold up a placard upon which the Holy Monogram of Jesus (IHS) was inscribed, and he would speak eloquently of the spiritual blessings to be derived from contemplating and reciting this name. By constant recitation, com-

Fig.2.3. The Monogram IHS is a traditional abbreviation of the name of Jesus, dating back to the third century of the Christian era. Its use by Saint Bernardino, Saint Vincent Ferrer, and others was to provide a focus for the invocation of the Holy Name of Jesus. The inscription on this woodcut reads, "Jesus is brighter than the sun and more fragrant than balsam; sweeter than all sweetness, more lovable than all things. May the name of Our Lord Jesus be blessed forever." Late fifteenth-century woodcut. (Courtesy of National Gallery of Art, Washington, D.C., Rosenwald Collection B-3385.)

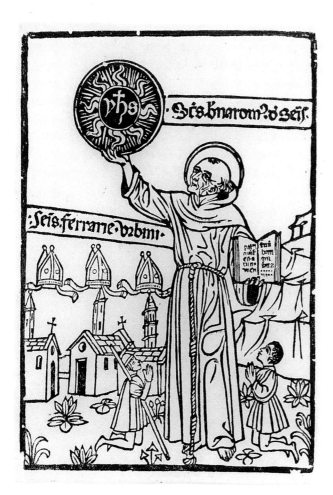

Fig.2.2. Saint Bernardino of Siena, holding the placard of the Holy Name of Jesus. Northern Italian woodcut, 1470–1480. (Courtesy of National Gallery of Art, Washington, D.C., Rosenwald Collection B-3297).

bined with penance and faith, the practitioner would eventually inscribe the name upon his heart: "The best inscription of the Name of Jesus is that to be found in the innermost heart of hearts: the next best is in words, and finally the visible Name written or carved."[13] Devotion to the name of Jesus was an ancient spiritual method that Saint Bernardino in his preaching made

> accessible to all men in an immediately understandable manner, that devotion which in its most direct form, as concentration upon the inwardly-spoken Name, has been from time immemorial one of the chief means of spiritual concentration. . . . The holy man of Siena thus made one of the most inward treasures of contemplative tradition outward and popular, doing so deliberately with the object that for many, through its compelling power, it might become inward again.[14]

Practices such as praying the rosary and reciting the divine name required penance and a state of pu-

rity as their firm basis, but more than that, they required faith and a fervent confidence in God's grace. It is in this sense that medieval Catholicism, in spite of an exterior emphasis upon works, is ultimately a religion of faith, a way of love, for it is through the "perfection of faith" that love becomes real and fully perfected itself:

> Knowing that a man is not justified by the works of the law, but by the faith of Jesus Christ, even we have believed in Jesus Christ, that we might be justified by the faith of Christ, and not by the works of the law: for by the works of the law shall no flesh be justified. . . . I am crucified with Christ: nevertheless I live; yet not I, but Christ liveth in me: and the life I now live in the flesh I live by the faith of the Son of God, who loved me and gave himself for me (Saint Paul, Letter to Galatians 2:16,20).

PENANCE IN SPAIN

Spain faced unusual political and cultural problems in the medieval period due to the Moorish occupation, which began in 710 and lasted until 1492 when the last stronghold, the Islamic Kingdom of Granada, was finally vanquished. In spite of these outside cultural and political pressures, the Spanish Church in the Middle Ages was closely allied with Rome, and Catholicism in Spain reflected the same series of transformations that had taken place in Christian thought and practice in the rest of Europe.

The monastic reforms of the eleventh century soon spread to Spain. French Cluniac monks established new monasteries in Castile and Leon with the express purpose of uplifting the moral quality of monastic life. In the twelfth century Cistercian monks from Citeaux in Burgundy followed the Cluniacs, founding reformed monasteries in northern Spain.

The new mendicant orders of the thirteenth century were quick to establish themselves in Spain. Saint Dominic was of Castilian birth, so the Dominicans were especially influential. The Franciscans, once they overcame early difficulties of acceptance by the secular clergy, became very powerful in Spain. As in other parts of Western Europe, the mendicant friars in Spain reached out to the people, preaching the need for personal repentance and living a spiritual life. At an early date, the mendicants were responsible for establishing their Third Orders and confraternities in Spain. For instance, in Salamanca the Brotherhood of Penance of Christ (Hermanos de la Penitencia de Cristo) was founded in 1240 and established a hermitage dedicated to the Holy Cross on the grounds of the Franciscan convent.[15]

The practice of penitential self-flagellation developed in Spain in a similar manner and for the same reasons as in the rest of Western Europe, but it never reached the extreme proportions, so threatening to the Church and the sacraments, that it had in the northern countries. Public flagellant processions were known at least as early as the beginning of the twelfth century; in the year 1100, according to Padre Agustín de Herrera, a plague of locusts caused the people to appeal to the Church for aid. Bishop Gregory of Ostia responded by organizing, among other pious actions, penitential processions *"con disciplinas de sangre,"* that is, with participants flagellating themselves, in the effort to appeal to God's mercy.[16]

There is no indication that the widespread flagellant movements of 1260 and 1349 had a dangerous effect in Spain; rather, it appears that self-mortification was for the most part practiced in a regulated manner within the confraternities and Third Orders under sponsorship of the mendicant friars.[17] In fact, it was under mendicant auspices that in the early 1400s self-flagellation again reached public proportions. The noted Spanish-born Dominican friar, Saint Vincent Ferrer (1350–1419), inspired by a vision in the year 1398, devoted himself to the preaching of penance among the people of Spain and elsewhere. He soon was followed wherever he went by bands of flagellants whom he organized into a confraternity known as the "company of Master Vincent." These groups lived under a strict rule that the saint established and observed himself, for he lived an austere life, fasting frequently, sleeping on the floor, and traveling on foot. Due to the control he exerted over his followers, he was able to defend himself successfully against charges that these bands of flagellants were dangerous to public order or were heretical.

Saint Vincent Ferrer and his followers were remarkably effective in regenerating Christian fervor wherever they went, and he must be counted as one of the most important of the late medieval mendicant friars who served to spark the spirit of reform first introduced by Saint Francis and Saint Dominic. His effectiveness was noted by numerous commentators, and there were many reports of miracles accompanying his preaching, particularly in Spain. After a preaching mission in the town of Orihuela, an official reported that the churches were overflowing; there was a dramatic increase in confessions and the taking of communion, a decline in sorcery, blasphemy, and other sinful acts, and a great reconciliation of enemies.[18]

Saint Vincent's preaching has traditionally been characterized as purely eschatological, that is, concerned with the need to reform due to the coming judgment of God. However, as Francis Oakley has shown, it was not only the fear of God that he wished to inspire in his listeners but also the love of God. His preaching was firmly Christocentric, for he continually emphasized Christ's sacrifice for man and the need and value of the imitation of Christ. His preaching of penance in isolated towns was followed by clerics, who taught the basic truths of the faith in an effort to make Christian precepts more meaningful for the laity. Although he preached severely on the harsh realities of the Last Days and the divine Judgment, he equally realized that the "road to true and lasting repentance was one along which men had to be beckoned by encouragement and hope rather than fear."[19]

The penitential processions sparked by the preaching of Saint Vincent Ferrer combined elements of both penance and mercy. In the proceedings for the canonization of Vincent in 1455, an eyewitness, who was a royal judge of Toulouse, described these processions:

> They made processions through the city and carried a crucifix and another standard of the Passion of Christ, and a third in which one saw the Virgin with her Son under the cross, laid out on her bosom [the Pieta]: behind them came a lot of people, men and women. The men sang litanies, carrying burning candles [brothers of light]: behind them went the women who were many, and preceding them was a group of twenty or thirty in the manner of beguines. And there were many penitents who whipped themselves with *disciplinas* [whips], nobles and plebians, about two or three hundred.[20]

Saint Vincent also popularized an invocation of the name of God which was uttered by the penitents in these processions: "Senyor Deu, Misericordia!" (Lord God, mercy!) This invocation he repeated three times at the end of his sermons and prayer sessions, teaching the people to say it. Like his disciple Bernardino of Siena, Saint Vincent taught the need for divine mercy, not through works alone but through faith made to live in constant prayer.[21]

Thus in Spain penitential practices remained embedded within the matrix of the spiritual life as one of the prime purificatory means of reforming the soul. What served to maintain this orthodoxy was to a great degree the identification of penitential practices with the suffering of Christ, for this ever reminded the practitioner that Christ's suffering, and hence his own penance, was but one stage in the progress of the soul towards God. Just as Christ transcended suffering and even death, so the pious Christian hoped to find everlasting life through his active identification with the Savior.

This Christocentric view found support from every side within the Spanish Church: it was advocated by the mendicant orders, which, while not denying the importance of the Virgin Mary and the saints, continually focused the attention of the worshippers upon Christ. In this, Saint Vincent Ferrer is but one outstanding example of the mendicant view. Equally, the liturgy of the Church itself was focused more narrowly upon the Holy Eucharist: for the laity it was the most significant means of communion with the divine. In this ritual reenactment of Christ's sacrifice, His real presence was in the sacrament, and union between the divine and human was achieved. The growing emphasis upon the Eucharist resulted in the establishment by Rome of the new Feast of Corpus Christi, which became one of the most important public festivals in Spain and elsewhere by the late Middle Ages.

Although the new emphasis upon Christ's suffering humanity dates from the eleventh century within the monastic and mendicant orders and in Church dogma and ritual, it was slow to be taken up in the practices of the people, particularly in Spain. The gradual growth of the Christocentric view among lay people may be seen in a study, made by José Sanchez Herrero, of wills of thirteenth- and fourteenth-century Leon.[22] In the thirteenth century the figure of Christ does not appear in the wills, which give praise only to God and the Blessed Virgin. In the early fourteenth century the wills make mention of Christ, "who purchases our soul with His precious blood." Finally, in the second half of the fourteenth century there are specific references to Jesus Christ, who "redeems our souls with his precious blood," and also to His "passion on the tree of the cross."

The main force for spreading this new devotion to the suffering of Christ in the thirteenth and fourteenth centuries was the mendicants, with their Third Orders and confraternities. The movement received its greatest impetus from Saint Vincent Ferrer in the early 1400s and continued to spread in lay devotion through this century. By the early 1500s the emphasis upon Christ's suffering was vividly enacted by flagellant confraternities devoted to one or another aspect of the passion and crucifixion. These organizations were quickly becoming prominent in Spanish life and greatly increasing in active membership.

PENITENTIAL CONFRATERNITIES IN SPAIN

In the fifteenth and sixteenth centuries in Spain, as elsewhere in Western Europe, active lay participation in the spiritual life continued to increase. Confraternities of all kinds arose; every city, town, and village had its congregations dedicated to the Blessed Virgin, to its patron saint, to the Holy Sacrament, and in particular, to the many different advocations of Christ in His suffering and crucifixion.

One of the earliest and most important penitential confraternities devoted to Christ was that of the Vera Cruz (True Cross). According to Dominican tradition, the Vera Cruz had its origin in the congregations of Saint Vincent Ferrer, the flagellant "companies of master Vincent." Spanish-born Dominican friar Agustín Dávila Padilla, writing in Mexico in the 1580s, declared: "the confraternity of the True Cross (which also derives from our Order and was born in the preaching of the valorous Spanish Apostle Saint Vincent Ferrer) is founded in the most pious devotion of the Cross of Christ, in whose memory the devout Christians walk in procession, shedding their blood."[23]

Flagellant confraternities in Spain prior to 1500 have not been well documented, but there is some historical evidence for a continuing tradition for the Vera Cruz from the time of the preaching of Saint Vincent to the early sixteenth century. As early as 1411, Saint Vincent named a new church in Salamanca "the Vera Cruz" after it was converted through his preaching from a Jewish synagogue. A confraternity of the Vera Cruz existed in Seville under Franciscan auspices as

early as 1448, and that of San Juan de Puerta Nueva in Astorga dates from at least 1494.[24]

However, the confraternity of the Vera Cruz really began to blossom in Spain in the early sixteenth century, and soon it had the support of both the Dominicans and the Franciscans; many chapters were either founded or reorganized under mendicant auspices. For instance, in Salamanca the confraternity of the Vera Cruz was established, or perhaps revitalized, by the Franciscan friar Diego de Bobadilla in May 1506 when he "began to preach and to popularize the Brotherhood of the Cross," soon attracting 150 members. Such flagellant groups at this time had full Church approval. In 1508, Pope Julian II granted a bull of benefaction and indulgence to this "congregation of *disciplinados*" (self-scourgers) in Salamanca.[25] In 1536, Paul III again gave papal blessings to this flagellant confraternity: "to the members of both sexes called the *disciplina* of the Holy Cross or of Penitence."[26] Thus the members practiced their penitential activities openly, with Church approval, and usually their processions were led by clerics or friars.

In the early 1500s many flagellant confraternities were founded in Spain, and often they obtained large memberships. The Vera Cruz itself was established in Cáceres in 1521, in Cabra in 1522, in Villalpando in 1524, and in Toledo before 1536. There were others, too, devoted to different aspects of Christ's suffering and crucifixion: the Sangre de Cristo (Blood of Christ) was founded in Valencia in 1535 and in Barcelona by 1544. By 1575 in Toledo there were three flagellant brotherhoods in addition to the Vera Cruz: the Santo Nombre de Jesús (Holy Name of Jesus), Nuestra Señora de la Soledad (Our Lady of Solitude), and Las Angustias de Cristo (The Afflictions of Christ). By 1580 in New Castile there were twenty-one towns with chapters of the confraternity of the Vera Cruz, five with that of the Sangre de Cristo, and at least six other brotherhoods devoted to Christ's passion. Many of the groups had their own chapels. Other important flagellant confraternities of the sixteenth century included those of the Cinco Llagas de Jesús (Five Wounds of Christ), Nuestro Padre Jesús Nazareno (Our Father Jesus Nazarene), the Santo Sepulcro (Holy Sepulcher), Nuestra Señora de los Dolores (Our Lady of Sorrows), and many others.[27]

Their activities included charitable concerns such as operating hospitals for the poor, and they provided aid for their own members, including members' funerals and masses for the dead. During moments of civic or natural crisis as well as on certain holy days throughout the year, they assembled for penitential processions. However, given the emphasis upon Christ's suffering, it is not surprising that their major processions took place during Lent and Holy Week.

In larger towns and cities of Spain, thousands of *disciplinantes*, along with other pious people, took part in these processions. They were divided, at least

as early as the sixteenth century, into Brothers of Light, who carried candles while marching, and Brothers of Blood, who whipped themselves during the procession. A Portuguese commentator, viewing the Holy Week processions in Valladolid in 1605, noted: "There can be many *disciplinantes* who do not have faults in them because they are all brothers and share the obligation of brotherhood. Some are called brothers of light because they are obliged to walk with a light, which is a large torch with four wicks; the others, the brothers of blood are obliged to discipline themselves."[28]

This separation of the brothers between those "of blood" and "of light" recalls the early Christian distinction between penitents (and neophytes) and the baptized faithful, who at baptism also carried a candle to signify their "enlightenment" (see chapter 1). As we have seen, the same distinction was made in the flagellant processions led by the congregations of Saint Vincent Ferrer in the early 1400s.

These Spanish penitential confraternities were above all Christocentric, and their love of Christ was expressed especially in their devotion to images of Him and of His sorrowing mother. The images became central elements in the penitential processions of Holy Week, for the processions incorporated another long-standing medieval tradition: passion plays in which the crucial last events of Christ's life were dramatically reenacted. Holy images were especially made in order to play their part in these events. For instance, in the dramatization of the last meeting of Jesus and Mary prior to His crucifixion, an image of Mary as Our Lady of Solitude (Nuestra Señora de la Soledad) and an image of Jesus Nazarene (Jesús Nazareno) were ceremoniously brought together for this touching *encuentro* (encounter). The arms of both figures were articulated, that is, hinged at the joints, so that they could embrace.[29] In the same manner figures of Christ in the Holy Sepulchre (Cristo Entierro) were also hinged and had holes in the hands and feet so that they could be put through the different stages of the crucifixion and descent from the cross. These enactments and the articulated images, as we shall see, continued to be the focus of Holy Week practices in Spain and the New World through the nineteenth and twentieth centuries.

In sixteenth- and seventeenth-century Spain many statues of Jesús Nazareno, Nuestra Señora de Dolores (Our Lady of Sorrows), Nuestra Señora de la Soledad, El Señor Crucificado (the Crucifixion), and El Cristo Entierro soon became known for miracles and became centers of devotion attracting pilgrims to their shrines. In this they replaced some, but not all, of the earlier miraculous shrines dedicated to different images of the early medieval Madonna in Majesty. This idealized and rigorously hieratic representation of Mary seated with the Christ Child on her lap was an expression of the transcendent focus of Christianity that was still predominant in the early Middle

Ages, for it emphasized the triumphant majesty of Christ and the all-encompassing mercy of Mary. The Madonna in Majesty, while sympathetic and loving in aspect, remained beyond the world. In contrast the passion figures represented particular aspects of Christ's worldly existence and stressed the need for active human involvement in His suffering, that is, in practice the conformation of the human to the divine will. This for the faithful of the late Middle Ages was the only road to divine mercy.[30]

The emphasis of the medieval period upon individual action and salvation continued to grow in the sixteenth and seventeenth centuries. The saving of souls became the central focus of the Catholic Church, and much of the reform of the Catholic Reformation as enacted by the Council of Trent (1545–1563) was directed to this end. However, the earlier corporate notion of the Church and all Christians constituting the "body of Christ" also continued to find expression in this period. The corporatism of the early Church emphasized the organic unity of all the faithful, lay and clerical alike, who would be saved, in contrast to the rest of the profane, pagan world. In sixteenth-century Spain, even with its new emphasis upon individual penance and salvation, the laity still shared a spiritual bond, but now it was primarily a common awareness of their fallen state and the need to perform penance, to be charitable, and to seek divine mercy. The corporatism of this period is well expressed in the penitential and other spiritual activities of the confraternities, which had the effect not merely of sanctifying the individual member but also of breaking down the barriers among the people and thus unifying them.[31]

The all-important penitential processions of Holy Week annually served to renew faith and unify the community by involving them in a sacred activity that transcended worldly divisions. As William A. Christian, Jr., has shown, one important expression of these and similar processions was the evocation of public weeping.[32] Weeping expressed personal remorse and the melting of hearts hardened by worldly selfishness. Thus the emphasis upon the sadness of the occasion of Christ's passion, eloquently expressed in the statues of the sorrowful Mother, served this positive purpose, and the processions and dramatic enactments had much the same effect as did the earlier flagellant processions. A French visitor to Spain as late as 1765, although critical of some aspects of the Holy Week processions, also noted their important communal effect: "It is rare when Easter season does not produce fifteen days of change in the manners of the city of Madrid. Enemies are reconciled, lovers give each other up, the confessors are charged to make secret restitutions, there is no more dissipation, spectacles, indecency, or intrigue."[33]

In the rest of Europe the changes wrought by the Reformation and the rationalism of the seventeenth and eighteenth centuries gradually brought an end to the traditional penitential processions, except in isolated areas. In much of Spain the situation was markedly different. The widespread fervor of the sixteenth century, of which the confraternities were one expression, affected all segments of society and continued to do so through the 1600s. While in northern Europe secular views were gaining ground, in Spain religion still ordered all aspects of life, as the majority of the population strived for sanctity and salvation:

> the heightened religiosity of later sixteenth-century Spain cannot be ascribed merely to imperial, social or ceremonial form, for it projected a new model of Catholic holiness for human lives . . . in which perhaps for the first time in western history the style of sainthood became a social model sought after by a significant cross-section of society.[34]

Spain thus remained outside the trends of the rest of modernizing Europe, for Spanish religious fervor and its expression remained intact until the mid-eighteenth century seemingly without concern for, and sometimes in conscious opposition to, tendencies in other countries. The flagellant processions continued throughout the eighteenth century, although often in larger cities they became more concerned with public spectacle than with public penance.

The effects of the "Enlightenment" began to be felt in Spain by the mid-eighteenth century. Under the leadership of Charles III and his ministers, some of whom were highly influenced by French rationalism, an extensive series of ecclesiastical reforms were begun in the 1760s with the purpose of reducing the power of the Church in civil affairs. These reforms had many far-reaching implications for the legal status of the Church and of the clergy in Spain and her possessions, and in some cases they directly affected popular Catholic traditions. For instance, in 1765 Charles III prohibited the public performance of the ancient and very popular *autos sacramentales* (morality plays), and beginning in 1766 the Spanish confraternities came under attack from the reformers, who were concerned with the *cofradías'* economic strength and autonomy and their potential for organized opposition to Crown policies.[35] Finally, in 1777, Charles III's cedula dated February 20 (probably the beginning of Lent) censured public penitential processions. This cedula prohibited

> the abuse introduced in all of this reign . . . of having penitents of blood or *disciplinantes* and *empalados* [empaled ones] in the processions of Holy Week, those of the Cross in May and other rogation days. They evoke, instead of edification and repentance, scorn from the prudent, amusement and uproar from the boys, and amazement, confusion and fear from the children and women, and even more injurious results, rather than good example, or the expiation of their sins.[36]

A slightly different wording of this royal decree goes on to say that "those who have the true spirit of com-

punction and penance should choose more rational, more secret and less exposed means, with the counsel and direction of their confessors."[37]

The year 1777 marks the date when the Spanish government with at least some backing from the Church hierarchy officially condemned public flagellation, and gradually the custom began to die out in the cities. However, in the Spanish countryside and in rural areas throughout Spain's far-flung possessions, flagellant processions continued to be held, surviving in isolated places like New Mexico into the twentieth century.

Penitential Practices in Colonial Mexico

"A Spanish Church was imposed upon a native Christian society, and the Mexican Church appeared finally, not as an emanation of Mexico itself, but of the mother country, something brought in from without, a foreign framework applied to the native community. It was not a national Church, but a colonial Church, for Mexico was a colony, not a nation."

—ROBERT RICARD, *The Spiritual Conquest of Mexico*

THE CONQUEST of Mexico in the early 1500s was marked by the rapid establishment of Spanish authority over a large portion of the former Aztec kingdom and conversion of the native population to Catholicism. As Robert Ricard has noted in the passage quoted above, Mexican Catholicism of the sixteenth century was above all Spanish Catholicism. In its structure, its thought, and its practice, the Spanish Church was transferred intact to the New World. The patterns we have seen established in Spain in preceding centuries were immediately elaborated in New Spain.

The primary responsibility for the spread of Catholicism in New Spain fell to the mendicant orders: the Franciscans arrived in 1523, soon followed by the Dominicans and the Augustine canons and later by the Jesuits, the Carmelites, the Mercedarians, and several other orders. In the nascent period of colonization the New World attracted the "observants" and "spirituals" among the Franciscan and Dominican orders—those reformers who wished to return to the original rigor and purity of their founders. These groups were excited by the challenge and the prospect of preaching and converting the Indians. They had long felt that European society was quite decadent, that the true spirit of reform was not heeded in the Old World. In contrast they saw the Indians as yet untouched by the worldliness and sophistication of Europeans: the Indians had pure hearts, but due to their naïveté they had been led by the devil into paganism. The friars thought they could easily be reformed and could become true members of the "Age of the Holy Spirit," which many of these spiritual friars still longed for and expected.[1]

The first half-century of the Conquest was a euphoric period for the friars. These reforming mendicants were energetic in their efforts and were pleased with the apparent ease with which conversions took place. The friars and the settlers brought with them Hispanic Catholicism in all its rich complexity, and as far as possible, Christian values and practices followed by the Spanish population were instilled among the newly converted Indians. Thus the Christocentric focus of sixteenth-century Spain was expressed with equal fervor in the practices of New Spain, as elsewhere in Spanish America: the ceremonies of Lent and Holy Week, with flagellant processions, the reenactment of the passion and crucifixion, and the seminal images of Christ and the sorrowing Mother, all played their important role. At the same time the fervent devotion to Mary as source of divine mercy flowered with equal strength in the New World: many Spanish advocations of the Virgin were established in New Spain and numerous new Marial advocations emerged throughout the colonial era.

Lay participation in the spiritual life continued in New Spain through the same formal means as obtained in Spain. Confraternities fostered both public and private penitential practices and other activities dedicated to the love of God; the mendicant friars, in particular the Franciscans, both by their pious example and their regular observances served to inspire the faith of the laity; and in the late colonial period, as the influence of the mendicant orders waned, new Church-sponsored organizations, such as the Santa Escuela de Cristo (Holy School of Christ), attempted to increase lay fervor through more carefully controlled forms of penance.

PENITENTIAL CONFRATERNITIES IN NEW SPAIN

Among the first Catholic institutions to be established in the New World were the confraternities. In the sixteenth century the same confraternities that the mendicant orders had fostered in Spain were recreated in New Spain among the Indian, mixed-blood, and Hispanic populations. The most important and wide-

spread penitential brotherhood in Spain, the Vera Cruz, was established in Mexico during the first years of the Conquest. In 1527 the "cofradía de la Santa Veracruz" in Mexico City petitioned for two plots of land on which to build a hospital and chapel.[2]

The Santa Vera Cruz was established among both Indian and Spanish populations in Mexico City and began to flourish immediately. A Franciscan account of 1541 describes the activities of this confraternity among the Indians in Mexico City:

> All of them, both men and women, belong to the brotherhood of the Cross, and not only on this night [Holy Thursday], but on all the Fridays in the year and three times a week in Lent they scourge themselves in their churches, the men on one side of the church and the women on the other. They do this before the bell rings for the Ava María, and many days in Lent they do it after nightfall. When they are troubled with drought or illness or any other adversity they go about from church to church, carrying their crosses and torches and scourging themselves. But the scourging on Holy Thursday is a notable sight here in Mexico, both that of the Spaniards and that of the Indians, who are innumerable—in some places five or six thousand and in others ten or twelve thousand. In Tetzcoco and Tlaxcallan there are apparently some fifteen or twenty thousand, although when people are in procession the numbers appear greater than they really are. The truth is that they march in seven or eight ranks, and men, women, children, the lame and the halt all take part. . . . Some use wire scourges, and others make them of cord, which sting no less than the wire ones. They carry a great many torches of pine knots well bound together which give a great deal of light.[3]

Other sixteenth-century Franciscan commentators describe similar processions organized by the Cofradía de la Santa Vera Cruz and other confraternities. Fray Gerónimo de Mendieta, writing in the last decades of the century, mentions in addition to the Vera Cruz the brotherhoods of Nuestra Señora de la Soledad, Nombre de Jesús, and the Santísimo Sacramento.[4] On Holy Thursday, he notes, the procession of the Vera Cruz in Mexico City had more than 20,000 participants, of which 3,000 were *penitentes*, and on Good Friday more than 7,700 *disciplinantes* took part in the procession of La Soledad. On the morning of the Resurrection (Easter) the procession of San José took place, and in it went

> all the members of both confraternities of the Vera Cruz and Soledad (which is a great number), very orderly, with candles of wax in their hands, and others of them by the sides, innumerable people, both men and women, almost all of whom also carried candles of wax. They went arranged by their *barrios* [neighborhoods], according to the superiority or inferiority that they recognized among themselves, in conformity with their ancient customs. All the wax is as white as paper, and both the men and women, also dressed in white and very clean, walk until dawn or a little before; it is one of the most beautiful and solemn processions of Christendom. The viceroy Don Martín Enríquez said that it was one of the most worthwhile things that he had seen in his life.[5]

Mendieta, however, held the pessimistic view of the spirituals among the Franciscans who saw European influence in decidedly negative terms, and his comments, written after 1571, reflect a recognition of the end of that euphoric first phase of the Conquest in which it was expected that the Indians would become exemplary Christians. After describing in some detail the pious practices of the Indians, he notes that "in these good and holy customs of supererogation and counsel that they received at the beginning of their conversion much has been lost with the communication and mixture of the Spaniards and other races of people."[6]

While the reports of the early friars naturally focused upon the Indians, the activities of the Spaniards also encompassed the same range of belief and practice that pertained in the homeland. By the mid-sixteenth century penitential confraternities were well established among the Spaniards in Mexico City and elsewhere. Alonso de Zorita, a lawyer and government official writing in the late 1500s, noted that "there is another confraternity of the Vera Cruz which is of blood, in which more than 400 *disciplinantes* march on Holy Thursday, and in their procession there are thirty or more crucifixes, each one of the size of a man, and they are so light that each Christ figure does not weigh even twelve pounds."[7]

Other confraternities of Spaniards noted by Zorita include those of the Nombre de Jesús, *disciplinantes* under the auspices of the Augustinians; and, under Dominican auspices, one devoted to Our Lady (title not stated). He also describes confraternities of Blacks and Indians.

The Dominican friars established confraternities such as the Vera Cruz and the Soledad among the Spaniards as well as the Indians. As we have seen in chapter 2, they credited the Spanish Dominican Saint Vincent Ferrer with establishing the first Cofradía de la Vera Cruz in Spain during the early 1400s.[8] There were other Dominican confraternities established in sixteenth-century Mexico, some of them particular to their order, such as the one devoted to Saint Vincent Ferrer, which made its procession on Monday of Holy Week, and that of the glorious martyrs San Crispino y Crispiniano, which did not make processions of blood. The Dominicans also played an important role in the spread throughout Mexico of the popular confraternities of Nuestra Señora del Rosario (Our Lady of the Rosary) and of the Santo Entierro de Cristo (Holy Burial of Christ).

The Santo Entierro (also called the Descendimiento y Sepulcro), founded in Rome in the mid-1500s by a Dominican friar, was established in Mexico in 1582. The principal activity of this brotherhood was the ritual reenactment of the Descent from the Cross and the Burial of Christ. On Good Friday, in the church of Santo Domingo in Mexico City, a stage twenty by twelve feet was set up in front of the altar to represent the hill of Calvary. On it were arranged rocks and wild plants and the crucifixions of Christ and the two thieves:

On the Cross of Christ our Lord is put His very devoted image which in this land is made of cane [caña de maíz] with the beauty that is required for that spectacle. . . . On the rest of the stage are placed the images which will be carried on stretchers [andas] in the procession. . . . on the right hand of the Holy Crucifix is the image of the Queen of the Angels [Our Lady of Solitude] who stands upright dressed in mourning, with only a cloth in her hands which serves to wipe the tears from her face. The image is made in such a manner that with some ropes that are managed under the andas she can raise her hands and the cloth to her face and also bow her head and bend her body. All of this serves for much devotion of the people when the descendimiento is made. . . . at two P.M. the sermon is begun, which serves as a speech for those who scourge themselves, and for the sentiment of all.

After the sermon, all the clergy ceremoniously ascend the stage and the one who preached the sermon asks Our Lady, "with the most tender words that God offers him," permission to remove Christ from the cross. Then two priests climb ladders which have been placed by acolytes on either side of the Christ figure. At each rung of the ladder the priests make a short prayer and kiss the rung before ascending further. Once they have ascended they begin to take out the nails and unfold two white towels with which they tie Christ's hands to the cross. Next they uncover the face of Christ, raising up the long hair which covers it. Then they remove the insignias of the passion: the vinegar-soaked sponge that is on top of a pole at one side of the cross and on the other side the lance with which Christ's side was pierced. The priest who preached the sermon (usually the provincial or the prior) ceremoniously presents the insignias (including the crown of thorns) one by one to Our Lady, who each time receives them in the cloth in her hands with a bow of her head, "which greatly moves the audience." According to the commentator,

This ceremony and that which the preacher says about it serve to make everyone esteem those instruments [the insignias] of our redemption, and it makes some acknowledge how much Christ has done for them, each one receiving: for the pleasure of his appetite, the bitterness of mortification [i.e., the vinegar-soaked sponge]; and for his feet and hands, the nails of fear; and for his side, the wound of love; and for all his life, the cross, imitating that of Christ.

The preacher then explains to the audience the sacred significance of each insignia of the passion. When Our Lady receives the crown of thorns she embraces it, raises it to her face, and puts it in her eyes, which indicates her esteem "of that relic, which in the grave infirmity of sin, made bloody the head, Christ, in order that all the body [i.e., the faithful] that was infirm might become healthy, without the head having more than the appearance of infirmity." After all three nails have been removed the corpus remains hanging from the towels with which the priests have tied it to the cross, then they ceremoniously remove it from the cross and lower it down to the other

priests waiting below, who receive the body in a winding-sheet and carry it to the arms of Our Lady. The preacher then asks Our Lady's permission to bury the body of her Son, and with devout singing of hymns, the procession begins.

The procession of the Holy Burial is most elaborate; in fact, so elaborate that the commentator expends half a page of convincing prose to justify it, saying essentially that as Christ's nature was both human and divine, it is fitting that He be buried with the "ceremonies of a King, recognizing him as the true God, King of Kings and Lord of Lords." Just as the funeral rites of a prince will display his earthly triumphs, the procession of the Burial begins with Christ's triumph over death; it is led by

a little cart covered with mourning cloth and in the middle of it a Cross, at the foot of which Death [la muerte] is prostrated and in whose arms hangs an inscription which says: ubi est mors victoria tua? Death where is thy victory? And on the other side: Ero mors tua o mors: Death I will be thy death. These are insults from the author of life. . . . This cart is drawn by three trumpeters all dressed in black tunics, and playing their trumpets out of harmony from time to time, they cause majesty and sentiment.

The death figure is followed by all the insignias of the passion, each one given its due reverence. Included among these is the image of the face of Christ known as the cloth or veil of Veronica: "Then the figure of the Most Holy Face comes next, with which the woman Veronica was well rewarded when she went out in the street of bitterness to receive the Redeemer of souls, offering a cloth to wipe away some of His sweat and blood. This devout insignia is stretched on a small staff, which is held up in both hands of the one who carries it."

The veil of Veronica is immediately followed by the cross, without the figure of Christ. It is draped from arm to arm with a long white towel which droops in the middle, and on each side of it stand the lance and the sponge on its pole. The cross is followed by men at arms with the insignias of the passion embroidered in gold on black on the chest and back of their robes. They are followed by four priests with silver sceptres in their hands and by a choir of friars. Next, four priests carry the body of Christ on an elaborately decorated anda that is covered by the sheet in which He was received by the priest when they lowered Him from the cross. This is followed by a standard bearer with a banner displaying "the royal coat of arms of Christ, which are the insignias of His passion." The mourning image of Our Lady of Solitude dressed in black comes next; she is "the widow who feels most the absence of her sweet husband and dear son and true God."

The regal funeral procession is followed by the members of the confraternity of the Descendimiento y Sepulcro de Cristo, who are scourging themselves: "instead of carrying mourning emblems, they shed

their own blood for him." Among them there are only two floats: one carrying Saint Peter and the other Mary Magdalene, the patroness of the confraternity. After transferring the image of Christ to a more sumptuous sepulchre, the procession proceeds to the church of the convent of Our Lady of the Immaculate Conception, where they ceremoniously place the sepulchre upon an especially created funeral monument.

The body of Christ remains in the church until the morning of Easter Sunday, when the triumphant and joyful procession of the Resurrection takes place. Now the priests and images are dressed in white, instead of black, and an image of the Resurrected Christ (Cristo Resuscitado) holds the prime position. The confraternity of the Vera Cruz joins with that of the Santo Entierro in this procession, and a statue of Our Lady of the Rosary accompanies them, as well as "the glorious Magdalena very happy for the resurrection of her master." The Most Holy Sacrament is also taken in the procession, which is followed by a mass and a brief sermon, "and with this all the sorrow of the burial of Christ our Lord is finished in joy; this is the end that our penitence in this life will have: to be rewarded afterwards with glory in the other life."[9]

We have dwelt at some length upon this important ceremony, for it is the source of many of the most popular images of the passion, images that were propagated in Spain, Mexico, and New Mexico in the form of paintings, sculpture, and prints and that served to remind the faithful of each aspect of Christ's suffering and crucifixion. Our Lady dressed in black with the cloth in her hands is known most commonly as Our Lady of Solitude. A statue of her is found in most Catholic churches in Mexico and New Mexico to the present day. She is also often depicted in paintings with the insignias of the passion that the priests have presented to her and with the dead Christ in her arms. The insignias of the passion often appear by themselves in paintings and prints, but one of the most popular images is that of the cross after Christ has been removed, with the two ladders, the lance, and the sponge on the pole, the towel draped over the cross, the crown of thorns, the nails, and often various other insignias. The cross simply draped with the towel, without other insignias, is commonly depicted.[10]

The figure of Death in its cart was of particular importance and will be discussed below in the consideration of New Mexican images (see chapters 4 and 10). The veil of Veronica was depicted either by itself or in the hands of Saint Veronica. Since both Our Lady of Solitude and Saint Veronica are dressed in black and both hold cloths, the two were often confused in popular usage.[11] Finally, the image of Christ in the Holy Sepulchre (Cristo Entierro), which the priests carry in the procession of the Holy Burial, was found in nearly every church in Mexico until the late 1800s. In New Mexico this image continued to be

used in processions in the late nineteenth and twentieth centuries, and a few examples survive today in churches such as Santa Cruz de la Cañada and in cofradía chapels (see plates 69 and 78).

The confraternity of the Santo Entierro and the ceremonies that it sponsored, thanks in part to the efforts of the Dominicans, quickly spread throughout New Spain in the late 1500s and early 1600s. In the town of Amecameca south of Mexico City the confraternity was established at an early date by Dominican friar Juan Paez. Amecameca became the shrine of a popular miraculous image of Christ in the Holy Sepulchre. It was, prior to the establishment of the confraternity, the hermitage of the saintly Franciscan, Fr. Martín de Valencia, who in a cave on a hill above the town established his cell and "in it he fled from the conversation of men and found that of the angels."[12] The miraculous Cristo Entierro probably predates the establishment of the Dominican confraternity, and its popularity has certainly outlived the Dominicans, for the ceremony and procession of the Descent from the Cross and the Holy Burial were performed every year until they were forbidden in 1885 by the enforcement of the anti-clerical laws of the government.[13] Amecameca and the shrine of the Cristo Entierro is still a popular pilgrimage site today, attracting many thousands of people annually.

In colonial Mexico the ceremonies of the Descent from the Cross and the Holy Burial were by no means limited to the Dominicans and the confraternities they established, but were promoted by other orders and by the Church hierarchy. This is the case with most of the confraternities among the Spaniards: while in their beginnings they may have been established and their ceremonies promoted by one or another of the mendicant orders, they soon spread to all of the cities and larger towns and came under archdiocesan authority.

The Franciscan order was the first to venture into the western and northern frontiers of New Spain; their primary purpose, of course, was the conversion of the Indians, but they also served in the establishment of the newly founded villas of the Spaniards. In the Kingdom of Nueva Galicia, the city of Guadalajara was founded in 1531 and then moved to its present location in 1542. The first confraternity to be established in that city, and probably the first in all Nueva Galicia, was that of the Santa Veracruz y Sangre de Cristo, which, on April 15, 1551, was officially founded by Guadalajara's leading citizens and approved by the city's first bishop, Don Pedro Gómez Maraver. In addition to its spiritual exercises, this confraternity was responsible for establishing and operating the first hospital in Guadalajara. Among the flagellant exercises the members conducted was

the procession of the blood on Holy Thursday at 11 P.M., in commemoration of the hour in which Christ, our life, sweat blood in the garden. The *mandatum* sermon is preached the said night, and the most important people

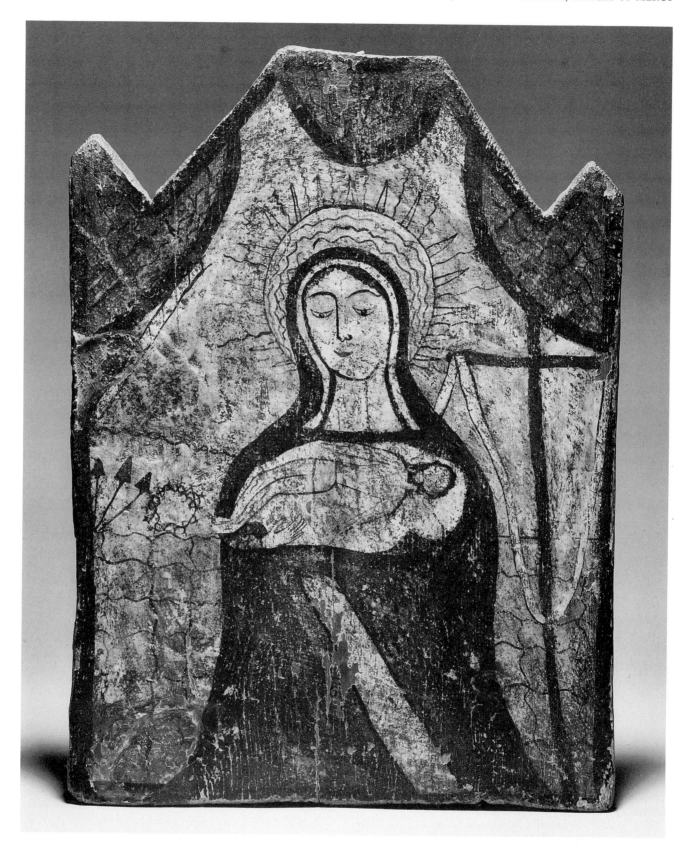

Fig.3.1. The Dead Christ in the arms of Our Lady of Solitude, by the Quill Pen Follower, New Mexico, circa 1860–1880. Known as the Pieta (Pity), this image dates in European iconography from the medieval period. In this naïve rendering a tiny Christ is held by Our Lady in the cloth in her arms. Behind her on the right is the shrouded cross, and on the left are the insignias of the passion (crown of thorns and three nails) and also the ladder. (Courtesy of the Museum of International Folk Art, Santa Fe, New Mexico. Photograph by Blair Clark.)

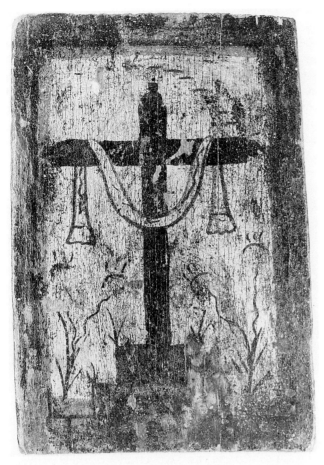

Fig.3.2. The Most Holy Cross and the Holy Shroud. School of the Truchas Master, New Mexico, 1780–1840 (Taylor Museum 909). (Photograph by Jonathan P. Batkin.)

of the city take part in the tender ceremony of washing the feet of the poor who are helped with alms, and afterwards the procession walks until dawn, for they go by all the churches of the city, in silence and with great devotion.[14]

This confraternity was deemed to be of such civic importance that the city *cabildo* (municipal council) voted in 1658 to require that the leading civic official (*alcalde ordinario de primero voto*) be perpetually the rector of the group and that in its processions he carry a standard, marching in front of all the nobility of the city. However, some seventy-eight years later in 1736 the confraternity was in a moribund state with only a few members. In that year Matías de la Mota Padilla was appointed rector and, at the time of writing his *Historia*, was attempting to revive the organization.[15]

The second confraternity to be founded in Guadalajara was that of Nuestra Señora de la Soledad y Santo Entierro de Cristo, which was established under the auspices of the Dominican friar Archbishop Fray Domingo de Arzola on February 21, 1589. This confraternity appears to be identical in its function to that of the Santo Entierro de Cristo, established by the Dominicans in Mexico City in 1582. Among its

founding members were the two highest members of the Church: the *vicario general* Don Melchor Gómez de Soria and Don Francisco Martínez Tinoco, who was the dean and precentor of the cathedral. Its secular founders included Gaspar de la Mota, alderman in perpetuum of the city, and thirty other of Guadalajara's "most important citizens."

Its principal activities, which were still observed at the time of Mota Padilla's writing in 1742, were the processions of Good Friday and Easter Sunday: "their institution was to make the procession on Good Friday, which today is still the custom: they arrange themselves as brothers of the blood and of light and oblige themselves to go out in the procession in robes and sharp-pointed caps (*capirotes*), with scapularies of black taffeta and their escutcheons with the image of Our Lady of Solitude, their faces covered, barefoot and in total silence. . . ."[16] Like the procession that was made by the confraternity of the Santo Entierro of Mexico City, described earlier, the Guadalajarans carried the image of Christ in the Holy Sepulchre through the streets, stopping at all the principal churches and ending up at the church of the nunnery located at the hospital of San Miguel, where the im-

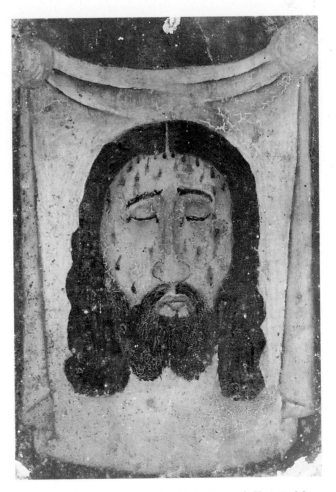

Fig.3.3. Veil of Veronica (The Holy Face of Christ). Mexico, mid-nineteenth century (Taylor Museum 3470). (Photograph by Gary Hall.)

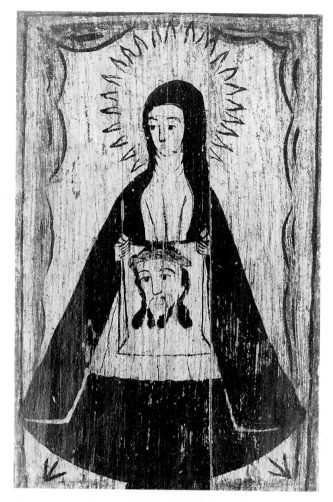

Fig. 3.4. *Saint Veronica holding the veil. In New Mexican usage this image is sometimes confused with Our Lady of Solitude, who is also dressed in black and holds the cloth to receive the instruments of Christ's passion during the ceremony of the Descent from the Cross. School of José Aragón, circa 1830 (Taylor Museum 934). (Photograph by Jonathan P. Batkin.)*

age was deposited. On Easter Sunday, again paralleling the practice in Mexico City, this confraternity joined with that of the Vera Cruz to make the joyful procession of the Resurrection.

As the conquest of Mexico progressed northward, many new towns and villas were established in the frontier areas. With the Spanish conquerors came the Franciscan friars, who established churches and convents in each new area. The confraternities of the Veracruz, Nuestra Señora de la Soledad, and the Santo Entierro, as well as several others, including the Animas Benditas (Blessed Souls), the Sangre de Cristo (Blood of Christ), and the Santísimo Sacramento (Most Holy Sacrament), were the first to be established in the new areas. Two hundred miles north of Guadalajara, the silver-mining town of Zacatecas was founded in 1548. Many of its founders were Guadalajarans, and in 1551 they established, in the same

year as that of Guadalajara, the confraternity of the Santa Veracruz.[17]

By the early 1600s, if not earlier, the confraternity of Nuestra Señora de la Soledad y Santo Entierro de Cristo had been established in Zacatecas, for in the year 1606 this confraternity joined with the Veracruz for a public penitential procession appealing for divine mercy to end a severe drought that had brought an epidemic to the city. In this procession statues of Christ Crucified and Our Lady of Solitude were carried through the streets. Such processions, described as "processions of blood" (i.e., flagellant), were repeated in 1629 and 1633 due to "pestilential epidemics," caused by recurring drought.[18]

By the early 1600s communities of Spaniards were well established in northern Mexico from Guadalajara all the way to Santa Fe in the remote kingdom of Nuevo México. As these communities gained in size, social complexity, and wealth, many new confraternities were added to the original two or three that had been started with the founding of the community. By the early 1700s there were literally dozens of confraternities in the larger cities of northern New Spain and as many as twelve to fifteen in the smaller towns. These new confraternities were for the most part devoted to one or another advocation of Jesus or Mary or one of the Catholic saints. The members were responsible for maintaining the holy image, the altar, and in some cases the church of their patron. They often were responsible for organizing and paying for a particular public procession during Holy Week or some other festival, such as their patron's feast day. In addition, they were obliged to pay for certain masses and other Church functions during the year; they also paid for funeral services and masses for members who died. These obligations were met through the dues and donations of the members and the income provided by plots of land, livestock, orchards, wineries, and other assets owned by the group.

The confraternities provided the most important means for active involvement in Church functions by the laity, giving them both a focus for their devotions and a role to play in the maintenance of the cultus, for it was through the confraternities that the wide range of Catholic worship—the panoply of popular saints, advocations of Jesus and Mary, and yet other devotions—could be successfully maintained. The confraternities provided an organizational core for the complexity of practices that made up the Church, and they also provided a relatively stable and essential part of Church finances, for without these supererogatory practices that they funded, ritual observances would have been stripped to the minimum. The rich complexity of Hispanic Catholicism, which had both negative and positive aspects, was highly dependent upon the devotion of the faithful members of the confraternities. For the members, the confraternities not only provided a focus for their devo-

tion—and in some cases the means to living a more meaningful spiritual life—but they also provided an organization for mutual benefit and protection. The confraternity was a bulwark against the vicissitudes of the world, a bulwark which became more and more important as the Hispanic world began to destabilize in the late 1700s and early 1800s.

By 1732, according to one commentator's listing, there were at least thirty-six confraternities in the prosperous northern mining center of Zacatecas. Under the auspices of the city's cathedral there were nine confraternities. Among them were the Santísimo Sacramento, Nuestra Señora de los Zacatecas, Animas Benditas, and Jesús Nazareno. The Dominicans maintained confraternities of Nuestra Señora del Rosario, the Santa Veracruz, and their Third Order. The Franciscans were responsible for their own Third Order and six confraternities, among which were their Santa Veracruz, the Santo Entierro, and Jesús Nazareno. The Augustinians had ten confraternities; at least one of these was for Mestizos (mixed bloods)

and at least four for Indians, with the others for Spaniards. The Jesuits had two confraternities; the Mercedarians had three; the convent of Saint John of God and the Franciscan Colegio of Our Lady of Guadalupe each maintained one. All of these, the commentator notes, were duly founded "with apostolic authority"; that is, they were approved and regulated by the Church.[19]

In 1767 the formerly wealthy mining town of Real de Sombrerete, founded in 1567 northwest of Zacatecas, was on the decline due to low mining production, but it still managed to support at least thirteen confraternities in seven major churches, including the Dominican convent and the Franciscan convent with its Third Order chapel. The confraternities included a brotherhood of the Santo Entierro located in the ancient church of Veracruz, the congregation of Nuestra Señora de los Dolores in the Franciscan convent, and those of Nuestra Señora de la Soledad and Nuestra Señora del Carmen in the church of Our Lady of Solitude. There were also several new *cofra-*

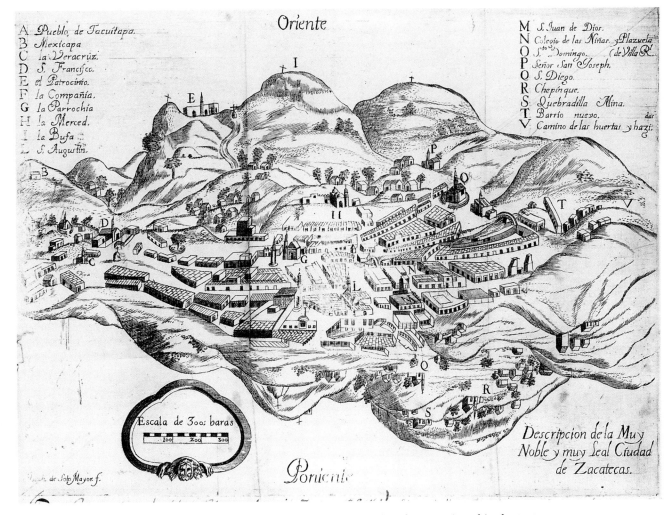

Fig.3.5. Plan of Zacatecas, Mexico, in 1732. The churches mentioned in the text are located in this plan. (From José de Rivera Bernardez, *Descripción breve de la muy noble y leal ciudad de Zacatecas*, Mexico, 1732. Courtesy of the Bancroft Library, University of California, Berkeley.)

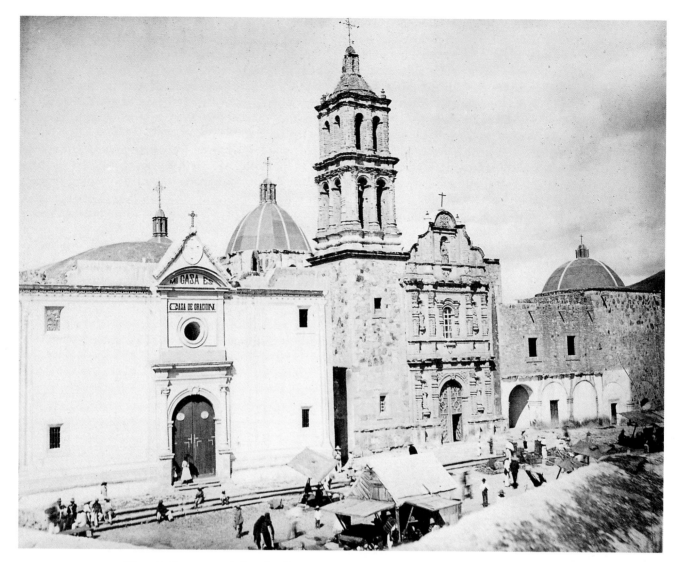

Fig. 3.6. *Convento* and church of San Francisco, Sombrerete, Zacatecas, Mexico, circa 1890. (Courtesy of the Huntington Library, San Marino, California.)

días devoted to particular saints: Santa Efigenia, Santa Bárbara, and San Nicolás Tolentino.[20]

In March 1761 Durango Bishop Pedro Tamarón y Romeral, during his first *visita* of his vast northern bishopric (which included New Mexico), spent Holy Week in Sombrerete, where he witnessed and took part in the traditional ceremonies and processions. On Holy Thursday, March 19, he noted in his journal that he performed the ceremony of the washing of the feet (*mandatum*), listened to the sermon preached by Sombrerete's priest, then at night walked, certainly in a procession, the "seven stations," no doubt stopping at each of the major churches, "praying the rosary through the streets while walking, and found himself in the night ready to go off to bed (thanks to God) feeling extremely robust."

On Good Friday he arose at the usual time between seven and eight and at the proper hour, accompanied by the priests, he went to the parish church, dressed in his pontifical robes, said mass, and prayed. After that the processions began:

from the balcony of the hall of his lodging house, where he had watched processions the night before, he saw the procession of Jesús Nazareno which left from the church of Santo Domingo; and yesterday afternoon he saw, from the parish church, the procession of Our Lord of Charity which left from His church. In the afternoon [the Bishop] went to the parish church and there prayed until finishing the lauds of morning; there he saw the Procession of the Holy Burial which departed decently, and he joined it until it ended at the church of the Santa Veracruz, where it had begun. This church is called by another name, "the old Soledad," because it is where Nuestra Señora de la Soledad was before they built the sumptuous temple which today is at the side of the said Veracruz. From this His Most Illustrious Lord went to the said temple of Nuestra Señora de la Soledad, and there he said the Rosary with the many people who had gathered, and then at night he went back to his lodging house.[21]

North of Sombrerete, the town of Nombre de Dios, which had been founded as a Franciscan mission about 1560, had several confraternities; among them the Cofradía de la Santa Veracruz, which had the obligation of maintaining the image of the Resurrected

Christ, and the Cofradía de Jesús Nazareno, which maintained in the parish church the altar and image of this advocation of Christ in His suffering. In 1767 among the possessions of this latter confraternity were:

a large image of Jesús Nazareno
a large cross of wood
two tombs [funeral monuments], one new and the other old
several large *andas* of wood
more little *andas* of wood and their little red wheels
other *andas* of painted wood
seven small bells of silver and seven relicaries embedded in the said *andas*
the image of Our Lord of the Three Falls[22]
a crown of silver with *potencias* [three rays of light] and cross of wood
a silver nail with which the cross is affixed
another image of the Holy Ecce Homo with his crown, *potencias* and staff of silver[23]
another image of Jesús Nazareno with which they solicit[24]
an image of Our Lady of Guadalupe
an image of the Holy Veronica
a standard which has Our Lady of the Rosary and on the other side Señor Ecce Homo.[25]

Even the small and not wealthy Indian community of San Sebastián de Sain Alto, a satellite of Sombrerete, had at least two confraternities, and although church furnishings were sparse in comparison to those of larger communities, they were well prepared for performing the essential Holy Week observances. The inventory of the church in Bishop Tamarón's 1761 visit included "a Lord [Christ] crucified, a sepulchre with all that is necessary for the Holy Burial of Christ."[26]

Farther north and east the small but wealthy agricultural community of Santa María de las Parras (now in the state of Coahuila) had in 1767 nine confraternities, including that of the Santo Entierro, Jesús Nazareno, Santo Ecce Homo, Nuestra Señora de los Dolores, Nuestra Señora del Rosario, Señor San Nicolás, Benditas Animas del Purgatorio, Señor San Joseph, and the Santísimo Sacramento. These groups were all well endowed, for Parras was the richest town in the bishopric of Nueva Vizcaya (Durango) in the eighteenth century due to its thriving wine and brandy industry, which served to supply most of northern Mexico.[27] Each confraternity owned vineyards and several had their own distilleries and wine cellars. The Cofradía del Santo Entierro was well endowed with "three well-cared-for vineyards enclosed with walls and one, well cultivated, enclosed with buckthorn bushes (*espinos*)." The group also owned a house with all their offices in it and a wine cellar next to it, in which they had seven casks, three small casks, five barrels of all sizes, a wine press with its *saranda* (sieve), two medium-sized clay vats, a new large vat, a caldron for cooking must (*arrope*), two pots for extracting brandy, three-quarters of an *arroba* (about twenty-five pounds) of copper, a medium-

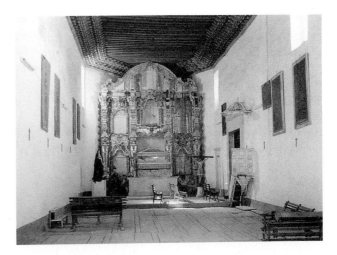

Fig.3.7. Interior of the church of the Santa Vera Cruz, Sombrerete, Zacatecas, Mexico, 1984. In 1984 this church appeared little changed from Bishop Tamarón's 1761 description. The eighteenth-century gilded altar screen was still in place and in its center was the image of Christ in the Holy Sepulchre, perhaps the very one used in the Procession of the Holy Burial, which, according to Tamarón, concluded in this church. (Photograph by William Wroth.)

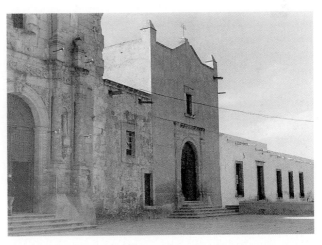

Fig.3.8. Exterior view of the church of the Santa Vera Cruz, Sombrerete, Zacatecas, Mexico, 1984. To the left is the portal of the church of Nuestra Señora de la Soledad, which Bishop Tamarón also visited in 1761 and described as "the sumptuous temple which today is at the side of the said Veracruz." (Photograph by William Wroth.)

sized funnel, a new bucket, a small table of a *vara* (about thirty-three inches) in size, and sixteen new glasses and jars.

This wealthy confraternity was responsible for the chapel of the Santo Entierro and the Christ figure in its sepulchre in the principal niche of the reredos (altar screen) of the chapel. The Holy Sepulchre had twelve clear glass windowpanes in it, "with four angels at the corners and at the sides Our Lady of Solitude and Saint John the Evangelist and above it a large Most Holy Christ [Crucified]." The confraternity also owned statues of Our Lord of the Re-

surrection (with its own niche in the wall of the chapel), Jesus Nazarene, Christ at the Column, and two large crosses. For the Holy Week ceremony for which they were responsible, they had "six large iron nails for the descent (from the cross), an iron hammer that serves for the same purpose and three ladders painted black."[28]

Thus all over the northern frontier, in towns large and small, the lay confraternities flourished and served to maintain the many aspects of Catholic observances, including the essential Holy Week processions. While some of these *cofradías* were simply devoted to the maintenance of a particular image and its altar, others had more extensive functions and served, as confraternities had traditionally since the Middle Ages, as an important support for the spiritual life of the members. While some of them were devoted to prayer, charitable works, and mild exercises of penance, others continued through the eighteenth century to perform acts of self-mortification both as private exercises and in public times of penance such as the Holy Week processions and during civic or natural crises.

Throughout the 1700s, however, there tended to be increasing control exerted by ecclesiastical authorities over the practices of self-mortification. In the next sections we will consider other, more formal Church organizations in which self-mortification was practiced—and controlled—in colonial Mexico: the Franciscan Third Orders, the preaching missions of the Franciscan friars in northern Mexico, and the Santa Escuela de Cristo (Holy School of Christ).

THE FRANCISCAN THIRD ORDER OF PENANCE IN MEXICO

By the 1500s the Franciscan Third Orders in Europe were in a period of decline; they were not revived in Spain until the late sixteenth century, and thus they were not established in New Spain until the early seventeenth century. The first Mexican Third Orders were founded nearly one hundred years after the Conquest; the earliest was that established in the Province of the Most Holy Name of Jesus in Santiago de Guatemala (which was then part of the Kingdom of New Spain), founded in the year 1613. It was soon followed by establishments in 1614 in the cities of Puebla de los Angeles and Nuestra Señora de Zacatecas and in 1615 in the city of Mexico.[29]

In the popular observances devoted to the passion, the Third Orders did not play as essential a role as did the confraternities. In part this was due to the Third Orders' late establishment in New Spain: confraternities such as the Santa Vera Cruz, the Santo Entierro, and the Santísimo Sacramento were established in virtually all Spanish and many Indian towns in New Spain well before the end of the sixteenth century. They were responsible for the major Lent and Holy Week festivals and for the processions and images associated with them. A second reason for the lesser role of the Third Orders is that in many cases their members, in emulation of the friars (and this was formally established in their rule), withdrew from the world, gave up their material possessions, and lived a quasi-monastic life. This was certainly the case, for instance, in Santiago de Guatemala, where the Third Order brothers maintained their own convent attached to the church of the Calvario. In the patio of this church were "the poor and humble cells of the virtuous Tertiary brothers, who took vigilant care of the adornment and cleanliness of this venerable and marvelous sanctuary. From this patio one passes to a large and excellent orchard of many exquisite fruit trees which these devout brothers of the Third Order of my patron San Francisco also employ themselves in cultivating."[30]

A third reason for the more limited influence of the Third Orders was that until the time of Mexican independence, they were open only to members of pure Spanish blood; mestizos and Indians could not belong. In contrast, among the confraternities there were many especially for the Indians and mixed races, as well as for the Spaniards.[31] This limitation of the Third Orders meant that in practice they were usually established only in larger towns and cities by wealthier Spaniards, and their influence did not spread as readily throughout the social order, or to rural areas. We will return to this point in discussion of the Santa Escuela de Cristo.

The Third Order members, however, did devote themselves to at least one important public activity associated with the passion of Christ: the construction and maintenance of the Via Crucis, or stations of the cross. The Via Crucis was a popular devotional observance that had long been promoted by the Franciscan friars. The prototypal Via Crucis was that of Jerusalem, where pilgrims visited and prayed at the traditional sites of the last events of Christ's passion and crucifixion. In Europe the stations of the cross were established as a form of pilgrimage in miniature: those who could not go to the Holy Land could relive the passion of Christ by ceremoniously walking the Via Crucis. Typically, there were fourteen stations of the cross arranged along a road or path leading to the hill of Calvary; each station represented a particular event in these crucial last moments of Christ's life, including His condemnation, His carrying the cross and three falls under its weight, His last meeting with Mary, His meeting with Veronica, and His crucifixion, death, and entombment.

In the early 1600s in the larger cities of New Spain the newly founded Franciscan Third Orders took it upon themselves to erect elaborate stations of the cross, often along a major avenue leading out of the city toward a hill that had been selected to be the hill of Calvary. The fourteen stations, which originally had simply been crosses, perhaps enshrined in a grotto, were transformed into very ornate small cha-

pels, culminating finally in a large and elaborate chapel of the Calvary, which, as we have seen in the case of Santiago de Guatemala, might be the site of an entire conventual establishment administered by the Third Order. The Tertiaries thus contributed a permanent and no doubt impressive architectural monument to the sacred landscape of their cities, a constant visual and public reminder of Christ's passion and sacrifice.

In Puebla de los Angeles the Third Order established in the 1600s a lavish Via Crucis to which citizens contributed elaborately adorned chapels, and it quickly became an important part of public worship:

the Via Crucis of the Calvary has been acclaimed both for its site which so resembles the original and for the chapels that it has; Christian devotion has made fourteen of them that they may serve as churches; every one is twelve *varas* long by six wide, of vaulted architecture, and one admires not so much the beauty of the art with which they are made as their adornment and the neatness of the altar screens and the jewels with which they are enriched. Every one of the said owners, in vying with one another, has made them, and in devout competition each one has done his best with his chapel; although all are of the same size, each is singular in adornment. All have richly adorned sacristies and everything necessary for Mass. They have their bells, interior patios with gardens and with living quarters in which some Secular Priests live as guards: for such paradises such Custodians are necessary.[32]

Every Friday during Lent in the cities and towns of Mexico, Third Order members made a procession along the Via Crucis carrying their statue of Jesús Nazareno and stopping at each of the stations for prayers and brief sermons by participating friars and priests. Each succeeding Friday more and more people took part in this weekly procession, which proceeded from the church of San Francisco along the "Street of Bitterness" (as the street of the Via Crucis was called) to the Calvario. In Santiago de Guatemala the leading city officials took part in this procession; because of the large crowds they kept an eye out for disorders, but

it turned out quite to the contrary. They saw much that caused them tenderness and edification; for, in addition to the general peace, devotion and affectionate sighs with which the people visited the holy stations, kneeling both in the street of bitterness and within the Calvario, there were many *penitentes* of blood, others with crosses and some kneeling at all the stations. Not only this first time but every Friday and in all the stations, these principal authorities and dignities saw this most abundant fruit of the station and foundation of the Holy Calvary.[33]

This "most abundant fruit" of the Via Crucis, as in the Holy Week ceremonies, was the effective personal involvement of the faithful in the suffering of Christ. It was not merely a public spectacle or a social duty to attend but a reaffirmation of essential Christian values and of the divine purpose of life. The Via Crucis also provided the clergy with the opportunity to preach on subjects relative to these questions with the purpose of inspiring such a reaffirmation among the faithful and of reminding them of the transformational character of Christ's suffering and crucifixion (as discussed in chapter 1).

In Santiago de Guatemala during the Lenten season of 1620, each Friday at the conclusion of the Via Crucis a different Church dignitary preached the culminating sermon of the Calvario. A typical sermon, delivered by the Reverend Don Ambrosio Diaz del Castillo on the fifth Friday, began with the words of Jesus in St. Matthew: "If any man will come after me, let him deny himself and take up his cross and follow me. For whosoever will save his life shall lose it; and whosoever shall lose his life for my sake, shall find it. For what is a man profited, if he shall gain the whole world and lose his own soul?" (Matthew 16:24–26). The preacher then went on to discuss the meaning of these words, speaking of the need for

the abnegation of the passions which drag us down and the means by which everyone can fruitfully carry his cross . . . he explained why one had neither holiness without the cross, nor the cross without holiness, and he explained why in order to crucify ourselves with Christ, we have to live crucified to the world; and concluding most highly, why one has to walk this most holy station not only with bodily steps but with spiritual, contemplating and feeling the sorrows of our Redeemer. Those who know how to conform themselves to Him shall be glorified together with Him (alentó a ser conglorificados con El, los que supiesen de El compadecerse).[34]

In addition to their public duties, the Third Order members dedicated themselves to a rigorous and active spiritual practice throughout the rest of the year. In larger towns and cities, often right next to the church of the Franciscan convent, the Third Order had its own chapel in which regular exercises were performed. Every Sunday of the year members heard sermons in their chapel, and on Mondays, Wednesdays, and Fridays they had moral lessons and "exercises of mortification": "some put themselves on the Cross [unos puestos en Cruz], others on their knees, with a skull, others carrying Crosses, and others prostrated on the ground; from which one takes spiritual fruit for the soul."[35]

The spiritual life of the Third Order, since it was regulated by the friars, was by no means arbitrary; the obligations of the members were carefully spelled out in their constitutions, which no doubt were required reading for every new member. The *Libro de las Constituciones* published in Mexico City in 1760 notes in Rule XV, entitled "Time when there must be *disciplina*":

We agree that the said *disciplinas* be made, as they have until now been made, as the Rule dictates, every Friday of the year, at the vespers of communion, and Mondays, Wednesdays and Fridays of Lent and of Advent, from All-Saints Day until Christmas, with a sermon on the Fridays of Advent and Lent preceding the *disciplina*, that

our *Padre Visitador* [the friar in charge of the Third Order] is accustomed to make . . . and if in the course of the year some precise necessity should arise, it remains the choice of the said *Padre Visitador* and the Minister to make the said *disciplina* at other times that seem appropriate, without suppressing or prohibiting the ones that are specified.[36]

These *Constitutions* spell out the exercises that are essential and cannot be omitted: "never in our Chapel shall the spiritual exercises of Monday, Wednesday and Friday of Lent and Advent be omitted, which will end with *disciplina* preceded by the Sermon. The Via Crucis on Fridays of Lent with sermon and Mass in the chapel of the Calvario and the Procession of the Cord."[37]

The *Constitutions*, apparently since 1636, strictly limited unlicensed public processions in which scourging took place, for no brother "shall make any mortification in public without license of the said *Padre Visitador* and the Minister, by the Rule of June 7, 1636."

By 1802, no doubt in response to the Spanish royal cedula of February 22, 1777, prohibiting public scourging, the Rule of the Third Order no longer even mentions self-mortifications beyond a rigorous schedule of fasting. The members should eat no meat four days a week, with a full fast on Fridays. They should pray the seven canonical hours every day, attend mass daily, and pray for deceased members. On the second Sunday of each month they are expected to take part in the procession of the cord. And above all they should avoid illicit gambling, taverns, and "suspicious houses."[38]

Nor does the Rule of 1802 mention the Via Crucis, probably an indication that by this date these elaborate public processions were diminishing in importance, due in large part to the high cost of maintaining the fourteen chapels of the stations. By the early 1800s the prosperity of New Spain was on the decline: fourteen sumptuously decorated chapels used only six days a year were an extravagance that was increasingly difficult to bear.[39] In 1820 the Via Crucis chapels in Mexico City were in a state of disrepair and neglect, with garbage strewn around them; at night, according to Don Miguel Cervantes, president of the city council, they served as shelters for "noxious" people. Therefore, Cervantes proposed that they be demolished. Attempts by the Third Order to preserve them were fruitless, and in 1824 all the chapels but that of the Calvario were torn down.[40]

PREACHING MISSIONS OF THE FRANCISCAN FRIARS IN NORTHERN MEXICO

The institution of the Via Crucis was not limited to the Third Orders nor to the larger towns and cities but was promoted by the Franciscan friars wherever they established themselves, for it required not the elaborate chapels that were often built by wealthy patrons but simply a series of crosses along a road or path leading to the Calvario. In later years, especially after the anticlerical laws of the nineteenth century that prohibited public religious processions, the observance took place within the nave of the church with the stations of the cross, as they often are today, arranged along the walls. In the colonial period the Via Crucis thus became one of the most important and universally practiced Lenten and Holy Week functions in which the essential events of Christ's passion were relived by the faithful.

The Franciscans also instituted another form of public penance, which was of particular importance in northern Mexico: this was the preaching mission in which penitential processions were a regular part. In the late 1600s Franciscan missionary efforts were directed to the northern frontier, where there still remained unconverted and often difficult Indian tribes. In 1682 the Colegio Apostólico de Propaganda Fide of Santa Cruz de Querétaro was established both for the propagation of the faith among the Hispanicized populace and for the conversion of the Indians. It was the first of four Franciscan colleges responsible, along with the existing Franciscan *provincias* (territorial "provinces" or jurisdictions), for the administration of the majority of the northern missions in the late colonial and early republican periods.[41]

In 1707, friars from the Colegio de la Santa Cruz de Querétaro founded another missionary college, Nuestra Señora de Guadalupe, just outside the city of Zacatecas. Fray Antonio Margil de Jesús, known for his missionary efforts in Guatemala and later in Texas, was brought back from Guatemala to lead the new institution. In addition to propagating the faith among the Indians, the friars of the *colegios* of Querétaro and Zacatecas played a significant role among the mestizo and Hispanic populations of the frontier area.

One of their important duties was to conduct frequent preaching missions among the faithful (*misiones de fieles*), which had the same purpose and form as those of the early European friars discussed in chapter 2, such as Saint Vincent Ferrer and Saint Bernardino of Siena: they were intended to inspire repentance and a renewal of faith and fervor among the laity. These preaching missions utilized penitential processions along the Via Crucis as the primary means of active repentance, followed by the methodical practice of the Holy Rosary.

In beginning a preaching mission the friars of the Colegio de Guadalupe, after coordinating their efforts with the local clergy, would enter a town in solemn procession carrying a standard displaying a large painting of Our Lady of the Refuge of Sinners (Nuestra Señora del Refugio de Pecadores). This advocation of the Blessed Virgin, especially cultivated by the Jesuits, became in 1744 the patroness of these Franciscan missions.[42] After ceremoniously entering the town and saying mass, the friars would begin a series of inspiring sermons: "it was customary that one of the first sermons they preached in the mission be de-

Fig.3.9. View of the Colegio de Nuestra Señora de Guada-lupe, Zacatecas, Mexico. Lithograph drawn by Y. Perez, Salamanca y Cia. (From José F. Sotomayor, *Historia del Apostólico Colegio de Nuestra Señora de Guadalupe de Zacatecas*, Mexico, 1874.)

voted to the Santa Via-Crucis, explaining and teaching the faithful so holy and beneficial a devotion."[43]

These preaching missions through the first half of the eighteenth century were fervently penitential, following the practice of the friars themselves in their private devotions. The head of the Colegio de Guadalupe, Fray Antonio Margil de Jesús, in addition to his work among the Indians of Coahuila and Texas led preaching missions for the faithful in many parts of New Spain. In one memorable mission which he led in the city of Valladolid (now Morelia, Michoacán):

> they preached many sermons in all the churches and convents, and on the day of the procession of penitence, leading the procession with a wooden cross was a prebendary prelate [*un señor prebendado*—a high secular priest of the cathedral]. The Brothers of the Third Order of Penitence followed him, with a multitude of other lay people, dressed in clothes of mortification, some scourging themselves, others with crosses and ropes, some walking crucified [*aspadas*] and many tied with cords. The community of Franciscan friars then followed, all barefoot, with ropes at the neck; interspersed with the sackcloth of the friars was the silk of the many prelates of the very illustrious ecclesiastical council, which made a most respectful and venerable sight: in penance and dignity they differed from the friars only in their cloth-

ing. This penitential squadron accompanied a beautiful crucifix which some *penitentes* of the nobility carried. Behind them a multitude of women walked, observing their station with silence. . . . In this procession the Reverend and Venerable Father Guardian Fr. Sebastián de Oro, well known for his virtue, did not cease to exhort the *penitentes* to sorrow for their sins . . . from four p.m. until seven the tears and sobs of all this most numerous gathering could not be wiped dry.[44]

These *misiones de fieles* fulfilled the same purposes as those of medieval Europe: through preaching and active penance, hearts were melted, enmities healed over, and faith renewed. The friars of the Colegio de Guadalupe, who left detailed accounts of these activities, felt that they were very successful, measured by the large numbers of people who everywhere in northern Mexico took part in and benefited from the missions. The friars were well aware of the august and apparently still vital tradition they were perpetuating, even as late as the 1780s:

> In the history of the seraphic religion [the Franciscans] it is said that, in the sermons preached by San Antonio de Padua, San Bernardino de Siena, San Juan de Capistrano, San Jácome de la Marca, San Bernardino de Feltro and others, it happened that not even the largest churches were sufficient for the crowds; this is verified in the missions that the friars of this Colegio [of Guadalupe] are making, not in just one place or another, or just on certain occasions, but almost in every place and on every occasion.[45]

The success of the preaching missions depended upon two principal factors: the virtues and personal example of the friars and the receptivity of the faithful. The Spaniards and Hispanicized mestizo and Indian populations were receptive to the message and means of repentance; they responded to the example of holiness and the life of poverty and penance lived by the friars. As discussed earlier, the New World attracted the "spirituals" among the Franciscans, those friars closest to the original spirit of Saint Francis. This spirit of reform still survived among the friars of eighteenth-century Mexico, particularly on the northern frontier, where, in contrast to the settled and wealthy life of central Mexico, there remained a challenging field for their missionary spirit.

It was not only in peak events of heightened emotions such as the preaching mission that the friars had their effect, but it was also in their daily example and the reputations they had for fervor and piety. While there were undoubtedly both mediocre and bad friars, the records abound with accounts of the lives of virtuous, brave, and zealous mendicants who lived as Saint Francis had lived (and perhaps even more severely) and who were not afraid to live among hostile Indians or to confront the evil practices of government officials when the situation demanded it.

A typical example among the many we could cite is Fray Diego Alvares of the Colegio de Guadalupe de Zacatecas, who took the habit in 1715. He was widely known for his humility and the self-mortification that

he continually practiced, and these qualities attracted all kinds of people to him:

> in many places when it was known that the Father [Alvares] had arrived, many people went to see him, some in order to take counsel in their doubts, others to receive counsel on their works, and all found what they were looking for in his great charity, making himself available for all and accommodating himself to all, both with people of high position and ability and with the rustic and ignorant poor.[46]

Although colonial Mexico was a highly structured society, Fr. Diego Alvares continually ignored social convention. For him, the traditional Franciscan vow of poverty was not simply an abstract ideal but a lived reality. When traveling, "he did not sleep inside houses but always outside where he spent his time with the servants. . . ." His example to the laity included not only his great charity, poverty, and humility but also his rigorous public self-mortification, so common until the late 1700s among these mendicant friars: "He did not stop scourging himself even when walking on the roads; many lay people have testified to this, and also it can be inferred because many times when he came to the colegio, where he scarcely remained a very few days, he looked for a scourge to take away with him."[47]

In the late 1700s the emphasis upon self-mortification among the Franciscans began to lessen, as did public penitential practices generally throughout northern Mexico. The rising tide of modern humanistic thought which finally had its impact in late Bourbon Spain was in turn reflected in Mexico. The friars of the Colegio de Guadalupe and of the other *colegios* and *provincias* were in close touch with events in Spain; many of them were Spanish born, and there was considerable travel and communication between the convents and *colegios* of the Old World and the New.

Fray José Antonio Alcocer, who led so many preaching missions in the 1770s and 1780s, strikes a new note in his description of the penitential procession:

> In it the men walk making the penance that their fervor dictates; their fervor is such that the missionaries have a lot of trouble in stopping the penances that some carry on with atrocity. However, the missionaries tell them [to stop] when they are exhorting themselves to the penance they want to make, following the cedula of our Catholic Monarch of February 20, 1777, which although it was not published in America, is observed on the part of this *colegio*; and even before they had this notice, they already avoided in the said processions of Penitence, that which in the notice is prohibited, especially the scourgings of the blood which they never permitted.[48]

That the Franciscans of the Colegio de Guadalupe followed this royal edict is indicative of a general relaxation, beginning in the late 1700s, of the former severity of their practices. On January 26, 1778, the Sacred Congregation of the Propaganda Fide, which oversaw the activities of the *colegios de propaganda fide*, decreed that the whipping of *novicios* (neophyte fri-

ars) was prohibited, although our chronicler modifies this prohibition, saying that it means only that moderation should be used.[49] The same chronicler describes the practices of his own master of *novicios*, Fr. Toribio Jaques, under whom he was trained at the Colegio de Guadalupe in 1781: "with us he prayed the *corona*, the office of the most Holy Virgin, that of the dead, and on Fridays the Via-Crucis, but with the circumstance that my master [Fr. Jaques] prayed it crawling on his knees with a cross on his shoulders, without demanding of us this penance, nor any other exercise which was not practiced in this Province."[50]

This relaxation in severity of the Franciscan practices and gradual abandonment of the extremes of self-mortification was paralleled among the laity, especially among the upper classes in the larger cities of New Spain, where a certain level of sophistication and worldliness had begun to prevail. However, the essential aspects of the penitential observances of the Church calendar, especially those of Holy Week, did not change, and in isolated areas and among the poorer people, as we shall see, self-mortification continued unabated in spite of royal cedulas and efforts by the friars and church authorities.

The newly emerging sophistication among the upper classes signaled on the one hand a certain loss of fervor that would lead eventually to the indifferentism and anticlericalism of the nineteenth century, but on the other hand it also signalled the emergence of a sense of balance and moderation in the spiritual life, a correcting of the sometimes extreme emphasis upon the stage of penance so that the other two stages might also be fully lived by the pious Christian.

A manual for the practice of a serious spiritual life, written in Mexico in 1807, describes in detail the practices appropriate for the three stages through which the soul passes: penance, love, and union, which the author denotes in the traditional terms often used: the Purgative Way, the Illuminative Way, and the Unitive Way. In his discussion of the Purgative Way, the author finds corporal penance for the most part inappropriate and "dangerous to the health," for the purpose of penance "is not to take the life from the body but rather to abase the spirit."[51] The author is particularly negative about the use of scourges: "These are not appropriate when they are cruel, for, besides the fact that they make themselves public with the trail that they leave, they take away too much strength and prostrate with excesses and are not the most sensible, thus one should flee from these imprudent maserations."[52]

Even fasts the author finds dangerous if they are excessive. In place of these extremes he recommends a hard bed, a simple diet (no sweets), and prayer vigils, plus "prudent and moderate penance and mortification regulated by the [spiritual] Director." Temptations are to be avoided by, among other means, constant prayer and recitation of the sweet name of

Jesus. Proper accomplishment of the Via Purgativa leads naturally to the Via Illuminativa, in which the seeker ought to practice the virtues: humility, obedience, chastity, modesty, temperance (the "purgative" virtues); prudence, justice, courage (the "illuminative" virtues); and faith, hope, and charity (the "unitive virtues"). Finally the Via Unitiva is practiced, in which, through loving contemplation, union of the soul with God is reached.

In the late 1700s the traditional emphasis upon extreme self-mortification in both Spanish and Mexican Catholicism began to abate. However, self-mortification did not by any means die out as an active spiritual practice. It continued, within approved Church discipline, as a highly regulated but still severe penitential practice, and it continued among the people as a popular public display of penance in the unlicensed activities of individuals and brotherhoods.

THE SANTA ESCUELA DE CRISTO (THE HOLY SCHOOL OF CHRIST)

The Santa Escuela de Cristo emerged in the 1600s and 1700s as an important organization in which penitential practices were perpetuated, in a highly regulated manner under Church authority, as a means for active purification and repentance. The Santa Escuela differed from other confraternities in the emphasis placed upon the teaching of Christian piety to its members. The members followed a highly structured set of practices under the direction of a priest or friar, with the purpose of eliciting repentance and instilling fervor and Christian virtue.

This emphasis upon "school" and teaching of virtue indicates another important aspect of the Escuela de Cristo. It was intended primarily for the edification of the poorer classes of mestizos and Hispanicized Indians who lacked the advantages of the rich and their access to Christian piety. The Escuela de Cristo served the purpose not only of increasing fervor but of channeling it, to regulate the fervent expressions of the unlettered faithful and prevent the excesses or profanations of sacred observances that were always a problem for the Church in New Spain.[53]

One of the earliest congregations of the Santa Escuela de Cristo in New Spain was founded in Santiago de Guatemala in 1664 by the priest Don Bernardino de Ovando. The original *convento* of San Francisco had fallen partly into ruin by the early 1600s, but a group of Indians continued to maintain within it the chapel of the Santa Vera Cruz (built in 1552) for their worship. With these Indians as its original constituency, the Santa Escuela was established at the site by Ovando and a new church was built. The Santa Escuela was later placed under the auspices of the Oratory of San Felipe Neri, a congregation of priests living under the rule established by Saint Philip Neri. Another congregation of San Felipe Neri was established in the Espinosa chapel in 1689, and the group soon came to assume considerable impor-

tance in Santiago de Guatemala. In 1704 the city council decided to take as their patrons and protectors against earthquakes "the Holy Christ that is located in the church of Our Lady of Carmen, which is the copied effigy and true likeness of the Holy Christ our Lord that is in the church of the Pueblo of Esquipulas, and the Lord San Felipe Neri, Patron of his Congregation founded in the Church of the School of Christ."[54]

In the early 1700s the Santa Escuela de Cristo spread to the other cities in New Spain. In Guadalajara the Escuela de Cristo was founded by members of the Mercedarian order about 1730. By 1742, when Mota Padilla described their activities, they had a sumptuous large chapel, dedicated to the prodigious image of Nuestro Señor del Rescate (Our Lord of the Redemption), a "true copy" of the original painting. This congregation was made up of artisans of mixed blood and Hispanized Indians, who attracted attention and admiration by the fervor of their exercises: "The sanctuary [of the Santa Escuela de Cristo] was built at the expense of the *escolapios* who are the poor officials of the craft guilds, but they are so obedient that one is amazed to see a congregation of plebeians who partake of the sacraments in a formal community, attending the exercises of prayer and scourging with as rigorous an observance as the most austere friars would practice."[55]

This congregation of the Escuela de Cristo was founded by Sebastián de Victoria, a friar of the Order of Our Lady of Mercy, and it was clearly directed to the instilling of Christian virtue among the poorer classes. Apparently in twelve brief years it had been very successful, for "the families [of the members] give a thousand blessings to Fr. Sebastián de Victoria, upon seeing the reform of the customs of their husbands, slaves, sons, brothers and servants, and the whole Republic also praises him, for the profit that it experiences."[56]

The "rigorous observances" of this Escuela de Cristo included a thirty-three-day vigil in September and October called the "vindications of Christ" (*desagravios de Cristo*), a period of atonement for the offenses (*agravios*) Christ suffered, during which constant prayer and discipline were practiced daily. The thirty-three days signifies the number of years in Christ's life on earth.[57] In Guadalajara both the members of the Escuela de Cristo and those of the Third Order of St. Francis practiced this exercise. On the thirty-third day both groups made a public procession of penitence, but there was quite a difference between the upper-class members of the Third Order and the much poorer participants in the Escuela, who marched

> without capes, barefoot, faces uncovered, with crowns of thorns on their heads, ropes around their necks and crosses on their shoulders, and these poor ones edify more than the brothers of the Third Order, who in the same form, at a different time, make a similar procession

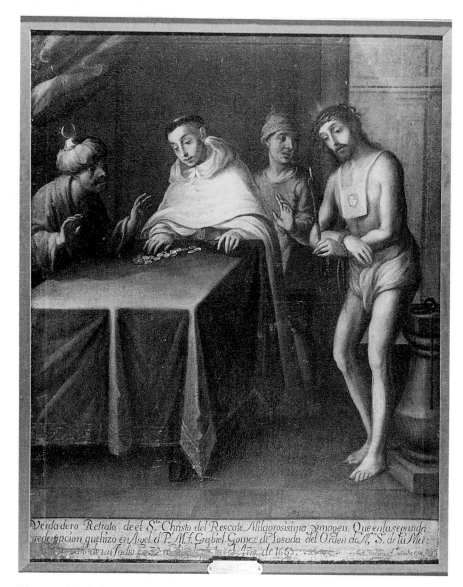

Fig.3.10. Verdadero Retrato de el Santo Cristo del Rescate Milagrosísima Ymagen (True Copy of the Most Miraculous Image of Our Lord of the Redemption), painted in Mexico by Antonio de Torres, 1714. The Mercedarian order, which revered the Holy Christ of the Redemption, was founded in the thirteenth century for the purpose of redeeming Christian captives from the Moors. (Courtesy of the El Paso Museum of Art, El Paso, Texas.)

on the last day of the said *desagravios*, which they also make in their church, because the Third Order is composed of all the republicans and citizens of quality upon whom there is the obligation to give a good example by their better education; but in the poor Negroes, Indians, Mestizos, Mulatos, freed slaves, slaves, and half-breeds (*lobos*), one sees such reform of their habits, such exercises of virtue! Truly it confounds the friars; and with so much spirit these poor ones embrace the doctrine of their school.[58]

Clearly the commentator finds more sincerity and fervor in the exercises of the poor members of the Escuela de Cristo than in those of the Third Order, whose members were perhaps more concerned with social position than with manifesting spirituality.

Another Escuela de Cristo in Guadalajara, apparently of the same character and purpose, was dedicated to Our Lady and performed "similar exercises" in the church of Nuestra Señora de la Soledad. The two groups cooperated closely and "with holy brotherhood" attended one another's exercises. Following normal custom in the confraternities, they also took care of their sick and their members' funerals, and they devoted much effort to the aid of the infirm in the hospitals: "with cloths on their shoulders and their little baskets, they bring support to the hospitals and two by two they kneel at the foot of the bed of each sick person to serve them the meals. See now how much the city has to thank the friars of this most

sacred order [Our Lady of Mercy] for the reform of the customs and the exercises of virtue that are followed in their sacred school."[59]

A study of the constitutions of the Escuela de Cristo, however, suggests that the main purpose of the organization was not charity as such but rather the edification and spiritual improvement of the members, purposes reached primarily through highly regulated practices of self-mortification:

> The institute and end of this Holy School is spiritual progress and the aspiration of all to the fulfillment of the will of God, His precepts and counsels; each one travelling to perfection according to his state and its obligations, with correction of his life, with penitence and contrition for sins, mortification of the senses, purity of conscience, prayer, frequency of the Sacraments, works of charity and other holy exercises.[60]

The extant *Constituciones* were published on behalf of one congregation in Mexico City, but there is evidence that the same rules obtained for the other congregations of the Escuela de Cristo in New Spain. The Mexico City group was founded and maintained a chapel in the Hospital de Nuestra Señora de la Concepción y Jesús Nazareno, under the protection of the Blessed Virgin and the glorious saints Juan Nepomuceno and Felipe Neri.[61]

Its *Constituciones* also refer to the organization as the "Santa Escuela de Jesús Nazareno" (Christ in His suffering), and they note that "this school is most interior and withdrawn (*retirada*), and its principal institutes are the exercises of mortification and penance." These *Constituciones* describe in detail the adornment of the chapel in which the Santa Escuela meets and the exercises to be practiced at the weekly meetings held every Thursday. The altar of the chapel is to have statues of Christ and the Virgin Mary, and over the seat of the director (the Padre Obediencia), statues of "our Fathers San Juan Nepomuceno and San Felipe Neri. At the foot of the altar will be placed two skulls, and bones of the dead and two bundles of scourges."[62]

The self-mortification practiced by the Escuela de Cristo is placed squarely in the context of the imitation of Christ's passion, as the name of the organization itself indicates. The director begins the weekly meetings with a sermon describing in detail Christ's suffering before the crucifixion: how He was tied to the column and "vigorously whipped, crowned with thorns and dressed in purple, slapped and spat upon." This fervent sermon no doubt is made even more poignant by the sight of the statue of Jesús Nazareno in view of all the participants. The sermon ends with these directions: "Brothers, serve the Lord with fear, pick up the scourges in your hands . . . and let us bring to an end this bad way of life that we have."[63] Then, while the director recites two penitential psalms (50 and 129), the participants flagellate themselves. This self-mortification takes place under the eye of the director, who is a priest, and it is subject to his regulation, following the carefully prescribed rules of the organization.

The Escuela de Cristo served as a means of controlling and channeling fervor, making it a premeditative means to spiritual development. In this it clearly drew from the example of the Jesuits, who introduced a cooler, more reflective and intellectual element into post-Reformation Catholic practice. The Jesuits were pragmatists who utilized traditional means, such as self-mortification, in a more rational, calculated manner for the achievement of traditional spiritual ends. Their rationality and efficiency, arising in response to the Reformation, was often in sharp contrast to the older orders, whose approach was frequently more emotional and who were burdened by centuries of inefficient practices. As one writer has noted: "the Franciscans were the 'heart' of the missionary enterprise in America; the Jesuits were its 'mind.'"[64]

Saint Philip Neri (1515–1595) was a contemporary and friend of Saint Ignatius Loyola, the founder of the Jesuits. His congregation of the Oratory and the Santa Escuela de Cristo which the Oratorians fostered were among the many Catholic organizations arising from the Counter-Reformation in response to the challenge of Protestantism.[65] Their purpose was to make Catholic practices more real and concrete for the faithful by promoting a deeper involvement in the ritual life of the Church. This they did by urging more frequent sacraments, particularly Holy Communion, and by a more methodical and accessible spiritual practice that would be available to all classes of society.

As we have noted, the Santa Escuela de Cristo was an organization primarily intended to involve and to edify the mestizos and Hispanicized Indians who formed the artisanal classes of the cities of New Spain. The 1819 edition of the *Constituciones* of the Santa Escuela clearly indicates the democratic nature of this organization. The members, called Disciples, were to "treat each other with love, equality and fraternal charity, for the Disciples of the Holy School of Christ are brothers: 'and all ye are brethren,' Matthew 23." The *Constituciones* further specify that membership is open to all Catholics regardless of rank: "It is required that there be no exclusion of persons, for all who enjoy the benefit of holy Baptism are enlisted under the banner of our Divine Master who called every one without exclusion of persons: *Multi sunt vocati* [many are called]."[66]

In 1760 and 1761 the energetic bishop of Durango, Pedro Tamarón y Romeral, established congregations of the Santa Escuela de Cristo in five principal cities of his large bishopric on the northern frontier: Durango, Chihuahua, Parral, Sombrerete, and Alamos. Newly appointed to Durango, Bishop Tamarón devoted considerable efforts to promoting Christian

zeal among the far-flung communities of his bishop-ric, traveling as far north as Taos and Santa Fe, Nuevo México. In assessing the situation in the cities of this vast realm, he found the need to institute the Santa Escuela as a means for promoting zeal among the populace; for instance, in the Real de los Alamos on February 17, 1760: "His Illustrious Lord established in this Real the Escuela de Cristo in a thorough man-ner, in order that the faithful will acknowledge spe-cial fervor for the divine cult."[67]

In the first meeting in Alamos, held on Thursday, February 21, Tamarón began "as always with his most fervent exhortation, much to the liking of the citizenry," which was followed "with a large gather-ing making with great devotion all their exercises." The following day, being a Friday during Lent, "at 4:30 in the afternoon he made a most fervent exhor-tation for perseverance in the most fruitful devotion of the Via Crucis, which he found established here and immediately after, he took part in the said most devoted procession which ended with the sermon of the night."[68]

It is clear from this quotation from Bishop Tama-rón's diary of his visita pastoral that he did not intend the Escuela de Cristo to supplant existing penitential observances such as the Via Crucis but rather to sup-plement them, to provide a structured organization for the faithful that would meet weekly through the year, not only in Lent and Holy Week. The following Thursday, with the bishop still present, the Escuela had its second meeting:

> one of the affairs of this day was the quite lengthy [bien dilatado] auto of establishment of the Escuela de Cristo, leaving in it the rule, constitutions and offices; then [His Illustrious Lord] prayed the rosary and visited the five altars . . . followed by the most fervent exercises of the Holy School in the same manner as last Thursday; the humility with which the said Illustrious Lord asked to be admitted as one of them filled all the brothers with ten-derness, and the great Spirit with which he exhorted the perseverance of the said school, newly established in this parish church.[69]

On August 6, 1760, Bishop Tamarón arrived in Chi-huahua, where he and the resident priests undertook a preaching mission that was followed on August 17 with the establishment, "with great painstaking," of the Escuela de Cristo. On the August 28, along with the resident clergy, a large gathering of citizens took part in the weekly exercises of the Escuela. The bishop established the Escuela de Cristo in Sombre-rete on March 5, 1761, and as we have discussed ear-lier, he proceeded to stay in that real through Holy Week. On March 26, the Thursday after Easter, he "went to the parish church to perform, as was cus-tomary, all the exercises of the Holy School," but be-cause of the "solemnity" of Holy Week just past, he dispensed with the scourging and substituted for it a most fervent sermon on the subject: "how the Res-urrection from the death of sin to the life of grace must not be like that of Lazarus and other resusci-tated Apostles who return to death, but rather like that of Lord Christ for whom there is no death."[70] In dispensing with the scourging in this meeting of the Escuela de Cristo, the bishop was carefully following the Constituciones cited above, which state that "there is no scourging . . . the Thursday after Easter . . . the Sermon should be lengthened."[71]

In all five cities Bishop Tamarón followed the same means of establishing the Santa Escuela de Cristo, but he did not want to spread this penitential devotion to smaller communities throughout the bishopric for fear of problems arising through lack of regulation, misunderstanding of its means and ends, and over-zealous mortifications. In his voluminous report to the king in 1765, the bishop described in some detail the efforts he made to inspire and edify his faithful, beginning with the clergy:

> The priests and their assistants were examined on moral matters and that touching their ministries . . . and moral conferences were established on the Thursdays of each week; they applied themselves greatly to the study both for this and for the strong examinations that were made, which were on morals as well as grammar and Christian doctrine, for here there are few who are stupid but many who are lazy [aquí son pocos los tontos pero muchos los flo-jos]. The devotions that were particularly promoted dur-ing the visita [of 1759–61] were those of the Holy Rosary of Most Holy Mary Our Lady and the School of Christ Our Lord: they did not have this holy exercise and I started five schools [of Christ] that are in this cathedral [of Durango] and in the parishes of Los Alamos, Chihua-hua, Parral and Sombrerete, which are large towns and since His Divine Majesty is exposed [como se expone su Divina Majestad], it might not be done with the proper decency in small towns.[72]

Neither Bishop Tamarón nor the Constituciones of 1760 and 1819 make any mention of the public peni-tential processions such as that performed by the Escuela de Cristo in Guadalajara in the early 1740s. Generally speaking, by the latter half of the 1700s such processions when under the auspices of Church authority no longer included the more extreme forms of self-mortification such as flagellation. As we have seen, the friars of the Colegio de Guadalupe in Zaca-tecas forbade public self-scourging by 1777, following the royal cedula of that year. By this time, too, the penitential confraternities of the large cities of New Spain had lessened their practices of self-mortifica-tion that were formerly observed in the Holy Week processions. The processions themselves and the other Holy Week observances, however, continued to be the central focus of the liturgical year and to ful-fill the same transformational purpose (described in chapter 1) that they traditionally had.

Until the anticlerical laws of 1857, Holy Week was the major public event in Mexico, unifying the faith-ful in one transcendent purpose and for this moment each year unifying the secular and religious realms as the highest civic officials joined the clergy in the observances. The momentary unity of secular and

religious also extended to the enactment of special laws for Holy Week forbidding unnecessary secular activities during this most sacred time. For instance, in the city of Durango, Governor Joseph Carlos de Aguero's proclamation of March 27, 1768 prohibited "all kinds of diversions in the days of the coming Holy Week . . . the days in which is made the commemoration of the Holy Passion and Death of Our Savior Jesus Christ, in which all Catholics and the Christian Faithful should occupy themselves virtuously." The governor's proclamation goes on to prohibit explicitly the various forms of gambling and sports then popular in Durango: billiards, cockfights, handball, and card games are particularly singled out, and it is ordered that the doors of the rooms in which these diversions take place be closed until Easter Sunday and not admit anyone, whatever his quality or condition. The fine for violating this order the first time is to be decided by the governor, the second time is to be 100 pesos, and the third time is to be three months in jail. One wonders if such stiff sentences were really imposed.

Mercantile activities were strictly limited during Holy Week in Durango, and the stores and markets were required to be closed during the afternoon processions: "all the merchants in the commercial district may not have the doors of their stores open during those hours, without having any respect for such a virtuous Act as is performed in the said procession." The fine for violating this rule was only twenty-five pesos, but it was to be "promptly and effectively exacted by the order of the Lord Governor." Governor Aguero also noticed that neither the merchants of the business district nor their employees were taking part in the processions, and he ordered "their attendance in the said Processions as it is an Act so religious, Christian and devout; and if, by some impossibility that happens to them, the said merchants cannot take part, they must be sure that their employees must take part."[73]

For the most part, these rules were voluntarily followed by the faithful, and Holy Week in Mexico continued to be a most sacred time in which secular diversions ceased. This state of affairs continued, though with increasing friction between Church and state, until the 1850s.[74] Mme. Calderon de la Barca, in her highly detailed descriptions of Holy Week in Mexico City in 1842, notes that "from this day (Palm Sunday), during the week, all business is suspended, and but one train of thought occupies all classes, from the highest to the lowest."[75]

While public self-mortification assumed a much lesser role and even died out in the large cities of Mexico in the late 1700s, this was not the case in the towns and rural areas, where these practices continued in spite of official disapproval until the 1850s. Change generally moves from city to town to isolated village, and rural people, as is well known, tend to conserve customs long out of style and forgotten in the cities. Reports from the provinces of penitential processions during Holy Week are recorded in central and northern Mexico through the 1850s, but are much fewer after 1857. For example, T. Robinson Warren, who lived in Guaymas from 1851 to 1853, described Holy Week as celebrated in Sonora with "torch-lighted processions" on Good Friday, "in which the penitents take a prominent part. . . . Some bind huge wooden crosses to their backs, and drag them around for hours, in the line of procession. Others bind crowns of thorns upon their heads, every step they take blood exuding from their pierced brows; others are bound by hugh chains, while others, naked, are followed by scourgers."[76]

By the year 1870 Col. Albert Evans could speak of the "flagellantes [sic] of twenty years ago" at the sanctuary of Our Lady of Guadalupe, who were no longer to be seen there.[77] From this date on, public self-mortification appeared sporadically in Mexico. While one cannot completely count out the existence of penitential confraternities in the last 100 years, it appears that most public mortifications in the recent past have been performed not by groups but by individuals who have sworn a vow (*promesa*) to do so in return for divine favors granted. Such individual actions continue in Mexico to the present day.[78]

Penitential Practices in New Mexico: The Brotherhood of the Sangre de Cristo

IN THE LENTEN season of 1833 an uneasy Father Antonio José Martínez wrote to the Bishop of Durango, Don José Antonio de Zubiría, concerning the activities in the Taos valley of northern New Mexico, of a Brotherhood of the Sangre de Cristo (Blood of Christ):

> In the time that I have had in my charge the spiritual administration of this parish [San Gerónimo de Taos], there has been a congregation of men in a Brotherhood of the Blood of Christ, who make exercises of penance during the Lenten seasons principally on Fridays, all of Holy Week, Fridays from this time until Pentecost, and other days of such significance in the year. These exercises consist of dragging wooden crosses, whipping themselves with scourges, that they have for the purpose, piercing their backs with sharp stones or flints until the blood flows; and other rigorous means such as the following: They walk barefoot, even over the snows, and [illegible]; naked, with only certain coverings over their private parts, or in white short trousers, and neckerchiefs over their faces in order not to be recognized, and yet to be able to see. In the said days of Lent and all those of Holy Week, they do this everywhere by day, but in the processions of Holy Week, they have the custom of marching in front of the images in the manner described, so that they cause a great spectacle to the bystanders. They say that thus it has been granted to them from time immemorial.[1]

Padre Martínez found in his parish a particularly strong and well-organized penitential Brotherhood, following "from time immemorial" the same practices we have traced in European and New World Catholicism since the Middle Ages. It is not surprising that these practices should have come to New Mexico nor that they should have survived unabated until the second quarter of the nineteenth century, when thanks to Padre Martínez they first came to official notice.

In fact, the very first settlers of New Mexico brought with them the practice of self-mortification during Holy Week. Don Juan de Oñate established the first Spanish settlement in New Mexico in 1598 and was its first governor until 1608. Oñate was the son of one of the four founders of the city of Zacatecas, Don Cristobal de Oñate, an early conquistador. At this time, as discussed in chapters 2 and 3, self-mortification was an integral part of Catholic observance, practiced at all levels of Mexican society: in Zacatecas, Guadalajara, Mexico City, and everywhere Spanish settlements had been established.

Juan de Oñate's activities are described in detail by one of his officers, Gaspar de Villagrá, in his *Historia de La Nueva México*, written within ten years of the expedition. In 1598, on the long trek to New Mexico, Oñate and his expedition celebrated Holy Week where they were encamped, somewhere south of present-day El Paso. On Holy Thursday, March 20, Oñate ordered that a large temporary chapel be built; in it was placed a representation of the Holy Sepulchre:

> With an honor guard of soldiers led by the General [Oñate] and with the friars on their knees, they kept a vigil all night long. They were very contrite *penitentes*, making a large and bloody scourging and asking God with tears and supplications . . . that He show them the way through those most dismal deserts and wild torturous mountainous regions, so that the Church might be brought to remote New Mexico, for the important and salutary good it would bring there; for that sorrowful holy night His very precious blood was shed no less for them than for the many who receive and enjoy it, for His goodness is not refused. In loud voices by themselves in the field the women and children, barefoot all prayed for mercy, and the soldiers in two groups scourged their own shoulders with cruel blows, urgently praying for aid, and the humble, devout friars dressed in hair shirts [*cilicios*] urged them on with outcries and supplications.

It was not only the friars and the soldiers with their wives and children that took part in this self-mortification, but also Juan de Oñate himself and his two nephews, for at this time all levels of society in New Spain participated in these practices during Holy Week and other times of the year: "The General [Oñate] in a secret place that he wanted only me to know, kneeling, with fountains of tears from his eyes, like the others, rending his shoulders, he shed a sea of red blood, and he prayed to God that He have mercy upon the entire camp under his command. . . . His two nephews also scourged themselves at their posts, until dawn."[2]

By 1626 the colony of New Mexico was well established; there were missionaries at most of the Indian pueblos, and many of the Indians were at least nominally converted to Christianity. In January of that year the new Franciscan custodian for New Mexico, Fray Alonso de Benavides, arrived from Mexico to as-

sume his office. Among the Christianized Indians Fray Alonso found penitential practices to be the norm, willingly followed. He suggests this in his recounting of an incident at the pueblo of Xumanas (Las Humanas, now known as Gran Quivira) southeast of Albuquerque. Here, an "old sorcerer" came up to him and accused the Christians of being crazy because "you go through the streets, flagellating yourselves, and it is not well that the people of this pueblo should commit such madness as spilling their own blood by scourging themselves." Benavides notes that the man no doubt had been "in some Christian pueblo during Holy Week when they were flagellating themselves in procession." After the man stormed off, Fray Alonso explained to the people "the reason why we scourge ourselves," and he says that they were even "more confirmed in their desire to become Christians."

In summarizing the progress of the Franciscans among the Pueblo Indians, Benavides claims that the Indians were for the most part fine and obedient Christians who during Lent came "with much humility to the processions, which are held on Monday, Wednesday and Friday." On these days they performed penances in the churches and "during Holy Week they flagellate themselves in most solemn processions."[3]

While Benavides does not mention penitential practices among Spaniards in New Mexico, there is no reason to doubt that the Spanish faithful, with the guidance of the friars, continued to carry on the same exercises that were universally followed in New Spain and were introduced by Juan de Oñate and his men at the founding of the colony. Upon arriving in New Mexico in 1626, Benavides found that the villa [town] of Santa Fe, which was the only Spanish settlement, had a population of about 250 Spaniards, "most of whom are married to Spanish or Indian women or their descendants. With their servants they number almost one thousand persons." He immediately set about building a new and "very fine" church, the previous one having collapsed. Regarding the people of Santa Fe, he reported that they were very well instructed in religious matters and that they set a good example: "The most important Spanish women pride themselves on coming to sweep the church and wash the altar linen, caring for it with great neatness, cleanliness and devotion and very often they come to partake of the holy sacraments."[4]

While the Spanish settlers brought penitential practices to New Mexico, it is clear that, as elsewhere, the friars fostered these practices and continually inspired the faithful to maintain their fervent observances. One of the most important observances fostered by the Franciscans was the Via Crucis, which, as discussed in chapter 3, they promoted throughout New Spain. Under Franciscan guidance, the Via Crucis (stations of the cross) was also performed in New Mexico. In 1729, for instance, the solemn procession

of the "Santa Via Crucis" along the Bernalillo road was mocked by a wealthy Spanish settler of questionable faith, Pedro de Chávez. Fray Pedro Montaño, the friar at San Agustín de Isleta, who probably led the procession, severely criticized Chávez for his irreverence.[5]

These Lenten processions of the Via Crucis continued to be observed in New Mexico through the 1700s. The ecclesiastical visitor Fray Francisco Atanasio Domínguez, in his voluminous report of 1776 on the missions of New Mexico, mentions the practice in at least three places: Santa Fe, the pueblo of Santo Domingo, and Abiquiú. In the cemetery next to the church of San Francisco in Santa Fe, there were "around the inside against the wall . . . nine little adobe tables like altars at regular intervals. Above each is a small adobe niche, or shrine, in the form of an arch, each holding a wooden cross for the Via Crucis." At Santa Fe, Domínguez notes, the friar in charge, Fray Francisco Zarte, gave doctrinal sermons on Sunday afternoons and led the Via Crucis on Fridays during Lent.[6]

The increasingly negative attitude of authorities in late eighteenth-century Spain and Mexico toward public self-mortification was no doubt reflected in New Mexico. There is no mention of such public practices in either Bishop Tamarón's report of 1760 or in Domínguez's report, or in any other known document of the period. However, it is unlikely that these practices had ceased to exist. Domínguez does mention with approval the practice of self-scourging fostered by Fray Sebastián Fernández at Abiquiú, but apparently this took place within the church and only at night. Domínguez notes that at Abiquiú there were prints of the Via Crucis mounted on boards, arranged around the nave of the church, and he says that on Fridays during Lent the people performed "the Via Crucis with the Father [Fernández], and later, after dark, discipline [self-scourging] attended by those who come voluntarily, because the Father merely proposes it to them, and following his good example there is a crowd of Indians and citizens. He is very attentive to the needs of the dying and very zealous for the honor of God."[7]

Clearly in the late eighteenth century, although change was in the wind, the "good example" of zealous friars still inspired the faithful to self-mortification as it had for centuries in Spain and Mexico.

At this time the growing uneasiness with public self-mortification may have induced a certain amount of caution and secrecy among those who participated. As discussed in chapter 3, it is likely that the increasing importance in Mexico of the nocturnal exercises of the Escuela de Cristo (School of Christ) was one response to this uneasiness. It was a means of controlling self-mortification, for such practices were performed at night under the watchful eye of a priest, inside the church or meeting room of the group.

As we have seen, Bishop Tamarón established five

congregations of the Escuela de Cristo on the northern frontier. Although the bishop prudently limited them to large towns and cities, it is likely that they were known and their influence felt in smaller communities. That the Escuela de Cristo was known and its practices imitated in New Mexico is suggested by a comment made in 1817 by the ecclesiastical visitor Don Juan Bautista Ladrón del Niño de Guevara in his inspection of the parish church at Santa Fe. Guevara was unhappy to find seven human skulls in a room next to the church:

> The seven skulls, which were found exhumed, in a room adjacent [to the church], will be immediately reburied, without permitting the use of any other skulls in the Church or in exercises which they observe imitating the practice justly established in the Schools of Christ, in which [the skulls] are of wood; it will be understood precisely that all partial or total exhumations cannot be made without express license of the Illustrious Ordinaries.[8]

In the larger communities such as Santa Fe, Santa Cruz de la Cañada, and Albuquerque, various confraternities, as well as the Franciscan Third Order, were established by the mid-eighteenth century. Although not as wealthy and well organized as those in colonial Mexican cities, they performed the same functions: care of a church or chapel altar and its images; sponsorship of processions, masses, and other ceremonies; and care of spiritual and physical needs of its members and those of the community at large. Documentary references to New Mexican confraternities often note that they were either moribund, inactive, or "not in good order." However, most of these references are comments by ecclesiastical visitors made on the basis of the church records available to them, which deal mainly with the group's finances. Such comments give an outside and "official" view of the group and may not tell the whole story of their activities.

Among the confraternities noted by Bishop Tamarón in New Mexico in 1760 are two in the parish church of San Francisco in Santa Fe: Nuestra Señora del Rosario (La Conquistadora) and the Santísimo Sacramento. The accounts of these groups, presented by the mayordomo Bernardino de Sena, "could not be settled because they were so mixed up." At the same time, at the petition of Governor Francisco Antonio Marín del Valle and "all the citizenry," the bishop gave his approval for a new confraternity dedicated to Our Lady of Light at the Castrense chapel, then under construction.[9] By 1818, however, this confraternity had sunk to "a ruinous and lamentable state," according to ecclesiastical visitor Reverend Juan Bautista Ladrón del Niño de Guevara.[10]

In his 1776 report Domínguez notes seven confraternities in New Mexico. In addition to the three mentioned above, he lists the *cofradía* of the Poor Souls in Albuquerque and those of San Miguel, Nuestra Señora del Carmen, and the Santísimo Sacramento in Santa Cruz de la Cañada.[11] Domínguez makes only brief mention of Franciscan Third Orders in New Mexico, but in a later document, the report of Fray Cayetano José Bernal in 1794, there is more information concerning their activities. Bernal states that there are chapters of Tertiaries established in Santa Fe and Santa Cruz de la Cañada that were founded shortly after the Reconquest (1692–1696), "although the exact year is not known." He distinguishes the Third Order from the confraternities on the basis of its licensing by the proper ecclesiastical authorities, who serve as its legitimate superiors and govern it according to directives received from Rome, all of which make it "a true Order like the First Order which the Friars profess, although with distinct Constitutions and Rule."[12]

These two chapters, according to Bernal, exist thanks to the devotion of the Brothers, and their funds are only what each member contributes, "with which in La Cañada they pay for the fiesta of San Luis and of the Immaculate Conception, and a sung mass with a procession the second Sunday of each month." However, because there are very few Brothers, they cannot always raise the necessary funds. The chapter in Santa Fe uses its funds to pay for the fiesta of San Luis, mass with a procession the second Sunday of each month, and the sermon of the Three Falls of Christ on Good Friday of Holy Week. Bernal also notes that there is a Third Order in Albuquerque, but this group is quite inactive due to lack of funds.[13]

It is clear that virtually all forms of Catholicism as practiced in late colonial Mexico were also followed in New Mexico. Practices in New Mexico differed not in substance or significance but only in elaboration; the poverty of this isolated northern province and the sparseness of frontier life meant a less elaborate expression of religious faith, yet the essentials were the same.[14] The same confraternities were established, the same aspects of the faith were expressed in the important ceremonies such as those of Holy Week, and the same practices of self-mortification were observed from the founding days of the colony. In what follows we will attempt to demonstrate that these practices and the penitential Brotherhood of the Sangre de Cristo which fostered them, and which gained such prominence in nineteenth-century New Mexico, must derive directly from the traditional forms of Hispanic Catholicism.

ORIGINS OF THE PENITENTIAL BROTHERHOOD OF THE SANGRE DE CRISTO

Since the latter half of the nineteenth century, the New Mexican penitential Brotherhood, which we now know as the Brotherhood of the Sangre de Cristo, has evoked much comment and interest from the outside world. Most of this response has been negative, due to a lack of understanding of or sympathy with the purposes of self-mortification in the Christian con-

text. At the same time, however, serious scholars, as well as the territorial churchmen, have attempted to understand the Brotherhood and to trace its origin. The origin of the Brotherhood remains in question, and a definitive answer is not likely until more early documentary evidence comes to light. However, based upon the information available it is possible to make a statement concerning the roots of penitential practice in New Mexico.

Research on Spanish and Mexican penitential practices and the recently discovered correspondence between Padre Antonio José Martínez and Bishop José Antonio Zubiría provide some evidence that casts doubt upon the two most prominent theories of the origin of the Brotherhood and suggests a third alternative. The first theory is that the Brotherhood derived from the Franciscan Third Order. It has been proposed that the Third Order congregations, after most of the Franciscan friars had left New Mexico in the early 1800s, were transformed or else naturally developed into unlicensed *hermandades* devoted to penance. The lack of spiritual authority, either regular or secular, gave free rein to these groups to develop from what had once been highly regulated Third Order congregations. Proponents of this theory cite as evidence the long history of the Third Order in New Mexico, perhaps established as early as the 1690s; the similarities in purpose, structure, and practice between the Third Order and the later penitential Brotherhood; and the lack, prior to 1833, of any clearly identifiable penitential confraternity in New Mexico as the source for the Brotherhood.[15]

In the second prominent theory the idea of the Third Order origin is rejected, and it is proposed that the Brotherhood is a "late transplant" of a penitential confraternity from southern Mexico or Guatemala. According to Fr. Angelico Chavez,

a society or groups of similar societies which came from southern Spain to the New World after the discovery of America did not come up to New Mexico during the first two centuries of existence as a Spanish colony. . . . Sometime in the Secular Period [1790–1850], some individual, or more than one, came to New Mexico from New Spain (soon to become Mexico), or from some other Spanish colony to the south, where such penitential societies had long existed. Such individuals had belonged to such a society, to be able to impart its organization and ritual to their new neighbors here in New Mexico. . . . Within a few years the movement had spread, despite Bishop Zubiría's prohibition, from the Santa Cruz and Chimayó area to almost every village in New Mexico.[16]

In a more recent writing, Chavez asserts that

it is certain that the idea had been introduced from southern Mexico or Guatemala during the present [nineteenth] century, brought in most likely by some late immigrant, or by some *familiar* in the household of one of the first secular priests from Durango. There was Don Manuel Rada, for example, the Mexican secular priest who had served the longest in Santa Cruz, from 1821 to 1828; among his servants might have been the first *peni-*

tente. . . . Or the idea could have been introduced twelve years before by some servant of Don José Vibían Ortega, who was the very first secular priest to serve the Santa Cruz parish in 1798.[17]

Chavez thus first proposes a late introduction of the penitential Brotherhood into New Mexico, perhaps as late as the 1820s. He also suggests the likelihood of the Brotherhood's being introduced by a servant or, in another writing, someone of mixed blood.[18]

In our view there are several problems with both the "late transplant" and the "Third Order" theories of the origin of the penitential Brotherhood in New Mexico. In their place we would propose a third alternative: (1) that there is a continuity of penitential practices and organizations in Hispanic Catholicism extending from medieval Spain to colonial Mexico and finally to New Mexico and surviving there until the nineteenth century; (2) that the integral role of these practices and organizations and their universality in Mexico and New Mexico makes the idea of a late transplant unlikely and unnecessary; and (3) that, for several reasons to be discussed, the Brotherhood of the Sangre de Cristo appears to have developed independently from the Franciscan Third Order.[19]

From our discussion of Spanish and Mexican Catholicism in chapters 2 and 3 it is clear that penitential practices, both public and private, were an integral and essential part of the religion. They were not limited to one region, one social class or race, or one time period but were practiced everywhere the religion took root, by all classes and races, from the Middle Ages through the eighteenth century. In Mexico and New Mexico they were particularly fostered by the missionary friars, but they also had, as it were, a life of their own: penance in some form was an expected and obligatory part of Catholicism, a necessary means of self-purification (see chapter 1).

The idea of a late transplant of organized public penitential practices from a mixed-blood confraternity in southern Mexico or Guatemala implies that these practices were not universal but rather were limited to the lower echelons of society and to certain geographical areas, and that they were not previously carried on in New Mexico. As discussed earlier, the first governor, Don Juan de Oñate himself, introduced self-mortification into New Mexico in conformity with the practices of the Franciscans accompanying him and those of his own relatives and his soldiers. All were unified in the performance of this activity. There is enough evidence to suggest that self-mortification, both public and private, continued to be practiced in New Mexico throughout the colonial period and no evidence or logical reason to contradict such a statement.

However, proponents of the theory of a late introduction of the Brotherhood into New Mexico cite as evidence the lack of documentation of the existence of penitential *cofradías* before 1833. While it is true

that their prior existence is not specifically documented (and we will deal with this question below), there is evidence for the antiquity of the penitential Brotherhood which came to public notice in 1833 and for the long continuity of its practices in two documents written by Padre Martínez and Bishop Zubiría. In Martínez's letter to Zubiría of February 21, 1833, quoted above, after describing in detail the activities of the Brotherhood of the Sangre de Cristo in the Taos area he notes that "they say that [these practices] have been granted to them since time immemorial." Most significantly, he takes no issue with this statement, which certainly suggests a long and continuous tradition rather than a recent innovation. The latter most likely would have drawn his strong negative comment.

Evidence for such a tradition is also found in a previously unpublished comment of Bishop Zubiría. In his famous and often quoted "Special Letter" of July 21, 1833, Zubiría states that in Santa Cruz there is "a Brotherhood of Penitentes" that has existed for "a goodly number of years" (ya de bastantes años atrás). Chavez suggests that this goodly number is probably "a mere dozen or a couple of decades."[20] However, in the records, held in the Durango Cathedral Archives, of Zubiría's visitation to Santa Cruz de la Cañada in July 1833, the wording is somewhat different and suggests a much longer period of time. He notes that he is prohibiting "a certain Brotherhood of Penitentes in this villa, now ancient [ya antigua]."[21] Thus it is clear that both Martínez and Zubiría accepted the antiquity claimed for the Brotherhood by the members in Taos and Santa Cruz.

Both the antiquity of the Brotherhood and the long continuity of its traditions is supported by an interesting account written in 1875 by H. C. Yarrow, a naturalist on the Wheeler expedition in New Mexico. In Yarrow's discussion of Taos he gives a detailed description of the "Penitentés" and quotes at length from notes furnished by "an old resident of New Mexico" who stated that this organization

> has not been countenanced by the recent representatives of the church, though in former years [it] was not only countenanced but encouraged, and the churches were made the theater of the most severe whippings. . . . There is hardly a reasonable doubt but that the ceremonies of the penitents have been transmitted from generation to generation from the flagellants of ancient times, and have been introduced from Old Mexico, at the time when they were encouraged by the priests.[22]

Notes made in the 1870s by William G. Ritch of interviews taken by Samuel Ellison, now in the Ritch Collection at the Huntington Library, also suggest the likelihood of the antiquity of the Brotherhood, dating its activities in Santa Fe at least to the 1790s:

> 1800. Penitenties [sic] existed in New Mexico.—Sam Ellison interviewed Thomas Rendon, born and always lived in Santa Fe 86 years of age (1878) says there were penitenties at Santa Fe as long ago as he can remember.

> Has been no processions since the coming of Kearny (1846). Another man of about the same age (name not known) also born and raised in Santa Fe made the same statement.
>
> April 14, 1878. Pedro José Medina a Pueblo Indian of Zia born the year of the eclipse (1806) says tradition places the Penitenties in New Mexico for time indefinite, he saw them as long ago as he can remember among Mexicans.

Finally, the Brothers themselves also claimed great antiquity for their practices. The 1861 "Rules for the Internal Government of the Pious Fraternity of the County of Taos" state: "The members . . . must know that our teaching since ancient times (tiempos antiguos) has been the devotion of the blood of Christ."[23]

The lack of any earlier documentary evidence for the Brotherhood in New Mexico does not necessarily preclude its existence but rather suggests that until the late eighteenth century its activities were so much a matter of course that they required no comment: nearly everyone was performing these penances during Lent and Holy Week and other times of the year. The original sixteenth-century penitential brotherhoods in Spain and Mexico such as those of the Vera Cruz, the Sangre de Cristo, the Santo Entierro, Jesús Nazareno, and Nuestra Señora de la Soledad, as we have seen, all had approval for their activities and often had the guidance of the friars, and they usually were headed by leading citizens of the community. A penitential brotherhood may well have quietly existed in New Mexico, or the self-mortification and observances they performed may have taken place within one of the known confraternities, such as the Santísimo Sacramento or Nuestra Señora de Rosario. In the 1600s and 1700s specific permission to perform penitential activities would not necessarily have been sought or required by these confraternities, nor by less formally constituted brotherhoods in New Mexico. By the late 1700s, when public self-mortification began to come under fire, the Brothers performing penance may have become more discreet about their activities, particularly during the very infrequent ecclesiastical visitations. By not making their questionable practices known to the Visitor, they avoided inciting his wrath and possible stricture.

It is clear now that the recently discovered letter of Padre Martínez to Bishop Zubiría of February 17, 1833, served to inform the latter of the existence and activities of the penitential Brotherhood and obviously triggered his condemnatory "Special Letter" of July 21 the same year. Without Martínez to inform him, Bishop Zubiría might never have found out about the Brotherhood in New Mexico. Thus the lack of earlier documentation does not preclude either the existence of the Brotherhood or the penitential activities for which it later would be known.

Our rejection of the "late transplant" theory of the Brotherhood's origin does not negate the possibility of influences from the south. There was continual in-

terchange of people, ideas, and goods between Mexico and New Mexico throughout the colonial and republican periods. All aspects of New Mexican life were inspired by this interchange: the territory was by no means an isolated backwater in which nothing changed. The importance of central and northern Mexican pilgrimage shrines in inspiring New Mexican devotions has been documented, and it suggests the great influence that Mexican religious observances had in New Mexico and the essential continuity between the two areas.[24]

Clearly, New Mexicans could have seen or taken part in penitential observances on their visits to the south, and members of penitential brotherhoods in Mexico could have traveled and migrated north to add their ideas and practices to an already existing body of observances in New Mexico. The apparent influence of the Escuela de Cristo upon New Mexican practices is an example of this interchange. It is possible too that in the early 1800s the Brotherhood in New Mexico, in response to the lack of priests and the potential for spiritual disintegration in their communities, became more formally organized, adopting written rules and a more unified organization, perhaps without benefit of priestly advice and consent. However, it is not necessary to posit a source in southern Mexico or Guatemala for these possible changes, nor the introduction of a completely new and foreign cult; penitential practices were already well established in New Mexico and the changes could have occurred from within. If there were outside influences, it is much more likely that, as we shall discuss below, they came from much closer to home: from the northern frontier of Mexico, within the same diocese of Durango of which New Mexico was a part.

The problems with the "Third Order" theory of the Brotherhood origin are the following. First, the traditional activities and purposes of the Franciscan Third Order, as critics of this theory have pointed out, were significantly different from those of the New Mexican Brotherhood.[25] The Third Order had a larger purpose than that of the Spanish and Mexican penitential confraternities. The Tertiaries sought to emulate as far as possible the life of the friars, even in some cases withdrawing from the world and living in *conventos*. In contrast, the members of the penitential confraternities, while also seeking to live a pious life, focused particularly upon the aspect of penance. As we have seen, the Spanish and Mexican penitential confraternities devoted themselves to one or another aspect of the suffering of Christ. The same focus holds true for the New Mexican Brotherhood.

A statement of purpose from a Brotherhood document of 1871 articulates this primary focus upon penance:

Cochiti, 2 January 1871. The purpose of every congregation being: First of all, the sanctification of self and the expiation of one's sins through penance and mortification of one's flesh and especially one's heart, remembering what the Apostle said, 'I fulfill through my body whatever is lacking in the passion of Jesus Christ'; Secondly, the giving of good example to all one's neighbors by a life lived under rules, mortified and Christian.[26]

In addition to this emphasis upon penance, the Brotherhood rules, following Spanish and Mexican confraternity tradition, also emphasize mercy, and hence acts of charity, as a formal part of their activities. In several versions of the rules, the Brothers are enjoined to perform the traditional seven corporal and seven spiritual works of mercy, which are intended to relieve both the physical and the spiritual miseries of others.[27] Thus, the traditional first two stages of the spiritual life, penance and love, are the central features of the New Mexican penitential Brotherhood and are incorporated in its rules.

There are also many structural similarities between the New Mexican Brotherhood and the Mexican and Spanish penitential confraternities, similarities which are not shared by the Franciscan Third Order. For instance, the division of the members into Brothers of Blood and Brothers of Light is a distinction found, as we have seen, as early as the congregations of Saint Vincent Ferrer in the beginning of the fifteenth century, and it continued in the Spanish and Mexican confraternities of the succeeding centuries. The Third Order, however, apparently did not make this distinction.

The costumes of the New Mexican penitential brothers appear to derive from those of the Spanish and Mexican confraternities. As Padre Martínez notes in his letter to Bishop Zubiría, they wore masks over their faces, were bare-chested, and wore *calzonsillos blancos*, short white trousers of the type worn by the often masked Spanish and Mexican penitents. In contrast, the Third Order costume consisted of a simplified form of the Franciscan habit, and it was such an important part of Tertiary life that serious members would request in their wills to be buried in it.

The New Mexican Brotherhood seal of initiation, itself a form of penance, was not a Third Order practice. It consists of the incising of parallel lines between the shoulder blades of the initiate; the incision is made by a sharp piece of flint, the *pedernal* mentioned by Martínez in his letter to the bishop. This ancient practice perhaps derives from the medieval European congregations of flagellants for whom the cross between the shoulder blades was a sign of divine election.[28]

On historical grounds there also is reason to doubt the "Third Order" theory of origin of the New Mexican Brotherhood. As noted in chapter 3, the penitential confraternities were established in Mexico in the early 1500s shortly after the Conquest, nearly 100 years prior to the establishment of the Franciscan Third Order. Flagellant activities during Holy Week were brought to New Mexico with the first settlers in

1598 and again documented by Fray Alonso de Be-
navides in 1627, long before the Third Order was es-
tablished in the colony.

There are, however, practices which the Third Or-
der and the New Mexican Brotherhood share: for in-
stance, flagellation itself; the Lenten processions of
the Via Crucis, which often included self-mortifica-
tion; and the devotion to the blood of Christ and Je-
sus Nazarene.[29] Since the Franciscan friars were the
spiritual mentors of the New Mexicans from 1598 un-
til the early 1800s, it is not surprising that the Broth-
erhood should follow some practices of Franciscan
origin in its observances. The Via Crucis, as we have
noted, was promoted by the friars among all the
people they served: on the northern frontier of Mex-
ico it was universally practiced. Finally, it should be
remembered that in both Spain and early colonial
Mexico the Franciscans were responsible for promot-
ing not only their Third Order but also penitential
confraternities such as that of the Vera Cruz. This
point leads to another conclusion: there certainly
could have been overlapping membership between
the Franciscan Third Order and the penitential Broth-
erhood in New Mexico. No doubt some pious and
fervent individuals belonged to both. However, the
evidence cited thus far and the points, now to be dis-
cussed, in the correspondence between Martínez and
Zubiría strongly suggest that the New Mexico broth-
ers in fact formed a separate penitential confraternity
of Spanish origin, the Brotherhood of the Sangre de
Cristo.

Padre Martínez names these penitents "the Broth-
erhood of the Sangre de Cristo" in his letter of Feb-
ruary 21, 1833, to Bishop Zubiría. In Zubiría's re-
sponse of April 1, he repeats this name: "the Brothers
or members of the congregation called the Sangre de
Cristo." Clearly, to both men the name was a familiar
one; it evoked no special response. After commenting
at length upon the inappropriateness of the peniten-
tial activities of the Brothers and upon Martínez's ef-
forts to control them, the Bishop ends his letter with
this comment: "With regard to the request to estab-
lish a Third Order in that parish [Taos], we will speak
about this soon, since our meeting is not to be de-
layed much longer."[30]

This comment, apparently in response to a sepa-
rate letter, is strong evidence that the Third Order
and the Brotherhood of the Sangre de Cristo were
separate entities. The Brotherhood existed in Taos but
the Third Order did not, and it seems likely that Mar-
tínez wished to start it as a means of both controlling
and legitimizing inappropriate and unlicensed activi-
ties of the Brotherhood. In August 1833 Martínez ap-
parently was appointed by the Franciscan Custodian
at least as "temporary director" of the New Mexican
"Third Order," most likely after discussing the matter
with Zubiría during his visit and receiving his ap-
proval. Later, in 1856, Martínez claimed to have had

Fig.4.1. Padre Antonio José Martínez (1793–1867). (Cour-
tesy of Ward Alan Minge. Copy print courtesy of the Mu-
seum of New Mexico, Neg. no. 11262.)

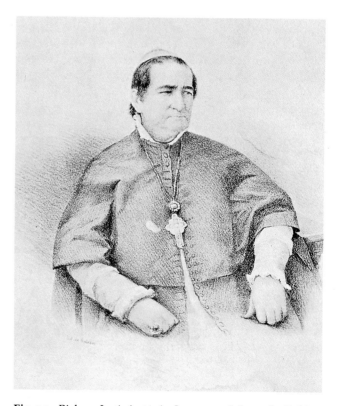

Fig.4.2. Bishop José Antonio Laureano López de Zubiría
(1795–1862). (Courtesy of the Museum of New Mexico,
Neg. no. 13140.)

a subdelegation from the next-to-last Franciscan custodian for receiving both men and women into the Third Order. This subdelegation, he stated, had the approval of Bishop Zubiría.[31] Martínez clearly attempted to control and perhaps legitimize the activities of the Brotherhood by identifying it with the Franciscan Third Order, and his efforts certainly contributed to the idea prevalent in the late nineteenth century that the former derived from the latter.

LA HERMANDAD DE LA SANGRE DE CRISTO

As we have seen, penitential confraternities of the Sangre de Cristo were established in Spain in the 1500s; William A. Christian, Jr., cites as examples one in Valencia founded in 1535 and one in Barcelona which regularly took part in penitential processions after 1544.[32] In northern Mexico the confraternity of the Sangre de Cristo, combined with that of the Santa Vera Cruz, was founded in Guadalajara in 1551; among its activities was a flagellant procession on Holy Thursday in commemoration of the hour in which Christ sweat blood in the garden of Gethsemane.[33]

Confraternities of the Blood of Christ were established elsewhere in northern Mexico; of particular significance for its possible influence upon those in New Mexico is the one established in San José de Parral in the present state of Chihuahua. Bishop Tamarón in his 1760 visitation to Parral describes an altar dedicated to the Sangre de Cristo in the church of the Compañía Sagrada de Jesús and mentions in his inventory "two processional crosses and a standard of the Blood of Christ."[34] In Bishop Don Estevan Lorenzo de Tristan's visitation to Parral, April 14, 1806, he lists among the confraternities one dedicated to the Sangre de Cristo, and he orders their members "to make two curtains for the altars of the Blood of Christ and the Christ of the Column."[35]

In considering possible influences upon New Mexican penitential practices, it makes more sense to examine those of the northern frontier of Mexico than to suggest that influences somehow leapfrogged from southern Mexico and Guatemala all the way to northern New Mexico. The existence of the confraternity of the Sangre de Cristo in Guadalajara and further north since the mid-1500s suggests not a late transplant from the far south but rather the continuing influence of well-established organizations and practices found in northern Mexico.

Communications between Parral and northern New Mexico were frequent and continuous during the colonial era. Parral was a city of considerable importance in the eighteenth century (one of the five Bishop Tamarón felt was large enough to have an Escuela de Cristo), and it lay close to the trade and pilgrimage route extending from Santa Fe to San Juan de los Lagos and Guadalajara. Parral was directly on the route between Santa Fe and Durango, and there were many political, mercantile, military, and religious ties

between the two areas, as well as family ties: many New Mexicans through the years had come from Parral and other nearby communities in Chihuahua and Durango.

Throughout the colonial era and the first half of the nineteenth century, New Mexicans made an annual trading expedition to the south, often going as far as Guadalajara. Along the way they stopped at popular pilgrimage shrines such as those of Nuestro Señor de Mapimí in Cuencamé (Durango), the Santo Niño de Atocha near Fresnillo (Zacatecas), and Nuestra Señora de San Juan de los Lagos (Jalisco). Festivals at these shrines were both spiritual events and occasions for trading; the two activities took place simultaneously. Each year New Mexicans also attended the fairs at the city of Chihuahua and at Valle de San Bartolomé (now Valle de Allende), only twenty miles from Parral. The latter fair was promoted by the viceroy of New Spain, José de Yturrigaray, about 1806, particularly for the benefit of New Mexicans.[36] It should be remembered that New Mexico during this period was not merely a far isolated outpost of Spain but an integral part of northern Mexico, tied to this region by an intricate web of political, economic, religious, familial, and cultural bonds.

Thus it should not be surprising that religious observances in the city of Parral and other northern sites should resemble and perhaps have influenced those of New Mexico. In Parral, for instance, there was not only the confraternity of the Sangre de Cristo but also the closely related Santo Entierro. In 1760 Bishop Tamarón found the following images and other objects in their chapel:

> Nine paintings of the Passion . . . a small Holy Sepulchre. A medium-sized Crucifixion. Another smaller crucifixion with little ladders and [statues of] the pious men of the Descent. Four statues (ymagenes de bulto), very old, of the Child Jesus, Our Lord, Saint Peter, Saint Nicholas. A large chest in which is kept the casket of the Holy Sepulchre. A canopy of blue satin that covers the casket, with its covering of linen. A lectern from Michoacán. . . . A little wooden stool. A small cross. Another large cross painted green. Two ladders painted the same. Death in her cart (La muerte en su carretón). A large wooden cross painted green.[37]

Here were all the objects needed for the important Holy Week ceremony of the Descent from the Cross and Burial of Christ, just as Fray Agustín Dávila Padilla described it in Mexico City in 1582 (see chapter 3): images of the Crucifixion, the Holy Sepulchre, large crosses, the ladders, and, of great interest for New Mexico, the image of Death in her cart.

In eighteenth-century New Mexico the Holy Week ceremony of the Descent from the Cross was also practiced, and larger communities, such as Santa Fe, Albuquerque, Santa Cruz de la Cañada, and Taos, all had their articulated images of Christ in the Holy Sepulchre for this ceremony.[38] In the nineteenth and early twentieth century the articulated image of Christ

in the Holy Sepulchre was found in many of the *moradas* (meeting houses) and chapels of the Brotherhood of the Sangre de Cristo, and was utilized by the Brothers in performing the Crucifixion, Descent, and Burial of Christ.[39]

Two other objects in the Parral inventory were also used extensively by the penitential Brotherhood in New Mexico: the figure of Death in her cart and the wooden cross painted green. As we have seen, the death cart was, as early as 1582, an integral part of the procession of the Descent and Burial of Christ, signifying His victory over death.

It has been suggested that the New Mexican death figure used by the Brotherhood was either an isolated survival of late medieval death imagery (translated to nineteenth-century New Mexico, according to one commentator, through the means of the tarot card for death) or a spontaneous appearance in New Mexico about 1860, "a psychic readjustment of Spanish culture to the new Anglo pressure."[40] As Louisa Stark has pointed out, a much more likely source is the universally practiced Holy Week procession of the Descent and Burial of Christ, which included the figure of Death in her cart.[41]

Death figures are to be found in other church inventories on Mexico's northern frontier. In addition to the example cited in Parral, Bishop Tamarón notes in his 1767 inventory of the altar of the confraternity of Blessed Souls in the parish church at Real de Rosario (now in the state of Sinaloa), "*una muerte*," that is, a death figure. Immediately preceding this entry, he lists: "A casket of palm wood, lathe-turned, that cost sixty pesos. A chest in which is kept the casket. Some old *andas* on which Our Lady accompanies the Holy Sepulchre in procession and which have just been repaired. A holy sheet which cost six pesos. . . . An image of Our Lady of Solitude."[42] This proximity of the death figure to the Holy Sepulchre suggests it was used in the traditional manner in the Holy Week procession of the Descent and Burial of Christ. Since this ceremony, with the death cart as an integral part of it, was practiced all over colonial Mexico and in New Mexico as well, there is no reason to doubt a continuous tradition of its use, which survived among the Brotherhood of the Sangre de Cristo in New Mexico in the nineteenth century.

Descriptions of the use of the death cart by the Brotherhood all derive from the late nineteenth and twentieth centuries.[43] By this time it appears to have been used as a reminder of the evanescence of life and as a penitential devotion: the cart loaded with rocks would be dragged by one or two brothers over extremely rough country in Holy Week penitential processions. It is possible that its other significance—Christ's triumph over death—was by this time forgotten, or perhaps this simply has not been documented in the descriptions of ceremonies.

The other item in the Parral inventory to be found

also among the penitential Brotherhood of New Mexico is the wooden cross painted green. Such crosses are frequently listed in colonial church inventories on the northern frontier. In New Mexico a number of them have been collected from Brotherhood *moradas*. In construction and technique they appear to date from the mid-1800s or earlier. The color green symbolizes the merciful, life-giving qualities of the cross, emphasizing the fact that the crucifixion is not a negative event, sorrowful though it is, but rather a positive one, giving divine life to the faithful. There are also many black crosses which emphasize the aspect of sorrow and mourning (see plate 112).

A related image that connects New Mexican penitentialism with the northern frontier is that of Our Lord of Esquipulas. This is a miraculous Guatemalan image of Christ crucified on a "living" cross, painted green and sprouting leaves and branches. Devotion to this image appears to have been introduced to New Mexico in the early 1800s. In 1805 a child at El Potrero in Chimayó was christened "Juan de Esquipulas" by Fray Sebastián Alvarez, the resident Franciscan friar at Santa Cruz de la Cañada. In 1813 Bernardo Abeyta (uncle of the child so christened) petitioned in the name of the residents of Potrero to the same Fray Sebastián for permission to build a chapel dedicated to Our Lord of Esquipulas, who had already been honored since 1810 in a small chapel of the Abeyta family. By 1816 the Potrero chapel was completed and its elegant door, still to be seen today, was made at the expense of Fray José Corea, the resident friar at Santa Cruz, who had succeeded Alvarez.[44] Bernardo Abeyta, founder of this chapel, was also the acknowledged leader of the Brotherhood of the Sangre de Cristo until his death in 1856. Pointing out this close connection between the shrine devoted to Esquipulas and the penitential Brotherhood in New Mexico, some writers have suggested that both were introduced from southern Mexico or Guatemala at the same time.[45]

However, the devotion to Our Lord of Esquipulas, although originating in Guatemala, was widespread throughout Mexico. What we have suggested concerning the Mexican penitential confraternities also applies here: there is no reason to posit a direct introduction from Guatemala leapfrogging Mexico when the devotion was common all over central Mexico and was found also in the north, ranging as far as northern Sonora.

It appears that devotion to this dark-complexioned image of Christ was not only spread by Christianized Indians and mestizos, as Chavez suggests, but also, and perhaps primarily, by Franciscan friars. In the 1690s friars from the Convento de la Santa Cruz in Querétaro, Mexico, led by Antonio Margil de Jesús and Melchor López de Jesús, were sent to Guatemala, and in 1694 they founded the Hospicio del Calvario (Hospice of the Calvary). In the year 1704 Margil de Jesús founded the Colegio de Cristo Crucificado in

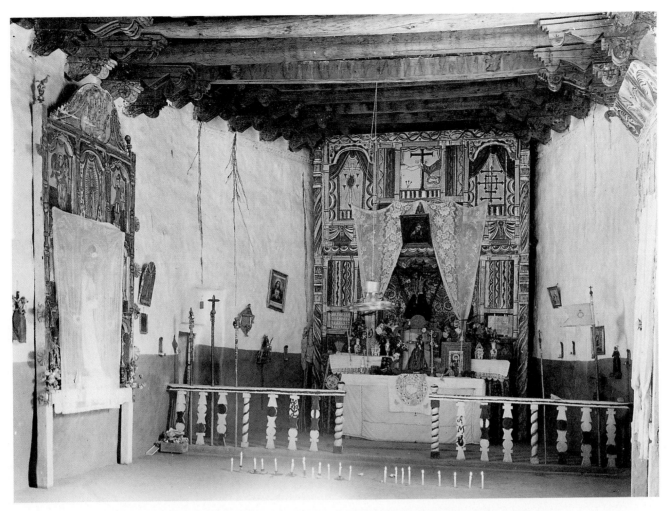

Fig.4.3. Main altar at the Santuario de Chimayó, dedicated to Our Lord of Esqui-
pulas. (Courtesy of the Museum of New Mexico, Neg. no. 13755.)

Santiago de Guatemala and spent several years there, traveling all over the country before returning to Querétaro and later founding the Colegio de Guadalupe in Zacatecas. Without doubt Margil de Jesús and his fellow Franciscans were perfectly familiar with this miraculous image of Esquipulas, which, as we have seen, in 1704 was one of the patron protectors of Santiago de Guatemala (see chapter 3).

In a recent work, Luis Enrique Orozco proposes that Margil de Jesús and his friars brought this devotion back to Querétaro with them, and he convincingly argues that the many shrines and altars to Our Lord of Esquipulas in Nueva Galicia (the present states of Jalisco and Michoacán) owe their origin to Franciscan friars of the eighteenth century. Orozco points out that this devotion did not exist in northern Mexico in the early 1700s, before Margil and his friars returned from Guatemala. Later during the 1700s the devotion was found in many of the Jaliscan communities under Franciscan auspices, apparently having been established by the resident friars. Orozco cites as examples Zapotlan (Ciudad Guzmán), Tuxpan, Cocula, Tenamaxtlán, Juchitlán, and others.[46]

Thus it is quite possible that Fray Sebastián Alvarez or some other Franciscan could have introduced the devotion to Our Lord of Esquipulas to the Chimayó area of New Mexico, where it was avidly embraced by Bernardo Abeyta. As Borhegyi notes: "The correct spelling of the name Esquipulas as we find it in Don Bernardo's letter and in the parish records, as well as the proper iconographical style of the crucifix in the Santuario of Chimayó, indicates that someone must have had first-hand knowledge of the original image and cult in Guatemala."[47] That "someone" with accurate knowledge could have been a Franciscan friar, such as Alvarez, or it could have been Don Bernardo Abeyta himself, and, as we have indicated, he would not have had to go all the way to Guatemala for this knowledge. He could well have visited one of the many shrines to Our Lord of Esquipulas in central and northern Mexico, seen the *"sagrada copia"* of the miraculous image, and brought home devotional booklets giving the history, feast day, and other information concerning the advocation.[48] While more research is necessary to comprehend fully the means by which this devotion spread to northern Mexico, it is

likely that the Franciscans played an important part, as they did with so many devotions on the northern frontier.

THE BROTHERHOOD OF THE SANGRE DE CRISTO IN NEW MEXICO AFTER 1833

The penitential Brotherhood in New Mexico has been known since the 1860s by the name, La Hermandad de Nuestro Padre Jesús Nazareno. However, as we have seen, the Martínez-Zubiría correspondence of February–April 1833 quite definitively names the group the Brotherhood of the Sangre de Cristo. It appears that (1) this is the original name of the group, perhaps surviving continuously from the Mexican and Spanish Brotherhoods of the Blood of Christ of the early 1500s, and that (2) this name survived in New Mexico until the late 1850s when, under pressure from the outside world (most notably Bishop Jean Baptiste Lamy and his foreign clergy), the name was changed to honor the most important advocation of Christ in the Brotherhood's observances: Nuestro Padre Jesús Nazareno. This change in name no doubt took place to avoid the public attention that the name "The Blood of Christ" would give to a flagellant brotherhood.

The earliest surviving Brotherhood rules of 1853 are entitled "Rule of the Holy Brotherhood of the Blood of Our Lord Jesus Christ, for making the exercises of Our Father Jesus Nazarene." Section 6 of this document is dated from "Santuario de Esquipulas, 17 February of this year 1853" and directed to the "Elder Brother (*Hermano Mayor*) of the Blood of Our Lord Jesus Christ of the town of Cochiti." This section ends with: "I, Bernardo Abeyta Principal Elder Brother of the Holy Brotherhood of the Blood of Our Lord Jesus Christ, give this present rule to one of the Brotherhoods under my care."[49]

The original name, "la Santa Hermandad de la Sangre de Nuestro Señor Jesucristo," appears again, in a document from the town of Abiquiú in 1856. But after Abeyta's death in that year, and with the increasing efforts of Bishop Lamy to regulate the Brotherhood, the name was changed, officially at least, by 1860. A document of February 13, 1860, names the confraternity "'The Brotherhood of Our Father Jesus,' from the Rule given by the *Hermano Mayor* of the Brotherhood of Penance, the deceased Bernardo Abeyta." The Brotherhood of the Sangre de Cristo is not mentioned in this document.[50] Most Brotherhood constitutions, transcribed and translated by Steele and Rivera, adopt the new name, but the old name, Sangre de Cristo, continues to be used in less formal documents and in the observances of the Brotherhood.

A curious document entitled "Sensilo Paralelo de la Religion y del Fanatismo" (Simple Parallel of Religion and Fanaticism) was printed in Taos, May 10, 1860, and was presumably written by Padre Martínez or one of his close followers. It includes a letter dated April 12, 1860, and addressed to Don Miguel Griñe and Don Juan de la Cruz Medina that concerns friction between the Brotherhood and the new clergy of Bishop Lamy. This letter begins, "Your servant in philanthropic union of the mystical body of that Brotherhood of the Blood of Christ wishes your health."[51]

A draft of an article written in the 1870s and now in the Ritch papers, attempting to connect the Brotherhood with the Franciscan Third Order, begins: "Penitentes de la Preciosa Sangre de Nuestro Señor Jesucristo or the 3rd Order of the Seraphic Father Saint Francis Assisium." This suggests that the old name "Sangre de Cristo" was still current at that time among the Hispanic informants to whom Ritch and Samuel Ellison were talking. In 1886, in his will, José Guadalupe Vigil, most likely a member of the Brotherhood in Talpa, declared that he owed the "Fund of the Blood of Christ" three *fanegas* (1.6 bushels) of wheat.[52]

As we have noted, most confraternities focus upon one aspect or attribute of divinity, to which they wholeheartedly devote themselves. The penitential confraternities that became prominent in Spain and Mexico in the 1500s focused particularly on the suffering of Christ; each one chose a different aspect of His suffering, upon which they focused their devotion. Thus we find that in the New Mexican confraternity now called the Brotherhood of Our Father Jesus Nazarene, the prayers and observances of the group still reveal that aspect of Christ's suffering for which the Brotherhood was originally named: the Blood of Christ.

As discussed earlier, the rules promulgated by the Brotherhood in Taos in 1861 state that "our teaching since ancient times has been devotion to the blood of Christ," and new members are to be asked: "Do you declare . . . that you will offer yourself as a devotee to the blood of Christ and will imitate to the best of your ability the perfection and example of Christ?" Members were called "esclavos [slaves, servants] de la Sangre de Cristo." *Esclavo* is a term commonly used in colonial Mexico to designate a member of a confraternity, and is still found on ribbon badges worn by the Brothers (see plate 111). This designation is well documented in the inscriptions on the roof boards of the Chapel of Our Lady of Talpa. The chapel was constructed in the year 1838 through the devotion of the "esclavo" Nicolás Sandoval, who was a leading member of the Brotherhood in Taos county. Two prayers on the roof boards are made in the name of the "esclavos de la Sangre de Cristo." One of the inscriptions on the casket for the Cristo Entierro in the chapel, written in 1873 by the carpenters who made it, reads, "A credo to the Blood of Christ for the life and health of Manuel Griñe and his family." This exact prayer is found in the "Rules" of February 17, 1853.[53]

One further question remains to be discussed concerning the penitential Brotherhood in northern New Mexico: this is the apparently contradictory role of

Padre Martínez, who at first censured the Brotherhood, then later became their chief advocate. Understanding Martínez's role will lead us to an understanding of the major spiritual function played by the Brotherhood both before and after the American Occupation of 1846.

Padre Martínez in his February 21, 1833, letter told Bishop Zubiría that in no uncertain terms he was prohibiting the public penitence of the Brotherhood of the Sangre de Cristo:

> For the present I have suspended their public activity and have permitted them only to do it at night and during the day in solitary places, because it makes me very uneasy (*disonante*), the manner in which they have done it until now, and more so since their number has increased. Also it has scattered discord among them and other consequences that cause scandal. So in the meantime I am consulting your Lordship as to what I should prescribe for them in this case: whether they should continue, be modified or simply just cease.
>
> In regard to all I have said, I ask your Lordship to tell me what to do in this case.

Bishop Zubiría's response, written in Chihuahua, April 1, 1833, gave Martínez full support for his suspension of the Brotherhood's public self-mortifications:

> The indiscreet devotion of penances which the Brothers or members of the congregation called of the Blood of Christ are accustomed to make cannot but harm the body and the soul; for this reason, the judgment you made to suspend such excesses of public penances is entirely to my approval: sustain your prohibition, imploring if necessary the aid of the civil authorities; and meanwhile I with knowledge of these things cannot see what would be any better; you will be able to exhort them privately, if it is their desire, as it should be, to appease divine justice and please God, in regard to which the best way to please Him is to listen to and docilely obey the voice of their pastors, being content for now with doing penances in the privacy of the church, always with moderation.[54]

Martínez's prohibition was directed to the public aspects of Brotherhood practices of self-mortification. Educated in the liberalizing atmosphere of northern Mexico during the revolutionary period that began in 1810, Martínez, more than most of his fellow Taoseños, was imbued with modern secular thought, in which such traditional public forms of penance had no place. He was disturbed by these public activities for the "scandal" and "discord" they created in the slowly modernizing society of republican New Mexico. He knew well that such activities were no longer publicly practiced in the city of Durango, where he had lived during his years in the seminary, and he knew that his friend and mentor, Bishop Zubiría, would support his action. In relation to the conservative piety of most rural New Mexicans, Martínez and Zubiría were representative of the liberalizing mode of thought of the Mexican clergy of the era. It had after all been more than fifty years since Charles III of Spain had banned public flagellant processions in 1777; in this time humanistic thought had begun to permeate Church doctrine, together with an increased sensitivity to social problems due to the revolutionary upheavals of the period.

The liberal priest Martínez took it upon himself in 1833 to ban the public penances of the Brotherhood of the Sangre de Cristo; yet by 1851, if not earlier, he was known as their mentor and spokesman, a role he played until his death, after which more than 300 members of the Taos Brotherhood showed their respect by marching in his funeral procession. Why did such a change in his attitude take place?

Between 1833 and 1851 a momentous event occurred: the American Occupation of 1846. This change in sovereignty and introduction of a new, predominantly Protestant culture in New Mexico compelled a reordering of priorities for Padre Martínez. The major threat to the stability and vitality of Hispanic life was no longer the overzealous penitential piety of the Brotherhood, but rather its opposite: the threat of indifferentism, apathy, and social dissolution caused by the introduction of new and decidedly undesirable influences. The very life of Hispanic culture was now at stake, for the invasion of Anglo-Americans threatened to usurp not only political sovereignty but all the traditional elements of the society as well. In this new and dangerous situation, suddenly Martínez and the Brotherhood were allies; both, perhaps for different reasons, desired to maintain the core values of Hispanic Catholic culture against the massive changes threatening from the outside world.[55]

While this goal was especially important after 1846, the roots of dissolution and indifferentism in Hispanic Catholicism actually extended back to the late 1700s; revolutionary, anticlerical, and other modern ideas were in the air at this time even in remote New Mexico, and apathy and empty formalism were recurring problems in Catholic practice.[56] A consciousness of these problems may in fact have led to the creation of a more formal organization of the Brotherhood in the period 1790 to 1820.

What were undercurrents and sporadic problems prior to 1846 became major issues after that date. Both the Brotherhood and Padre Martínez realized that their very way of life was at stake. In the traumatic changes beginning in the mid-nineteenth century, the Brotherhood became the preserver of traditional Hispanic spirituality. The notion of purification through suffering, which was so essential to the spiritual life, was consciously maintained by them. Equally important was the conscious desire to lead an upright and moral life in the face of rapidly changing values and social dissolution: "our profession requires us to live as moral men, not men demoralized," and to provide an example for the community.[57]

Since 1833 and particularly since 1846, the outside world has focused upon the self-mortifying activities of the Brotherhood, in particular, their flagellation

and carrying of heavy crosses. Emphasis upon these practices, particularly by Anglo-American commentators since the late nineteenth century, has almost obscured the important role of the Brotherhood in preserving the essential values of Hispanic Catholicism both for the individual and for the community at large. The purpose of their self-mortification is not to mindlessly punish the body but to transform the heart, so that the individual can transcend the downward tendencies of worldly desires and vices. The leaders of the Brotherhood in formulating their rules in the nineteenth century realized this deeper significance. The 1871 rules quoted earlier clearly state that the purpose of the Brotherhood is the "sanctification of self and the expiation of sins through penance and mortification of one's flesh and *especially one's heart.*"[58] Similarly, the 1853 rules esteem contemplation upon the *meaning* of their activities over an unthinking mortification: "For as Saint Albert the great affirms, it is more important for the salvation of our souls first if there is the recollection of and meditation upon the passion and death of Our Lord Jesus Christ, more so than if one fasted with bread and water every day of his life, more than if he scourged himself until his blood spilled, and if he walked the entire world on his knees."[59]

The most important public activity of the Brothers was and still is their communal celebration of Holy Week in all its richness and significance, for it serves to renew and affirm man's bonds with God and with his fellow man. In these observances communal participation in the passage through the three stages of the spiritual life is annually enacted, just as it always has been in Spain, Mexico, and New Mexico. Holy Week is still the microcosm of the spiritual life during which the faithful purify themselves, receive the love of God in Christ's sacrifice, and are reborn with Him in the Resurrection.

PART 2

The Images and Their Makers
Taylor Museum Santos Made in New Mexico and Colorado After 1860

Introduction. The Penitente Brotherhood in Northern New Mexico in the Late Nineteenth and Early Twentieth Centuries

by Marta Weigle

Por ser mi divina luz	By this Divine Light,
Ay! Jesus de l'alma mia	O Jesus of my soul,
Llevando en mi compania	I take in brotherhood
A nuestro Padre Jesus.	Our Father Jesus.
Escuchen bien, pecadores,	Listen well, sinners,
Los esclavos de Jesus,	All ye slaves of Jesus,
Cumplan con el juramento	And comply with your oath
De nuestro Padre Jesus.	To our Father Jesus.

—Initial stanzas of an *alabado*, or hymn, transcribed and translated
from a Penitente brother's *cuaderno*, or copybook,
by Alice Corbin Henderson in the 1930s.[1]

THE BROTHERS of Our Father Jesus, commonly known as Penitentes, are generally men of Hispanic descent who live in or have migrated from the rural communities of northern New Mexico and southern Colorado.[2] Today an officially recognized, incorporated lay religious society of the Roman Catholic Church, the Brotherhood or Confraternity developed from folk religious practices in the northern Rio Grande Valley during the late eighteenth and early nineteenth centuries. Localized groups, which came to be known as *moradas* (a term applied to both the chapter and its meetinghouse), contributed substantially to the physical, social, and spiritual welfare of pioneer Hispanic communities, most of which did not enjoy adequate Church ministrations until well into the twentieth century. *Moradas* sponsored pious observances, especially during Holy Week, and provided year-round mutual aid for members and charity for the community. After 1850, some local chapters began to develop district and then regional associations known as *concilios* (councils) to guide and coordinate organizational, charitable, and ritual activities between them. *Moradas* and councils of the Penitente Brotherhood, many of them under the archbishop's Supreme Council, continue to operate today, but their membership, estimated at from perhaps two to four thousand, has dwindled dramatically since World War II.

Even during the nineteenth century, Hispanic villages were not solidly Penitente. Men from wealthier families rarely joined the Brotherhood, which generally attracted ranchers with small holdings, tenant sheep herders, and laborers. Ideally, nonmember villagers expected Brothers to be morally upright and deeply pious, but more cynical outsiders believed exemplary behavior applied only to relationships with other members and their families. On the whole, however, mutual respect prevailed between Brothers and their neighbors, whether rich or poor. Although there were some tensions, community life was enhanced by the presence of a functioning *morada*, which served as an informal court, welfare agency, place of worship, and burial society. As Reyes N. Martinez of Arroyo Hondo observes: "Faith, exalted by its very simplicity, Hope of Salvation, through the imitation of Christ's suffering, and Charity unlimited toward their fellowman—these form the Trinity governing the 'Penitente' cult of Taos county, New Mexico."[3]

The tangible, fraternal benefits of Brotherhood membership include monetary help and timely donations of food, labor, and vigils for the sick or incapacitated. Sometimes members are required to subscribe to insurance plans for burial expenses, but more frequently *moradas* act as effective, informal burial societies, working with or without the priest and/or undertaker in conducting the wake, funeral, and interment, whether of Brothers, their families, or their neighbors. Cleofas M. Jaramillo describes Arroyo Hondo mortuary customs, which were typical of Hispanic communities elsewhere:

> When a wake was held for a deceased person, it sometimes lasted two nights, according to the wealth of the deceased or of the relatives. The next morning a home-

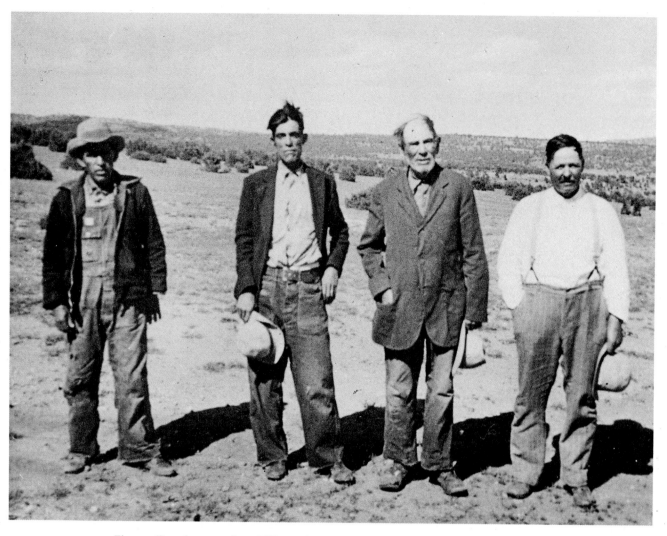

Fig.5.1. Four *hermanos* from El Burro, New Mexico, 1930s. (Photograph by Harry H. Garnett. Taylor Museum Archives.)

made pine coffin, containing the remains, was carried in a wagon to the cemetery. The women mourners stayed at the house, lamenting. The *resador* ["reader"], the singers, and the crowd of bareheaded people followed the wagon chanting the *alabados* in mournful voices. . . .

En route to the *campo santo* or to the Church cemetery, . . . a stop or two was made. At each stop a wooden cross was afterwards propped up with a mound of stones [*descanso*] to remind the passer-by to pray for the repose of the soul of the dead, whose funeral procession stopped at that place for rest.

When the deceased belonged to a family whose members belonged to the *penitente* brotherhood, groups of flagellants visited the remains from midnight on, after most of the people had left the wake. . . . In the summer the wake was held in the open yard, . . . under the silent spell of the night the mournful chants instilling their sad cadence into one's soul.[4]

Her brother Reyes N. Martinez notes that "if the deceased was a member of the Penitente fraternity, the members of that order come and take the body to their 'morada' (lodge house) for a special ritual there, then bring it back to the wake, and throughout the night continue to and from the wake in processions,

singing to the accompaniment of the weird noises of a reed whistle [*pito*], through the streets of the village."[5]

Although all Brothers are considered equal with respect to the divine, elected temporal officers, called Hermanos de Luz (Brothers of Light), govern the *morada*, supervise its rituals, and organize its charities. The highest position is that of hermano mayor (elder brother), who serves as chief administrator, arbiter, and overseer of all rituals and is considered a trusted, capable leader within the confraternity and the community. Other positions may include the *celador* (warden), who maintains order within and outside the morada; the *maestro de novicios* (teacher of the novices), who supervises and examines all who seek to become Brothers; the *tesorero* (treasurer); the *secretario* (clerk), who keeps the records and rule book; the *mandatorio* (agent), who notifies members of meetings and duties and collects alms or dues; and the *enfermero* (nurse), also known as the *hermano caritativo* (charitable brother), who supervises charitable acts. Positions requiring special skills are those of *rezador*

(reader), who reads the prayers and rituals from a copybook; *pitero* (flutist); *cantador* (singer); and *sangrador* ("blood-letter"), also known as the *picador* ("pricker"), or *rallador* ("grater"), who carefully inflicts the seal of obligation on the back of a novice or brother preparing to do penitential exercises.[6]

To become a Brother, the initiate must devote himself to the passion of Jesus and commit himself to lead a simple, selfless, and exemplary Christian life. He is expected to remain a practicing Roman Catholic and to maintain a good relationship with his wife and family. Men join the Brotherhood for a variety of reasons: because their fathers and grandfathers were members; because they vowed to do so if adverse family or personal conditions like sickness or injury were alleviated; because of religious and philosophical convictions; or because they desire prestige or fellowship. In Arroyo Hondo, as elsewhere, boys were sometimes "'entregados a la Sangre de Cristo'

Fig.5.2. *Hermano* holding statue of the Blessed Virgin, San Mateo, New Mexico, circa 1890. (Courtesy of Southwest Museum, Los Angeles, Photo no. P.16550.)

[delivered to the Blood of Christ] by their parents."[7] The initiation ritual by which a novice becomes an Hermano de Sangre (Brother of Blood) involves six rites: (1) a ceremonial knocking at the *morada* door by the blindfolded novice, accompanied by a sponsor; (2) the novice undressing and donning the active penitent's white *calzones* (trousers); (3) a formulaic question-and-answer recitation of Catholic creed and profession of Brotherhood loyalty; (4) veneration of the cross; (5) cutting the *sello* (seal) on the novice's back and delivering ritual lashes; and (6) a rite of forgiveness between the new Brother and all those who are already members.[8]

Brotherhood rituals are enacted both privately and publicly, but all begin and end in the *morada* (dwelling place). Most *moradas* are simple, unobtrusive structures with at least two rooms plus a storage room or loft. One room, usually the only one heated, serves for meeting, eating, and sleeping, while the other is an *oratorio* (chapel).[9]

Those who formally enter or visit the *morada* recite a prayer called *"El Verdadero Jesus"* ("The True Jesus") as they approach, enter, and come to the main altar. Reyes N. Martinez recorded and translated a version from Mrs. Alcaria R. Medina of Arroyo Hondo in 1940:

¿Quien da luz en esta casa?	Who gives light in this house?
Jesus.	Jesus.
¿Quien la llena de alegria?	Who fills it with gladness?
Maria.	Mary.
¿Quien le conserva la fe?	Who preserves its faith?
Jose.	Joseph.
Luego bien claro se ve	Then it is clearly seen
Quiero alcanzar el perdon	I want to attain forgiveness
Teniendo en mi corazon	Carrying in my heart
A Jesus Maria y Jose.	Jesus, Mary, and Joseph.
Los demonios vengativos	The vengeful demons
Nos procuran perturbar	Try to perturb us
Y asi con grandes motivos	And thus with the greatest of reasons
La cruz nos ha de librar	The cross will deliver us
De nuestro enemigos.	From our enemies.
Para no caer en el precipio	That I may not fall in the precipice
Me valgo del Redentor	I avail myself of the Redeemer
Y en su servicio me ofresco.	And to His service I dedicate myself.[10]

Thomas J. Steele, S.J., and Rowena A. Rivera have studied nine New Mexican and Mexican variants of this prayer, which they claim is "one of the most important" in the repertoire of Penitente poetry:

> Recited in its most proper setting by leader and Brothers upon reaching the door to the morada, it signals the beginning of the rituals that will take place within. This simple yet significant ceremony, held immediately before entering the chapter house, is a formal Adoration of the Cross, a collective gesture of making the Sign of the Cross echoing in its small way the fundamental Penitente identification with the passion and death of Jesus Christ

on the cross. . . . It also emphasizes the function of any prayer to initiate, to purify, and to reaffirm belief and intention during the three last and holiest days of Lent.[11]

Public Penitente services may take place in the *morada*, in the village church, at private chapels or shrines in and around the community, or at Calvarios (Calvaries), marked by one or three large crosses in the vicinity of *moradas*. In May 1936 Reyes N. Martinez described "the old church at the upper plaza in Arroyo Hondo, . . . built in the year 1824 . . . and dedicated to Nuestra Senora de los Dolores, Our Lady of Sorrows," whose feast day was celebrated annually on November 26. The church was "originally built in the shape of a T, facing southward, two side chapels adjoined the main building, one to the east and one to the west. It has been remodeled in recent years, the west side chapel having been torn down and the flat roof on the main building replaced by a pitched roof. The old bell was traded for one of newer make."[12] Martinez elaborated his description of the church and included an account of the two *moradas* and two private chapels in June 1936:

> The village proper is divided into three sections or groups of houses, the central section being crossed by State Highway #3, and the other two sections being equidistant from it, one a mile above to the east, and the other one mile below to the west. . . .
> The old church and the morada are at the upper plaza. The church, a massive structure in comparison with the other houses, is built within a cemetery enclosure, has walls four feet thick, . . . and contains old and rare imagery of those times. It was originally built with a flat roof and a supporting "estribu," or buttress, on each side of the front entrance, but has been remodeled to some extent in recent years. The tableau and the original altar were sold to antiques collectors years ago and an altar of modern make stands now in place of the original. The morada, or lodge house of the Penitente cult, stands on a hill to the south of the town-square, made conspicuously prominent by its large wooden cross standing in front of the entrance to the east. It also contains some rare and very antique pictures and statuary and all the paraphernalia of the cult. Built in the shape of an L, it has only one narrow door and one small window to insure privacy.
> At the entrance to the village-limits on State Highway #3 from the south, stands the "Capilla," or private chapel, and a few feet below, the old Vicente Martinez house . . .
> About fifty yards west of the State Highway, as it turns northward at the corner of the Jose Ignacio Rael store, stands the morada of another branch of the Penitente fraternity. This morada is about fifty feet in length, subdivided into three rooms and containing only one small, narrow door and one small window. At the west end is the private chamber where the secret rites of the cult are held; this has no outside door or window, light being afforded by candles or lanterns, day or night. This morada has, also, the large wooden cross standing in front of the entrance, facing south, and contains many relics in statuary and old pictures. Some of the statues of this morada were stolen recently; among these, "Death," with her bow and arrows, rode away in her old cart for parts unknown. A small house of prayer, the Oratorio, stands at

the east limits of the village-square. This is the community house of prayer and also contains some interesting images of a bygone era.[13]

The Penitente Brotherhood is primarily associated with Lenten and Holy Week observances. However, *moradas* also marked patron saints' days for their chapters and often helped with annual village fiestas. Liturgical celebrations like Corpus Christi and All Souls Day might be observed too. Brothers and villagers at Arroyo Hondo celebrated the Franciscan feast of Nuestra Señora de los Angeles de Porciuncula on the evening of August 1 to 2. According to Cleofas M. Jaramillo, it is

> the most important event, excepting Holy Week. The two *moradas* combine for this wake. The gloomy interior of the old church was illuminated by tallow candles placed on tin sconces hung on the side walls and stuck on the mud floor before the statues of *La Sangre de Cristo* (Christ on the Cross) and *Nuestra Senora de Los Angeles* (Our Lady of the Angels), which were brought down from their niches and set before the sanctuary steps.
> The weird strains of the flute announced the approach of the *penitente* procession which stopped outside. The women and men kneeling on the mud floor moved to the sides, men to the left, women to the right, opening an aisle for the penitente chief and the brethren of light, who passed in, chanting hymns accompanied by the lonesome notes of the flute.
> With arms crossed, they knelt in prayer before the statues, while the *mayordomo del velorio*, chief of the wake, distributed to each person a lantern . . . made from a beer bottle, the bottom of which had been taken off by tying a string saturated in kerosene around it, and then burning off the string. Through the open bottom, candles were set in the neck of the bottle and lighted.
> The penitentes, numbering about thirty, led the procession. First, walked the flagellantes, their bare backs streaming with blood. In unison, their whips were raised first over one shoulder and then over the other. They took two or three steps, paused, and then swung the palm whips over their shoulders again. Following the flagellants were those carrying crosses, each guarded by an *acompañador*, walking by his side. The brethren of light and the men carrying burning pitch-wood torches came next. In the middle of the procession walked the men with the statues; behind them came the *resador* and the singer, Hemerejildo, reciting with great fervor the rosary on large blue and white glass beads hung around his neck. The women followed. The two lines of candle light circled the town, and the outline of the square could be seen from the top of the hill.
> Each decade of the rosary was offered in song. . . .
> The lonesome lament of the flute and the wailful chant, punctuated by the painful slap of the palm whip, lingered in the echo of the hill after the procession had gone back into the *morada*.[14]

Her brother notes that:

> Perhaps once, during the night of La Porciuncula, a single penitente, his arms and body bound tightly with a chain to a cross, would make a visit to the church. As the cross to which he was bound was a little less in length than his own height, the progress of this penitente would be slow, being hindered in walking by the rigid upright beam. . . . The trip from the morada to the

Fig.5.3. The upper Arroyo Hondo *morada* in the 1930s. (Photograph by Harry H. Garnett. Taylor Museum Archives.)

church and back to the morada would take at least three quarters of an hour. This kind of penance used to be one of the most severe, as, after a few minutes of being bound in this manner, the retardation of the circulation of the blood would cause the veins on the arms to stand out like cords and the trunk of the body to assume a purplish-blue color. Sometimes the "hermano" would fall in a faint to the ground and the chain would have to be loosened till he recovered sufficiently to stand up again, when he would be bound again with the chain and walked back to the morada.[15]

During Holy Week, the *morada* becomes a literal home for the Brothers in retreat there, usually from Tuesday evening through Good Friday night or Holy Saturday morning. Family and neighbors bring the special, meatless foods of the season, which are exchanged in a community-wide network, especially at noon on Holy Thursday and Good Friday.[16] Brothers also receive a number of visitors, including Hermanos from other *moradas* and villagers, who bring gifts of candles and money in exchange for prayers recited for their deceased by the Brotherhood. Lorin W. Brown states that in Cordova many of these visitors were women, some of whom

> make these pilgrimages in their bare feet. . . . Sometimes a woman will come to the lodge on her knees for the last thirty or forty feet and ask for bread, in God's name. A Brother will come to the door and give her a crust of dry bread and a cup of sagebrush tea, bitter as gall. The woman's dead relatives are then mentioned in petitions the Brethren address to God or some saint for the repose of their souls.[17]

According to Reyes N. Martinez, some Arroyo Hondo visitors followed

> a custom that used to be frequently observed years ago, "ir a pedir santos" (to ask for saints). Some persons, usually women, used to make promises to carry a certain santo in a procession and used to go to the moradas and ask for "Nuestra Señora del Carmel," "San Antonio," "Mi Comadre Sebastiana" (a name by which "La Muerte," Death, used to be commonly known), or for some other santo to carry in processions of penitentes. These persons who carried santos were always given a place of honor in the procession, usually in the middle, between two rows of "penitentes de disciplina."[18]

Brothers of Blood, those who were actively practicing public self-discipline, were carefully prepared and supervised. Reyes N. Martinez describes the procedure:

> It is the duty of the "Hermano Rallador" . . . to prepare the members for the sacrifice. They are stripped to their waists and by a special process of massage applied with the palm of the hands the Rallador benumbs the muscles on both sides of the spine. Using a razor-edged piece of flint . . . , he makes from three to six surface cuts into the flesh, lengthwise on each side, then hands the Brother a whip made of hemp or sizal with which he at once starts to whip himself with vigor. This process is applied to several members till the required number is reached. Then from two to six very heavy wooden crosses are brought forward and placed on the naked shoulders of the men. The "Sangre de Cristo," or Blood of Christ, statue, held in front by one member, is also brought forth, accompanied by two singers, one on each side. All are arranged in parade formation, the ones with

the crosses heading the procession, an even number on each side. The Sangre de Cristo trio also take their place at the head between the rows.

The march starts to the tune of a reed whistle and weird chants of the "acompañadores," or helpers, coupled with the lashing of backs and the rasping noise of the crosses as they are dragged along the ground. Occasionally one or two with big loads of cactus strapped to their naked backs, the spines penetrating deep into their flesh, or bound with chains accompany the procession. All the ones performing the sacrifices wear dark-colored rags or handkerchiefs over their faces and walk on their bare feet, even in zero-degree weather. Sometimes they wend their way toward the church, where the rest of the community joins them in the ceremonies. On other occasions they go toward the "Calvario," or Calvary.[19]

Although other active penitents might continue their discipline inside the church, Jaramillo notes that Brothers "never walked into a church or chapel carrying their crosses, [but] slipped from under them covered with their blanket, and each pair left their two crosses standing outside, interlocked in some way."[20]

Hermanos de Sangre engaged in active public penance were sometimes thought to be revenants whose black hoods concealed skulls and whose bodies might appear insubstantial or skeletal. In part, such legends were used to frighten away unwanted onlookers. However, Brothers themselves sometimes encountered ghostly flagellants, who were thought to be Penitentes unable to fulfill their vows through untimely deaths or those who had transgressed in their obligations. Such encounters were viewed as fearful, but to some, like Lorin Brown's friend from Cordova, seeing revenant Penitentes was "of great personal significance . . . , a sort of personal revelation that his quest for redemption was fruitful": "Manuel says he was not particularly afraid when he noted that the rest of his original company were unaware of these ghostly apparitions. He averred that these souls in torment had been revealed to him alone. This confirmed to him that his salvation was certain, that his life of self-denial had assured him of heaven. In this belief, he died."[21]

Muertes, or carved death angels, known as Doña Sebastiana, were sometimes carried in Brotherhood processions or dragged in carts as an active discipline. Alice Corbin Henderson's description from Abiquiú is typical:

Following the cross-bearers came a penitent dragging the *Carreta del Muerto* [sic]. This was a very heavy low wooden cart, with solid wooden wheels, like the old ox-carts. On it sat a small figure of Death, clothed in a rusty black dress, with staring obsidian eyes in a chalk-white face. The eyes caught whatever glint of light fell upon them, even though the face was in shadow, giving to the death mask an uncanny sense of life. The figure held a drawn bow with the arrow stretched for flight. Tradition has it that the arrow once left the bow to strike the heart of a mocking bystander, killing him instantly. Variations of this tradition exist through all the mountain villages and are occasionally applied to some specific person, long since dead.

Sometimes the figure on the cart is blindfolded, indicating death's blind uncertainty. Also other primitive instruments of death are sometimes concealed in the cart—an ax-head, a stone hammer, or a heavy rock. . . .

The penitent dragged the *Carreta del Muerto* by a horse-hair rope passed over his shoulders and under his armpits, the painful weight of the dragging cart cutting into his naked flesh—a penance as severe as any other, and increased by the fact that the axles of the cart were stationary, and where there was a turn in the path, the entire cart and its inflexible wheels were dragged by main strength.[22]

This was by no means a worship of death, as some have claimed, but a memento mori, a vivid reminder of mortality and the need to prepare for death, in the hopes of a good death, "*buena muerte*, one in the state of grace leading to entrance into heaven."[23]

All Holy Week activities are the responsibility of the *hermano mayor*, who orchestrates both private and public observances according to local traditions, contemporary circumstances and personnel, Brothers' personal requests, and his own sense of appropriate rituals and penances. Throughout Holy Week, he and other *morada* officials oversee the stations of the cross and various dramatic readings/tableaux that are put on by the Brotherhood for themselves and their community.

Most New Mexican chapels, churches, and *moradas* have indoor stations of the cross affixed to their walls. During Holy Week, Brothers also set up outdoor *estaciones* (stations), using small wooden crosses to mark the symbolic Via Crucis between the first station, usually the large cross in front of the *morada*, and the fourteenth, usually the large cross or crosses several hundred yards away that is designated as the Calvario. In April 1940, Reyes N. Martinez transcribed and translated a short prayer and hymn associated with the Way of the Cross and recited to him by Mrs. Alcaria R. Medina of Arroyo Hondo:

Oracion: Adoremos a este Cristo y bendicenos, que por tu santa cruz y pasion y muerte redimiste al mundo y a mi pecador. Amen.
Prayer: Let us adore this Christ and [may Thou bless us who] by Thy cross and passion and death Thou redeemed the world and me a sinner. Amen.
Note: This short prayer is said at the end of the recital of each station, people kissing the ground as they rise to walk to the next station.
Cantico: Los inmensos dolores de Jesus Soverano.
Answer: Lloren los corazones de todos los cristianos, por la pasion y muerte de nuestro Senor.
Hymn: The immense suffering of Sovereign Jesus.
Answer: Cry hearts of all Christians, for the passion and death of our Lord.
Note: This short hymn is sung as people walk from one station to the other.[24]

Martinez also recorded ten stanzas of an *alabado* "sung usually during the Lenten season, during the Via Crucis." Its first two stanzas read:

Con rendida devocion	With humble devotion
Preparense a caminar	Make ready to go
A acompanar al Senor	And accompany the Lord

Que en una cruz a expirar	Who is about to die upon a cross

Mi Dios por mi padecio,	My God suffered for me,
Y yo tan desconocido,	And I so ungrateful,
Arrastrado y escupido,	Dragged and spat upon,
Con tormento feroz.	With fearful torment.[25]

Cleofas M. Jaramillo notes that the Via Crucis observed on Good Friday afternoon at three o'clock was joined by flagellants, cross bearers, and a penitent dragging the death cart, while the hymn sung was a verse from the "*alabado de las columnas*":

En una columna atado,	Onto a pillar,
Estaba El Rey del Cielo.	The King of Heaven was tied.
Chorus	
Herido y ensangrentado	Wounded and bloody,
Y arra[s]trado por los suelos.	He was dragged on the ground.[26]

Brothers and villagers in Arroyo Hondo also observed the *emprendimiento*, or seizure of Christ, at two o'clock in the afternoon of Holy Thursday. According to Cleofas M. Jaramillo:

> The men carrying the statue of *Nuestro Padre Jesus*, a life-sized statue of Jesus of Nazareth, crowned with thorns and dressed in a long red tunic, led the procession out of the Church. The *resador*, reading the seizure and trial of Christ, walked behind the statue, followed by the throng of women.
>
> From *la morada* on the opposite side of the town two files of brethren of light, representing the Jews, started out. These men had red handkerchiefs tied over their heads with a knot on top representing a helmet. They were preceded by a man dressed like a centurion. The Jews carried long, iron chains and *matracas*, or rattlers. On meeting the procession coming from the Church, they stopped before the statue and asked "Who art Thou?" The men carrying the statue answered, "*Jesus de Nacareno* (Jesus of Nazareth)." The Jews then seized the statue, tied the statue's hands with a white cord, while their leader read the arrest sentence. The other Jews stood, loudly clanging the chains and rattling the *matracas*. They led the procession back to the *morada*, carrying with them the statue.[27]

On Good Friday morning, the same two groups enacted the fourth station of the cross, *el encuentro*, the meeting between Jesus and His Mother on the way to Calvary:

> This time the group that left the Church carried the statue of *Nuestra Señora de la Soledad* (The Sorrowful Mary), dressed in black; a black mantle covering her head, over which a silver halo shone. The procession of men representing the Jews came from the *morada* carrying the statue of Christ. The two groups met half way around the town. . . . One of the women took a white cloth from her head, and approaching on her knees wiped the face of the statue, while the grieving Marys wept real tears aloud. The *resador* read the passage of the meeting of Christ and His Mother as the procession walked back to the Church.[28]

The simulated crucifixion, in which a black-hooded, white-shrouded Brother was briefly bound to a cross during a short meditation or sermon on the last words or an appropriate song or prayer, took place sometime on Good Friday afternoon. In Arroyo Hondo, Jaramillo remembers:

> The largest and heaviest cross was picked out and laid upon the shoulder of the *hermano* who chose to represent the crucified Christ. A crown of thorns was placed on his head, and a bunch of prickly cactus was hung on his back. Laboriously, the *penitente* dragged the scraping cross up the rocky trail. Two brethren of light walked on each side of him, one reading the three falls in the Stations of the Cross from an open book in his hand. The other, acting the part of Simon Cyrene, helped the *hermano* lift the weighty cross when he stumbled and fell under its weight. A group of brethren of light had already dug a pit and gathered a pile of rocks by Calvary Cross. They stood around the *calvario*, awaiting the arrival of the *Cristo* brother, who on reaching the hill was stretched upon his cross and tied with ropes. The cross was raised and placed in the pit surrounded by the pile of rocks to hold it upright.
>
> The *hermanos* knelt with bowed heads around the cross, praying and reciting the Seven Last Words of the crucified Savior. The voice of the man upon the cross grew more and more faint, as he repeated the words, until his body hung limp, and he was taken down and carried on a blanket, too weak to carry his cross back to the *morada*.[29]

Las Tinieblas, the so-called earthquake or Tenebrae service commemorating the chaos following Jesus's death when the dead walked the earth, takes place on Holy Thursday and/or Good Friday night. Arroyo Hondo's began at dusk on Holy Thursday with a rosary recited by villagers and Brothers during a procession around the church. The Tinieblas (Darkness) ceremony continued inside, where, according to Reyes N. Martinez's description,

> lights are put out for intervals of from ten to fifteen minutes, during which chanting, rattling of chains, knocking on benches and other furniture, blowing of the reed-whistle and beating of the "caja" (small drum) take place simultaneously. A lighted match, swung about in a circle by the man directing the ceremony, signals the end of each dark interval, then the candles on the altar are lighted again.[30]

In Cordova, the Brothers of Light and of Blood openly entered the church for Holy Thursday's Tinieblas, and "in some cases, two or three of the penitents will throw themselves face down in front of the door, thus signifying that they wish the people to walk on them as they enter, [and] there is little squeamishness in complying with this request."[31] Inside, the Brothers kneel or lie prostrate in front of the altar. The doors are closed, and all candles but thirteen to seventeen on the altar are extinguished. According to Lorin W. Brown:

> A lone singer from the *morada* takes up his position near one end of the row of candles on the altar and starts a hymn of peculiarly haunting quality. . . . As he concludes each verse, he reaches out and pinches a yellow candle flame. . . . Having extinguished the last light, he makes for the low door of the sacristy, which opens off the altar space to the left. Passing through this door, the dim light afforded by his shaded lantern is cut off also, leaving the church in utter and appalling darkness.

Suddenly, a voice calls out "*Ave Maria*" whereupon a deafening tumult breaks out. It is the clapping of hands added to the clattering racket of the *matracas* in the hands of the Brethren. When the noise dies down, someone is heard saying:

Un sudario en el nombre de Dios por l'alma del difunto Jose ———. (A prayer for the repose of the soul of the deceased Jose ———, in the name of God.)

A subdued murmur is heard as most of the assembly join in the semi-whispered response to the request. Another name is called out, and the request is complied with. Perhaps three or more requests for prayers are called out and complied with when the same voice again calls out "*Ave Maria*," and the clapping of hands is resumed with the accompanying sounds as before. As from a great distance, the voice of the lone singer is heard from the sacristy above the tumult of the clapping hands, the *matracas*, and the rattling of heavy chains.

The service continues for nearly an hour, but the time seems longer. . . . The whole ritual is awe-inspiring, with a touch of the uncanny, and to many it is a great relief when the door of the sacristy opens and the faint light of the lantern signals the end.

The Brethren form a line and shuffle backward toward the door, with the huddled blood-caked figures in white drawers in their midst. As they reach the door, they make a genuflection toward the front of the church and pass into the yard. Heavy crosses are lifted onto benumbed backs, and the scourges swing again.[32]

At Cordova, as at Arroyo Hondo, Abiquiú, and elsewhere, the Tinieblas is a dramatic highpoint of the village year. Penitente Brothers and villagers literally huddle together in the din-filled, disorienting darkness while symbolically taking a stand in the face of this chaos by calling out the names of their beloved departed, those who built their community. Perhaps more important, in the tumult and prayer of the Tinieblas all the living fulfill the charge given by the deceased in the following funeral hymn, as transcribed and translated by Alice Corbin Henderson:

Adios por ultima vez	Good-by for the last time,
Que me ven sobre la tierra	Those who see me on this earth.
Me echan a la sepultura	Place me in the sepulcher
Que es la casa verdadera.	Which is truly my house.
Adios todos los presentees	Good-by, all those present,
Que me van a acompanar,	All who accompany me,
Rezen algun sudario	Pray a *sudario*
Para poder alcanzar.	In order to overtake me.
Adios todos mis proximos,	Good-by, all my neighbors,
Toditos en general,	All, all in general,
Encomienden mi alma a Dios,	Commend my soul to God,
No me vayan a olvidar.	And do not forget me.
Fin-Fin-Amen	The End-Amen[33]

José Benito Ortega: **Bultos** *and* **Retablos,** *and Other* **Retablo** *Makers*

BULTOS BY JOSE BENITO ORTEGA AND HIS SCHOOL

EAST OF THE Rocky Mountains in New Mexico, one artist and his workshop dominated the production of *bultos* (statues) in the late nineteenth century. The work now attributed to José Benito Ortega (1858–1941) was earlier identified as the "flat figure" style due to the frequent use of milled lumber; it was also identified as the Mora style because so many pieces were found in the vicinity of Mora, New Mexico. In 1943, Wilder and Breitenbach first described and illustrated five images in this style: "The 'Flat Figures:' One of the most commonly encountered styles in New Mexican *bultos.* . . . A great many specimens are reputedly from Mora County, New Mexico, and it is possible that the name Mora may be properly applied to the style. The dominant characteristic of this type is the flat body, and the severe impelling countenance."[1]

In 1962, apparently through the agency of Taos *santo* collector Charles D. Carroll, E. Boyd met José L. Morris, who identified the prolific Mora *santero* as his uncle José Benito Ortega. Morris had a copy of his uncle's baptism record, showing that he was born in Mora, March 20, 1858, and baptized "Jose Benito Ortega."[2] Apparently in later life he was known as Juan Benito Ortega.

According to Morris and to Ortega's youngest daughter, Refugio Sandoval (also interviewed by Boyd), Ortega lived in the village of La Cueva, four miles east of Mora, until 1907, when he moved to Raton. Documentary records cited by Boyd confirm his residence and indicate that for a time he lived at Coyote de Mora, a village probably on Coyote Creek northeast of La Cueva, possibly today's Rainesville.

José L. Morris told E. Boyd that his uncle was an itinerant *santero* apparently working in the same manner as Juan Ramón Velázquez, his contemporary in the western regions of Hispanic New Mexico. Morris said that his uncle would walk "from village to ranch house . . . with a small bundle of tools and no materials. He would stay with the families who wanted *santos* until he had finished their orders."[3] José Benito Ortega was extremely prolific, but according to his nephew he did not have a helper. However, it seems likely that at least family members assisted him, and

the presence of two related styles from the Mora area suggests the possibility, as we shall discuss, of an Ortega workshop.

Today there are to be found more images attibutable to Ortega than to any other New Mexican *santero* of the nineteenth century—more than 200 *bultos* in public and private collections. For many years, Ortega and the two artists working in similar styles supplied virtually all the communities in Mora, San Miguel, and Colfax counties, east of the Sangre de Cristo range. Figures by Ortega have been found in Colorado's neighboring Las Animas County, and a few in communities west of the Sangre de Cristo range in New Mexico.

The work of José Benito Ortega falls into two groups, which were produced for two distinct but interrelated markets. On the one hand he made images of a wide variety of popular saints and holy personages for the use of individuals, families, and some of the churches in his area. Surviving images in this category include Nuestra Señora del Carmen, San José, La Sagrada Familia, San Antonio, San Acacio, Santa Librada, San Isidro Labrador, and others. Ortega was the last New Mexican *santero* to make images of these popular household saints in such quantities.

In other areas at this time, the production of *santeros* was almost entirely devoted to passion figures (Cristo Crucificado, Jesús Nazareno, Nuestra Señora de la Soledad, etc.) for Brotherhood *moradas*. Only an occasional popular saint was produced, no doubt in response to a special request. In the isolated eastern villages, in contrast to other areas, there was still a demand for locally made popular images. These villages did not have sufficient numbers of the earlier local images, since they were settled later and were distant from the Rio Grande communities. Nor apparently were they satisfied with, or able to afford, commercially made plaster statues.

The other market for Ortega's work was the Brotherhood of Our Father Jesus Nazarene, formerly the Brotherhood of the Sangre de Cristo. Ortega made large quantities of passion figures for eastern New Mexico *moradas*, figures that perpetuate many traditional attributes. The demand for popular saints in New Mexico appears to have slackened by the 1880s,

while the need for passion figures continued into the early 1900s. Thus the popular saints may represent Ortega's early work (1870s–1880s), while the passion figures are distributed throughout his career until he stopped carving, circa 1907. The dispersal of Ortega *santos* also reflects these trends, for many of the popular saints were available in the 1920s to collectors such as Frank Applegate, while the *moradas* tenaciously held onto the passion figures until the late 1940s or later.

Like other *santeros* of the day, Ortega's work was extremely stylized, at a far remove from naturalism. His figures tend to be static, somewhat awkwardly conceived, with little definition to the bodies. The treatment of the faces is virtually the same for every piece he made, whether the subject is male or female, young or old (except for the distinction of a beard). The eyes protrude and stare, the nose is quite large and slightly turned up, the chin is clearly defined, often slightly pointed. The overall impression given by these images is that they are robust and honestly conceived, but they lack the grandeur appropriate for saintly imagery. They have the requisite impersonality of traditional sacred art, but not the surpassing beauty.[4]

Two groups of figures in the Taylor Museum share characteristics with the pieces attributed to José Benito Ortega but are the work of other hands. These figures suggest that Ortega had a workshop, or at least worked closely with and influenced other artists. These two groups are named here the Schools of José Benito Ortega I and II. Five pieces representing the School of José Benito Ortega I, all of them *morada* figures, are in the Taylor Museum. Three of these are from eastern New Mexico: Mora (TM 1246), Las Vegas (TM 5734), and Rociada, six miles south of Mora (TM 3851). The close proximity of two of these villages to Ortega's home in La Cueva strengthens the likelihood that the two artists worked together. The School of Ortega I pieces differ from the work of Ortega himself in the more delicate treatment of the faces, which are longer and narrower than Ortega's, with sharp, slender noses. This angularity is also reflected in the figures, particularly the *Jesus Nazarene* and *Christ Crucified*, with their elongated, narrow torsos. Other features, such as the hands, are virtually identical to those in Ortega's work.

Four *bultos* in the Taylor Museum, all from eastern New Mexico, are attributed to the School of José Benito Ortega II.[5] Two of these figures are part of a group said to represent the crucifixion of Christ and the two thieves who were crucified with him. According to collector Harry Garnett, this unusual, elaborated crucifixion scene was hung upon the walls of the *morada* at San Gerónimo, New Mexico, east of Las Vegas. In the center hung Christ Crucified (TM 3718, plate 18). On the left was Jestas, the unrepentant thief, who is painted a dark blue grey (TM 3720), and on the right was San Dismas, the repentant thief (TM 3719). This third piece is in the style of José Benito Ortega. The location of these derivative pieces in the eastern New Mexico area and their grouping with an Ortega piece lend support to the supposition that this artist worked closely with Ortega. The figures in this group closely resemble Ortega's work but have less sharply defined facial features, which give a heavy, impassive aspect to the faces. All four pieces in this style have a long "V" incised in the center of the chest to form the rib cage, and the loincloths have diagonal bottom edges.

José Benito Ortega probably began carving as a young man in the late 1870s; he may also have painted *retablos* (paintings) in a quixotic primitive style, to be discussed below. During a period of about thirty years, he produced a large quantity of *santos* for eastern New Mexico communities. In 1907, after the death of his wife, he moved to Raton to live with some of his children. At that time he stopped making *santos*. He took up the work of a house plasterer and died in Raton in 1941.[6] Thus the work of José Benito Ortega and his school represents a last flowering of the art of the *santero* in New Mexico. Its abrupt end in 1907 clearly indicates that changing times had made the work of the folk *santero* obsolete, forgotten in the rush to modernity.

RETABLOS ATTRIBUTED TO JOSE BENITO ORTEGA

Two factors suggest the possibility that José Benito Ortega also painted *retablos*. First, there is a stylistic group of late nineteenth-century New Mexican *retablos* that shares traits with the paintings on the surfaces of a few Ortega and Ortega School *bultos*. Second, some of these *retablos* have inscriptions that are in the same hand as inscriptions found on certain Ortega *bultos*. E. Boyd first called attention to this correspondence, noting that the coloring of these *retablos* was the same as that of Ortega *bultos* and that "a few examples of both with semi-literate inscriptions painted on them are lettered in the same hand." She illustrated two *retablos* that she attributed to Ortega, as well as an Ortega *bulto* with painted faces on the skirt.[7]

One such *retablo* in the Taylor Museum and at least one in the Museum of International Folk Art have inscriptions in the same hand as the inscriptions on two Ortega *bultos* of Our Lady of Mount Carmel, one in the Marion Koogler McNay Art Museum (1950.255) and the other in the Dallas Museum of Art (1961.43).

Twelve *retablos* in the Taylor Museum are in the style attributed to José Benito Ortega and a considerable number are in other public and private collections. This style of painting is characterized by its freedom of execution. The forms lack definition and often seem to float ethereally in the picture plane, enclosed by quickly drawn borders. Like most late nineteenth-century locally made New Mexican *retablos*, these pieces are primitive in style and execution: hands are small and clawlike, elements are out of pro-

portion to one another, and bodies are often form-less. Yet at their best they still convey something of the spiritual quality of the saint portrayed.

Three pieces in the Taylor Museum were tree-ring dated by W. S. Stallings, Jr., in the 1940s, giving 1873 to 1878 as an average range for the cutting of the trees.[8] While this measure is rough, it does fit into the period in which José Benito Ortega worked. One of the pieces, *Santa Rita de Casia* (TM 1187, plate 19) has a bark date of 1859, which is the date of the last growth ring next to the bark, indicating the year the tree was cut. This piece and several others are made from milled lumber rather than hand-hewn panels, another indicator of late nineteenth-century provenance. Within this group of paintings are variations which suggest the work of another artist, possibly the sculptor of the School of Ortega I style.

OTHER LATE NINETEENTH-CENTURY RETABLOS AND PRINTS

In addition to *retablos* attributed to José Benito Ortega, several styles were painted by local artists in New Mexico in the late nineteenth century, most of them quite crude and often childish in their execution. In addition, prints began to assume a much greater importance in this period, often replacing the older *retablos*. Without attempting to account for every artist who worked in this period, the most prominent styles of painting are divided here into the following groups:

Retablo Style I: A group of small *retablos* somewhat akin to those attributed to Ortega. The artist worked in tempera and gesso on wood, producing awkward, asymmetrical renderings that suggest the work of a child. This is a fairly common type: nine examples are in the Taylor Museum, and several are in other collections. E. Boyd labelled the group "Banjo Eyes" due to the exaggerated staring of the eyes.

Retablo Style II: This group of *retablos* is characterized by the use of enamel paints on pine boards, the use of hand-carved frames on some panels, and direct reliance on prints. According to E. Boyd, these works originated in the Las Vegas, New Mexico, area: "There is a series of these panels, done in oil and/or enamels, all equally inept but usually in more monochrome dark brown. Mrs. Gilmore, who collected *santos* as far back as before World War I, formerly owned three of these, and said she had acquired them all in the vicinity of Las Vegas. They were from native owners and therefore had not been moved around by dealers. I would date them 1900 or plus."[9]

Boyd does not provide any evidence for a post-1900 date, which seems unreasonably late. Both the style and the reliance upon prints suggest a late nineteenth-century date.

Retablo Style III: This group of small *retablos* is characterized by awkward, blocky designs and thickly applied paints. In addition to three in the Taylor Museum, one is in the Adams State College collection (#65.1.45). One of the Taylor Museum pieces in this style has gesso-relief modeling.

Retablo Style IV: This group consists of three large oil paintings on flour sacks. They are crude but vigorous representations of *San Gerónimo*, *San Simón*, and *Nuestra Señora de Guadalupe*, probably intended to form an altarpiece. No other pieces in this style have been identified.

The Quill Pen Follower: The works of the Quill Pen Santero and his follower are described in *Christian Images in Hispanic New Mexico* (pp. 99–103, plates 63–67). The dates suggested there for the Quill Pen follower—ca. 1835–1850—have proved to be too early: a group of five other pieces in this style were tree-ring dated by W. S. Stallings, Jr., who discovered that all of them were cut from the same board and have a bark date (that is, a cutting date) of 1871. These pieces are clearly in the style of the Quill Pen follower: they share many details with the panels illustrated in *Christian Images*, plate 67; for instance, treatment of the drapes, the pedestals, and facial details. Like the work of the Quill Pen Santero himself, these pieces combine rather coarse and freely applied brushwork, particularly in the drapes and the figures, with delicate pen drawing. (See, for example, the angel wings and serpent of *The Guardian Angel* [TM 895, plate 39] and the serpent in TM 589 [plate 42]). E. Boyd locates three other pieces in this style in the Museum of International Folk Art collections, two in the Harwood Foundation, and one in a private collection.

Late Nineteenth-Century Prints: in homes and in churches and chapels religious engravings, woodcuts, and lithographs existed side by side with the New Mexican *santos*, often displayed in locally made decorative tin frames. Prints often were given the same respect as religious objects as were the *retablos*, as evident by the elegant frames, the inscriptions sometimes found on them, and their placement on an altar. They also continued to serve as models for the *retablo* painters; chromolithographs made in the eastern United States or Europe and imported by New Mexican merchants often replaced the earlier Mexican woodcuts as sources for the painters.

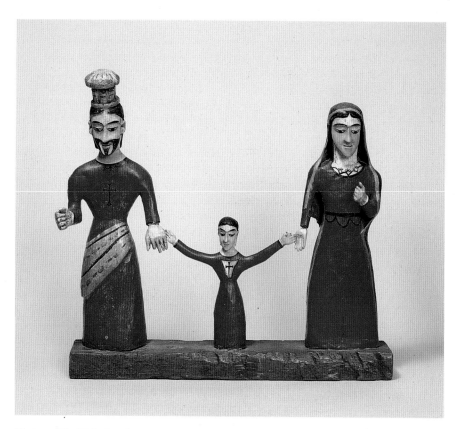

Plate 1. *The Holy Family*/La Sagrada Familia
José Benito Ortega
1875–1890
19″ x 21¾″ (all dimensions in inches)
Wood, water-based paints, gesso
TM 1596
Purchased by Alice Bemis Taylor from Frank Applegate in 1928 and accessioned in 1935. Gift of Alice Bemis Taylor. Considerable restoration and repainting. Illustrated in Wilder and Breitenbach, *Santos*, plate 39; Shalkop, *Wooden Saints*, 1967, plate 13.

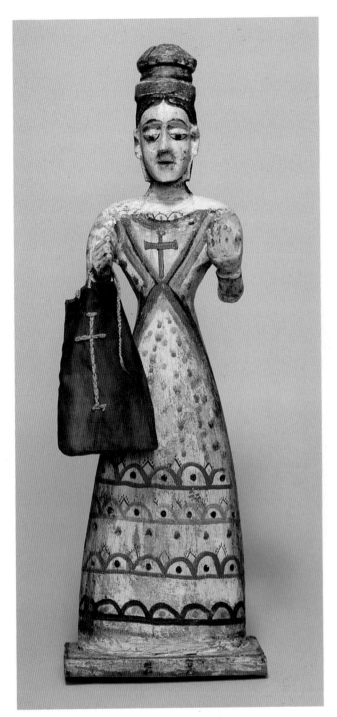

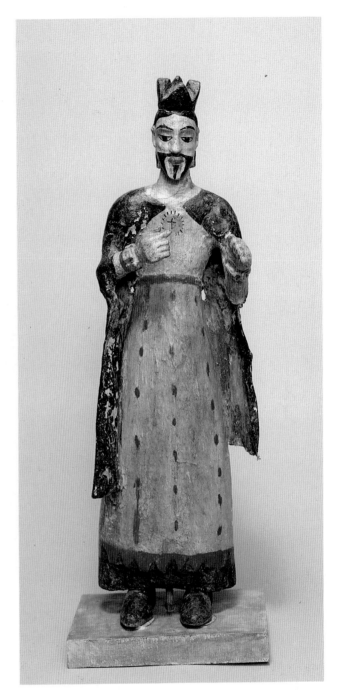

Plate 2. *Our Lady of Mount Carmel*/Nuestra Señora del Carmen
José Benito Ortega
Ca. 1875–1890
24″
Wood, water-based paints, gesso
TM 1239
Purchased from Harry H. Garnett and accessioned in 1943.
Neck and shoulders restored. Although original attributes
are missing, hands are correctly positioned for Our Lady of
Mount Carmel.

The lightly colored dress in shades of green and yellow
in unusual for Ortega, who often chose a more limited pal-
ette of bright red, black, and white. A fine example of Our
Lady of Mount Carmel by Ortega in the Marion Koogler
McNay Art Institute is inscribed by the artist along the bot-
tom of the skirt, "Nuestra Señora del Carmen la madre de
Jesus El Hijo de Dios."

Plate 3. *Saint Ignatius Loyola*/San Ignacio de Loyola
José Benito Ortega
Ca. 1875–1890
22½″ including nose
Wood, water-based paints, gesso
TM 7199
Collected by Nolie Mumey and purchased from the Mumey
sale at May D & F, Denver, 1968. Mumey collection 439.

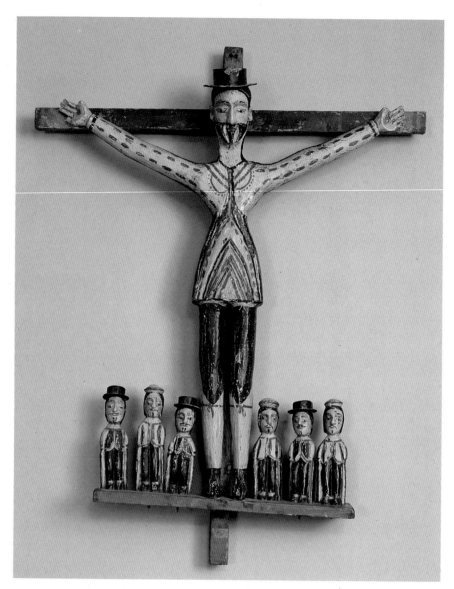

Plate 4. *Saint Achatius*/San Acacio
José Benito Ortega
Ca. 1875–1890
28¼"
Wood, water-based paints, gesso
TM 568
Purchased from James L. Seligman (Old Santa Fe Trading Post) and accessioned in 1941. Illustrated in George Kubler's *Santos*, plate VI.

Another Ortega *bulto* of San Acacio in the Museum (TM 1571) is illustrated in Wilder and Breitenbach, *Santos*, plate 1.

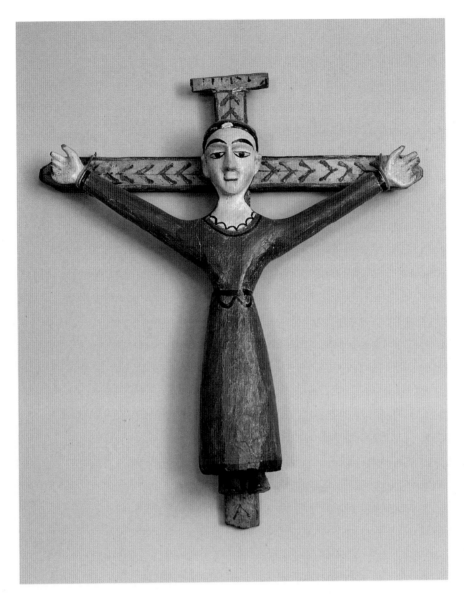

Plate 5. *Saint Liberata*/Santa Librada
José Benito Ortega
Ca. 1879–1890
15¾"
Wood, water-based paints, gesso
TM 1581
Purchased by Alice Bemis Taylor from Frank Applegate in 1928 and accessioned in 1935. Gift of Alice Bemis Taylor. Considerable repainting. Illustrated in Wilder and Breitenbach, *Santos*, plate 7.

Note high-button black shoes, a fashion introduced by Anglo-Americans in the mid-nineteenth century and added by Ortega to his *bultos*. Another Santa Librada by Ortega is in the Museum of International Folk Art and is illustrated in Stern, *The Cross and the Sword*, plate 98.

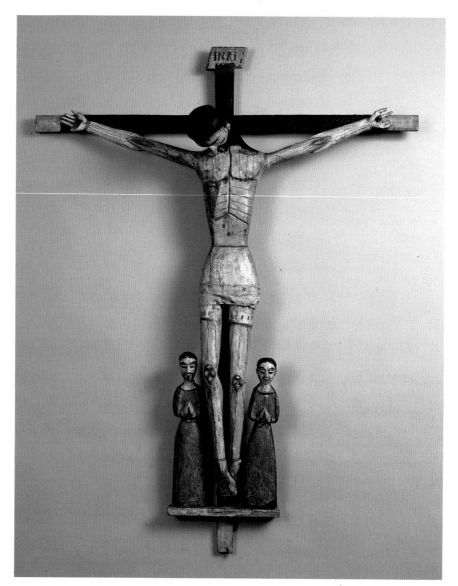

Plate 6. *Christ Crucified*/Cristo Crucificado
José Benito Ortega
Ca. 1875–1907
54″
Wood, water-based paints, gesso, cotton cloth
TM 3595
Purchased from Harry H. Garnett and accessioned in 1948. According to Garnett, this figure came from a *morada* near Cimarron, Colfax County, New Mexico (about forty-five miles north of Mora). Illustrated in Mills, *People of the Saints*, plate 4.

 The light blue color of the corpus of Christ is characteristic of several Ortega images of Christ Crucified (for example, TM 3944 and TM 3856), and is probably intended to portray the death of Christ. This interpretation is strengthened by the head of the figure in a near-horizontal position rather than upright as it is usually placed. According to E. Boyd, the blue painting of the corpus of Christ Crucified is a medieval convention that died out in Europe in the late Middle Ages.[10] We have seen no other New World crucifixions painted this way. The presence of Our Lady and Saint John as witnesses is a popular variant of the crucifixion, found in prints and paintings since the Middle Ages.

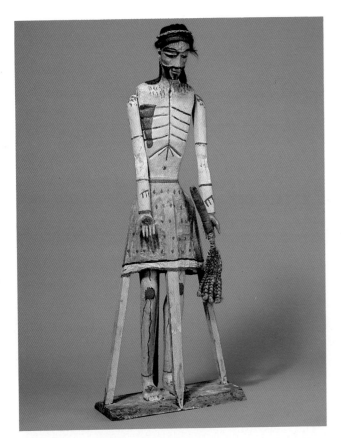

Plate 7. *Jesus Narene*/Jesús Nazareno
José Benito Ortega
Ca. 1875–1907
36"
Wood, water-based paints, gesso, cotton cloth
TM 3594
Purchased from Harry H. Garnett and accessioned in 1948. According to Garnett, this piece came from a *morada* near Cimarron and is the companion to the *Christ Crucified* (TM 3595) illustrated above.

This figure is one of four similar pieces in the Taylor Museum attributed to José Benito Ortega or his school (see TM 3851, plate 16, below). All four are supported by a framework of four narrow boards extending from the base to the midsection, beneath the waist cloth. This extra support was necessary for the frequent carrying of the *bultos* in processions such as the *encuentro* of Mary and Jesus during Holy Week. It is likely that the pieces were displayed both clothed (typically in a red robe) and unclothed, because on three of the pieces the waist cloth, legs, and supports are decoratively painted.

Three of these figures carry short yucca-fiber or horsehair whips, thus emphasizing the flagellation of Christ during Holy Week and providing a model to inspire the Brothers in their emulation of Christ's suffering. This imagery dates back in European iconography to at least the late Middle Ages. Woodcuts of the fifteenth century often depict the suffering Christ dressed, as are these New Mexican *bultos*, only in a loincloth, showing wounds of flagellation, and carrying a whip or a flail (plate 8).[11] Just as corporal penance survived in nineteenth-century New Mexico virtually unchanged from late medieval practices, the *morada* figures of New Mexico preserve equally ancient penitential imagery.

Plate 8. *Christ as the Man of Sorrows*
Northern Europe (Swabian or Rhenish)
Ca. 1480–1500
6¾" x 4¼"
Wood engraving
National Gallery of Art, Washington, D.C./Rosenwald Collection B-3086
Courtesy of the National Gallery of Art, Washington, D.C.
This representation of Christ as the Man of Sorrows shows the remarkable continuity of penitential imagery surviving in New Mexico in the late nineteenth century. The fervent penitentialism which arose in late medieval Europe is well expressed by this fifteenth-century woodcut of Christ holding a scourge in each hand, with wounds covering His body, and dressed in a loincloth. These attributes were perpetuated in Spanish colonial imagery and were still of vital importance in the penitential activities of the Brotherhood of the Sangre de Cristo in late nineteenth-century New Mexico.

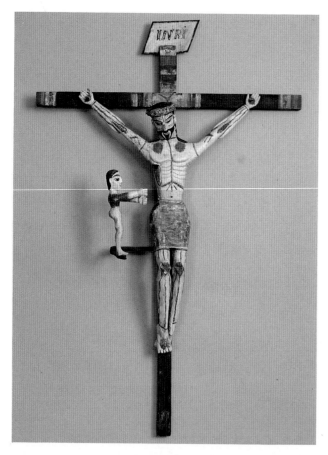

Plate 9. *Christ Crucified with Angel*/Cristo Crucificado con Angel
José Benito Ortega
Ca. 1875–1907
23¼"; cross 37"
TM 3905
Purchased from Harry H. Garnett and accessioned in 1950. According to Garnett, this figure came from the San Jose *morada*, near Mora, New Mexico.

This outstanding piece is a three-dimensional version of a traditional European subject usually found only in paintings and prints (plate 10). Below Christ's wound hovers, or in this case stands, a "cup-bearing" angel who catches the blood of Christ in a small chalice (lacking in this example). This symbolism directly expresses the central importance of the saving blood of Christ, which through the Holy Eucharist represented by the chalice offers mankind heavenly redemption.

This allegorical depiction was popular in late medieval Europe, dating back to at least the mid-fourteenth century, and it was perpetuated in Mexico through the colonial period.[12]

In New Mexico this image is found among the earliest surviving works—colonial hide paintings, that date to at least the early eighteenth century. Two New Mexican hide paintings of the crucifixion with cup-bearing angel are known. One, in the Fred Harvey collection at the Museum of International Folk Art (plate 11), was said in a 1920 *El Palacio* article to have originally graced the colonial chapel of "Captain Sebastián Martinez, near San Juan Pueblo," probably Sebastián Martín Serrano (d. 1772), whose private chapel at La Soledad and its hide paintings are mentioned by Domínguez in his 1776 report. At some point the painting came into the possession of a Penitente *morada*, perhaps in 1826 when Ecclesiastical Visitor Agustín Fernández San Vicente visited San Juan, and probably La Soledad, and ordered the removal of hide paintings from the San Juan church.[13] At the time of the *El Palacio* article the painting was said to have disappeared from the *morada* "some years ago," but in 1969 it was found in storage in the Fred Harvey collection with an old Harvey label on the verso which reads: "M. Larregoite obtained from chief morada of the Penitentes."[14] The "chief morada" of the Penitentes may still have been at Chimayó when the painting was collected, and in the 1820s the "chief morada" would have been at Santa Cruz de la Cañada. Both locations are close to La Soledad.

The antipathy of the Mexican ecclesiastical visitors to the old New Mexican hide paintings caused their removal from many churches. Some were destroyed, but others such as this one were preserved by the penitential Brotherhood of the Sangre de Cristo in their *moradas*. Thus the Brotherhood played a direct role in preserving not only the sacred ritual and religious customs of a bygone day, but also the sacred art.

As discussed in chapter 4, the Brotherhood's primary focus was the Blood of Christ. It is not surprising, then, that the Brothers should cherish this allegorical painting, *muy antiguo*, depicting the angel catching the Precious Blood, nor is it surprising that the Brotherhood should seek to perpetuate this imagery through the creation of three-dimensional representations. In addition to the piece illustrated, several late nineteenth-century statues of Christ crucified with the cup-bearing angel are in museum collections, and at least two have been photographed in situ as the focal point of *morada* altars: one at Arroyo Hondo carved by Juan Miguel Herrera (fig. 8.3, below), and two at Abiquiú by the Abiquiú *santeros*.[15]

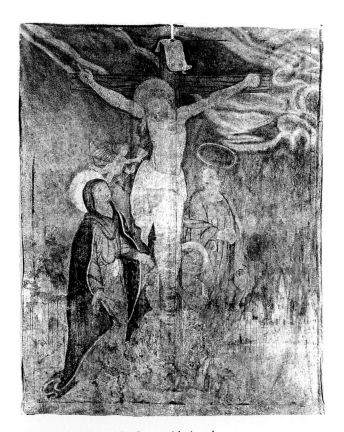

Plate 10. *Christ on the Cross with Angels*
Cologne, Germany
1481
Woodcut
10½″ x 6⅞″
National Gallery of Art, Washington, D.C./Rosenwald Collection B-3099
Courtesy of the National Gallery of Art, Washington, D.C.

Plate 11. *Christ on the Cross with Angel*
Unknown artist
Probably New Mexico
18th century
Water-based paint on animal hide
78¾″ x 65″
Museum of International Folk Art
Fred Harvey Collection FA 79.64-24
Courtesy of the Museum of International Folk Art, Santa Fe, New Mexico. Photograph by Blair Clark

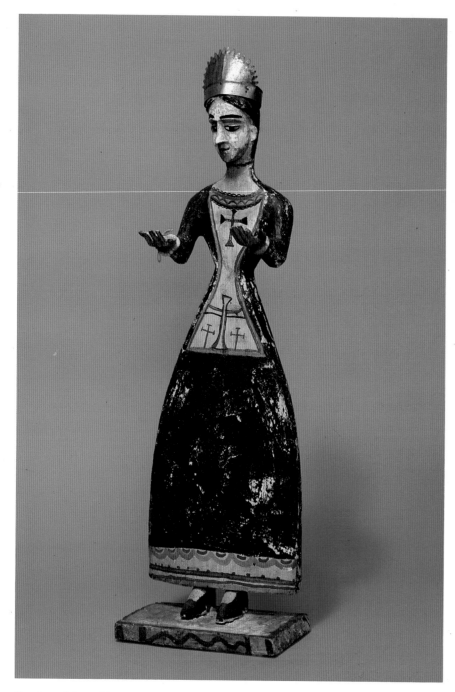

Plate 12. *Our Lady of Solitude*/Nuestra Señora de la Soledad
José Benito Ortega
Ca. 1875–1907
25½"
Wood, water-based paints, gesso, tin crown
TM 3853

Purchased from Harry H. Garnett and accessioned in 1949. According to Garnett, this piece came from Our Lady of Carmel *morada*, five miles from Aguilar, Colorado.

 Statues of Our Lady of Solitude are an essential part of the Holy Week ceremonies of the Hispanic world, including the Brotherhood enactments of the passion in New Mexico and Colorado in the late nineteenth and twentieth centuries. Two types of *bulto* of Our Lady of Solitude were made in New Mexico and Colorado. One is illustrated here: the arms are held out in front of the figure, positioned to hold a towel in which the instruments of the passion are placed during the ceremony of the Descent from the Cross, a ritual practice which dates back at least to the sixteenth century (see chapter 3). The second type is more versatile: the arms are jointed at the shoulders and elbows so that the figure can also be used for the Holy Week performance of the *encuentro*, in which the suffering Christ and his sorrowful mother ceremoniously embrace. An example of this type is shown below (TM 5734, plate 15). Other Ortega examples of the first type of Our Lady of Solitude include one in the Taylor Museum (TM 1353) and several in other collections.

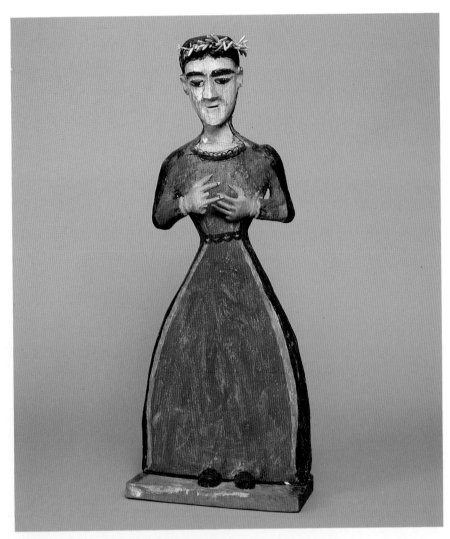

Plate 13. *Our Lady of Sorrows*/Nuestra
Señora de los Dolores
José Benito Ortega
Ca. 1875–1907
25″
Wood, water-based paints, gesso
TM 3586

Purchased from Harry H. Garnett and accessioned in 1948. According to Garnett, from a *morada* south of Las Vegas, New Mexico.

Our Lady of Sorrows is equal to Our Lady of Solitude in popularity, and in Brotherhood ceremonies images of her were sometimes used interchangeably with those of Our Lady Of Solitude during Holy Week. The key attribute (missing in this and the following example) is the dagger held in her hands and pointing to her heart.

The dagger (sometimes a sword) symbolizes the piercing of her heart with sorrow, which recalls the Gospel verse: "Yea, a sword shall pierce through thine own soul also" (Luke 2:35). Images of Our Lady of Sorrows occasionally have seven swords at the heart to represent the seven sorrows of Mary, the last four of which are: her encounter with Jesus on the way to Calvary, her witnessing the crucifixion at the foot of the cross, her witnessing the descent of Jesus from the cross, and her witnessing His burial.

The devotional image of Our Lady of Sorrows appears to derive from the earlier depiction of the crucifixion with Mary and John as witnesses. By the fourteenth century she had become an object of devotion by herself. By this time the now-famous hymn to her, Stabat Mater Dolorosa ("There stood the Sorrowing Mother"), had become popular, perhaps written and certainly propagated by, among others, penitential confraternities in southern Europe, particularly the groups in Italy and Provence known as the White Penitents (Albati or Bianchi). These groups marched in penitential processions wearing a white hooded robe with a red cross on the back, and they sang the Stabat as they walked. In the 1940s Juan B. Rael recorded a Spanish version of the Stabat Mater Dolorosa among the Brothers in San Luis, Colorado. He published this Brotherhood *alabado* under the title of "Estaba junto al madero."[16]

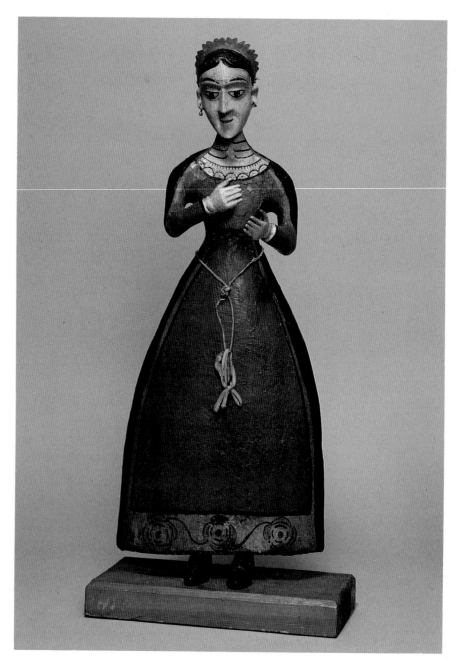

Plate 14. *Our Lady of Sorrows*/Nuestra Señora de los Dolores
José Benito Ortega
Ca. 1875–1907
24″
Wood, water-based paints, gesso, copper crown
TM 1595
Frank Applegate collection, gift of Alice Bemis Taylor. Considerable restoration and repainting. Illustrated in Wilder and Breitenbach, *Santos*, plates 8 and 9. The crown is made from a salvaged piece of copper sheet upon which scroll work had previously been engraved. Note the delicate floral motifs at the base. In restoration the arms have been incorrectly set so they no longer meet evenly at the breast.

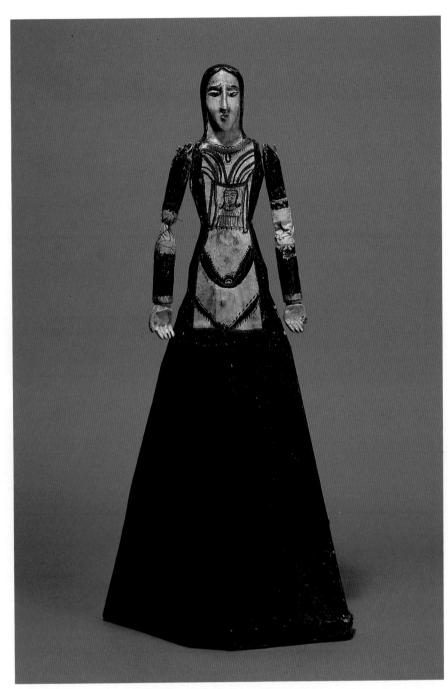

Plate 15. *Our Lady of Solitude*/Nuestra
Señora de la Soledad
School of José Benito Ortega I
Ca. 1875–1907
27″
Wood, water-based paints, gesso, cotton cloth, paper
TM 5734

Purchased from Harry H. Garnett and accessioned in 1959. According to Garnett, this figure is from a *morada* at Las Vegas, New Mexico.

An example of the type of Our Lady of Solitude in which the arms are articulated, as discussed above, plate 12.

Figures of Our Lady of Solitude from New Mexico—both this type and those with rigid arms—often have the Holy Face of Christ painted on their chests. This suggests confusion between this image with Saint Veronica, who traditionally holds the towel known as "Veronica's Veil," upon which an image of the Holy Face was miraculously imprinted. In Spanish and Mexican colonial practice, both figures are dressed in black, hold a cloth or towel, and are used in the ceremony of the Descent and Burial of Christ. It is therefore not surprising that over time in remote New Mexico they would tend to blend together. However, the distinction is still made in Brotherhood Holy Week ceremonies between Our Lady of Solitude and the three "Verónicas," young girls who hold the *sudarium* (holy cloth) and reenact the wiping of Christ's face during His passion.[17] Since figures of Our Lady of Solitude were carried in Holy Week processions, they were often built by the hollow-skirt method to make them light and easy to carry. In the present example, a simple four-piece framework similar to that used by Ortega in making images of Jesus Nazarene was covered with large scraps of paper and cloth dipped in gesso, then painted. No legs are necessary, since they would be totally hidden by the skirt.[18]

Another image of Our Lady of Solitude in this style and with the same construction method is TM 1248, said by Harry H. Garnett to have come from the first church at Mora, New Mexico (Santa Gertrudis de Mora).

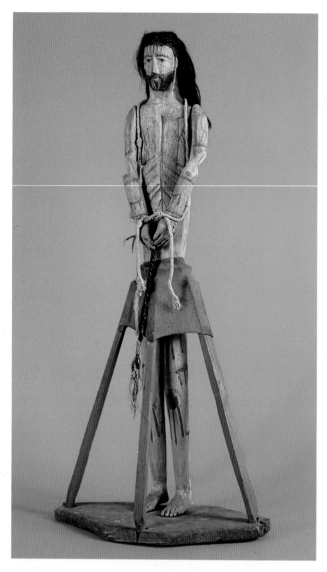

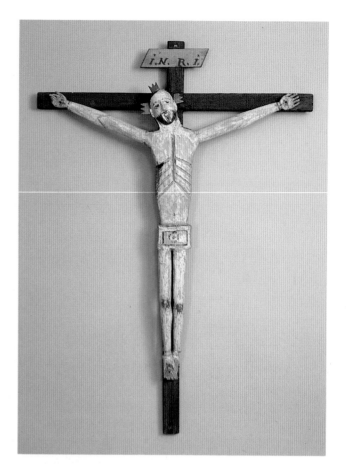

Plate 17. *Christ Crucified*/Cristo Crucificado
School of José Benito Ortega I
Ca. 1875–1907
42¼"
TM 5975
Purchased from M. G. Barr, Boulder, Colorado, and accessioned in 1963.
 The rectangular loincloth is most unusual.

Plate 16. *Jesus Nazarene*/Jesús Nazareno
School of José Benito Ortega I
Ca. 1875–1907
43¼"
Wood, water-based paints, gesso, cotton cloth
TM 3851
Purchased from Harry H. Garnett and accessioned in 1949.
According to Garnett, from a *morada* at Rociada, San Miguel
County, New Mexico (six miles south of Mora).
 This figure holds a short horsehair whip. For a discussion
of this type, see plate 7.

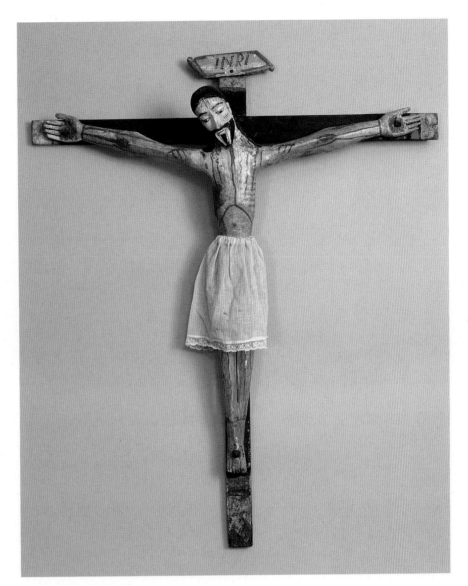

Plate 18. *Christ Crucified*/Cristo Crucificado
School of José Benito Ortega II
Ca. 1875–1907
39″
Wood, water- and oil-based paints, gesso
TM 3718
Purchased from Harry H. Garnett and accessioned in 1948. Garnett purchased this
piece from José María Delao, *hermano mayor* at San Geronimo, New Mexico, east of
Las Vegas.

According to Garnett, this figure was the centerpiece of a triptych intended to
represent the Crucifixion of Christ and the two thieves. It was hung between TM
3720 on the left, a crucifixion painted dark blue grey representing Jestas the unre-
pentant thief, also in the style of the School of Ortega II, and TM 3719 on the right,
another crucifixion said to represent San Dismas the good thief, this in the style of
Ortega himself.

Depictions of the Crucifixion of Christ and the two thieves are of late medieval
origin and are often found in both paintings and sculptures in colonial New Spain.
In the traditional representation of this scene, however, the thieves are depicted
tied to the cross with their arms over their heads rather than stretched out horizon-
tally. This insures that Christ alone assumes the position of the Crucified with arms
outstretched, and there can be no confusion between Christ and the thieves. In
these New Mexican examples, preexisting images of Christ Crucified were probably
adapted to portray the two thieves.

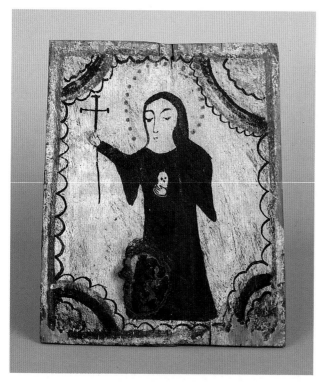

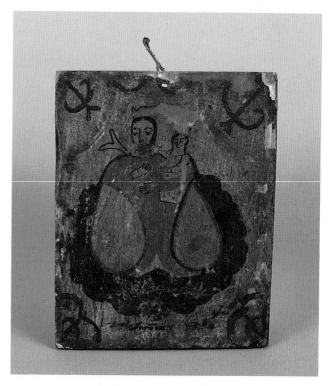

Plate 19. *Saint Rita of Cascia*/Santa Rita de Casia
Attributed to José Benito Ortega
Ca. 1875–1890
13″ x 11″
Milled pine, water-based paints, gesso
TM 1187
Frank Applegate collection, gift of Alice Bemis Taylor. Bark date determined by W. S. Stallings, Jr., to be 1859.

Plate 20. *Our Lady of Refuge*/Nuestra Señora del Refugio
Attributed to José Benito Ortega
Ca. 1875–1890
7″ x 5¾″
Pine wood, water-based paints, gesso
TM 1050
Purchased from the Old Spanish Trading Post.

This *retablo* is inscribed by the artist "Mi Señora del Refugio." Boyd notes in her description of this panel: "N.S. del Refugio. Similar to one in M.N.M. Crude, childish, looks like Spanish playing cards. Script 'Mi Senora del Refugio' mis-spaced so it runs uphill. Similar script in M.N.M. for a panel of N.S. del Carmen on same style of panel."[19] These *retablos* are inscribed in the same hand as at least two *bultos* by José Benito Ortega, thus providing evidence for the attribution of this painting style to him.

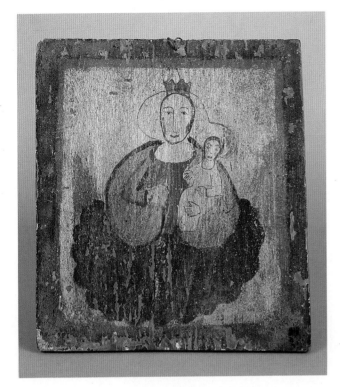

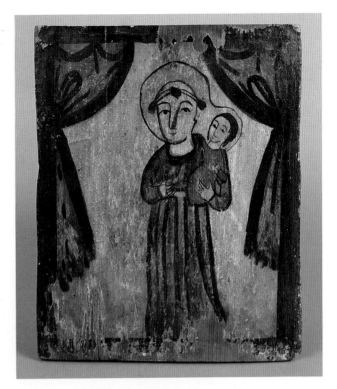

Plate 21. *Our Lady of Refuge*/Nuestra Señora del Refugio
Attributed to José Benito Ortega
Ca. 1875–1890
10¾" x 9"
Pine wood, water-based paints, gesso
TM 1100
Frank Applegate collection, gift of Alice Bemis Taylor.

Although the treatment of the faces differs somewhat from that in the previous example, the abstract renderings of the body and the cloud surrounding Our Lady are similar.

The existence of at least three late nineteenth-century *retablos* of Our Lady of Refuge—and the naming of Ortega's daughter, Refugio—attests to the continuing importance of this popular northern Mexican advocation of the Virgin, whose devotion was spread by the Franciscan friars of Zacatecas in the late eighteenth and first half of the nineteenth century. The many tin *retablos* of Our Lady of Refuge made in northern Mexico in the mid-nineteenth century doubtless contributed to her continuing popularity in New Mexico. See chapter 3 for further discussion.

Plate 22. *Saint Anthony of Padua*/San Antonio de Padua
Attributed to José Benito Ortega
Ca. 1875–1890
9¾" x 8"
Pine, water-based paints, gesso
TM 1114
Frank Applegate collection, gift of Alice Bemis Taylor.

One of the more carefully painted *retablos* in the style attributed to Ortega. The small clawlike hands, the double halo covering both heads, and the heavy ties for the corner drapes are all found on other paintings attributed to this artist.

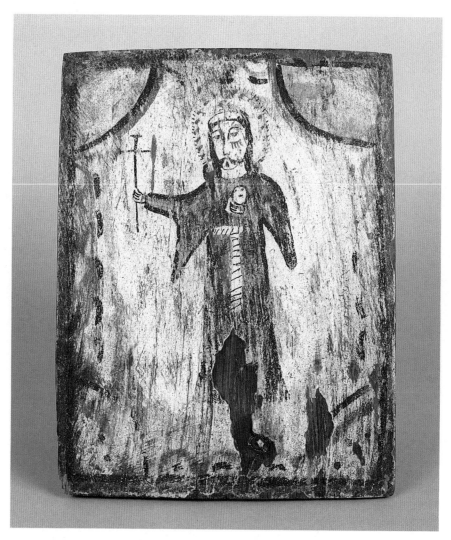

Plate 23. *Saint Francis of Assisi*/San Francisco de Asís
Attributed to José Benito Ortega
Ca. 1875–1890
12″ x 9½″
Pine wood, water-based paints, gesso
TM 905
Purchased from the Spanish and Indian Trading Company (James MacMillan) and accessioned in 1942.

Compare *Saint Rita* (plate 19) for similar treatment of the hands, arms, and sleeves and the skull held by the saints. The face bears similarities to that painted on the chest of a statue of Our Lady of Solitude (plate 15).

The faces on both *retablos* resemble those in *retablos* of Our Lady of Refuge attributed to Ortega in the Museum of International Folk Art (illustrated in Boyd, *Popular Arts*, fig. 209).

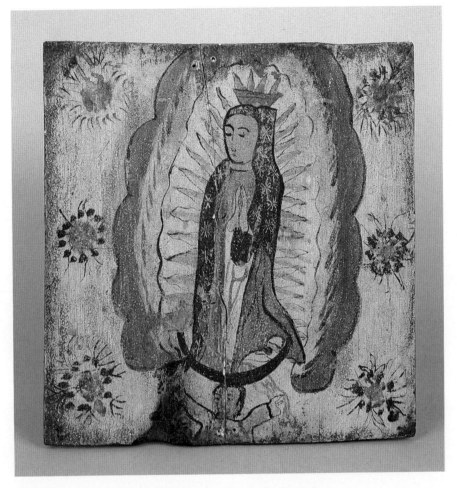

Plate 24. *Our Lady of Guadalupe*/Nuestra Señora de Guadalupe
Attributed to José Benito Ortega
Ca. 1875–1890
15¼" x 14½"
Pine wood, water-based paints, gesso
TM 1074
Frank Applegate collection, gift of Alice Bemis Taylor.

A freely rendered but appealingly naïve depiction of the most popular advocation of the Blessed Virgin in Mexico. The burn in the wood at the bottom of the panel was caused by a devotional candle placed too close to the image.

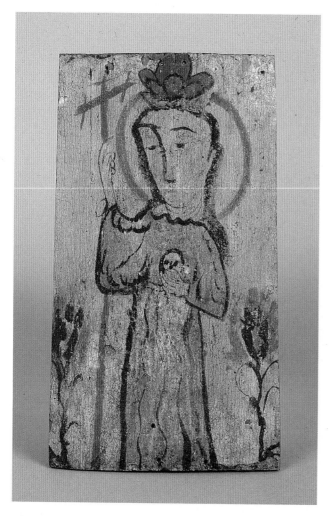

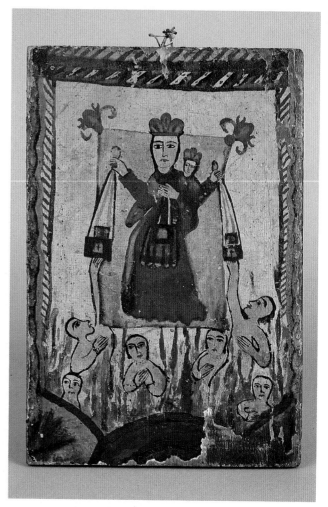

Plate 25. *Saint Rosalia of Palermo*/Santa Rosalia de Palermo
Attributed to José Benito Ortega
Ca. 1875–1890
10½″ x 6″
Pine wood, water-based paints, gesso
TM 1150
Frank Applegate collection, gift of Alice Bemis Taylor.

Plate 26. *Our Lady of Mount Carmel*/ Nuestra Señora del
Carmen
Attributed to José Benito Ortega
Ca. 1875–1890
13″ x 9″
Pine, oil-based paints, gesso
TM 505
Purchased from Elmer Shupe of Taos and accessioned in
1942.

 This piece differs in some details from the others in this
series and may be the work of a follower. It is the only one
painted in oil-based paints.

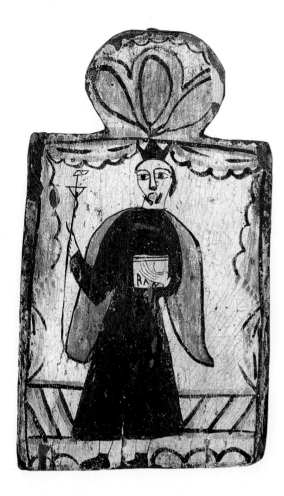

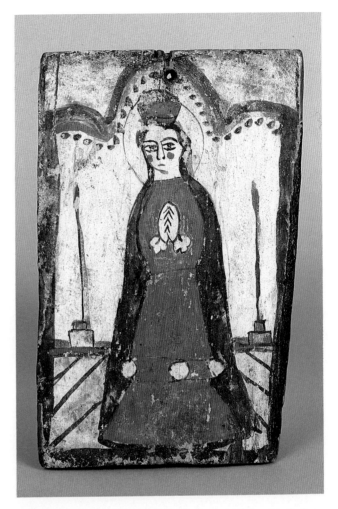

Plate 27. *Saint Ignatius Loyola*/San Ignacio de Loyola
Retablo Style I
Late nineteenth century
10¼″ x 6″
Pine wood, water-based paints, gesso
TM 919
Purchased from the Spanish and Indian Trading Company
and accessioned in 1942.

According to Stallings (untitled manuscript on New Mexican *retablos*), this piece has an outside dated ring (the latest observable growth ring on the board) of 1849, with an estimated cutting date of 1880 to 1886. This artist appears to have been influenced by the work of earlier New Mexican *santeros*, such as the Truchas Master.

Plate 28. *Our Lady of San Juan de los Lagos*/Nuestra Señora
de San Juan de los Lagos
Retablo Style I
Late nineteenth century
10¼″ x 6¾″
Pine wood, water-based paints, gesso
TM 941
Purchased from the Spanish and Indian Trading Company
and accessioned in 1942.

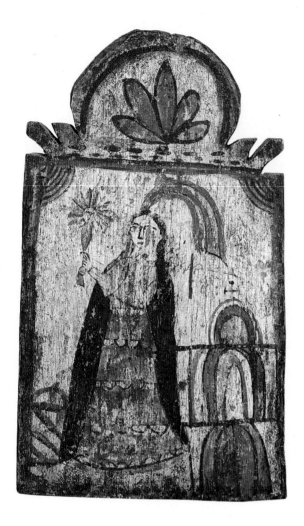

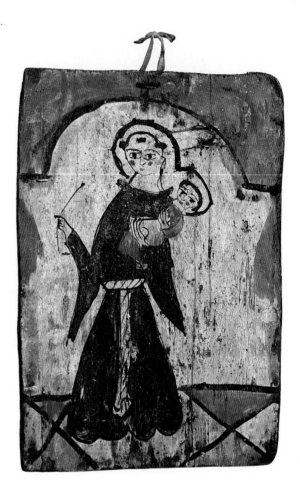

Plate 29. *Saint Barbara*/Santa Bárbara
Retablo Style I
Late nineteenth century
17¼″ x 10¼″
Pine wood, water-based paints, gesso
TM 955
Purchased from the Spanish and Indian Trading Company
and accessioned in 1942.
 One of the largest *retablos* in this style.

Plate 30. *Saint Anthony*/San Antonio
Retablo Style I
Late nineteenth century
10¾″ x 7¼″
Pine wood, water-based paints, gesso
TM 3934
Purchased from Harry H. Garnett and accessioned in 1950.
From the Candelario Collection, Santa Fe.

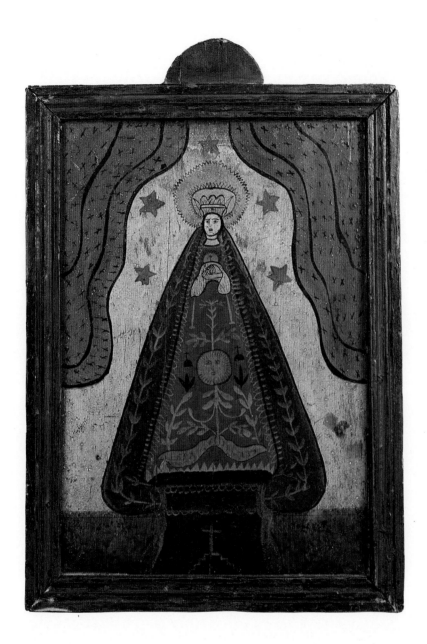

Plate 31. *Our Lady of Solitude*/Nuestra Señora de la Soledad
Retablo Style II
Late nineteenth century
17½" x 12"
Pine wood, enamel paints
TM 896
Purchased from the Spanish and Indian Trading Company and accessioned in 1942.
Illustrated in Kubler, *Santos*, plate 8.
 Inscribed "Ntra Sra De La Soledad."
 This image is closely based upon a Mexican print of the day, such as the one
illustrated in plate 32.

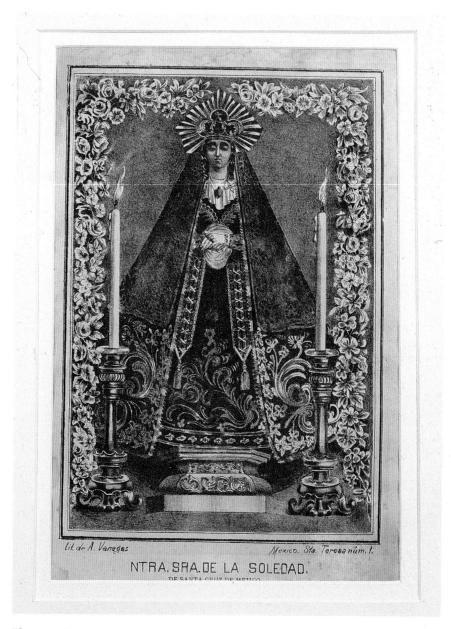

Plate 32. *Our Lady of Solitude*/Nuestra Señora de la Soledad
José Guadalupe Posada
Mexico City, Mexico
Late nineteenth century
12″ x 8″
Zinc etching
TM 5540
Purchased from the Vanegas Arroyo Press, Mexico City.

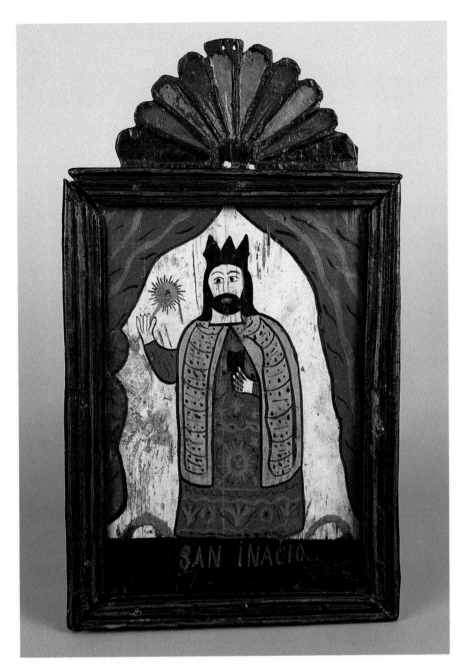

Plate 33. *Saint Ignatius Loyola*/San Ignacio de Loyola
Retablo Style II
Late nineteenth century
18″ x 10″
Pine wood, enamel paints
TM 952
Purchased from the Spanish and Indian Trading Company and accessioned in 1942
Illustrated in Mills, *The People of the Saints*, plate 25.
 Inscribed "SAN INACIO."

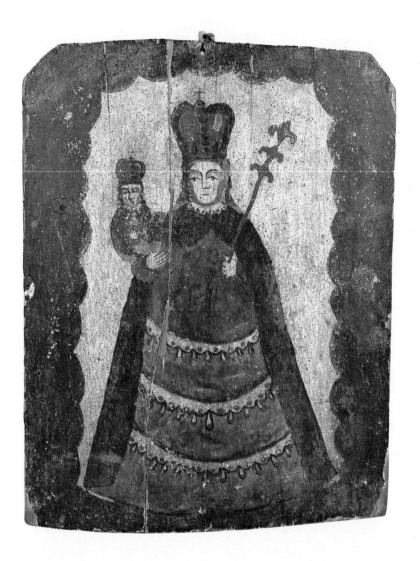

Plate 34. *Possibly Our Lady of Remedies*/Nuestra Señora de los Remedios
Retablo Style III
Late nineteenth century
12¾″ x 10″
Pine wood, water-based paints, gesso
TM 846
Purchased from Harry H. Garnett and accessioned in 1942.

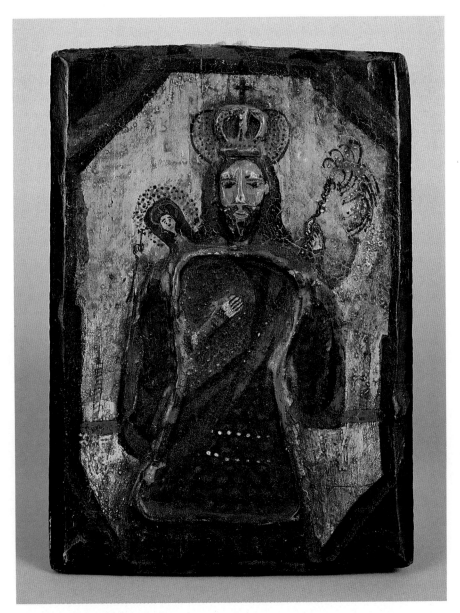

Plate 35. *Saint Joseph*/San José
Retablo Style III
Late nineteenth century
11″ x 8″
Gesso relief: pine wood, water-based paints, gesso
TM 3331
Purchased from Harry H. Garnett and accessioned in 1947.

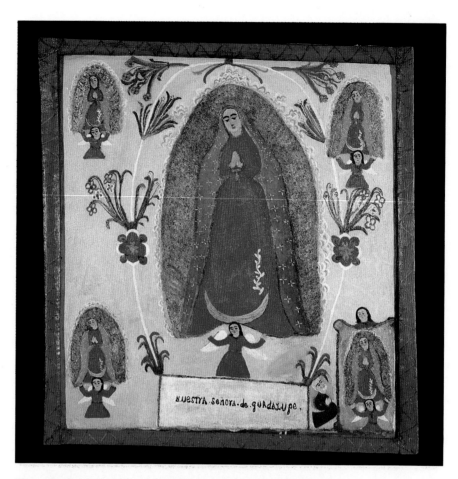

Plate 36. *Our Lady of Guadalupe*/Nuestra Señora de Guadalupe
Retablo Style IV
Late nineteenth century
36″ x 34½″
Cotton cloth, oil-based paints, wood frame
TM 7207
Purchased from the May D & F sale of the Nolie Mumey Collection and accessioned in 1968. Mumey collection 369. According to Mumey, these three paintings were formerly in the Candelario collection, Santa Fe.

 In her notes on the Mumey collection E. Boyd labelled these, "late, primitive style." Painted on flour sacks with the miller's brand name still visible. Inscribed "Nuestra Señora de Guadalupe."

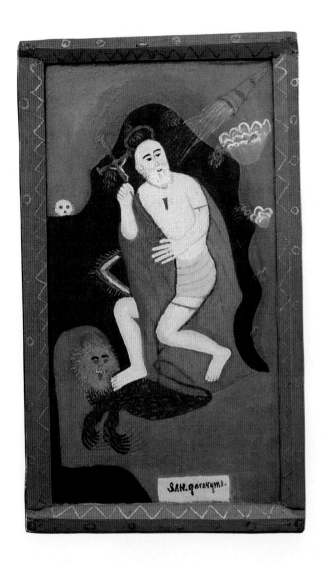

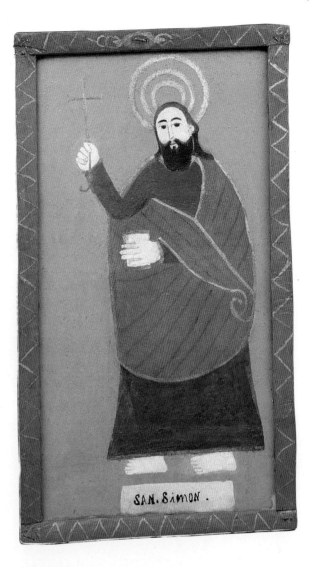

Plate 37. *Saint Jerome*/San Gerónimo
Retablo Style IV
Late nineteenth century
36″ x 21″
Cotton cloth, oil-based paints, wood frame
TM 7208
Mumey collection 370.
Photograph by W. L. Bowers
 Inscribed "Geronymo."

Plate 38. *Saint Simon*/San Simón
Retablo Style IV
Late nineteenth century
37″ x 20¾″
Cotton cloth, oil-based paints, wood frame
TM 7206
Mumey collection 212.
Photograph by W. L. Bowers
 Inscribed "San Simon."

These three paintings probably formed a triptych for the altar of a family chapel dedicated to Our Lady of Guadalupe.

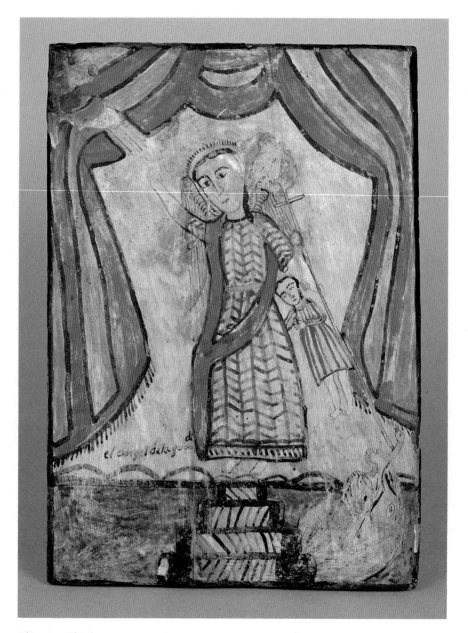

Plate 39. *The Guardian Angel*/El Angel de la Guarda
Quill Pen Follower
Ca. 1871–1880 (bark date 1871)
16½″ x 12″
Pine wood, water-based paints, gesso
TM 895
Purchased from the Spanish and Indian Trading Company and accessioned in 1942.
 Inscribed "el angel de la guardi[a]."

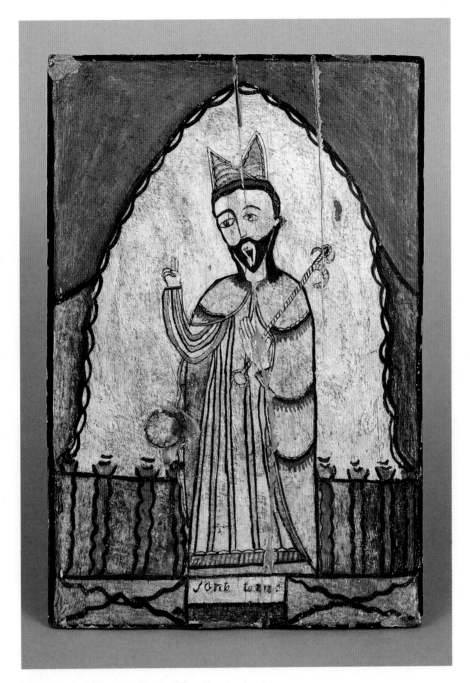

Plate 40. *Saint Thomas Aquinas*/San Tomás Aquino
Quill Pen Follower
Ca. 1871–1880 (bark date 1871)
17½″ x 12″
Pine wood, water-based paints, gesso
TM 924
Purchased from the Spanish and Indian Trading Company and accessioned in 1942.
 Inscribed "Santo Tomas."

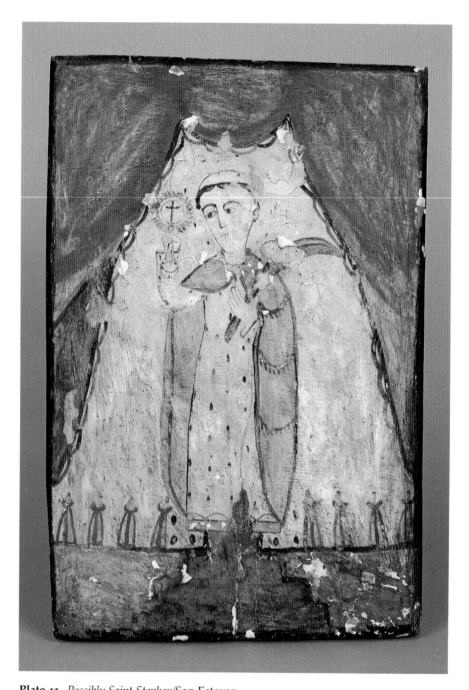

Plate 41. *Possibly Saint Stephen*/San Estevan
Quill Pen Follower
Ca. 1871–1880 (bark date 1871)
17¾″ x 12″
Pine wood, water-based paints, gesso
TM 902
Purchased from the Spanish and Indian Trading Company and accessioned in 1942.

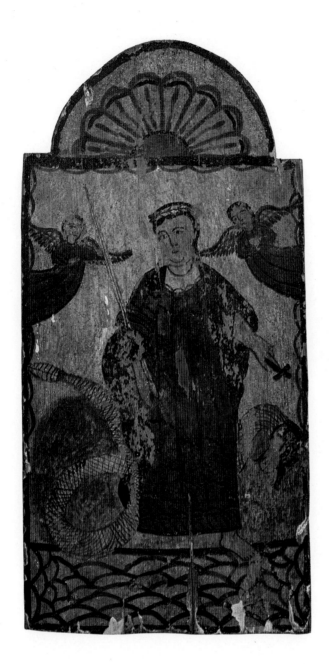

Plate 42. *Unidentified Female Saint*
Quill Pen Follower
Ca. 1871–1880 (bark date 1871)
15¾″ x 8″
Pine wood, water-based paints, gesso
TM 589
Purchased from Harry H. Garnett and accessioned in 1942. Cut from same board
as the others (plates 39–41) with bark date of 1871.

Plate 43. *Sacred Heart of Mary and Jesus*/La Sagrada Corazón de María y Jesús
Chromolithograph print
Eastern United States or Europe
1850–1900
8″ x 10″
TM 1990.6
Collected by Harry H. Garnett and given to the Taylor Museum, probably in the
1960s. From the upper Arroyo Hondo *morada*. The print is inscribed on the paper
frame: "George Archuleta. En paz descanso. un sudario y un quuredo [credo]."[20]

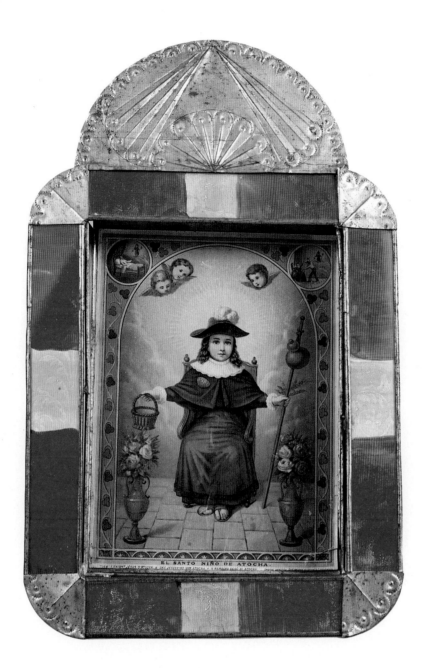

Plate 44. *Holy Child of Atocha*/Santo Niño de Atocha
Chromolithograph print
Eastern United States or Europe
Mid- to late nineteenth century
18″ x 11½″ (print, 11″ x 7½″)
TM 1215
Purchased from the Fred Harvey Company and accessioned in 1943.

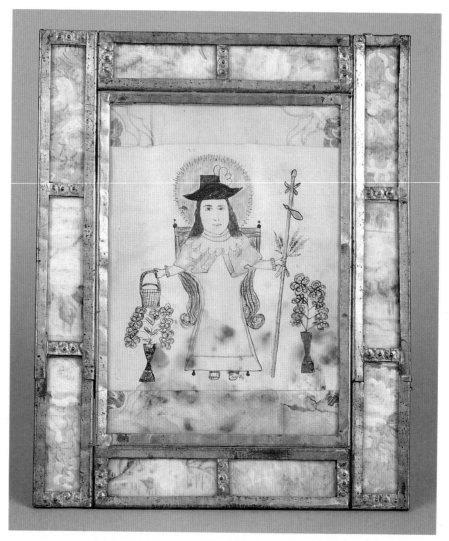

Plate 45. *Holy Child of Atocha*/Santo Niño de Atocha
Unknown artist
Probably New Mexico
1840–1880
13″ x 10½″
Pencil and crayon on paper, tin frame with wallpaper
TM 1212
Purchased from the Fred Harvey Company and accessioned in 1943.

This naïve and appealing drawing was carefully copied from a copy of the same or a very similar print as that shown in plate 44, demonstrating the continuing influence of prints as sources for New Mexican religious images. The great popularity of the Holy Child of Atocha in late nineteenth-century New Mexico is evidence of the continuing importance of the merciful aspects of Catholic practice, which, through devotions such as this one, those of the Sacred Heart of Mary and Jesus, and those of the Blessed Virgin (Our Lady of Guadalupe and many others), continued to balance the penitential aspects.

José de Gracia Gonzales

THE AMERICAN OCCUPATION of 1846 brought many changes to New Mexico's economy and social structure. United States sovereignty naturally attracted considerable numbers of eastern settlers to the newly acquired territory. These new settlers and the presence of a large military force produced a much more active and dynamic economy: in addition to merchants, soldiers, officials, and other professionals, many artisans arrived to fill the need for locally made goods and services. These included not only Anglo-Americans and European immigrants, but also Mexicans from the northern states of Mexico. While we normally think of the American Occupation as establishing a political barrier between New Mexico and Mexico, this was not the case in all areas. It is not generally known that the economic dynamism of the Americans brought numerous Mexican artisans to New Mexico: carpenters, adobe masons, blacksmiths, silversmiths, and others who were attracted by the prospect of higher income and greater demand for their products. This situation had already been noted by 1850 when that acute observer John Russell Bartlett visited the El Paso area. Since the arrival of the Americans, Bartlett stated that "the price of labor . . . has doubled and in some cases quadrupled. Day laborers (Mexican) receive five reals (sixty-two and a half cents) [per day], and find themselves. Mechanics, who are chiefly Americans, command very high wages. Carpenters and blacksmiths earn three dollars a day, and when they take jobs, more."[1] Similar conditions obtained further north, as far as Taos, and continued in effect through the 1880s. The border between Mexico and New Mexico was a political barrier but Mexico still continued, on a lesser scale perhaps, to infuse the culture and economy of Hispanic New Mexico through the late 1800s.

Not all these artisans came to satisfy American interests. The dying out of the religious painting tradition produced a void among the Hispanic population that could not be entirely satisfied by commercial chromolithographic prints or by the imageless neoclassic altar screens promoted by the French clergy. To fill this void, an itinerant painter named José de Gracia Gonzales, born about 1835 in Chihuahua, arrived in northern New Mexico in about 1860, perhaps fleeing the chaos resulting from the "Three Years War" between the liberal and conservative forces of Mexico.

José de Gracia Gonzales was the most important Hispanic painter working in New Mexico after 1860. He was responsible for painting or repainting several church altar screens in New Mexico; those he painted in the church at Las Trampas in the 1860s must be counted among the most significant surviving monuments of New Mexican folk art. He worked in a provincial neoclassic style, a simplified version of the academic painting of mid-nineteenth-century Mexico. The first clues toward establishing the identity of the painter of the altar screens in the church of San José de las Trampas came in 1948 when W. S. Stallings, Jr., of the Taylor Museum, at the suggestion of Willard Hougland, interviewed an elderly resident of Las Trampas, Gregorio Leyba. According to Stallings:

> When interviewed in 1948, he [Leyba] was blind and weak but possessed a clear and prompt memory. When I remarked that I understood he was a hundred years old, he immediately corrected me: "ninety-nine, I was born in 1849." Asked if he knew when the reredos in the church had been painted he stated that he remembered the time well, that he was a youth and had not yet married, that he was 19 or 20 years old. He added that the painter was a Sonorense (i.e. from the Mexican state of Sonora) had settled in Las Trampas, married a local girl and later had moved to Trinidad, Colorado to work for the railroad.[2]

In 1961, E. Boyd talked to the custodian of the Las Trampas church, Telesfor Lopez, then seventy-two years old, who stated that his grandfather had often told him the altar screens were painted by José Gonzales from Guaymas, Sonora, about 1883. Since this happened before Lopez was born he was probably mistaken about the date, and Gregorio Leyba's estimate of circa 1868 to 1869 is probably closer to the truth.

Another altar screen in this style, not far from Las Trampas, provides the physical evidence establishing José de Gracia Gonzales as the artist and the 1860s as the period during which he worked in this area. When the altar table at the church of San Juan Nepomuceno at Llano de San Juan, near Peñasco, was moved in the mid-1960s, a signed inscription was

discovered: "Este corateral lo pinto Jose de Gracia Gonzales a costa de Dr. Jose Dolores Duran. Dicha pintura se concluida hoy 20 de Julio ano de 1864."[3]

Gonzales probably painted the Llano de San Juan and the Las Trampas altar screens in the same period, 1864 to ca. 1869. During this time he may also have been commissioned to paint another altar screen for José Dolores Durán, who in the late 1860s built a private chapel on his property at Llano de Santa Barbara and dedicated it to Our Lady of Talpa, named no doubt after the Chapel of Our Lady of Talpa in Rio Chiquito near Ranchos de Taos. José Dolores Durán was a cousin of the Duráns and Sandovals of Rio Chiquito who built the original Chapel of Our Lady of Talpa in 1838 and had maintained it since that date. This Llano de Santa Barbara chapel is no longer extant.[4]

During the 1860s, while working in the Las Trampas–Peñasco area, Gonzales married María de Atocha Maestas, said to be from Mora, New Mexico, and by 1870 he had moved with his young wife to Los Cordovas, southwest of Fernando de Taos, in search of more work. In the 1870 territorial census for Los Cordovas, Gonzales gave his name as "Gonsales, Jose G.," his age as thirty-eight, his occupation as "painter," and his place of birth as "Chihuahua." He was described as a white male and as a citizen of the United States. His wife Atocha gave her age as twenty-three and her place of birth as "Territory of New Mexico."[5] He had at least one important commission while living in Taos: the church in Arroyo Seco has an altar screen painted by him (plate 47).

The statement by Gregorio Leyba, quoted above, that Gonzales had "moved to Trinidad, Colorado to work for the railroad" provided the clue to uncover new information about the artist's years in Colorado. In the 1870s he and his wife and son Andalesio moved to Trinidad, and he lived there until his death, probably in 1900 or 1901. They are listed in the 1880 federal census for Las Animas County, along with a second son Pedro Celestino, one year old, born in Colorado. Gonzales lists his place of birth as "Mexico" and his occupation, just as he did in 1870, as "painter." His wife is listed as "María," age thirty-four, born in New Mexico.[6] In the 1885 Colorado census for Las Animas County, Gonzales is listed as fifty-three years old, born in Mexico. His wife, "María M." is thirty-five, born in New Mexico, and there are two more children: Galine, age four, and Librato, age six months, both born in Colorado.[7]

In the *Directory of Trinidad, Colorado for 1888*, the first issued in that city, José Gonzales is listed as a painter living on High Street, and he is listed in the 1892 *Directory* without occupation at 219 High Street. The 1900 federal census for Las Animas County is especially informative. Gonzales is listed again as a painter born in Mexico (his father also born in Mexico), and the year of his immigration to the United States is given as 1860. He stated that he could read

and write (attested by his elegant Spanish inscriptions on at least two objects) but that he could not speak English. His wife is Tochita (Atochita, from Maria de Atocha), born in 1857 (this probably should be 1847) in New Mexico, with four of six children living. She can neither read nor write and cannot speak English. The children still living at home are Celestino, age eighteen, Salome, age seventeen, and Elias, age fourteen, all of whom can read, write, and speak English. The two boys list their occupations as "day laborers." At this time the Gonzaleses stated that they had been married 29 years.[8]

By the end of 1901 José de Gracia Gonzales was deceased. The Las Animas County tax list for December 31, 1901 lists the *estate* of Jose Gonzales," while the 1900 listing is simply "Jose Gonzales." A Deed of Trust dated January 15, 1904, lists as parties of the first part "Atochita M. Gonzales, widow of Jose Gonzales, deceased, J. A. Gonzales, P.C. Gonzales, Lee Gonzales, and Salome A. Romero, formerly Salome A. Gonzales, the only heirs at Law of Jose Gonzales, deceased."[9]

It is of great interest that José de Gracia Gonzales continued to list his occupation as a painter over a twenty-year span while living in Trinidad, in the 1880 census, the 1888 *Directory*, and the 1900 census. Apparently, in Colorado he continued to make his living, or at least a major part of it, as an artist. Several of his religious sculptures have been collected in the Trinidad area (plates 86–90). Certainly he was also painting during this long period of his life, but no Colorado paintings attributable to him have yet been found.

Coming at a time when the *santo* tradition in New Mexico was dying out, Gonzales breathed new life into it. He was a painter by profession who worked skillfully in the prevailing provincial, neo-classic style of northern Mexico. With its rich colors, oil rather than tempera paints, carefully drawn figures, and frequent use of floral and other decorative motifs, his painting is immediately identifiable as Mexican: it shares many characteristics with mid-nineteenth-century Mexican tin *retablos* as well as with provincial oil paintings on canvas of the same period (see plates 52 and 53).

Characteristic of the conservatism of the villagers of northern New Mexico, Gonzales was commissioned in many cases as a renovator of existing works rather than a creator of new ones. As E. Boyd notes, the wooden altar screens at Las Trampas had existed since the early 1800s, and an 1818 inventory describes the same images in the same positions as Gonzales painted them in the 1860s. He simply repainted the images that had been painted more than forty years earlier, possibly by the artist known as the Truchas Master.

The only altar screen at Las Trampas that was not in the 1818 inventory is the one in the right transept dedicated to Saint Francis of Assisi and painted in the 1860s by Gonzales.[10] There is no record of a Francis-

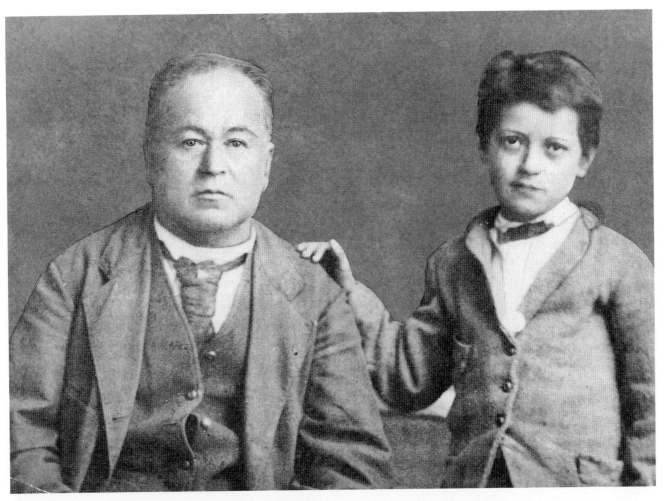

Fig.7.1. The painter and sculptor José de Gracia Gonzales and his son, Andalesio Gonzales, circa 1880. (Photograph courtesy of Adeline Aragon, copy print courtesy of the Colorado Historical Society.)

can Third Order existing in Las Trampas in 1818, so there would not have been a Third Order altar in the church. Perhaps the later efforts of Bishop Lamy and Father Martínez to align the penitential Brotherhood of the Sangre de Cristo with the Third Order resulted in the painting of this new altar screen in the right transept, next to the Brotherhood *morada* which at that time adjoined the exterior wall of the transept.

Evidence that Gonzales worked as a renovator commissioned to renew existing images may also be seen by an examination of his three *retablos* in the Taylor Museum. These pieces reveal that they, too, were painted over existing images, and that at least one was of the same subject before he overpainted it. Thus, Gonzales was commissioned not only to do new work but to renovate images; his unusual skills as an artist must have been eagerly sought in northern New Mexico by both individuals and communities.

José de Gracia Gonzales was also a sculptor. Several of his descendants living in the Trinidad area recall the family tradition that he was a sculptor who made his own molds and cast his works in plaster,

then carefully painted them.[11] Earlier, while he was still living in New Mexico, it appears that he made polychrome wood sculpture in a style in keeping with traditional New Mexican work. His granddaughter Mercy Valerio alerted us to a piece carved by Gonzales in the Taos area. Mrs. Valerio stated that in the 1940s when she was first married and had just moved from Trinidad to Taos, she was speaking to one of her neighbors, an elderly Taoseño, who in learning that her grandfather was José de Gracia Gonzales told her that he had a statue made by Gonzales that the artist had given his family many years earlier. This figure, a San Rafael, is in a tin-framed niche, also according to this man made by Gonzales. The San Rafael still belongs to the man's daughter, who allowed us to examine and photograph it in 1990.[12]

This figure provides the key for identifying the sculptural work of José de Gracia Gonzales. It conforms in style to the one piece of wood sculpture already attributed to Gonzales on more circumstantial evidence (plate 54), and it is in the same style as three previously unidentified pieces recently acquired by the Museum of International Folk Art from a His-

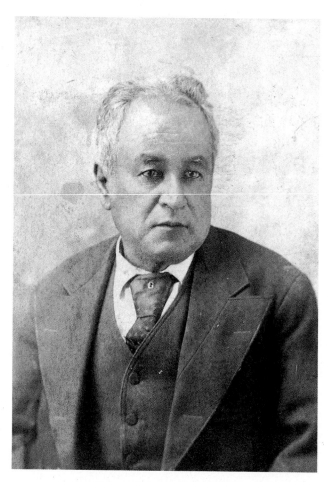

Fig.7.2. José de Gracia Gonzales, circa 1890. (Photograph courtesy of Belinda Gomez, copy print courtesy of the Colorado Historical Society.)

panic family in Taos (plates 55 and 56). In addition, five pieces in the Taylor Museum that were collected near Trinidad and were formerly named "Front Range Style I," are also in this style and are clearly examples of Gonzales's later work in Colorado (plates 86–90). These strongly carved and often brightly painted figures now constitute a stylistic group that we can with some certainty attribute to the hand of José de Gracia Gonzales.

In his later work in Colorado, José de Gracia Gonzales used pine instead of cottonwood or aspen and carved bodies with much more detail than most late nineteenth-century sculptors. He modeled faces and other details in plaster, often using a smooth, high-gloss paint so that the pieces resembled commercial plaster-cast statues (see chapter 9 below).

Gonzales may not only have modeled faces in plaster but also cast whole pieces. One unpainted plaster-cast piece has survived in the Gonzales family in Colorado and is attributed by family members to Gonzales (fig. 7.3). This small image apparently was cast in a mold made from a hand-carved original, for the evidence of carving may be seen in the details of the hand, rosary, flower, and dress of the saint. Although competently made, it is slightly rougher and

lacks the surface uniformity of commercially cast pieces, in which no evidence of working methods would be seen. The carving on the body of this plaster piece resembles the carving on some of his earlier wooden pieces. The face is in a naturalistic style quite

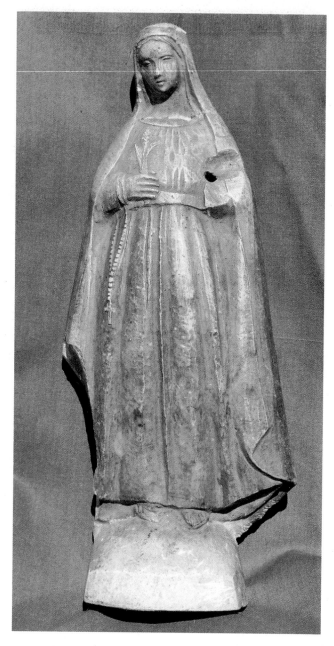

Fig.7.3. This plaster cast statue of Our Blessed Mother is attributed by family members to José de Gracia Gonzales. It is 9¹⁄₁₆" high and cast in at least two sections: the missing arm was separately cast and attached to the body. The head had been broken off and reattached. The back of the figure is flat and without detail, thus retaining the frontality of traditional sculpture and simplifying the casting process. Small pieces such as this one were probably made by Gonzales for individuals and would have been carefully painted by him. This unpainted example apparently remained in his workshop at the time of his death and was saved by family members. (Courtesy of Belinda Gomez, photograph by Mark L. Gardner.)

reminiscent of commercial plaster cast statues of the period and is similar to Gonzales's carved sculptural work in Colorado, in which the hair and sometimes the faces were modeled in plaster. It is likely that in later years, while living in Trinidad, Gonzales added plaster casting to his repertoire in order to be able to compete with the then-popular commercial plaster statues, probably offering his locally made pieces at a significantly lower price than the commercial ones that were unaffordable for many individuals.

As a painter, Gonzales was a professional, obviously trained in Mexico in the regional neoclassic style of the period. Family tradition reported by several of his descendants is that Gonzales was an illegitimate child and at a young age was apprenticed to an artist. His apprenticeship probably included training in methods of sculpture, perhaps even plaster casting, which in Mexico had always been a popular alternative to wood and stone carving.[13]

That José Gonzales also considered himself a sculptor is apparent from a recently discovered inscription on a statue of Our Lady of the Rosary in Truchas, New Mexico. Gonzales had been asked to retouch this figure and left the following record of his work: "This image was retouched thanks to Doña María Ramona Archuleta of San Antonio de Embudo [illegible]. It was done by me José de Gracia G [illegible] Sculptor from the same place of San Antonio [illegible]. This retouching was finished May 24, 1864."[14]

As discussed below (plate 49), Gonzales's painted decorative motifs often bear a close resemblance to those found on the statues attributed to the Abiquiú Santero. There is no evidence that Gonzales lived or worked in Abiquiú, but it is possible that he helped or influenced this sculptor, whose work has a decided Mexican flavor.

Recent research by Guadalupe Tafoya and by Robin Farwell Gavin has resulted in the identification of two more altar screens by Gonzales in the Peñasco area, both of them inscribed in his hand. One is dated 1861, thus one of his earliest works in New Mexico, and the other 1871, perhaps his last large commission before moving to Colorado. By this date his work was unlikely to receive support from the French-born clergy, who, whenever possible, replaced traditional painted altar screens with neoclassic assemblages in which there were seldom paintings but rather only niches for sculptures. In other churches, for instance at Cordova, Chimayó, and Santa Cruz, the parishioners were content with their earlier and well-maintained altar screens. His smaller *retablos* for household use had to compete with the ubiquitous and inexpensive chromolithographs.

What prompted Gonzales to move to Trinidad, Colorado, in the 1870s is not known. Perhaps he saw a better market there for his work. Since there is no evidence that he ever worked for the railroad or did any other kind of work, he must have had some success as an artist. Future research may turn up more evidence of Gonzales's work as a painter and sculptor in the Trinidad area, where he lived for approximately thirty years. Besides the three paintings in the Taylor Museum, a few examples are in the Museum of International Folk Art and a fine *Saint Joseph* is in the Millicent Rogers Museum (plate 51). Other Gonzales paintings may be identified in the future, but without careful study his work is difficult to distinguish from pieces painted in Mexico during the same period.[15]

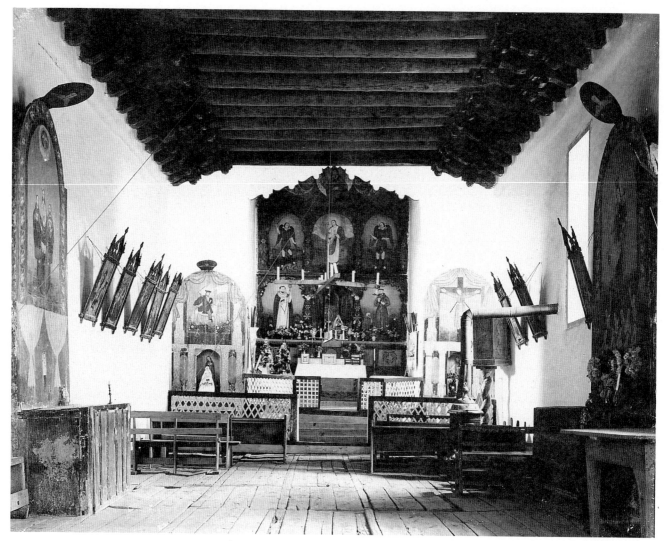

Plate 46. *Altar Screens*
José de Gracia Gonzales
Las Trampas, New Mexico
Ca. 1864–1870
Photograph by Laura Gilpin, circa 1945. Courtesy Laura Gilpin Collection, Amon
Carter Museum, Fort Worth, Texas
Five works by Gonzales are visible in the photograph: the main altar screen flanked
by two smaller screens and the two large screens (*colaterales*) on each side of the nave.

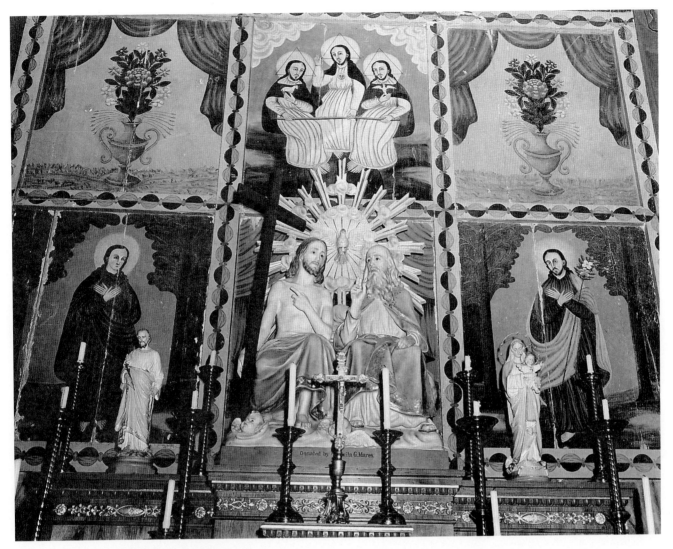

Plate 47. *Altar screen*
José de Gracia Gonzales
Arroyo Seco, New Mexico
Ca. 1865–1875
Photograph by Irving Rusinow, U.S. Bureau of Agricultural Economics, 1941. Courtesy of the National Archives, Washington, D.C.

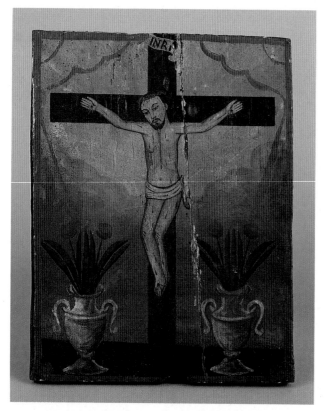

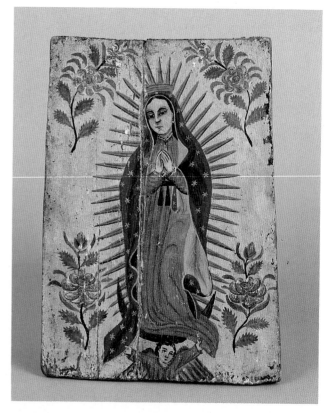

Plate 48. *Christ Crucified*/Cristo Crucificado
José de Gracia Gonzales
New Mexico
Ca. 1860–1875
11¾″ x 9″
Oil-based paint on pine panel
TM 508
Purchased from Elmer Shupe of Taos and accessioned in 1942. The small losses along the long vertical crack in the panel reveal a gesso surface underneath, impregnated in some areas with water-based paint, suggesting that this painting, like the other Gonzales *retablos* in the Taylor Museum, was executed on an existing painted panel.

Plate 49. *Our Lady of Guadalupe*/Nuestra Señora de Guadalupe
José de Gracia Gonzales
New Mexico
Ca. 1860–1875
11½″ x 8¼″
Oil-based paint on pine panel
TM 851
Collected by Alice Bemis Taylor and accessioned in 1942. Gift of Alice Bemis Taylor. Painted over an existing tempera and gesso *retablo*.

The decorative motifs on this painting are remarkably similar to those of the Abiquiú Santero, for instance the flowers on the loincloths of TM 1603 (plate 64) and TM 5699 (plate 66). The same hues of green, pink, red, and white are used in the same manner. This correspondence suggests the possibility that Gonzales worked with the Abiquiú Santero and influenced him, or actually painted his sculpture for him. If nothing else, it helps to confirm the "Mexican" quality of the Abiquiú style, discussed below in chapter 8.

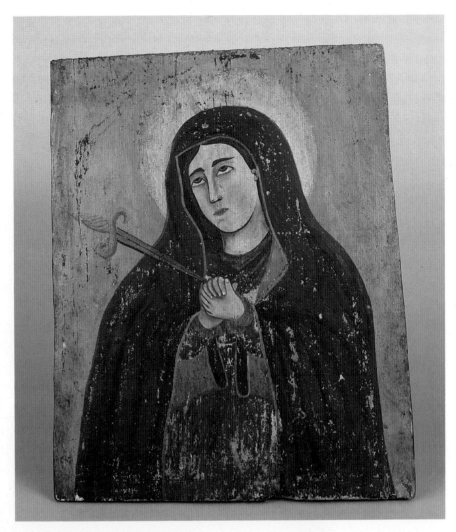

Plate 50. *Our Lady of Sorrows*/Nuestra
Señora de los Dolores
José de Gracia Gonzales
New Mexico or Colorado
Ca. 1860–1900
17½″ x 14½″
Oil and water-based paints on pine
panel
TM 2828

Purchased from Kohlberg's antique shop in Denver and accessioned in 1947.

The artist has painted over, in oils, an existing tempera painting of Our Lady of Sorrows, keeping the same overall form of the figure but redoing the face, hands, halo, background, and sword.

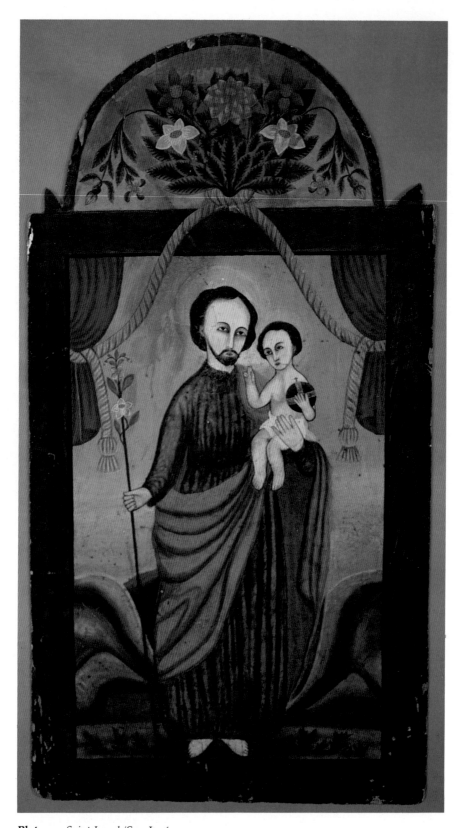

Plate 51. *Saint Joseph*/San José
José de Gracia Gonzales
New Mexico
Ca. 1860–1875
44″ x 22½″
Oil-based paint on pine panel
Millicent Rogers Museum 1980-17-36
Courtesy of the Millicent Rogers Museum, Taos, New Mexico
One of the largest and finest individual panels painted by Gonzales.

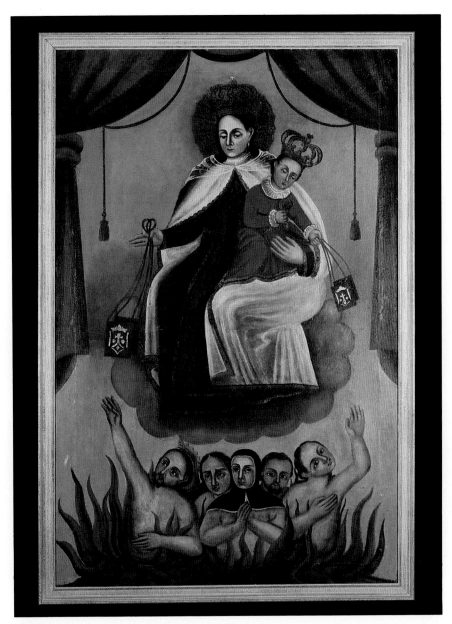

Plate 52. *Our Lady of Mount Carmel*/Nuestra Señora del Carmen
Artist unknown
Mexico
1867
48" x 31¾"
Oil on canvas
TM 1981.27
Provenance: Museum purchase. Former owner collected this piece in Mexico. Inscribed on back: "En 24 de Dbe. de 1867/ se acabo este cuadro de/ Nuestra Señora del Carmen" (on December 24, 1867 this painting of Our Lady of Mount Carmel was finished).

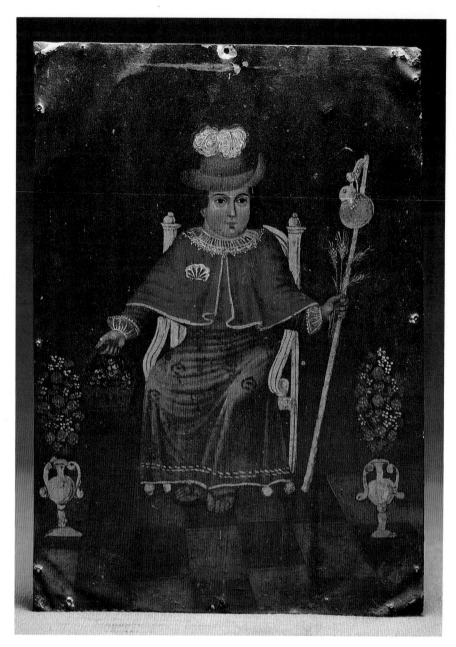

Plate 53. *Holy Child of Atocha*/Santo Niño de Atocha
Artist unknown
Mexico
Ca. 1850–1880
10″ x 7⅛″
Oil on tin
Cady Wells Bequest to the Museum of New Mexico
Museum of International Folk Art, Santa Fe
A.9.54-135
Courtesy of the Museum of International Folk Art, Santa Fe, New Mexico. Photograph by Blair Clark
This and the previous work are illustrated to show the correspondence between José de Gracia Gonzales's work in northern New Mexico and the popular provincial neoclassic style of both canvas paintings and tin *retablos* in the same period in Mexico.

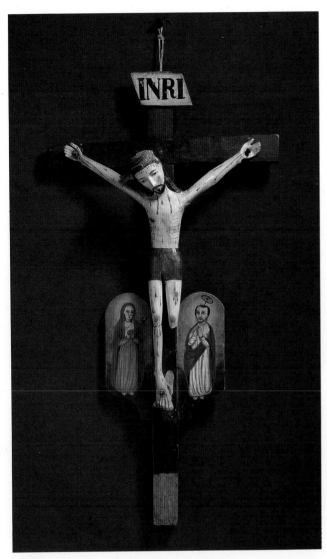

Plate 54. *Christ Crucified*/Cristo Crucificado
Attributed to José de Gracia Gonzales
New Mexico
Ca. 1860–1875
23½″ x 12¼″
Polychrome wood
Spanish Colonial Arts Society Collection
on loan to the Museum of New Mexico
Museum of International Folk Art, Santa Fe
L.5.56-68
Courtesy of the Museum of International Folk Art, Santa
Fe, New Mexico. Photograph by Blair Clark
The paintings of Mary and John are in the style of José de
Gracia Gonzales, which first suggested the possibility that
he also carved the statue. This is further supported by the
fact that the cross also appears to be late nineteenth cen-
tury, at least after the American Occupation, for stenciled
on the back is "ouis, Mo." (St. Louis, Missouri), indicating
that a board from an American packing crate was used. The
figure falls into the body of work now attributed to Gonza-
les; for instance, the painting details on the face are quite
similar to those on the faces of the two statues of Jesús
Nazareno at the Museum of International Folk Art (FA.
1989.40-3, plate 55, and FA.1989.40-1).

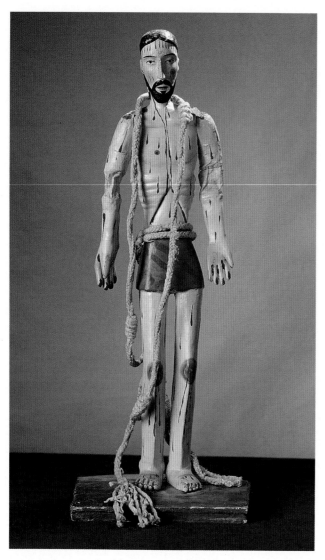

Plate 55. *Jesus Nazarene*/Jesús Nazareno
Attributed to José de Gracia Gonzales
New Mexico
1860–1875
21¼″
Polychrome wood
International Folk Art Foundation Collection
at the Museum of International Folk Art, Santa Fe
FA. 1989.40-3
Courtesy of the Museum of International Folk Art, Santa
Fe, New Mexico. Photograph by Blair Clark

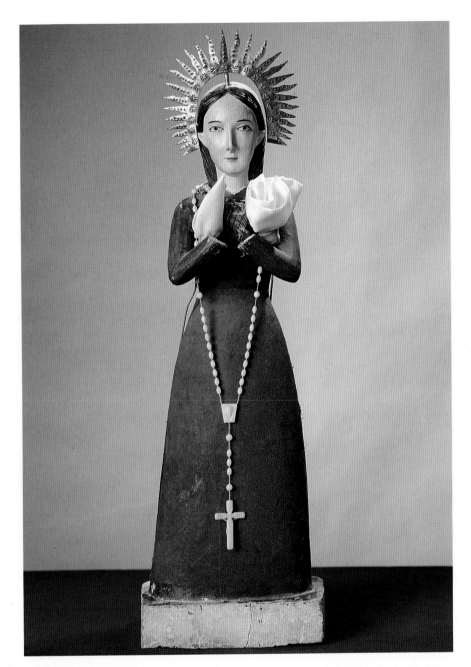

Plate 56. *Our Lady of the Immaculate Conception*/Nuestra Señora de la Purísima Concepción
Attributed to José de Gracia Gonzales
New Mexico
1860–1875
22″
Polychrome wood
International Folk Art Foundation Collection
at the Museum of International Folk Art, Santa Fe
FA.1989.40-2
Courtesy of the Museum of International Folk Art, Santa Fe, New Mexico. Photograph by Blair Clark
Plates 55 and 56 were acquired from a Hispanic family in Taos in 1989. The face of this statue of Our Lady is virtually identical in all its details to that of the Gonzales carving of San Rafael discussed in the text above, and the statue of Jesus Nazarene bears many of the same traits.

Artists of Taos and Rio Arriba Counties

TAOS COUNTY SANTERO

"TAOS GROUP" was proposed by Wilder and Breitenbach as the name for a series of seemingly related *bultos*, most of which are large-size passion figures. Of the nine pieces included in the Taos group by Wilder and Breitenbach, four can be attributed to known *santeros*.[1] Of the remaining five, two are from Taos county villages west of the Rio Grande (Ojo Caliente and Plaza Servilleta), one is from the Taos area, and two are from unknown locations. A sixth piece in this style is from Alcalde, Rio Arriba County, about twenty miles south of Ojo Caliente and forty miles south of Taos. All six pieces share enough characteristics that it can be said with some assurance they are by the same artist or at least from the same workshop. Since only one of them was actually collected in the Taos valley itself, we have here given the artist a more inclusive name, "The Taos County Santero."

The works attributed to this artist are characterized by the use of glass eyes, or more precisely, glass over painted eyes; they have simple hooklike ears, and usually the mouth is slightly open. They are painted in similar colors and style, and the figures of Jesus Nazarene and Christ Crucified all have slightly caved-in chests with diagonal ribs and non-anatomical ridges at the center.

The works of the Taos County Santero are strongly expressive in their large size, their bold painting style with much attention to Christ's wounds, and their powerful bodies and facial features. They have the quality of Mexican provincial carving of the Baroque era, a quality that is enhanced by the use of glass eyes, seldom employed by other New Mexican sculptors. These Mexican qualities they share (except for the glass eyes) with the work of another sculptor, the Abiquiú Santero. It is quite possible that the two artists worked together for a time; perhaps the Abiquiú Santero was for a brief period employed by the Taos County Santero, for the work of the latter appears to be slightly older. One piece, *Christ Crucified* (TM 1681, plate 67), shares characteristics of both styles. Although assigned here to the style of the Abiquiú Santero, it has several characteristics of the Taos County Santero's work, such as the ears, open mouth, loin-cloth, chest, and painting style. The fact that this piece and one in the Taos style both came from Ojo Caliente strengthens the connection between the two artists.

The work of an earlier artist may have been the inspiration for the Taos County Santero. An image of Christ Crucified (TM 5715, plate 62) that came from the *morada* at Velarde, Rio Arriba County, between Taos and Española, was said by Harry Garnett to have been originally at the Santuario de Chimayó. It appears to date from the first half of the nineteenth entury and is more refined and delicately carved than the work of the Taos County Santero but shares many characteristics with this style. Since the Santuario was an important early center for the Brotherhood of the Sangre de Cristo, this piece may well have been the prototype for images in the Taos style of Christ Crucified.

THE ABIQUIU SANTERO

A small group of passion figures apparently was made in the late nineteenth century in or near the town of Abiquiú, New Mexico, by two carvers working in closely related styles. The more striking of the two styles, here attributed to the "Abiquiú Santero," was first identified by Richard E. Ahlborn, who named the artist the "Abiquiú morada santero."[2] The second style, here attributed to the "School of the Abiquiú Santero," was also recognized by Ahlborn but without assigning the work to an Abiquiú artist.[3]

Ahlborn found three pieces in Abiquiú made by the Abiquiú Santero: *Saint John the Evangelist* in the east *morada*, and *Christ Crucified* and *Jesus Nazarene* in the south *morada*. There are seven images in this style in the Taylor Museum, at least two in the Museum of International Folk Art, one in the Kit Carson Museum, and one in a private collection. E. Boyd did not identify the Abiquiú Santero in her *Popular Arts of Spanish New Mexico*, but her accession notes for a Christ Crucified in this style in the Museum of International Folk Art (A. 71.31–96) include the following information: "This style unidentified but must have been made for *moradas* on Chama River, last quarter of 19th century. cf. Ahlborn, *Moradas of Abiquiu* showing two crucifixes much like this, also one from Mc-

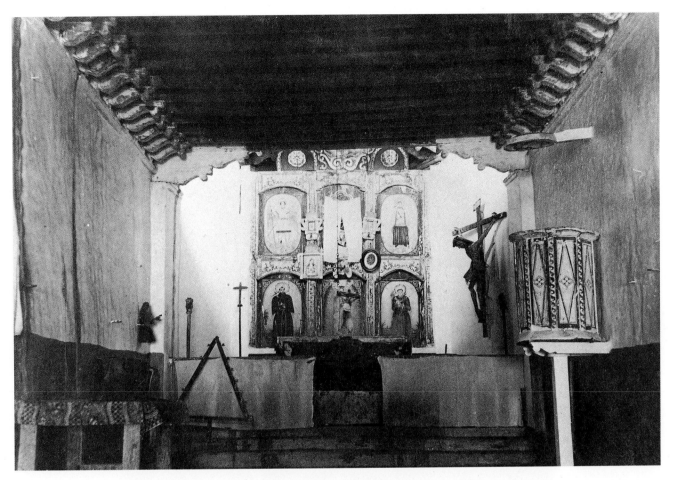

Fig.8.1. Interior of church, Ojo Caliente, New Mexico, circa 1885. On the right behind the pulpit is the crucifix, most likely by the Abiquiú Santero (see plate 67). In front of the altar to the left is the *tenebrario* (see chapter 11) and directly behind it the processional cross-staff and lantern. (Courtesy of the Museum of New Mexico, Neg. no. 14297.)

Cormick collection in Museum of New Mexico, and two more, all similar, in the Taylor Museum. Ref.: local folksay at Ojo Caliente re a late *santero*: 'Monico Benavidez.'"

Since one Abiquiú Santero piece in the Taylor Museum (plate 67) is thought to have come from the church at Ojo Caliente, this possible attribution is of considerable interest. In tying up "loose ends" in her *Popular Arts*, Boyd described a *santero* of Ojo Caliente named "Monico Villalpando": "Perhaps the *santero* of Ojo Caliente was Monico Villalpando whose name was given to Elmer Shupe in 1960 by an older resident of Ojo Caliente. This informant said that, as he recalled, Villalpando was at work about 1910. . . . As is usually the case, no example of Villalpando's work could be produced by the Ojo Caliente informants."[4] Because "Monico" is an uncommon man's name in New Mexico, it is likely that both references denote the same person, and Boyd or the informants have simply confused the last name.

Most examples of the Abiquiú Santero's work have been collected or documented in Brotherhood *mora-*

das west of the Rio Grande: at Abiquiú, Ojo Caliente, La Madera, and Tres Piedras. However, a few have been found east of the river in Velarde, Cundiyo, and as far east as Las Vegas. All but one of the collected pieces in this style are large figures of Christ Crucified and Jesus Nazarene used by the Brotherhood in Holy Week ceremonies.

Unlike other late nineteenth-century New Mexican folk images, the Abiquiú Santero *bultos* appear to have evolved directly from the dramatic realism of Baroque Mexican passion figures of the late eighteenth century. The figures are extremely expressive: the faces have strong features, enhanced by bright colors. The Abiquiú Santero may have come from or traveled in Mexico, or his distinct style may have emerged independent of direct influence from south of the border. Whatever the explanation, his work is another indication of the cultural continuity between Mexico and New Mexico that survived long past the 1846 American Occupation. The second group of Abiquiú images appears to be the work of a follower of the Abiquiú Santero: faces and figures are narrower

and less expressive but maintain many of the characteristics of the former style.

JUAN MIGUEL HERRERA

Juan Miguel Herrera (1835–1905) was an accomplished *santero* of the village of Arroyo Hondo, north of Taos. He was a well-regarded member of the community who, like many villagers, pursued several occupations to make ends meet. In addition to carving, he worked as a farmer and musician. In the 1860 New Mexico Territorial Census for Taos County, Arroyo Hondo section, "Miguel de Herrera," age twenty-five, gave his occupation as "fiddler" and his place of birth as Taos County. In the 1870 census, Herrera gave his occupation as "farmer," and in the 1900 census as "farm laborer."

Herrera was first identified as an image maker by Cleofas Jaramillo, writing about her early years in Arroyo Hondo in the 1870s and 1880s:

> On Good Fridays, when the little statue was placed on a little table in the middle of the church during the prayer

of the stations of the cross, mother called it *Nuestra Señora de la Soledad*, Our Lady of Solitude . . . Miguel de Herrera, the Santero, had used my aunt as his model.

> Don Miguel el Santero, who had modeled the sad-looking statue of *Nuestra Señora de la Soledad* after Aunt Soledad, now came and asked grandmother to let my mother pose for the statue of Nuestra Señora del Rosario, the pretty little statue of Our Lady of the Rosary, carried with Saint John on his feast day.[5]

Harry Garnett, inquiring in Arroyo Hondo in the late 1940s, found that several people still remembered Don Miguel Herrera and that his son Juan de Dios Herrera (fig. 8.2) (1888 to circa 1950) was still living. Juan de Dios Herrera had helped his father make *santos* and in his youth had made a few himself, one as late as 1908. He and Mrs. Crescencia Garcia (age eighty-four) and several other informants identified four pieces in Arroyo Hondo as the work of Miguel Herrera. Three are now in the Taylor Museum: *Cristo Entierro* (TM 1602), *Cristo Crucificado* (TM 3951), and *Jesús Nazareno* (TM 3859). Mrs. Garcia told Garnett that her grandmother, Mrs. Dolores Medina, had com-

Fig.8.2. Juan de Dios Herrera (1888–circa 1950), the son of Juan Miguel Herrera, in 1949. Juan de Dios Herrera learned to make *santos* from his father and made one piece as late as 1908, but did not continue making them in his adult life. The New Mexico Territorial Census of 1900 states that he was born in April 1888, the son of Juan M. Derrera (sic) and Juanita Derrera. According to Harry H. Garnett, he stated that he was sixty years old in 1949 and that his mother's maiden name was Romero. (Photograph by Harry H. Garnett. Taylor Museum Archives.)

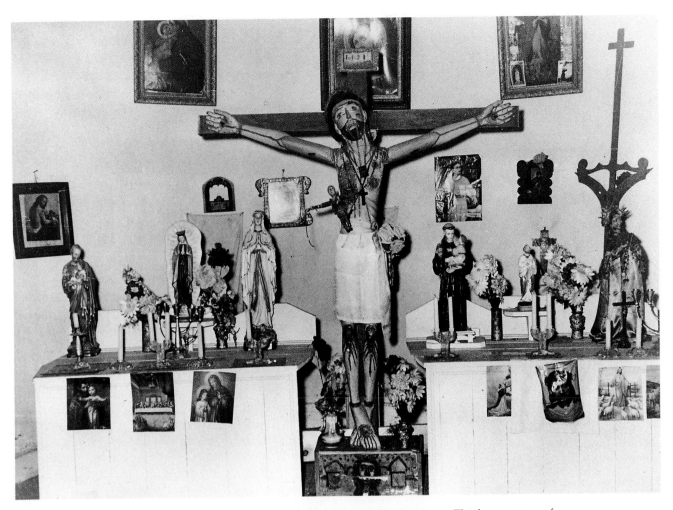

Fig.8.3. Altar of the lower Arroyo Hondo *morada*, circa 1940. The large statue of Christ Crucified is by Juan Miguel Herrera. (Photograph by Juan B. Rael. Courtesy of the National Museum of American History.)

missioned Herrera to make the *Jesús Nazareno* and had paid him five bushels of wheat for it. This information was verified by Meliton Medina of Arroyo Hondo, who said that the brothers of the lower Arroyo Hondo *morada* had claimed ownership of the image, but that Mrs. Garcia (his cousin) "proved that her grandmother paid five bushels of wheat to Don Miguel Herrera to make the Christ."[6]

In addition to the Taylor Museum's pieces by Herrera, at least four attributed to him were in Arroyo Hondo in 1969: a *Cristo Crucificado*, a *Jesús Nazareno*, and a *Nuestra Señora de la Soledad*, all in the church of Nuestra Señora de los Dolores, and a nearly life-size *Cristo Crucificado* in the lower Arroyo Hondo *morada* (fig. 8.3).[7] According to Juan de Dios Herrera and other informants, Juan Miguel Herrera was assisted in making large *santos* by his brother, Candelario, who died many years before him. Together they made the life-size *Cristo* in the lower *morada* and a *Cristo Entierro* for the church at Springer, New Mexico. Garnett thought that Herrera, with the help of his brother, "probably turned out hundreds of pieces" before his death in 1905. However, the only other

Herrera pieces we have been able to identify are a *Jesús Nazareno* and a *Nuestra Señora de los Dolores* in the Taylor Museum (TM 5106 and 5107, plate 72).

Herrera probably was apprenticed to or at least influenced by the earlier, anonymous "Arroyo Hondo Carver," whose work has been found in Arroyo Hondo and neighboring towns.[8] The two pieces just mentioned (TM 5106 and 5107) appear to be early Herrera works that show some characteristics of the Arroyo Hondo Carver. Herrera's later works, however, only bear a general resemblance to that of the earlier artist. They lack the fineness and sharp features of the Arroyo Hondo Carver's work, yet the most successful pieces have the straightforward, honest quality and powerful presence characteristic of the best late nineteenth-century *santos*.

JUAN RAMON VELAZQUEZ

The carving style now attributed to Juan Ramón Velázquez (circa 1830 to 1902) was first identified without attribution by Mitchell A. Wilder and Edgar Breitenbach, who in 1943 illustrated and described two examples in the Taylor Museum.[9] The attribution of

this work to Velázquez (also spelled Velásquez) was first published by José E. Espinosa in 1954, based on information provided by the trader Elmer Shupe of Taos. Shupe, in a letter to Espinosa dated October 4, 1952, noted that in 1899, he and his parents had settled in the small Rio Arriba County community of Canjilón, west of the Rio Grande: "At Canjilon we knew Pablo Velazquez and his father. Pablo we knew well. . . . I think Pablo was 30 or 35 years old. His father was tall, long white beard, seldom spoke. We didn't see him very often. . . . He was typical of the *paisano* at that time, long hair, long beard soiled with tobacco juice. I didn't know that he was a *santero*."[10]

Forty-four years later, when Shupe was working for the Forest Service at La Madera, he met Don Adolfo Ortega, the *hermano mayor* of the Brotherhood there, who sold him some *santos* from the *morada*. Among them was a *Jesús Nazareno* in the same style as one Shupe had purchased at Plaza Servilleta in 1928, now in the Taylor Museum (TM 1592, Wilder and Breitenbach, plate 52):

> So I asked the name of the *santero* and Mr. Ortega said Ramon Velazquez of Canjilon. I told him that I had once lived in Canjilon and that I knew Pablo and his father. That's him, Pablo's father was Ramon, Mr. Ortega said. He also said that Ramon Velazquez had made most all the *santos* in that part of the country. Mr. Ortega is 75 or 80 by now. . . . Crescencio Montoya of La Madera also backed Mr. Ortega's word. . . .
>
> In 1944 I bought another *Nuestro Padre Jesus* at Casita, six miles south of El Rito, from a Miss Romero, maybe 60 at that time. . . . This big *santo* was just like the other and she said Ramon Velazquez de Canjilon had made it.[11]

Shupe goes on to name two more informants who knew Ramón Velázquez as a *santero* and suggests his working dates as 1865 to 1890.

In Canjilón in April 1954 Shupe interviewed seventy-one-year-old Abelino Velázquez, another son of Juan Ramón:

> he recalled his father's making many *bultos*, and said that during the 1880s, when he was a small boy, this was his father's chief occupation. . . . He also said that when his father was very old, about 1899, he stopped making *santos* and that he died about 1902. In earlier years Juan Ramon made his own paints, but later, when there were house paints in the country stores, he used oil. It is worth noting that of the examples in the Museum of New Mexico by his hand, two have tempera paint and one has as its original and only layer of pigment, oil paints.[12]

The identification of Juan Ramón Velázquez is corroborated further by information from Harry Garnett concerning a piece in the Taylor Museum. In a letter to Mitchell Wilder dated March 1, 1952, he notes that the statue of Jesús Nazareno (TM 1402, plate 76) "came from a morada . . . 2 mi. N. of La Madera . . . called Ancones . . . the hermano mayor . . . said that Ramone Valesques [sic] made [it]."[13]

Juan Ramón Velázquez was the most prolific carver of *santos* in the Rio Arriba area west of the Rio Grande in the late nineteenth century. Virtually every community in this area had *santos* made by him. Taylor Museum pieces attributed to Velázquez were collected as far west as Gallina, as far east as Plaza Servilleta, as far south as Chamita (near San Juan Pueblo), and as far north as southern Colorado. Elmer Shupe located Velázquez's *bultos* at Casita (six miles south of El Rito), at La Madera, and at Cebolla and Canjilón. Don Ramón's son Abelino Velázquez told Shupe that his father "made *santos* for people at Canjilon, Cebolla, El Rito, Sevilleta [sic], Vallecitos, Petaca and other villages of the area."[14] Shupe noted in his 1952 letter that "there are not many *moradas* in Rio Arriba County that have sold out, and as I believe [Velázquez] was a prolific *santero*, I wouldn't be surprised but what some day when they do let go that there will be many to be had, possibly next in number to those by the *santero* [José Benito Ortega] of the flat figures of Mora."[15]

While Velázquez's output does not match that of José Benito Ortega, Shupe's assessment of the holdings of Rio Arriba County *moradas* may well have been accurate. In August 1958, E. Boyd, then curator of Spanish colonial arts at the Museum of International Folk Art, was invited by the Brotherhood members in Ensenada, a few miles north of Tierra Amarilla, to come up and see some *santos* from their *morada* that they wanted to sell. In June 1958 the *morada* had been broken into and one figure stolen, so it was decided to sell the rest, after putting them in safekeeping at the home of the *hermano mayor*.

> It was agreed to go to Ensenada, a few days later—visit by the curator [E. Boyd] and A. C. V. [Alan C. Vedder]. Met Manuel V. at T. A. [Tierra Amarilla] courthouse—picked up 4 more hermanos along road—each standing alone by house or fence, waiting. [Arrived] Cristino Lovato's [the *hermano mayor*]. The *santos* were in his bedroom. One tall N. P. J. N. [*Jesús Nazareno*] . . . a smaller N. P. J. N., 2 figures of the Virgin, med. sized crucifix . . . with wig & red paper roses at top of cross, and a San Juan Nepomuceno. All in fabric clothing. . . . All figures . . . were of style of Juan Ramon Velasquez of Canjilon and all in his method of his later years, painted with oils and no tempera layer underneath. Carving fine, stylized, all attention on faces and hands.[16]

Boyd was eventually able to purchase three of these *santos* for the Spanish Colonial Arts Society collection, but concerning the other three: "They said they had given the San Juan Nepomuceno to a *morada* at Coyote as they wanted it—'that is the way we do when we do not keep them'—the other figures had been 'either sold or given away.'"[17]

Most of the surviving pieces attributed to Juan Ramón Velázquez are *morada* figures associated with the passion of Christ: *Jesús Nazareno, Cristo Crucificado, Cristo Entierro,* and *Nuestra Señora de la Soledad.* There are a few notable images of other saints, for instance one of San Rafael and two of San José, discussed and illustrated below. A consistency of style characterizes

Velázquez's *santos*, and with the exception of the work of a Colorado follower (discussed below), few pieces suggest the work of apprentices. Velázquez's work is a pure folk art not at all derivative of high-art styles and far removed from naturalism. Faces are carved and painted in bold, masklike simplicity, giving them qualities of primitive and ancient art. As E. Boyd notes, his work is

akin in spirit to Etruscan concepts of imagery. After thousands of years, Velasquez unknowingly recreated a form of stylized effigy that emanates force, vitality, mystery and indifference to human frailties. Uncontaminated by sweetly naturalistic mass-produced religious "art," Velasquez seems to have satisfied the wants of his customers by making images as they existed in the minds of himself and his neighbors, images representing all that they were not, but to whose likeness they aspired.[18]

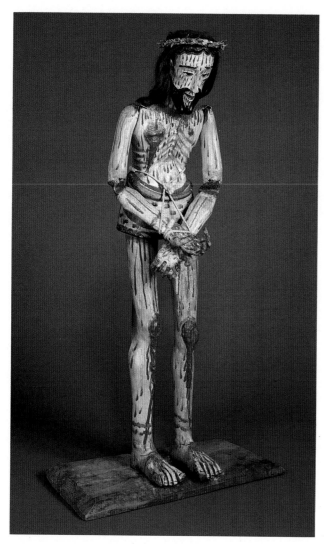

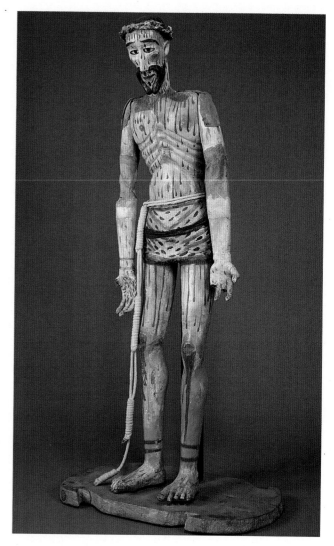

Plate 57. *Jesus Nazarene*/Jesús Nazareno
Taos County Santero
Ca. 1860–1880
50"
Wood, oil-based paints, glass, leather, cotton rope
TM 1605
Purchased from Harry H. Garnett and accessioned in 1937.
Gift of Alice Bemis Taylor. Illustrated in Wilder and Breiten-
bach, *Santos*, plates 34 and 35, and in Shalkop, *Wooden
Saints*, plate 4.

According to information provided by Garnett in 1957, he
purchased this piece from a Mrs. Morton and it had come
from the *morada* at Ojo Caliente. The location had originally
been given as "Servilleta [Plaza Servilleta], New Mexico."

Plate 58. *Jesus Nazarene*/Jesús Nazareno
Taos County Santero
Ca. 1860–1880
58"
Wood, oil-based paints, glass, leather, gesso, human hair
TM 1604
Purchased from Harry H. Garnett and accessioned in 1936.
Gift of Alice Bemis Taylor. Illustrated in Wilder and Breiten-
bach, *Santos*, plate 37, and in Mills, *The People of the Saints*,
plate 1. According to Garnett, this figure came from the
Ranchitos *morada*, just southwest of Taos.

Unlike the previous example, this figure stands erect.
Both are typical examples of the *bultos* of Jesús Nazareno
found in New Mexico and, in slightly more sophisticated
form, in Mexico.

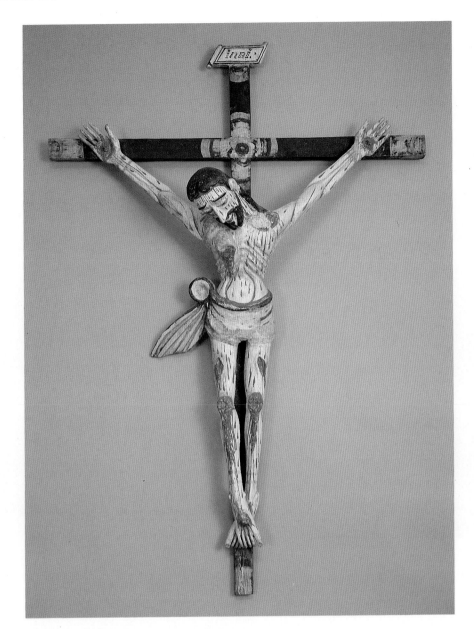

Plate 59. *Christ Crucified*/Cristo Crucificado
Taos County Santero
Ca. 1860–1880
72¾″ including cross
Wood, oil-based paints, gesso
TM 5695
Purchased from Harry H. Garnett and accessioned in 1957. Garnett obtained this piece from Elmer Shupe, who had purchased it from the *morada* at Alcalde, Rio Arriba County, about twenty miles south of Ojo Caliente and forty miles south of Taos. According to Garnett the figure was sold to Shupe because it was no longer in good enough condition to be carried in processions.

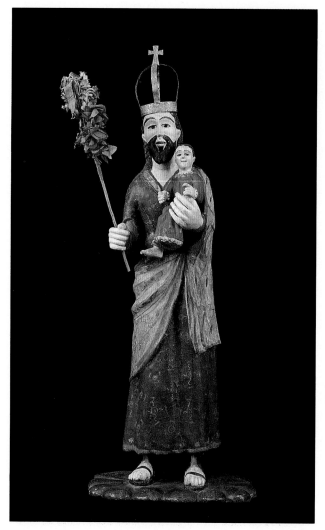

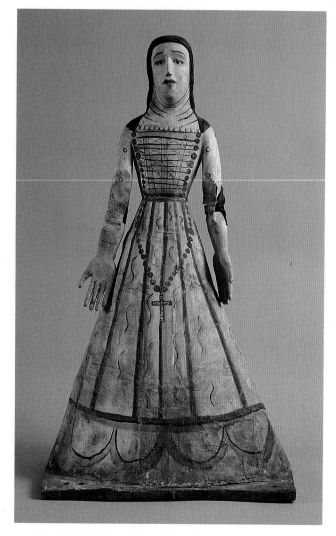

Plate 60. *Saint Joseph*/San José
Taos County Santero
Ca. 1860–1880
36″
Wood, oil-based paints, cotton cloth, glass, tin crown
TM 390
Purchased from the Fred Harvey Company, Santa Fe, and accessioned in 1941. This piece is illustrated by Wilder and Breitenbach, *Santos*, plates 18 and 19, prior to removal of its overpaint.

The piece shares many characteristics with those illustrated above, such as the glass eyes, shape of the ears, and open mouth. Another piece, closely related in style, is attributed to the Taos County Santero: the bare-chested *Our Lady of Sorrows*, illustrated in Wilder and Breitenbach, *Santos*, plate 4 (TM 1563). This figure, like so many images of Our Lady of Sorrows and Our Lady of Solitude, was obviously intended to be clothed. According to Garnett, it came from Plaza Servilleta, New Mexico.

Plate 61. *Our Lady of Solitude*/Nuestra Señora de la Soledad
Taos County Santero
Ca. 1860–1880
39″
Wood, water-based paints, gesso, glass, leather, cotton cloth
TM 401
Purchased from the Fred Harvey Company and accessioned in 1941. Illustrated in Wilder and Breitenbach, *Santos*, plate 47, where it is incorrectly called Our Lady of the Rosary.

This piece differs in some aspects from others by the Taos County Santero, for instance in the use of tempera paint. It is of hollow-skirt construction, and the base has holes in each corner to attach the figure to its *anda* (carrying platform). It would have been dressed in black for Holy Week ceremonies.

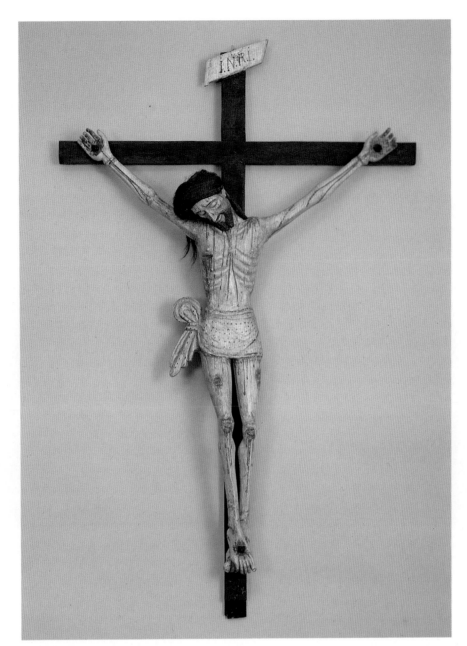

Plate 62. *Christ Crucified*/Cristo Crucificado
Unidentified artist
Santuario de Chimayó, New Mexico
Ca. 1800–1840
Figure 50"; cross 73"
Wood, water-based paints, gesso, glass
TM 5715
Purchased from Harry H. Garnett and accessioned in 1958. According to Garnett, this figure came from the *morada* at Velarde, north of Española, but it was originally from the Santuario de Chimayó. He estimated its date as "about 1825 or 1820."

This carefully carved image may have been the prototype for the work of the Taos County Santero.

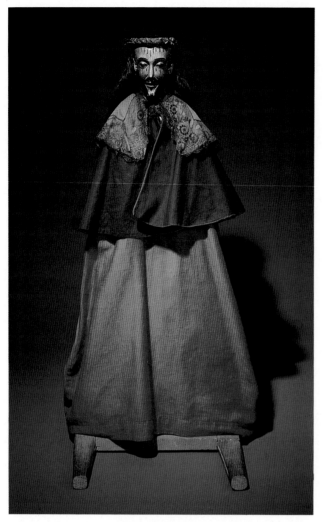

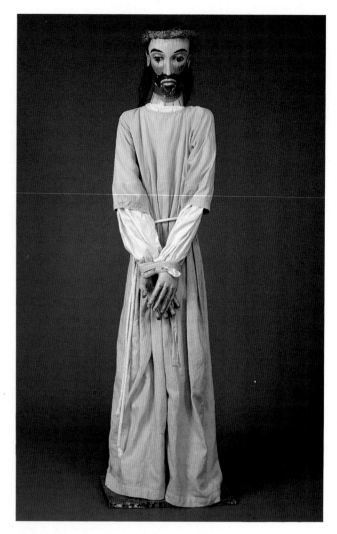

Plate 63. *Jesus Nazarene*/Jesús Nazareno
Abiquiú Santero
Late nineteenth century
41"
Painted cottonwood, cotton cloth
TM 5624
Collected by Harry H. Garnett and accessioned in May 1955. According to Garnett, from "Morada at Velarde, New Mexico."

The figure is constructed by the hollow-skirt method. Written in large, neat letters at base of the figure is: "JESUS DE NASARENO INRI. D." It is attached to a carrying platform (*anda*) for carrying in processions. Illustrated with inscription visible in Kubler, *Santos*, plate 3.

Plate 64. *Jesus Nazarene*/Jesús Nazareno
Abiquiú Santero
Late nineteenth century
64½"
Painted cottonwood, canvas
TM 1603
Collected by Harry H. Garnett and accessioned in 1938. Gift of Alice Bemis Taylor. From "morada in Cundiyo district." Illustrated in Wilder and Breitenbach, *Santos*, plates 24 and 25.

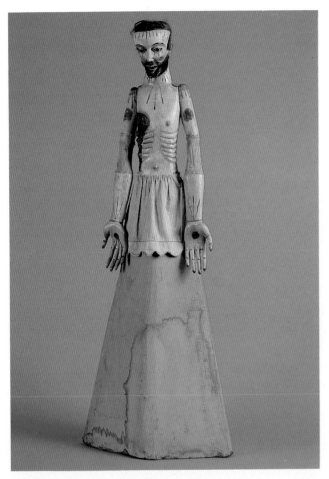

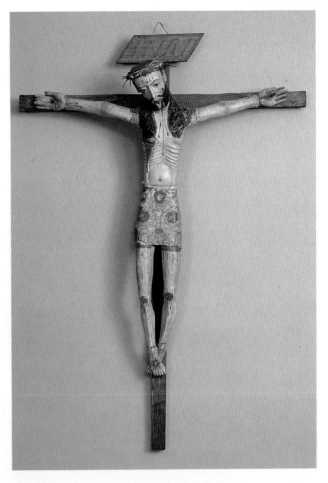

Plate 65. *Jesus Nazarene*/Jesús Nazareno
Abiquiú Santero
Late nineteenth century
46"
Painted cottonwood, canvas
TM 1568
Collected by Harry H. Garnett and accessioned in 1938. Gift of Alice Bemis Taylor. Garnett collected this piece from "Espinosa," probably Gilberto Espinosa, who by the 1930s had already assembled a large colleciton of *santos*. From "Abiquiu, New Mexico *morada*."

Another figure like that in plate 63 made by the hollow-skirt method and intended to be dressed. Illustrated in Wilder and Breitenbach, *Santos*, plate 36.

Plate 66. *Christ Crucified*/Cristo Crucificado
Abiquiú Santero
Late nineteenth century
Figure 34"; cross 46"
Painted wood
TM 5699
Collected by Harry H. Garnett and accessioned in 1958.

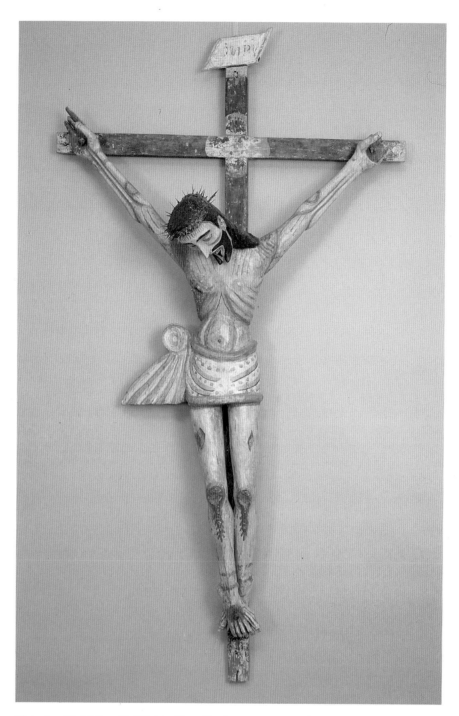

Plate 67. *Christ Crucified*/Cristo Crucificado
Abiquiú Santero
Late nineteenth century
Figure 66″; cross 87″
Painted wood
TM 1681
Collected by Harry H. Garnett and accessioned in 1945. Collected in "New Mexico,
El Rito district" according to accession card. This piece has several traits of the work
of the Taos County Santero, suggesting a connection between the two artists. In
1981 Father Jerome Martinez and residents of Ojo Caliente visited the Taylor Mu-
seum and identified this piece as coming from the old church at Ojo Caliente. In an
1885 photograph of the church (fig. 8.1) an image of Christ Crucified hangs on the
right-hand side of the sanctuary; it is most likely this piece, identifiable by the
unusual forward thrust of the head.[19]

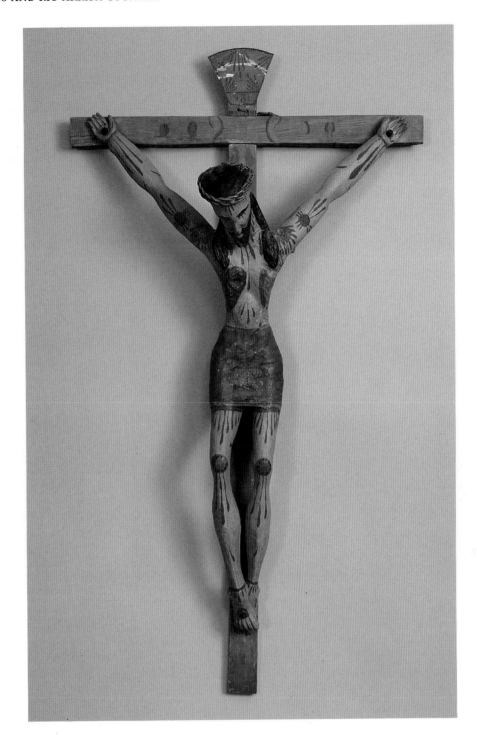

Plate 68. *Christ Crucified*/Cristo Crucificado
School of the Abiquiú Santero
Late nineteenth century
Figure 26½″; cross 36¼″
Painted wood
TM 5688
Collected by Harry H. Garnett and accessioned in 1957. According to Garnett, this piece is from the La Madera region, close to Ojo Caliente, New Mexico.

The two other Taylor Museum pieces in this style are also of Christ Crucified. One (TM 1468) was acquired by Garnett from the collection of artist J. H. Sharp in Taos in the 1930s or early 1940s. The other (TM 5663) was purchased from Rafael Gallegos, who lived six miles below Abiquiú. It was accessioned in 1957.

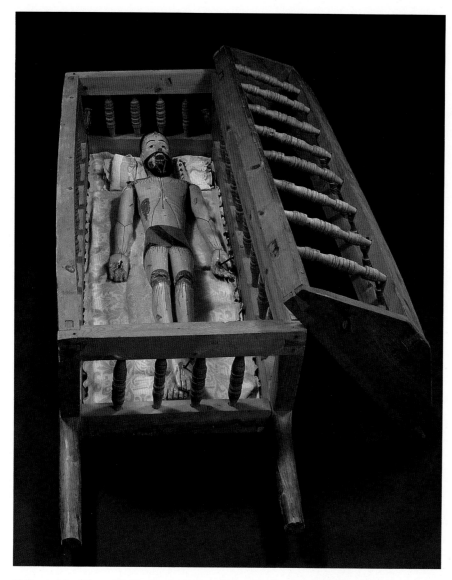

Plate 69. *Christ in the Holy Sepulchre/*
Cristo Entierro
Juan Miguel Herrera
Ca. 1860–1890
Figure 67"; casket 81"
Painted wood, leather joints
TM 1602

Collected by Harry H. Garnett and accessioned in 1936. Gift of Alice Bemis Taylor. Purchased by Garnett from "Mr. Varges" (sic), *hermano mayor* of the upper Arroyo Hondo *morada*, in June 1936.

Not only are the arms and legs of this figure articulated for enactment of the Crucifixion and Descent from the Cross, but the neck and jaw are articulated, apparently to simulate the last agony and perhaps the Resurrection of Christ. Cleofas Jaramillo described the use of this figure on Good Friday, when it was still in the Arroyo Hondo church:

> Under the altar lay *El Santo Entierro*, Christ in the Holy Sepulchre, in a long box with open grating in front. On Good Friday, when the statue was brought out at three o'clock, the jaws on the statue were set with a spring, were made to open and shut, simulating a person in his last agony. As people became accustomed to the new manufactured statues brought in, the old ones were gradually removed [from the church].[20]

Juan de Dios Herrera also described this *Cristo Entierro* to Harry Garnett: "When I asked him about the *santos* his father had made, he said he made many. Then he smiled, raised his hand to his chin and moved it up and down and said, "the one *santo* that my father made that people came for a long way to see was the Santo Entierro which was used in the upper Hondo church and Penitente morada."[21] The church was renovated by Father Joseph Giraud in 1916 and at that time its altar panels (now in the Taylor Museum) were removed and salvaged by the Brothers of the lower *morada*. The *Cristo Entierro* may have been transferred to the upper *morada* at that time, if not earlier.[22] Thus the Brotherhood *moradas* were not only the patrons of late nineteenth-century image makers but also preserved earlier images after they had fallen out of favor with the new French clergy.

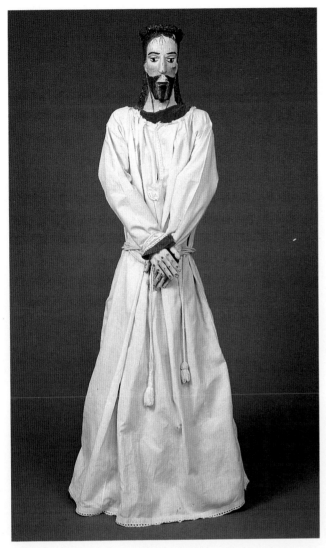

Plate 70. *Jesus Nazarene*/Jesús Nazareno
Juan Miguel Herrera
Ca. 1860–1890
53″
Painted wood, cotton cloth joints and waist cloth
TM 3859
Collected by Harry H. Garnett and accessioned in 1949. Formerly in the Medina family chapel in Arroyo Hondo. Purchased by Garnett from Meliton Medina after the latter joined a Protestant church. According to Mrs. Crescencia Garcia (age eighty-four in 1949), her grandmother, Mrs. Dolores Medina, paid Juan Miguel Herrera five bushels of wheat to make this figure. Reproduced in Wroth, *Christian Images*, plate 187.

This *Jesús Nazareno* held a 20″ x 24″ black wood cross.

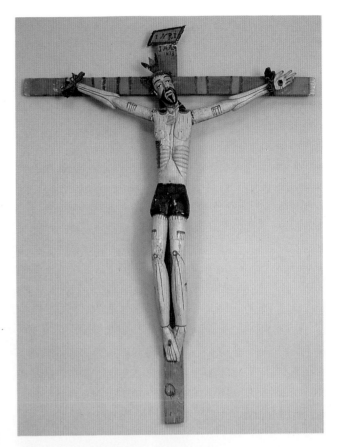

Plate 71. *Christ Crucified*/Cristo Crucificado
Juan Miguel Herrera
Dated 1873
Figure 44″; cross 60″
Painted wood, tin-plate crown, iron nails
TM 3951
Purchased by Harry H. Garnett in 1950 from "Spanish traders" in Taos who had obtained it in trade from the Brothers of the lower Arroyo Hondo *morada*. Accessioned in 1950. According to Garnett, this piece is also known as *Cristo Rey* (Christ the King) due to the crown on the head of the figure.

The letters "J. A. A. M." appear above the date "1873" at the top of the vertical member of the cross. According to Garnett's informant, Victor Arellano (*hermano mayor* of the lower *morada*), "J" and "M" are initials for "Juan Miguel," the artist's given names; "A. A." may stand for "Arroyo Abajo" (Lower Arroyo).[23]

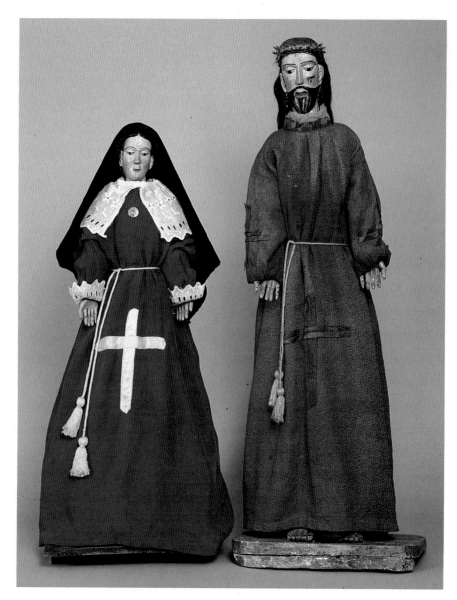

Plate 72. *Our Lady of Solitude*/Nuestra Señora de la Soledad
Attributed to Juan Miguel Herrera
Ca. 1855–1900
33″
Wood, water- and oil-based paints, gesso
TM 5107

Jesus Nazarene/Jesús Nazareno
Attributed to Juan Miguel Herrera
Ca. 1855–1880
39″
Wood, water- and oil-based paints, gesso
TM 5106
Collected by Harry H. Garnett and accessioned in 1954. Purchased by Garnett "from Spanish trader" in New Mexico.

 These two images are by the same hand and share characteristics of the work of both the Arroyo Hondo Carver and Juan Miguel Herrera. They are probably early works by Herrera, made under the influence of the Arroyo Hondo Carver.

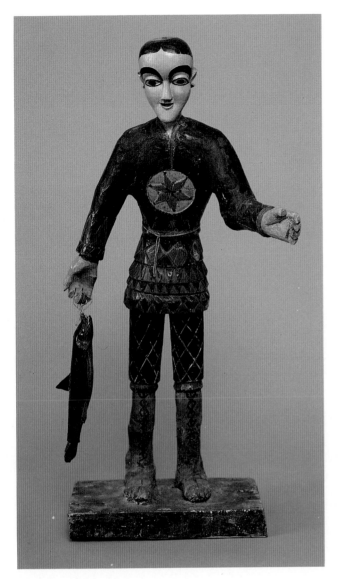

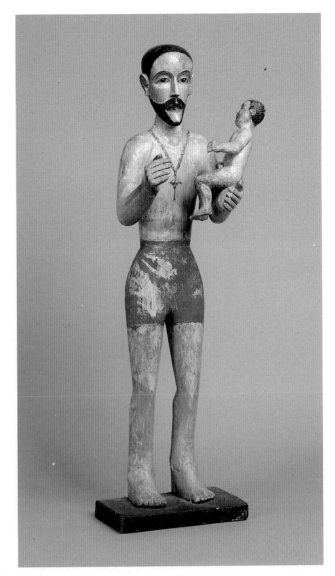

Plate 73. *Saint Raphael*/San Rafael
Juan Ramón Velázquez
Late nineteenth century
23½"
Oil paints on cottonwood
TM 1585
Purchased by Alice Bemis Taylor from Frank Applegate in 1928 and accessioned in 1935.

The intricate geometric carving on the tunic of this figure distinguishes it from other pieces by Velázquez, and together with the bold, simplified facial features makes it one of the most striking late nineteenth-century *bultos*.

Plate 74. *Saint Joseph*/San José
Juan Ramón Velázquez
Late nineteenth century
29¾", plus base
TM 3891
Purchased from Harry H. Garnett and accessioned in 1950. According to the accession record, this figure came from a *morada* near Las Vegas, New Mexico. If this is correct, it is the only known piece by Velázquez collected east of the Rio Grande.

The piece was clearly made to be dressed, and the hands are positioned correctly for Saint Joseph. The Christ Child is not the work of Velázquez.

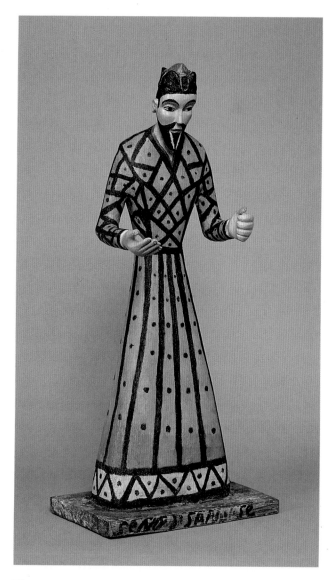

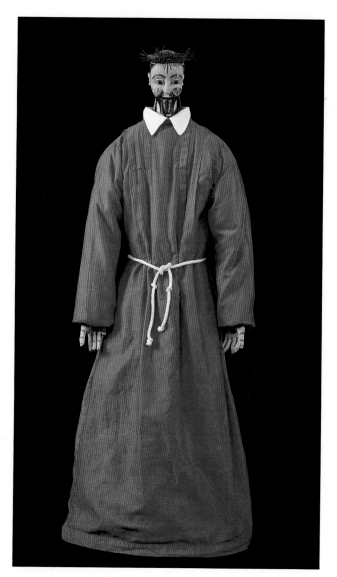

Plate 75. *Saint Joseph*/San José
Juan Ramón Velázquez
Late nineteenth century
30½"
Water-based paints and gesso on pine wood
TM 7211
Purchased at the May D & F sale of the Nolie Mumey Collection and accessioned in 1968. Mumey collection 427.

The biretta on the head suggests that this figure originally may have been Saint John Nepomuk, later transformed into Saint Joseph. The hands and arms are properly positioned for Saint Joseph's staff and the Christ Child, and the words "Senor San Jose" are painted on the front edge of the base over some indistinguishable words. In 1983 crude overpaint was removed, revealing the striking original light blue, black, and white patterned surface. At the same time the head and shoulders, which had been awkwardly reset, were returned to their proper positions.

Plate 76. *Jesus Nazarene*/Jesús Nazareno
Juan Ramón Velázquez
Late nineteenth century
47"
Oil- and water-based paints on cottonwood
TM 1402
Purchased from Harry H. Garnett and accessioned in 1943. According to Garnett in a letter to Mitchell Wilder, March 1, 1952: "the laughing *Cristo* [TM 1402] with the orange red painted body came from a *morada* . . . 2 mi. N. of La Madera . . . called Ancones . . . the *hermano mayor* . . . said that Ramone Valesques [sic] made [it]." A later note on the accession card apparently written by George Mills states that this piece came "from Llanito, a *morada* north of Taos."

In the Kit Carson Memorial Foundation collection is a remarkable *Jesús Nazareno* by Velázquez, articulated at the waist, neck, shoulders, and elbows. Two ropes, one running from the back of the head to the base, the other from the waist to the base, make it possible for an unseen operator to make the head and torso move. As discussed in chapters 2 and 3, articulated images of this type date back to sixteenth-century Spain and Mexico, and were used for the *encuentro* of Mary and Jesus and other Holy Week ceremonies.

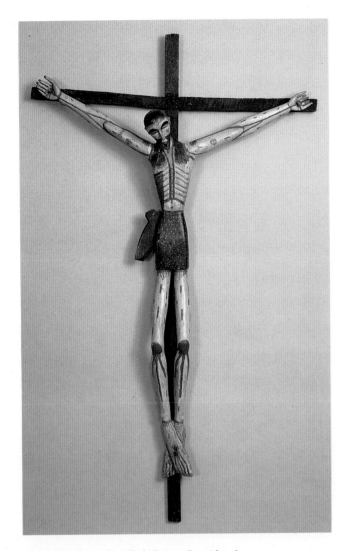

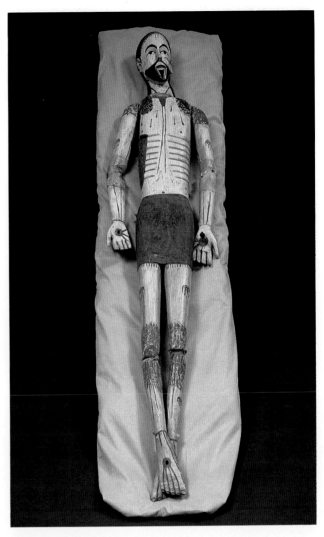

Plate 77. *Christ Crucified*/Cristo Crucificado
Juan Ramón Velázquez
Late nineteenth century
Figure 44″
Oil-based paints on wood
TM 594
Purchased from Harry H. Garnett and accessioned in 1941.
 This is an unusually elongated figure in which the legs are nearly half again as long as the torso and head. A similar Velázquez *Christ Crucified* in the Taylor Museum (TM 3585) is not as elongated as this one.

Plate 78. *Christ in the Holy Sepulchre*/Cristo Entierro
Juan Ramón Velázquez
Late nineteenth century
68½″
Oil paints on wood
TM 5780
Purchased from Harry H. Garnett and accessioned in 1960. According to Garnett, this piece was collected in Chamita, New Mexico. No casket was obtained with it.

Artists of Southern Colorado

SAN LUIS VALLEY SANTEROS

NINETEENTH-CENTURY Hispanic communities in southern Colorado did not develop the same strong tradition of image-making that flourished in New Mexico. By the time Hispanic villages in Colorado were settled in the 1850s, the art of making *santos* in New Mexico was already on the decline due to influences from the incoming Anglo-Americans.[1] For the Hispanic migrants, Colorado was a frontier situation, lacking the encompassing ambience and support of the long-established communities of New Mexico. Thus they were highly dependent upon Anglo-American products and were more vulnerable to outside influences.[2]

In this situation, religious images came from several sources. Some New Mexican *santos* were brought north by the migrants, while a great many commercial plaster images and chromolithographic prints were purchased through Anglo-American traders. In addition to these outside sources, *santos* were made in southern Colorado, principally for chapters of the Brotherhood of Our Father Jesus Nazarene. These pieces were apparently made by both itinerant New Mexican *santeros* and local artists.

As noted earlier, one of those itinerant artists may have been Juan Ramón Velázquez of Canjilón, New Mexico, who very likely worked in the San Luis, Colorado, area. His son, Abelino Velázquez, told Elmer Shupe that his father "did not make *bultos* at home and take them around the country but he had enough commissions for work to make it practical to go with his family and live, three or six months, in some place while he made the *santos*."[3]

His itinerant manner of working may account for the presence of Velázquez's *santos* in the San Luis area and for the development of a derivative style that emerged there in the late nineteenth century. One *Jesús Nazareno* by Velázquez in the Taylor Museum was said by Harry H. Garnett to have come from "an old morada" in the San Luis area (plate 79, TM 3879), and several pieces made in that area clearly derive from his style of work.

It seems likely that someone in San Luis, probably the *hermanos* of the Brotherhood of Our Father Jesus Nazarene, commissioned Velázquez to come there and make *santos*, and while he was there a local carver began working with him. Evidence for this is that the Velázquez *Jesús Nazareno* from the San Luis area (TM 3879), while clearly in his style, also shares characteristics with the derivative pieces. For instance, the figures are carved from flat boards rather than from the rounds normally used by this artist, and the faces are painted with the same type and colors of enamel paints. These characteristics suggest that Velázquez actually worked in San Luis, using locally provided enamel paints and milled lumber, and perhaps was assisted by an apprentice.

According to Marianne Stoller, San Luis Valley informants have said that sometime prior to 1900 a *santero* from the Abiquiú area or from Taos came to San Luis to carve images.[4] William Wallrich noted in 1951 that one of his informants, Joe Sanchez of Fort Garland, stated that his father had been a *santero*: "many years ago his father had been apprenticed to a *santero* in Ojo Caliente in northern New Mexico, but had decided after a time that he wanted to be a farmer, had left Ojo Caliente, and had come up to the San Luis Valley."[5] Joe Sanchez clearly remembered many details of his father's methods and materials. In discussing the gesso used to cover *bultos* and *retablos*, he said that the two best sources were in Coyote, twenty-two miles west of Abiquiú, and on the road between Parkview and Tierra Amarilla, about twenty miles north of Canjilón. His familiarity with these sources suggests that his father worked in that area, either with Velázquez, who would also have known and utilized them, or with the Abiquiú Santero.

Two groups of *santos* appear to derive from the work of Juan Ramón Velázquez. Most of these images were collected in or near the San Luis Valley of southern Colorado. The first group, which is most closely connected with Velázquez's work, we call "San Luis Valley Style I," and the second group, "San Luis Valley Style II." The San Luis Valley Style I pieces all share characteristics with those of Velázquez: concave faces, distinctive ears, knobs for wrist bones, and high, pronounced eyebrows. The San Luis Valley Style II pieces also share some of these characteristics, such as the treatment of the eyes and the wrist bones, but they differ slightly in other details, enough to suggest that they are the work of another artist.

FRANCISCO VIGIL

Wallrich's informants identified three other *santeros* in the San Luis Valley: Antonio Herrera, Juan Ascedro Maes, and Francisco Vigil, all of whom were said to have supplied *santos* for the Hispanic communities of the area. Wallrich illustrated a death figure from the Costilla, New Mexico, *morada* said to have been made by Herrera, apparently the only *santo* he could find by this artist. At least one piece by Francisco Vigil is known: the *Christ Crucified* in the Taylor Museum (TM 3590, plate 85). According to Wallrich, Vigil apparently "made only large *bultos*, specializing in near life-size, articulated figures used by *Los Hermanos Penitentes* in their *moradas* and in the serious pageantry attendant upon Holy Week. It is said he made such a figure only when he had a definite order and was paid "good money."[6]

This description applies to late nineteenth-century *santeros* in general; the demand for their work was limited to passion figures commissioned by the Brotherhood *moradas*. With little other interest in locally made pieces, it is not surprising that Vigil worked only when commissioned. His interest in producing only when he was paid "good money" reflects the influence of Anglo-American commercial values, replacing the older Hispanic barter economy.

The *Christ Crucified* in the Taylor Museum (plate 85) was identified as the work of Vigil by the collector Harry H. Garnett who stated in 1950 that this piece was "from a morada at old San Acacio about 4 or 5 miles southwest of San Luis, Colorado. Modesto Vigil, who lived at San Pablo, 4 or 5 miles southeast of San Luis, and was Hermano Mayor of the big morada at San Luis, said the figure was made by his father, Francisco Vigil, a santero who worked mostly in the '70s and '80s."[7]

Vigil's style, evident in this piece, is quite simple; the body retains the angularity of the original piece of wood with little depth in the carving. The facial features are simple and straightforward and somewhat reminiscent of the work of Juan Miguel Herrera of Arroyo Hondo.

JOSE DE GRACIA GONZALES IN COLORADO

The work of two late nineteenth-century *santeros* is associated almost exclusively with Front Range communities of southern Colorado, east of the Rocky Mountains and south of Colorado Springs. Hispanic settlement in this area concentrated, after 1850, in Pueblo, Walsenberg, Trinidad, and many smaller communities. Along with trapping and trading, stock raising and small-scale farming, coal-mining soon became an important occupation that drew many Hispanic families north from New Mexico.[8]

The sculpture of one of these artists was formerly identified as "Front Range Style I." We can now with great certainty attribute this work to the painter and sculptor José de Gracia Gonzales, who moved from the Taos, New Mexico, area to Trinidad, Colorado, in the 1870s. Of the five pieces in this style in the Taylor Museum, four are from *moradas* in or near the community of Aguilar, just north of Trinidad. These pieces are clearly by the same hand as those attributed to Gonzales in the Taos area (see chapter 7, above). With the identification in 1990 of Gonzales's sculptural style, several new pieces have been recently discovered. There are two images of Christ Crucified, both lacking provenience: one acquired in 1991 by the Taylor Museum from a New Mexican collection (TM 1991.16) and another in the Museum of International Folk Art (A.80.9–790). A third piece, The Holy Trinity, most likely made in his New Mexican period, is in a Taos County church. Several unusual techniques distinguished Gonzales's work from that of New Mexican *santeros* of the nineteenth century. The bodies are often of pine rather than the more commonly used cottonwood or aspen, while extremities requiring detail, such as hands and feet, are carved from these latter woods. The body of *Jesús Nazareno* (TM 3854, plate 87), including its heavy base, is carved from a single large piece of pine. More unusual is the use of gesso to model details, such as the faces and hair of several figures. Modeling in gesso was practiced by eighteenth-century New Mexican sculptors drawing on methods of colonial Mexico, but during the nineteenth century the practice was seldom utilized in New Mexico.[9] Gonzales probably learned this skill during his early artistic training in Mexico, where gesso modeling was still known and practiced. Other aspects of his sculptural technique recall Mexican methods: the deep carving of figures, approaching naturalism in style (plates 87 and 90); gesso undercoating of the figures; and leather hinges for the articulated joints.

It appears that for his later Colorado work Gonzales was influenced by, or consciously attempted to copy, the popular commercial plaster pieces in sentimental neoclassic style made in the eastern United States. By the late 1800s they were found in the churches of the larger communities of Colorado and New Mexico, and thus would have been a readily available model for the artist. In describing one of the Colorado pieces in Gonzales's style, E. Boyd aptly notes that the faces and extremities are "plainly influenced by plaster statues and their smug, swishy details."[10] These pieces are characterized by narrow, sometimes slightly misshappen faces, and narrow, almost squinting eyes. In Gonzales's Colorado work we have the unusual situation of an isolated folk-art style springing from commercially produced art; but perhaps this is not so unusual, for plaster images had become the urbane, academic religious art of the day. Academic art, through the media of engravings and woodcuts, had also inspired the folk artists of the early nineteenth century.

FRONT RANGE STYLE II

In October 1976, the Taylor Museum was asked by lawyers representing a southern Colorado Brother-

hood of Our Father Jesus Nazarene to assess the damage done to *santos* in an act of vandalism to their *morada*. Teenagers out hunting had broken into the isolated building, and the holy images had been knocked down, broken, shot at with a rifle, and generally mistreated. One image of Our Lady of Solitude had been stolen and was later found intact on the curb of a nearby city street.

In November 1976 the writer and photographer Myron Wood visited the *morada* and assessed and photographed the damage. Fortunately, most of the damage was to commercial plaster images that could be repaired or replaced. Estimates of the cost of repair and restoration were obtained from two conservators and submitted to the officers of the Brotherhood to use in their case against the vandals who had been apprehended.

These events marked the beginning of a cordial relationship with the officers of the Brotherhood, and in June 1977, several of them visited the Taylor Museum and said that they wanted to sell some of the *santos* to the Museum. They were concerned about future vandalism, and also the land surrounding the *morada* was up for sale, making the future uncertain for the continued use of the site. For these reasons, they wanted to see the locally made *santos* in their possession preserved in a museum.

Like many New Mexico and Colorado chapels and *moradas* since the late nineteenth century, this one contained a combination of locally made wood and commercial plaster images. The commercial pieces were of popular saints and holy persons such as Saint Anthony, Saint Francis, the Holy Family, Our Lady of Guadalupe, and the Holy Child of Atocha, while the locally made *santos* were the essential ones for Holy Week: Jesus Nazarene, Our Lady of Solitude, and Christ Crucified.

Among the indigenous *santos* were three striking pieces by an artist whose work has not been previously described or documented, which we have labeled the Front Range Style II. These three pieces, along with three others, were purchased from the

Brotherhood by the Taylor Museum in the fall of 1977. The Brotherhood retained two pieces for future Holy Week observances: *Nuestra Señora de la Soledad*, in yet another unknown but recent style, and *Jesús Nazareno*, in the style of José de Gracia Gonzales. They also kept a charming *San Isidro*, modeled in plaster by a local artist, and their commercial plaster images.[11]

Nothing is known concerning the identity of the artist of the Front Range Style II pieces. In 1977 the eldest members of the Brotherhood did not know who had made the pieces. These members included a woman of eighty-seven years who had taken care of the altar and *santos* in the *morada* since her childhood.[12] She and other elders could only say that the pieces had been in the *morada* as long as they could remember. This means that most likely the work of this artist dates at least to the early 1890s, if not earlier. Only one other piece in this distinctive style has been identified: a *Christ Crucified* in a nearby church.

The Front Range Style II artist worked in a simple, robust style. The faces are broad and boldly featured. Like José de Gracia Gonzales, and again harking back to eighteenth-century methods, the faces are modelled in thick gesso and attached to plain wooden heads. The bodies of the two figures of *Jesús Nazareno* are without detail and clothed in quite plain robes. The arms of one of the figures are jointed at the elbows with cloth, while the other has pegged joints at the elbows. The torso of one of these figures is thickly plastered with gesso. All of them are painted with commercial oil-based glossy house paints.

The artist produced his work in a vigorous style with little apparent influence from New Mexican *santos* and far removed from academic art. His *Christ Crucified* is a particularly well-executed and powerful piece that does full justice to the holy subject it represents. At the end of the tradition of Southwestern *santo*-making and at the farthest northern reaches of Hispanic culture, it is remarkable that this unknown artist quietly produced vital images for use in local *moradas* and churches, a late flowering of the traditional art of the *santero*.

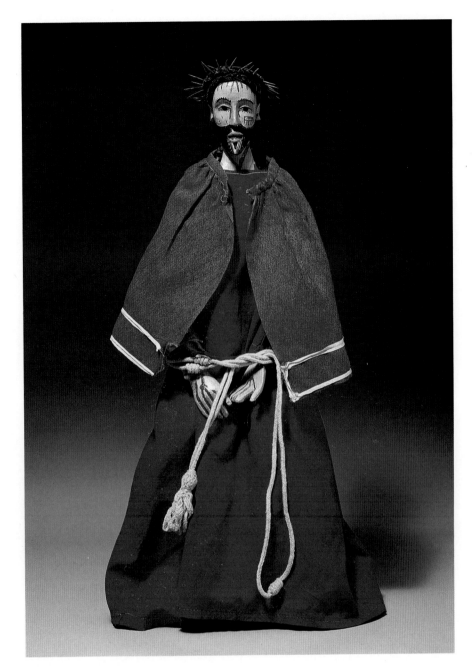

Plate 79. *Jesus Nazarene*/Jesús Nazareno
Juan Ramón Velázquez
San Luis Valley, Colorado
Late nineteenth century
28½″
Enamel paints on wood
TM 3879
Collected by Harry H. Garnett and accessioned in 1949. From "an old *morada*" in
the San Luis, Colorado, area.
 This piece is the link between Velázquez and the San Luis Valley Styles I and II,
for while clearly in Velázquez's style, the face is painted with the same type and
colors of enamel paints as TM 3881 (plate 80). Both figures, as well as TM 1341
(plate 81), have nearly identical facial details. Also, the painting of face is almost
identical to another Velázquez *Jesús Nazareno* (TM 3721).

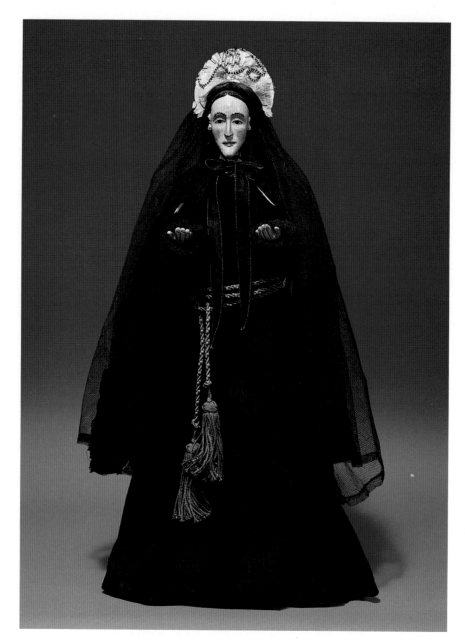

Plate 80. *Our Lady of Solitude*/Nuestra Señora de la Soledad
San Luis Valley Style I
Late nineteenth century
23⅜"
Enamel paints on cottonwood
TM 3881
Collected by Harry H. Garnett and accessioned in 1949. From an "old morada" in
the San Luis area, this figure is clothed in an elaborate dress, braided silk belt, lined
cape, wig, veil, and beaded crown. The beaded crown is of the same type as TM
3880 (plate 82).

 This piece is the closest in style to the work of Juan Ramón Velázquez (see plate
79, TM 3879).

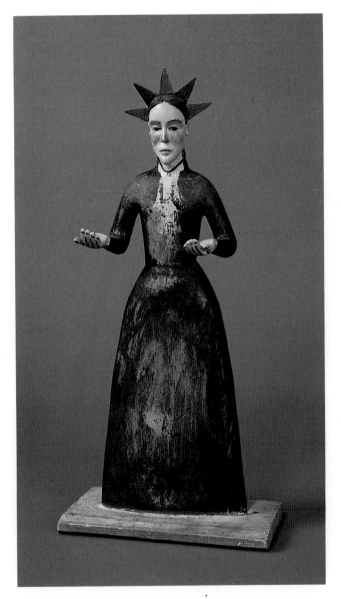

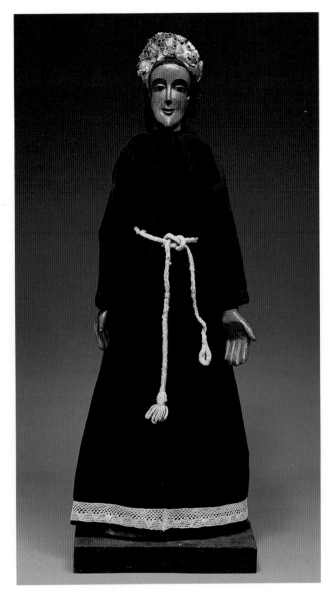

Plate 81. *Our Lady of Solitude*/Nuestra Señora de la Soledad
San Luis Valley Style I
Late nineteenth century
18¾"
Enamel paints on pinewood
TM 1341
Purchased by Alice Bemis Taylor from Frank Applegate of Santa Fe in 1928. Accessioned in 1935. Gift of Alice Bemis Taylor. A third piece in this style (TM 1977.25) is nearly the same height and shares many details of this figure and of TM 3881. It was purchased from the members of a Front Range Colorado *morada* in 1977.

Plate 82. *Our Lady of Solitude*/Nuestra Señora de la Soledad
San Luis Valley Style II
Late nineteenth century
25"
Enamel paints on cottonwood
TM 3880
Collected by Harry H. Garnett and accessioned in 1949. From an "old *morada*" in the San Luis area, most likely the same *morada* as TM 3881. Both pieces have unusual crowns consisting of beads appliquéd to colored fabric, backed by heavy paper.

This piece shares at least one characteristic with the San Luis Style I, a slightly concave face.

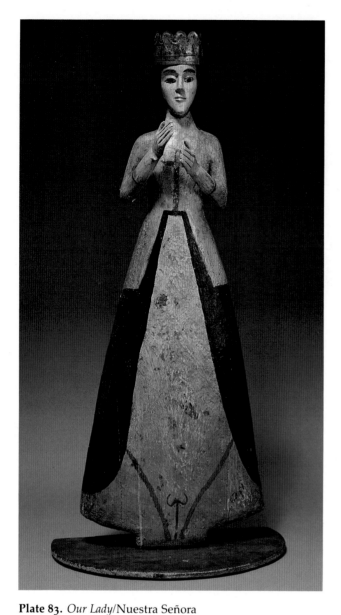

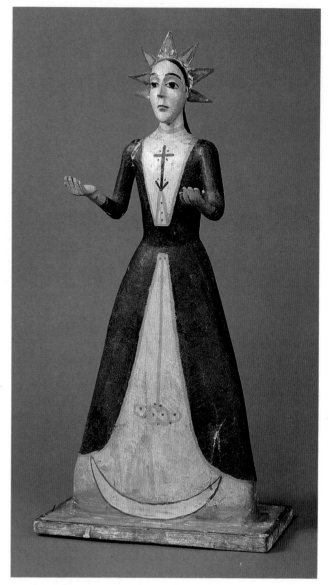

Plate 83. *Our Lady*/Nuestra Señora
San Luis Valley Style II
Late nineteenth century
27¾″ plus base
Enamel paints on cottonwood
TM 3863
Collected by Harry H. Garnett and accessioned in 1949.
From the Our Lady of Mount Carmel *morada*, five miles
from Aguilar, Colorado.

Plate 84. *Our Lady of Solitude*/Nuestra Señora de la Soledad
San Luis Valley Style II
Late nineteenth century
24¼″
Enamel paints on cottonwood
TM 1984.1
This piece was originally purchased by Alice Bemis Taylor
from Frank Applegate in 1928 and accessioned into the Tay-
lor Museum in 1935. Gift of Alice Bemis Taylor. It was de-
accessioned in 1950 and traded to Harry H. Garnett. In 1984
it was reacquired by purchase from Perry Keen of Pueblo,
Colorado.

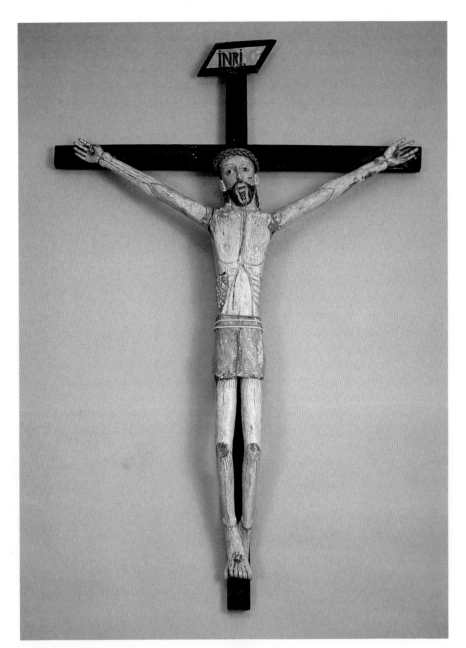

Plate 85. *Christ Crucified*/Cristo Crucificado
Francisco Vigil
Late nineteenth century
78½″
TM 3490
Purchased from Harry H. Garnett and accessioned in 1948. Purchased by Garnett from Florence Sena of Las Vegas, New Mexico. According to Garnett, this piece came from the *morada* at Viejo San Acacio, Colorado.

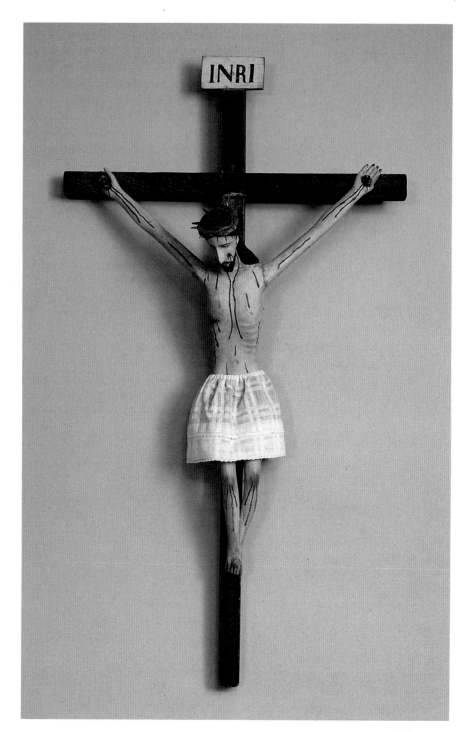

Plate 86. *Christ Crucified*/Cristo Crucificado
Attributed to José de Gracia Gonzales
Late nineteenth century
Figure 20″; cross 38½″
Wood, gesso, oil-based paints
TM 3855
Purchased from Harry H. Garnett and accessioned in 1949. From Our Lady of
Mount Carmel *morada*, five miles from Aguilar, Colorado.

 The hair is modeled in plaster; the crown of thorns is made of an unidentified
vegetal fiber.

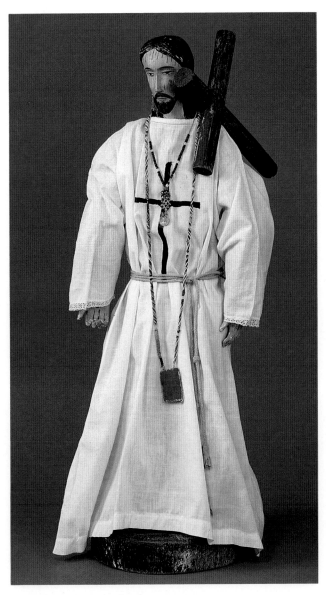

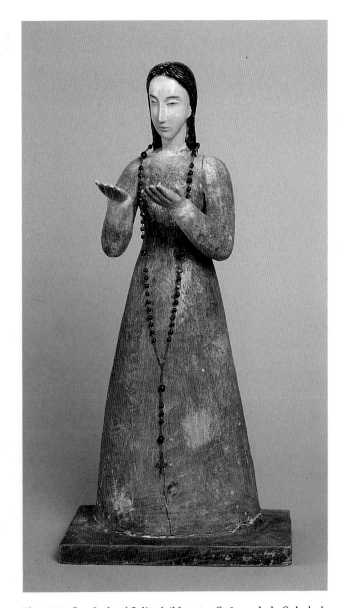

Plate 87. *Jesus Nazarene*/Jesús Nazareno
Attributed to José de Gracia Gonzales
Late nineteenth century
36"
Pine and cottonwood or aspen, gesso, water- and oil-based
paints, leather
TM 3854
Purchased from Harry H. Garnett and accessioned in 1949.
According to Garnett, this piece came from Our Lady of
Mount Carmel *morada*, five miles from Aguilar, Colorado.

The rectangular sewn cloth piece on the long beaded cord
around the neck of this figure is a *dominita*, a protective
amulet usually worn by individuals under their clothing to
ward off evil. Although this one is empty, typically the
cloth container might include a tiny cross, a print of a saint,
a piece of garlic, a piece of *cachana* root, and other protec-
tive items.[13] The shorter cord around the figure's neck is
made of an old rosary and has a beaded amulet and medal
of San Ignacio Loyola at its end. This amulet and the long
beaded cord of the *dominita* are rare examples of Hispanic
Southwestern beadwork, a little-known art form showing
Native American influence. Also of interest is the finely
braided handspun wool cord around the waist.

Plate 88. *Our Lady of Solitude*/Nuestra Señora de la Soledad
Attributed to José de Gracia Gonzales
Late nineteenth century
21"
Pine wood, gesso, oil-based paints
TM 7529
Purchased from James Economos and accessioned in 1971.
Said to have been collected in the Aguilar, Colorado, area.

Hair and possibly face modeled in gesso. Painting of the
body is roughly done, for the piece was made to be dressed
in clothing.

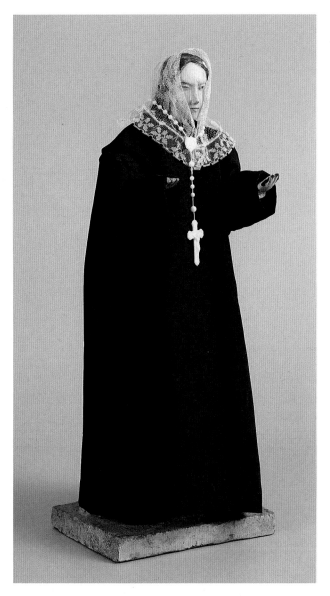

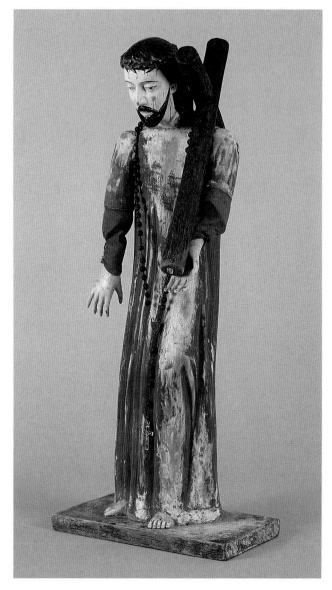

Plate 89. *Our Lady of Solitude*/Nuestra Señora de la Soledad
Attributed to José de Gracia Gonzales
Late nineteenth century
20¼″
Wood, gesso, oil-based paints
TM 1977.24
Purchased and accessioned in 1977. From a southern Colorado *morada*.

Hair and possibly face modeled in plaster. This is the least accomplished work among the pieces attributed to Gonzales.

Plate 90. *Jesus Nazarene*/Jesús Nazareno
Attributed to José de Gracia Gonzales
Late nineteenth century
25″
Wood, oil-based paints, gesso, leather, cloth
TM 7507
Purchased from James Economos and accessioned in 1971. Said to have come from the Aguilar, Colorado, area.

Crown of thorns and hair modeled in plaster. The figure is the most accomplished example in this style, with great attention given to facial details and an unusual degree of carving to the body, with details of the robe apparent and slightly bent knees. The resemblance to commercial plaster saints of the period is quite remarkable and is enhanced by the use of glossy enamel paints on the face, head, and crown of thorns.

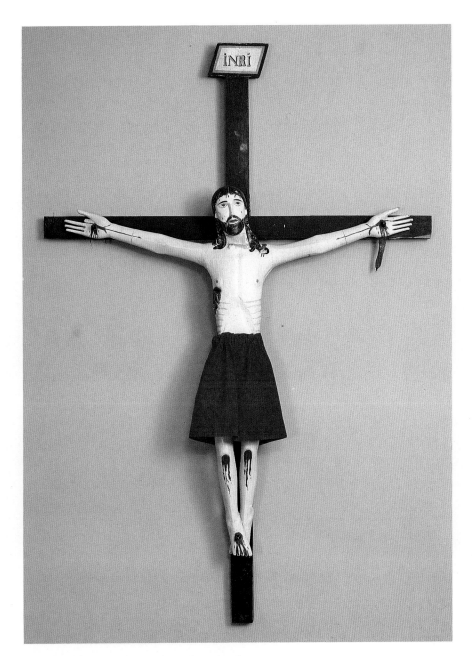

Plate 91. *Christ Crucified*/Cristo Crucificado
Front Range Style II
Late nineteenth century
Figure 35½"; cross 57½"
Cottonwood, gesso, oil-based paints
TM 1977.21
Purchased and accessioned in 1977. According to members of the southern Colorado Brotherhood of Our Father Jesus Nazarene from which this piece was purchased, it was known as *La Preciosa Sangre* (The Precious Blood). This is the traditional title for the central figure on the altar of the confraternity whose original name was the Brotherhood of the Blood of Christ.[14] The piece was damaged when the *morada* was vandalized in 1976; it was restored in 1980.

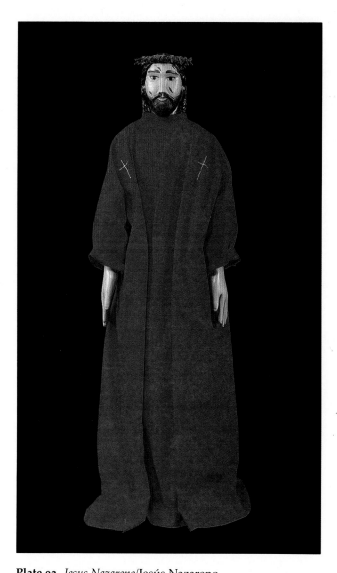

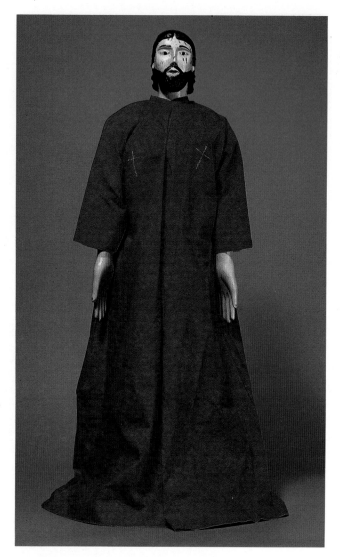

Plate 92. *Jesus Nazarene*/Jesús Nazareno
Front Range Style II
Late nineteenth century
35″
Cottonwood, gesso, oil-based paints, cloth
TM 1977.22
Purchased and accessioned in 1977. Much of the thick coating of gesso on the torso of this figure was lost in the vandalism at the *morada* in 1976. It was repaired in 1980.

Plate 93. *Jesus Nazarene*/Jesús Nazareno
Front Range Style II
Late nineteenth century
36″
Cottonwood, gesso, oil-based paints
TM 1977.23
Purchased and accessioned in 1977.

Figures of Death

SINCE THE DISCOVERY of New Mexican *santos* by Anglo-American art patrons in the 1920s, the figures of death found among the images of saints and holy persons have evoked strong comment from observers. The stark and relentless quality of these figures has startled nearly everyone who has seen them. According to Mitchell Wilder: "Daniel Catton Rich, Director of the Art Institute of Chicago, stopped dead in his tracks when he saw the Death Angel from Cordova [plate 94, TM 521]: 'One of the really significant examples of primitive art in America.'"[1]

More than any other works produced by New Mexican *santeros*, the death figures have the ability to produce "aesthetic shock," which Ananda Coomaraswamy has defined as "the shock or wonder that may be felt when the perception of a work of art becomes a serious experience."[2] The death figures shock us, stop us "dead in our tracks," not only because they are grim and awful but also because they are poignant reminders of the evanescence of human life. In shocking us, these figures fulfill one of their original purposes: since the Middle Ages they have served as reminders of death and as inspirations to the faithful not to attach themselves to the things of this world but rather to prepare themselves for the inevitability of death by leading a pious, prayerful life.

In European and New World usage, the personification of death has two distinct but related aspects. On the one hand it serves as a reminder and a warning. This aspect is seen in the attention paid since the Middle Ages to the allegorical representations known as the Dance of Death, triumphal images of death, the personification of death in morality plays, the use of death imagery on funeral monuments, and many other expressions of this preoccupation with mortality.[3]

The other aspect emphasizes the ultimate superiority of Jesus Christ over death. The victory of Christ over death is the triumph of His divine nature, which is eternal and all-powerful and does not succumb to death as does His, and all, human nature. As discussed in chapter 3, this aspect is vividly portrayed in the Holy Week ceremony of the Descent and Burial of Christ, in which death is not triumphant but rather is defeated by Christ and is portrayed beneath the cross with inscriptions reading "Death, where is thy victory?," and "Death, I will be thy death."

These two aspects of death imagery are united in the life of the faithful, for by taking the first aspect seriously and living according to Christian principles, they too will triumph over death through attainment of the eternal life of salvation. For the Christian believer in particular, and for traditional peoples generally, this emphasis upon the priority of the "other world" attained through salvation signifies a different attitude toward death than that of most modern people. Rather than a terrible void, a frightening opening into the unknown, death is for the believer simply a transition from one state of existence to another. If one's life is led virtuously, it is a blessed transition to a higher state, variously conceived as paradise, heaven, or union with God. Only for those who do not live righteously is death a thoroughly frightening prospect.

In the traditional view death does not have the absolute and wholly negative quality prevalent today. It is simply a veil between two states and a factor lived with in everyday life. Thus one finds in Mexico, for instance, a relaxed familiarity with death—a more natural attitude which draws upon both Catholic and ancient Mexican traditions—that is expressed in religious ceremonies, funeral ceremonies, popular art and song, and the famous Day of the Dead (*El Dia de los Muertos*) celebrations.[4]

The use of death figures by the penitential Brotherhood in New Mexico, as discussed in chapter 4, most likely represents a survival of the colonial ceremony of the Descent and Burial of Christ, apparently lacking, however, the emphasis on Christ's victory over death. The emphasis in Brotherhood usage appears to be on the aspect of death as a reminder, and not merely an abstract reminder but one made concrete by the penance of dragging a heavy death cart over rough ground to the hill of the Calvario during Holy Week. In some *moradas* a related ceremony that perhaps still reflects the aspect of Christ's triumph is performed annually after the election of new officers (the Brothers of Light). A large cart (such as the one illustrated in plate 99) drawn by two brothers is used to carry three or four of the newly elected officers, to-

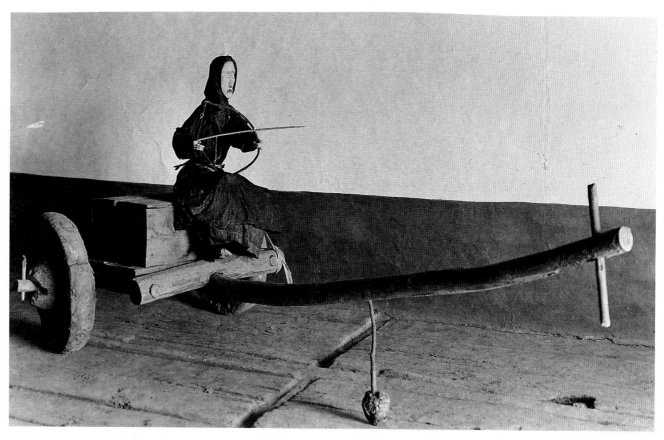

Fig.10.1. Death in her cart, Las Trampas, New Mexico, circa 1912. (Photograph by Jesse Nusbaum. Courtesy of the Museum of New Mexico, Neg. no. 13671.)

gether with the figure of *la muerte*, in a procession to the Calvario, amid the singing of *alabados* as they go.[5]

The aspect of death as a reminder of mortality is also expressed by the use in some *moradas* of smaller death figures without carts (fig. 10.2). These smaller figures have an iconic quality, quite different from the figures of death in her cart; they are closer to the memento mori, such as the human skulls traditionally used by ascetics and formerly found in *moradas* and chapels.

The smaller figures apparently were carried by women and children in Holy Week processions.[6] Death figures, both large and small, are often dressed in black shawls to resemble an aged woman and are known familiarly in New Mexico as "Doña Sebastiana" or "Nuestra Comadre Sebastiana." Since these figures often carry a bow and arrow, this name is apparently a reference to Saint Sebastian, who was pierced by arrows. Death figures were not available from commercial sources and could only be made locally; thus they were among the last pieces to be made in New Mexico before the *santero* tradition died out. Some figures may date as late as 1910 to 1920, a time when few other images were being produced locally.

How early these figures were made in New Mexico is a disputed question. Some scholars have suggested

that they were not made before 1860 because they are not mentioned in the archives, nor are there any documented pieces before that date.[7] However, death imagery was an integral part of Mexican culture, stemming back to Spain and the European Middle Ages as well as having indigenous roots. Death figures were used in Mexico since the early colonial period in the universal ceremony of the Descent and Burial of Christ, and, as discussed in chapter 4, they appear occasionally in eighteenth-century church inventories from the northern frontier of Mexico, so it is highly unlikely that these figures were unknown in Hispanic New Mexico before 1860. By the early nineteenth century, their use in Catholic Church ceremonies apparently had diminished greatly, and like so many other traditional elements of Hispanic Catholicism, they were preserved and used by the penitential Brotherhood. No nineteenth-century inventories of the holdings of Brotherhood *moradas* are known to exist, and prior to the 1860s there is little documentation of their activities beyond the letters of Father Martínez and Bishop Zubiría cited in chapter 4. These factors may account for what seems to be the sudden appearance of death figures after 1860.

Two extant death figures may date earlier than 1860. Both are attributed to carver Nasario Lopez of Cordova (Pueblo Quemado), whose work is discussed

Fig.10.2. Figure of Death (*La Muerte*) on wall of *morada*, Cebolleta, New Mexico, circa 1940. Two prints of the stations of the cross are visible next to the figure. (Photograph by Dorothy Stewart. Courtesy of the Museum of New Mexico, Neg. no. 30438.)

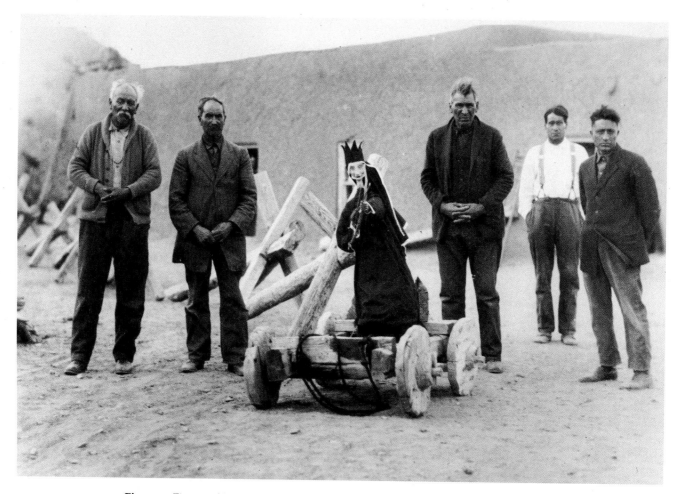

Fig.10.3. Figure of Death in her cart at Abiquiú, New Mexico, with five *hermanos* in front of *morada*, circa 1930. The heavy wooden crosses known as *maderos* can be seen stacked in pairs behind them. (Courtesy of the Museum of International Folk Art, Santa Fe, New Mexico.)

below. In the Taylor Museum there are six death figures: two are images of *La Muerte en su Carreta* (one attributed to Nasario Lopez) and four are smaller figures without carts, one holding a bow and arrow and another holding a scythe. There are several other authentic early pieces in the Museum of International Folk Art and other museum collections, and several have been photographed in situ in *moradas*.[8]

DEATH FIGURES BY NASARIO LOPEZ

Two death figures have been attributed to Nasario Lopez (1821–1891) of Cordova, New Mexico, the father of the renowned reviver of New Mexico carving, José Dolores Lopez. The famed *Death Angel of Cordova* in the Taylor Museum (plate 94) was purchased by Harry Garnett from José Dolores Lopez in Cordova in 1936. Garnett reported that José Dolores Lopez told him this image was made by his grandfather,

circa 1850 to 1875. Later research by E. Boyd and Charles L. Briggs indicated that the figure was made by Lopez's father, Nasario Guadalupe Lopez. According to E. Boyd, Nasario Lopez is also credited with making, around 1850, the death figure formerly in the church at Las Trampas and later moved to the *morada* (fig. 10.1).[9] Since Nasario Lopez was born in 1821, he could have made these and other figures of La Muerte as much as twenty years before the presumed 1860 appearance of the image of death in her cart. His models could very likely have been existing pieces in *moradas*, surviving from the use of the death figure in the ceremony of the Descent and Burial of Christ. The construction method of his *Muerte* in the Taylor Museum also suggests a pre-1860 date: the cart was joined without nails, using rawhide, wooden pegs, and mortise-and-tenon joints, and most of the members were hand shaped.

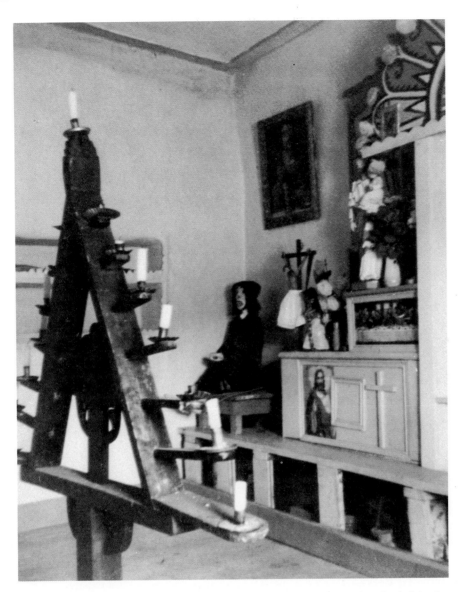

Fig.10.4. Altar of the upper Arroyo Hondo *morada*, circa 1935. On the left is the figure of Death (plate 98); in front of the altar is the *tenebrario* (plate 100). (Photograph by Harry H. Garnett. Taylor Museum Archives.)

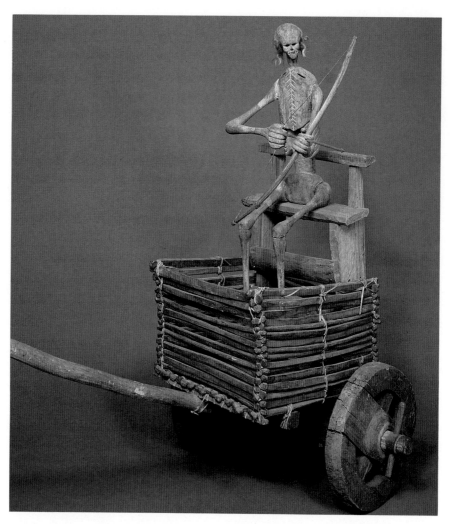

Plate 94. *Death in Her Cart*/La Muerte en su Carreta
Nasario Lopez
Ca. 1840–1875
51"
Cottonwood, gesso, leather
TM 521
Purchased from Harry H. Garnett and accessioned in 1938. Purchased by Garnett
from José Dolores Lopez of Cordova about 1936. Gift of Alice Bemis Taylor.

Illustrated in Wilder and Breitenbach, *Santos*, plates 30–32; Mangravite, "Saints
and a Death Angel," *Magazine of Art* 33, 3 (1940): 163; Shalkop, *Wooden Saints*, plate
8; and Briggs, *Woodcarvers of Cordova*, plate 11. See Garnett, "Background of Santos
in the Taylor Museum: Death Angel of Cordova."

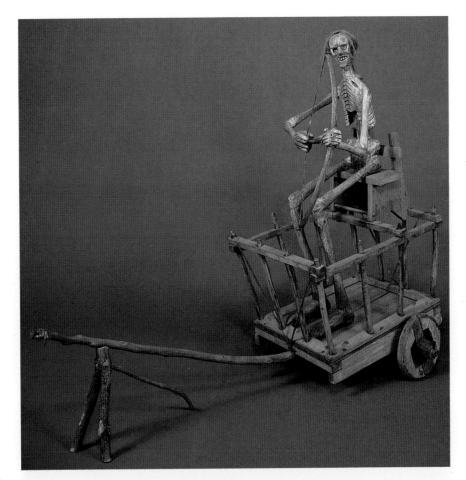

Plate 95. *Death in Her Cart*/La Muerte en su Carreta
Unattributed style
Ca. 1860–1890
44½"
Cottonwood, gesso, horsehair
TM 1692
Purchased from Harry H. Garnett and accessioned in 1949. Said to be from the
morada at Cañon Servilleta, probably the canyon of that name near the village of
Plaza Servilleta, north of Ojo Caliente.

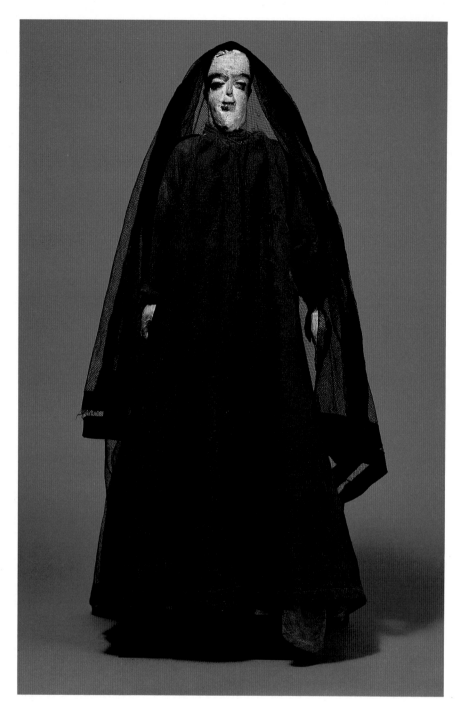

Plate 96. *Death*/La Muerte
Unattributed style
Ca. 1850–1880
27½"
Cottonwood, gesso, cotton cloth
TM 1350
Purchased from Harry H. Garnett and accessioned in 1936. Gift of Alice Bemis
Taylor. According to Garnett, this figure came from the *morada* at Valdez, north of
Taos. It may originally have been a figure of Our Lady, transformed through the
application of plaster to be a Death figure.

Illustrated in Mills, *People of the Saints*, plate 12 (the niche in that picture did not
come with the image).

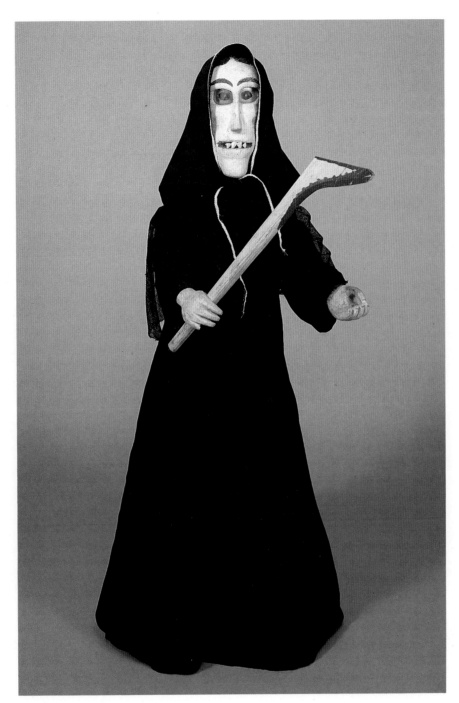

Plate 97. *Death*/La Muerte
Attributed to José Iñez Herrera
Ca. 1900–1915
38½"
Cottonwood, oil-based paints, sheep (?) teeth, mica eyes
TM 5626
Purchased from Harry H. Garnett and accessioned in 1955. According to Garnett, this figure came from the *morada* at El Rito, New Mexico, and was made circa 1915. It is attributed by Shalkop, probably based on information from Garnett, to José Iñez Herrera, to whom a very different piece in the Denver Art Museum—Death in Her Cart—is also attributed.[10]

 TM 5626 is illustrated in Shalkop, *Wooden Saints*, plate 8.

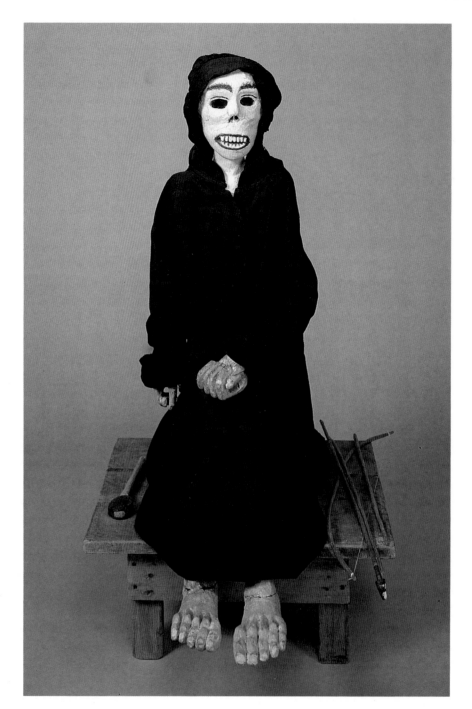

Plate 98. *Death*/La Muerte
Unattributed style
Ca. 1875–1900
35″
Wood, oil-based paints, gesso
TM 5625
Purchased from Harry H. Garnett and accessioned in 1955. This piece was originally in the upper Arroyo Hondo *morada*, ten miles north of Taos. It was photographed in situ on the left side of the altar of the *morada* by Garnett in 1936 (fig. 10.4). Published in Shalkop, *Folk Art*, plate 14.

Another small and crudely made death figure in the Taylor Museum (TM 5743) comes from the lower Arroyo Hondo *morada*. Illustrated in Shalkop, *Folk Art*, plate 21.

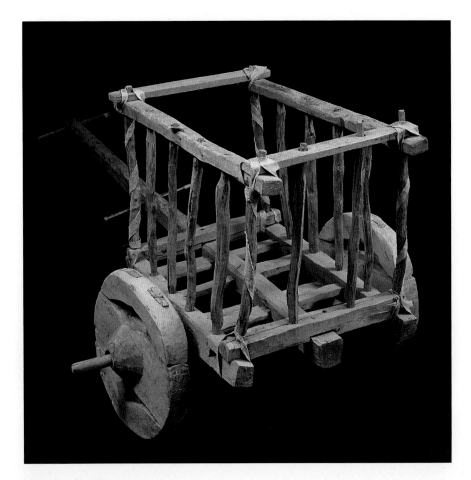

Plate 99. *Cart*/Carreta
Unattributed
Late nineteenth century
118″ x 53″ x 37½″
Wood
TM 7584
Museum purchase, 1972. Said to be from the *morada* at Talpa, New Mexico. Inscribed on the lower cross bar is "Año de 1914. . . ."

This cart was identified by a Brotherhood member from New Mexico as the type that was used by the Brotherhood to carry newly elected officers, together with a figure of *la Muerte*, in a procession to the Calvario to celebrate their election.[11]

Other Items Used by the Penitential Brotherhood in New Mexico

IN ADDITION TO images of saints and holy persons and figures personifying death, the Taylor Museum's collection includes ritual paraphernalia utilized by the penitential Brotherhood. Most of the items illustrated here were used in particular ceremonial observances or in the performance of penances. Other pieces formed part of the furnishings of the *morada*. Among the items in the first category are *tenebrarios* (ceremonial candelabra), *matracas* (cog rattles), and *cadenas* (chains) used in the Tinieblas ceremony, and *pitos* (flutes) and a *tambor* (drum) used in this and other observances. In the second category are heavy wooden *maderos* (crosses) used for penances. In the category of furnishings are candelabra, candle holders, lanterns, ribbon badges, smaller wooden crosses, and straw appliqué crosses.

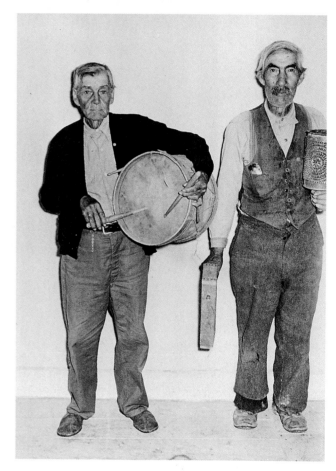

Fig.11.1. Two *hermanos*, Arroyo Hondo, New Mexico, holding drum, *matraca*, and lantern, circa 1950 (plate 110). (Photograph by Juan B. Rael. Courtesy of the Naitonal Museum of American History.)

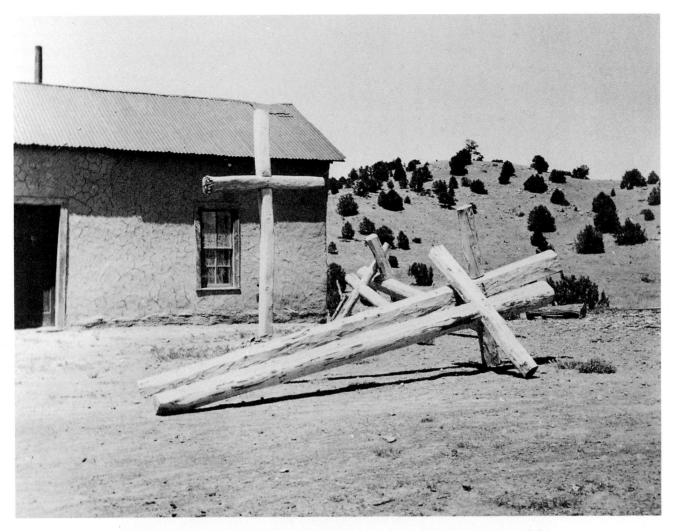

Fig.11.2. *Maderos* (large wooden crosses) in dooryard of *morada*, southern Colorado, 1950s. (Photograph by Myron Wood, Taylor Museum Archives.)

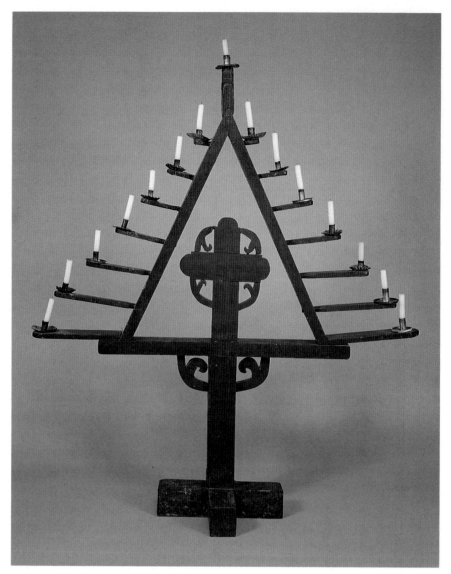

Plate 100. *Tenebrae candelabrum*/Tenebrario
Unknown maker
Late nineteenth century
63″
Wood, tin
TM 1622
Collected by Harry H. Garnett. From the upper Arroyo Hondo *morada*. Photographed in situ in the *morada* in 1936 (fig. 10.4). See also Shalkop, *Folk Art*, plate 14.

The Tenebrae (darkness; Spanish, *tinieblas*) ceremony is ancient, dating back to the early Christian era (see chapters 1 and 5 above) and continuing through the centuries with little change. The *tenebrario*, usually holding fifteen candles, is the essential element in this ceremony. Each candle is ceremoniously extinguished until darkness, symbolizing the death of Christ and the end of the world, is attained. The last candle, however, is hidden and not extinguished, and is later unveiled to symbolize the Resurrection.

Distinctive triangular-shaped *tenebrarios* were located in most churches in colonial Mexico. An unusually elaborate example, still to be seen in the Cathedral of Durango, is illustrated in plate 101.

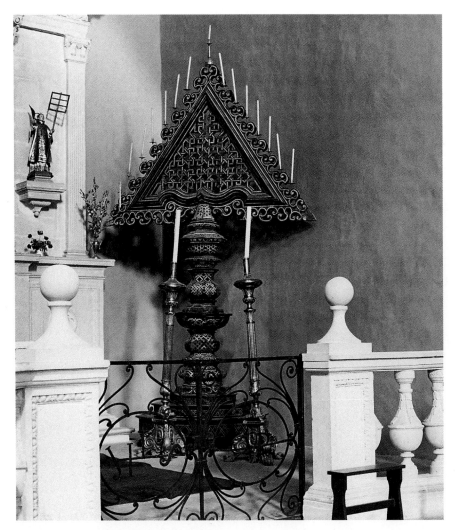

Plate 101. *Tenebrae candelabrum*/Tenebrario
Unknown maker
Early eighteenth century
About 72″
Wood, ivory, silver
Cathedral of Durango, Durango, Mexico
Courtesy of Gloria K. Giffords
According to Bishop Héctor Gonzáles Martínez, this *tenebrario* was made under the auspices of Bishop Benito Crespo, probably in the 1720s or 1730s.[1] It combines delicate geometric *mudejar* designs of Moorish origin in its center and base with Baroque ornament on its edges. Mexican colonial *tenebrarios* such as this one provided the models for those made in New Mexico.

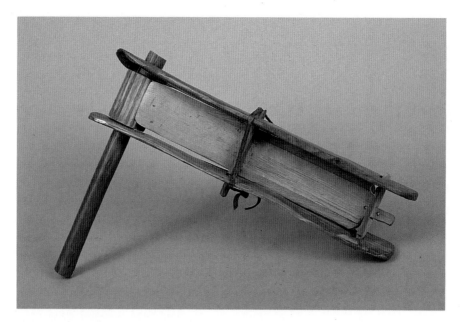

Plate 102. *Cog rattle*/Matraca
Unknown maker
Arroyo Hondo, New Mexico
Early twentieth century
18″
Wood
TM 3895
Purchased from Harry H. Garnett and accessioned in 1950.
Inscribed on the tongue of the *matraca* is "Jose E. Arellano es mi dueno/lla [ya] lo
saben! Arroyo Hondo/New Mexico, Abril 12 año de Dios de 1927″ (Jose E. Arellano
is my owner, now you know it! Arroyo Hondo, New Mexico, April 12, year of Our
Lord 1927).

The *matraca* is an ancient instrument whose primary function is the making of
raucous noise during the Tinieblas ceremony at the moment the room is plunged
into darkness. The *matraca* is also used sometimes during the stations of the cross
to accompany the *pito*, and in other ceremonies such as the *emprendimiento* (seizure)
of Christ.

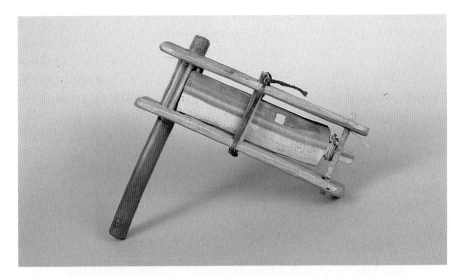

Plate 103. *Cog rattle*/Matraca
Unknown maker
Early twentieth century
12"
Wood
TM 3896
Purchased from Harry H. Garnett and accessioned in 1950. Probably from the upper Arroyo Hondo *morada* or one of its members. Inscribed: "Remember your bros once in a while as we have been good bros. J. P. A.," and, "cuando tocen esta musica acuerden de mi por favor Abril 3, 1931, R. C. J." (when you play this music, please remember me, April 3, 1931, R. C. J.).

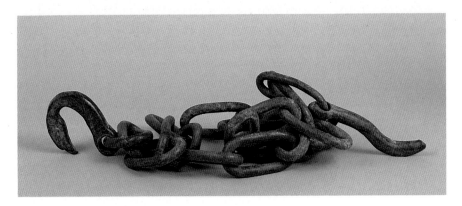

Plate 104. *Iron Chain*/Cadena de fierro
Unknown maker
Early twentieth century
96"
Iron
TM 7209
Collected by Nolie Mumey. Purchased by the Museum from the May D & F sale (#622).

Heavy iron logging chains were used during the Tinieblas ceremony to add to the loud, chaotic noise of the period of darkness.

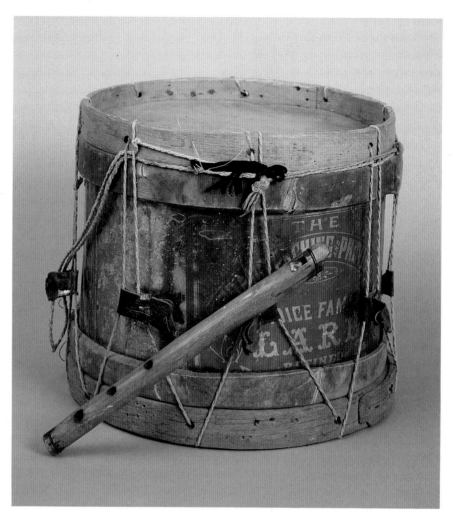

Plate 105. *Flute*/Pito
Unknown maker
Early twentieth century
12″
Wood, tin
TM 1663
Purchased by Harry H. Garnett from Juan Archuleta, Pagosa Junction, Colorado.

 The *pito* (played by the *pitero*) is used by the Brothers in several ceremonies during Holy Week. In addition to Tinieblas, it is played during the performance of the stations of the cross to accompany the singers. Its high, piercing sound is said to symbolize the sorrow that pierced Mary's breast at the death of Christ. It forms a fitting accompaniment to the sorrowful *alabados* (hymns) sung by the Brothers.

Drum/Tambor
Unknown maker
Late nineteenth or early twentieth century
11¼″
Tin plate, rawhide, wood, cotton string
TM 1626
Purchased from Harry H. Garnett and accessioned in 1944. According to Garnett, this piece came from the *morada* at Talpa. A similar drum is illustrated in figure 11.1.

 The drum was used by the Brotherhood to add to the noise during Tinieblas and in processions and other ceremonies. It was also used to announce the beginning of mass at church; see Wroth, *The Chapel of Our Lady of Talpa*, plate 9, which shows an elderly drummer at the door of the church of San Francisco at Ranchos de Taos, ca. 1900.

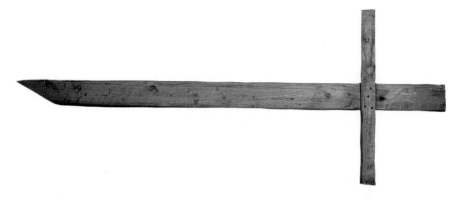

Plate 106. *Wooden Cross*/Madero
Unknown maker
Late nineteenth century
90"
Wood
TM 3899
Purchased from Harry H. Garnett and accessioned in 1950. From the upper Arroyo Hondo *morada*.

This large wooden cross is the type carried since the Middle Ages by Christian penitents in imitation of Christ's suffering and still employed by Brotherhood members in the nineteenth and twentieth centuries (fig. 11.2).

The term *madero* literally means "heavy timber" but in New World usage refers particularly to heavy wooden crosses dragged by penitents. The term is used by Padre Antonio José Martínez in the 1833 letter cited at the beginning of chapter 4 above: "sus exercicios consisten en arrastrar maderos . . ." (their exercises consist of dragging wooden crosses . . .). It is also used by Bishop José Antonio de Zubiría in his "Pastoral Letter" of October 1833, condemning the "hermandades de penitencia" and forbidding storehouses for "estos grandes maderos y otros instrumentos de mortificacion" (these large crosses and other instruments of mortification).[2]

This cross or one very similar is illustrated in situ in Arroyo Hondo by Rael, *The New Mexican Alabado*, p. 38.

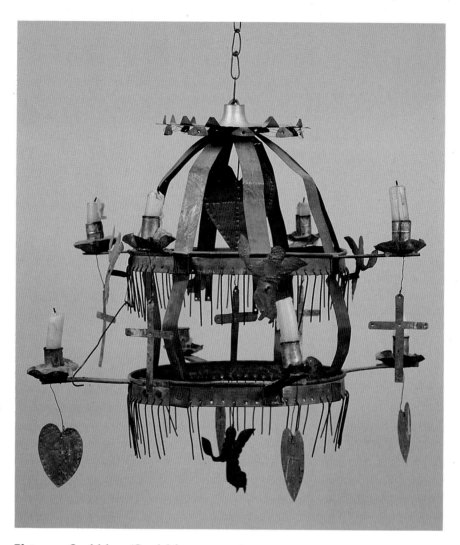

Plate 107. *Candelabrum*/Candelabro
Unknown maker
Late nineteenth century
16¼″
Tin plate, copper
TM 5629
Purchased from Harry H. Garnett and accessioned in 1955. According to Garnett this *candelabro* hung in the upper Arroyo Hondo *morada* above the chapel door.
 It is a particularly fine and unusual piece of New Mexican tinwork.

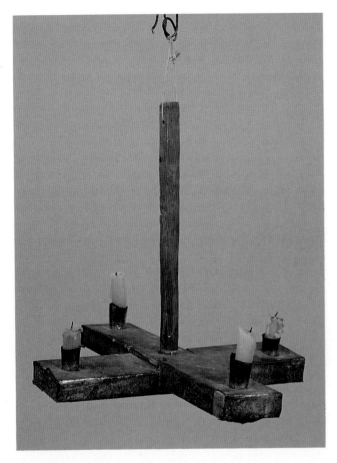

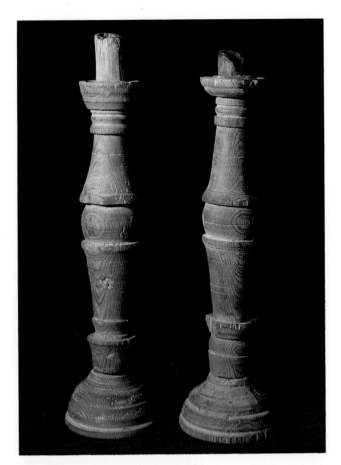

Plate 108. *Candelabrum*/Candelabro
Unknown maker
Late nineteenth century
12¾″ x 12¾″
Wood, tinplate
TM 7260
Museum purchase, 1969. Said to come from the *morada* at Placitas near El Rito, New Mexico.

This simpler type of candelabrum is more commonly used in *moradas* than the one illustrated in plate 107.

Plate 109. *Candlesticks*/Candeleros
Unknown maker
Mid- to late nineteenth century
12½″
Wood
TM 1462 and 1463
Photograph by W. L. Bowers
Gift of Harry H. Garnett and accessioned in 1943. Purchased by Garnett from artist Joseph H. Sharp, circa 1940. According to the accession record, it is "from the chapel and morada of San Antonio, now the studio of J.H. Sharp, Taos, New Mexico."

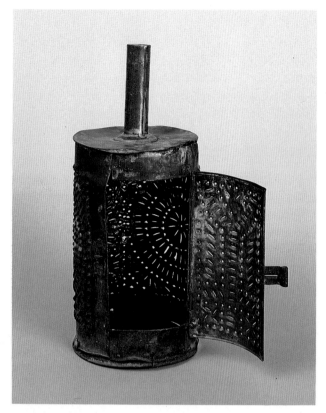

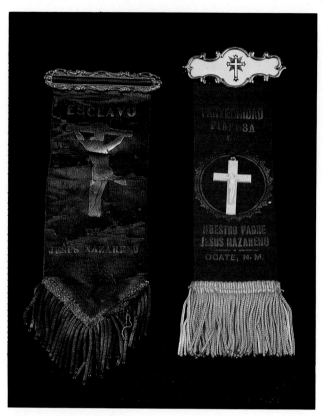

Plate 110. *Lantern*/Linterna
Unknown maker
Ca. 1850–1900
12¾"
Tin plate
TM 5630
Purchased from Harry H. Garnett and accessioned in 1955. According to the accession record, this candle lantern came from the upper Arroyo Hondo *morada*. It, or a very similar example, may be seen in figure 11.1. Held upright by the handle at the bottom, it is used to provide light during nocturnal processions. These lanterns were carried by the Brotherhood elders, the Brothers of Light, who since the Middle Ages in Spain and the early colonial period in the New World have lit the way for the Brothers of Blood, thus fulfilling a symbolic and a practical function simultaneously.

Plate 111. *Ribbon Badge*/Insignia de Listón
Unknown maker
Early twentieth century
8½" x 3"
Silk or cotton cloth, brass
Came with TM 3851
This ribbon badge was pinned to a statue of Jesús Nazareno (TM 3851, plate 16). It is imprinted: "Esclavo de Jesus Nazareno."

Brotherhood chapters in the late 1800s and early 1900s often had badges and banners imprinted for use in processions.

Ribbon Badge/Insignia de Listón
Unknown maker
Early twentieth century
9" x 2"
Silk or cotton cloth, brass, plastic
TM 5932
Accessioned in 1962. Gift of Mrs. Emma Martinez.

It is imprinted on both sides: "Fraternidad Piadosa de Nuestro Padre Jesus Nazareno, Ocate, N. M." (Pious Brotherhood of Our Father Jesus Nazarene). One side is red with gold fringe and a small crucifix, while the other is black with white fringe.

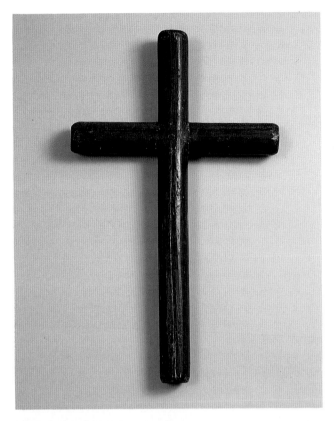

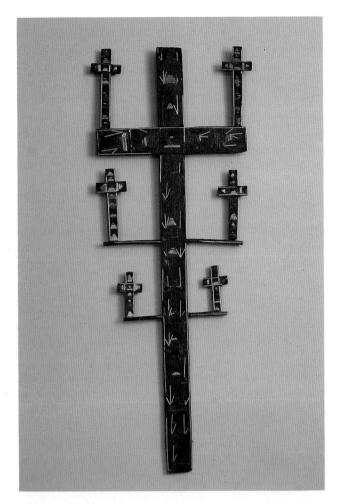

Plate 112. *Cross*/Cruz
Unknown maker
New Mexico or Colorado
Ca. 1850–1900
26½″
Wood, paint, gesso
TM 1662
Purchased from Harry H. Garnett and accessioned in 1944. According to Garnett, he purchased this cross from Juan Archuleta of Pagosa Junction, Colorado.

This cross is made of round members of wood and is a common type found in *moradas*, either painted black like this example, to signify the mournful aspect of the crucifixion or painted green to signify the life-giving aspect of the crucifixion. Both types are frequently listed in colonial Mexican church inventories (see chapter 4). This type of cross, as well as the more familiar cross-staff, was used at the head of processions, penitential and otherwise, and was known as the *guía* (*guión*). It may also have been used during the initiation of new members when the initiate holds a cross in his hands while reciting the oath of initiation.[3] It is the type of cross borne on the shoulder of large statues of Jesús Nazareno.

Plate 113. *Cross*/Cruz
First half of nineteenth century
35″
Wood and straw
TM 1472
Bequest of Mrs. John Frederick Huckel, presented to the Museum by Miss Katherine M. Harvey in 1943. Said to have come from a *morada* in New Mexico, probably collected by Herman Schweizer.

Straw appliqué crosses were popular in *moradas* and were usually placed on the altar and the side walls. This simple decorative art served as a substitute for the more precious ivory and metal inlays of Mexico and Spain (plate 101). This triple-arm cross, each arm with its pair of small crosses, is an unusually elaborate form.

Correspondence of Father Antonio José Martínez and Bishop José Antonio de Zubiría, February 21 and April 1, 1833*

LETTER FROM MARTINEZ TO ZUBIRIA, FEBRUARY 21, 1833

EN EL TIEMPO que hé tenido á mi cargo la administracion espiritual deste Curato, ha habido una congregacion de hombres en hermandad de la Sangre de Cristo, en exercicios de penitencia, que hacen en la cuaresma, principalmente los viernes destos, toda la semana mayor, viernes desde este tiempo hasta el dia de pentecostés, y otros dias de tal significacion en el año. Sus exercicios consisten en arrastrar maderos, asotarse con disciplinas, que al proposito tienen, picandose ante los lomos, hasta que se vierten la sangre, con piedras filosas, ó pedernales; y de otros modos rigidos a esta manera: andan descalsos aun sobre las nieves, y ———; desnudos, con solo ciertas coberturas en las partes pudendas, ó en calsonsillos blancos, y una mascada en la cara para no ser conocidos, y poder ver: En los dhos. dias de la cuaresma, todos los de dha. semana mayor, lo hacen de dia, y por todas partes; mas en las procesiones de los dias de dha. semana, tienen por costumbre salir delante de las imagenes en dha. forma, de suerte qe. causan una gran espectativa á los circunstantes. Dicen que así se les há concedido de tiempo inmemorial.

No obstante: por ahora los he suspendido de la publica competencia, y que solo lo hagan de noche les he permitido, y cuando de dia en lugares solitarios; porque se me hace muy disonante, del modo que lo han hecho hasta aquí; y mas aproporcion que se há aumentado el numero, tambien sembrado entre ellos discordias, y otros consïguientes que cain [sic] en escandalo; entre tanto consulto á V.S. Yllmo. lo que en el caso les deba dictar, para su continuacion, modificacion; ó si se quitar.

Por todo lo dho. suplicio á V. S. Yllmo., se sirva decirme en contestacion lo que en el caso deba hacer.

Dios gue. á V. S. Yllmo. ms. as. [Dios guarde a Vuestro Señor Ilustrísimo muchos años], San Geronimo de Taos en Nuevo Mexico, Febrero 21, de 1833.

A. Jose Martinez

Yllmo. Sor. Obispo desta
Diocesis de Durango Dn. Jose
Anto. de Zubiria.

ZUBIRIA'S REPLY TO MARTINEZ, APRIL 1, 1833.

No puede menos qe. exercitarse con grandes incombenientes del cuerpo y del alma la indiscreta devocion de Penitencias que acostumbran esos Hermanos ó congregantes llamados de la Sangre de Cristo; en esta virtud es muy de mi aprovacion la providencia dictada pr. V. en orden a suspender tales exesos de Penitencias publicas: sostenga V. en prohibicion, interpelando si fuere necesario el auxilio de la potestad secular; y mientras yó con presencia de las cosas no pueda ver lo que pareçe mas acertado, podrá V. exortarles privadamte. á que si es su animo como debia ser aplacar la divina justicia y dar gusto á Dios, en concepto de qe. el mejor modo de agradarlo, es escuchar y reguir con docilidad la voz de sus Pastores, se contenten pr. ahora con hacer Penitencia en el Privado de la Yglesia, guardando siempre moderacion = En orden á la solicitud de qe. se establezea un Tercen Orden en esa Parroquia yá hablaremos que nuestra vista no demorará mucho. Dios gue. á V. ms. as. Chihuahua Abl. 1o. de 1833.

*From the Archives of the Cathedral of Durango

Visit of Bishop José Antonio de Zubiría
to Santa Cruz de la Cañada, July 21, 1833*

VISITADOS LOS Libros de Hermandad de Ntra. Sra. Carmen y del Santisimo Sacramto., de Fabrica, de Confirmaciones y Cordilleras, en todas quedan sus correspond.^{tes} Autos de visita, concediendose en los dos primeros varias yndulgencias: en el Tercero queda el Auto que prece a esta razon: en el ultimo un Decreto en que se prohibe cierta Hermandad de Penitentes que ha havido en esta villa, ya antigua, los cuales desatendiendo y p^r. ventura no haciendo mayor aprecio de los medios de reconciliacion obligatorios y mas faciles de practicarse; se empliaban algunos dias en penitencias corporales muy duras, cargando pesadas Cruzes, hasta en distancia de mas de dos leguas.

*From the Archives of the Cathedral of Durango (Microfilm roll 16, frame 689)

Notes

PREFACE

1. In addition to Weigle's article herein, see also her *Brothers of Light*, chap. 7, "The Rituals," in which Holy Week and other brotherhood observances are described in detail. Good descriptions of Holy Week ceremonies are also found in Henderson, *Brothers of Light*; and Rael, *The New Mexican Alabado*. For an exhaustive, annotated bibliography containing many firsthand accounts (both reliable and not so reliable) of Brotherhood ceremonies, see Weigle, *A Penitente Bibliography*.

CHAPTER 1

1. "There is no spirituality which is not founded, in one of its constituent elements, on the negation of this dream [the illusion of existence]; there is no spirituality devoid of ascetic elements. Even simple mental concentration implies sacrifice. When the concentration is continuous, it is the narrow path, the dark night; the soul itself, this living substance full of images and desires, is sacrificed. . . . Clearly what matters is not that man should suffer, but that he should think of God. Suffering has value only in so far as it provokes, deepens and perpetuates this thought. Now it plays this part for every man who believes in God and in the immortality of the soul" (Schuon, *Spiritual Perspectives*, 137–38).

2. This process may be found in many religions, and the three stages of the spiritual life are generally conceived as fear (contraction), love (expansion), and knowledge (union). In Catholicism the three stages are often envisioned as the purgative way, the illuminative way, and the unitive way. See Tanquerey, *The Spiritual Life*; and Garrigou-Lagrange, *The Three Ways of the Spiritual Life*. See also Martín de Ballarta, "Verdadero Camino del Espiritu" (1807, copy in the Lilly Library), discussed in chapter 3.

3. "The fear of the Lord is the beginning of wisdom" (Proverbs 9:10).

4. St. Athanasius (d. 373) *Frag. Contra Novat.* (in PG XXVI, 1315), quoted in "Penance," *The Catholic Encyclopedia* 11:62.

5. Tertullian, *De Poenitentia*, cited in *The Catholic Encyclopedia* 11:630.

6. Tixeront, *History of the Dogmas* 2:185.

7. Evagrius Ponticus, *The Praktikos*, 14. Evagrius later puts the same thought in these terms: "*Agape* is the progeny of *apatheia*. *Apatheia* is the very flower of *ascesis*. *Ascesis* consists in keeping the commandments. The custodian of these commandments is the fear of God which is in turn the offspring of the faith" (36).

8. The non-Christian world was of course not uniformly profane and worldly: to name two examples, the Essenes among the Jews formed a striking counterpart to the Christian monastic communities, and the ancient mysteries of the Romans survived well into the Christian era.

9. Tertullian, 630. See also Aelfric, writing in the tenth century: "Men who repented of their sins bestrewed themselves with ashes and clothed their bodies with sackcloth. Now let us do this little at the beginning of Lent that we strew ashes upon our heads to signify that we ought to repent of our sins during the Lenten fast" (quoted in "Ash Wednesday," *The Catholic Encyclopedia*, 1:775.

10. "Ecce lignum crucis in quo salus mundi pependit." "Venite adoremus."

11. Tanquerey, *The Spiritual Life*, 745.

12. The last verses speak directly of knowledge of God, contrasting worldly existence with the Beatific Vision of the saved. In this world we see "through a glass darkly," and we know only "in part"; that is, divine knowledge is veiled from us, but on the Day of Judgment we will see "face to face" with God; we shall know God even as He knows us ("then shall I know even as also I am known").

CHAPTER 2

1. Principe, "Christology," in vol. 3 of *Dictionary of the Middle Ages*, 319–24, ed. Joseph R. Strayer. New York: 1983.

2. For a discussion, see Wroth, *Christian Images*, 13 ff.

3. Ibid., 5–13.

4. Little, "The Latin Church," 350.

5. Saint Peter Damian, *Opuscula varia*, in Ross and McLaughlin, eds., *The Portable Medieval Reader*, 49–50.

6. "Order of Preachers," in *The Catholic Encyclopedia*, 12:356.

7. Oakley, *The Western Church*, 188.

8. On medieval flagellants, see Cohn, *The Pursuit of the Millennium*, chap. 7; and Sumption, *Pilgrimage*, 272 and passim.

9. Hay, *The Church in Italy*, 67.

10. From the sermon *Veneranda Dies* in the late eleventh-century *Liber Sancti Jacobi*, quoted by Sumption, *Pilgrimage*, 124–25.

11. Pastor, *The History of the Popes*, 46. See also, Moorman, *A History of the Franciscan Order*, 271.

12. Oakley, "Latin Church: 1305–1500," in Strayer 3:369. See also Oakley, *The Western Church*.

13. Saint Bernardino of Siena, quoted in Burckhardt, *Siena*, 85.

14. Burckhardt, *Siena*, 82.

15. Sanchez Herrero, *Las Diocesis*, 386, 468–69, 473. See 196–220 for founding dates of the mendicant *conventos* in the Kingdom of Leon.

16. Agustín de Herrera, *Origen y Progresso del Oficio Divino*, Seville, 1645, book 2, chap. 47, quoted by Julio Puyol, "Plática de Disciplinantes," 245. On Gregory of Ostia, see Christian, *Local Religion*, 43.

17. It should be noted that Spain was by no means untouched by the heretical groups so bothersome to the Church in Italy and northern Europe, groups which often included self-flagellation as part of their practices. For in-

stance, in a Barcelona document of 1346, the bishop condemned a lay group of "beguini" (beguines were groups of lay religious women, often with heretical tendencies, in northern Europe) and "some brothers and sisters of the Third Order of Saint Francis, who are called 'continentes' or 'de penitentia' for daring to "keep a common house in many places and these they call 'fraterie.'"

> In them and in private places, they hold illicit conventicles: they also seek alms publicly and what is more detestable, although they are ignorant lay people and almost illiterate, they presume to discuss the scriptures and things pertaining to faith and the ecclesiastical sacraments. They place their temerarious interpretations before those of the holy Roman Church and of the Fathers. . . . They deviate from Catholic truth and blaspheme against the Catholic Church and its rules. Indeed in their many errors they go so far as to impugn the authority of the Roman Pontiff and mislead the simple in their ways. Because such things are damnable and scandalize the faithful, the bishop and chapter forbid anyone, even if they are brothers and sisters of the Third Order of Saint Francis, to live in common, to hold conventicles in public or private places or to beg publicly since the observance of their Order is not to be founded on begging and its members may own property and may even dispose of it by will (Hillgarth and Silano, *The Register Notule Communion 14*, item 258, p. 110).

This Barcelona group clearly shared the views of the heretical *fraticelli* movement of Italy whose members advocated absolute poverty and rejected the authority of the Pope. The *fraticelli* often had close ties with the "spirituals" among the Franciscans, many of whom turned away from the Church to join and often direct this extreme purist movement (see "Fraticelli," *The Catholic Encyclopedia*, 6: 244–49).

18. Oakley, *The Western Church*, 261 ff.

19. Ibid., 265.

20. The deposition of Johannes Inardi, seventy years old, Toulouse, 1455, quoted by Llompart, "Penitencias y Penitentes," 242.

21. Llompart, "Penitencias y Penitentes," 240–46. It is significant that Saint Vincent's invocation ("Lord God, Mercy") is virtually the same as the famous Jesus Prayer practiced as a spiritual method in the Greek and Eastern Churches: "Lord Jesus Christ, have mercy on me." See French, *The Way of a Pilgrim*.

22. Sanchez Herrero, *Las Diocesis*, 321.

23. Padilla, *Historia de la Fundación*, 561.

24. Sanchez Herrero, *Las Diocesis*, 473. See also Sanchez Herrero, *Las Diocesis*, 321, 484; and Liaño Gomez, *Historia de los Cofradías Sevillanas*, 76–77.

25. Sanchez Herrero, *Las Diocesis*, 473. The quoted passages are from the Archives of the Archdiocese of Salamanca, Cofradía de la Vera Cruz, "Constituciones de 1566," and "Bula de Julio II, 1 September 1508."

26. Sanchez Herrero, *Las Diocesis*, 473, quoting "Bula de Paulo III, 1 January, 1536."

27. This information on sixteenth-century confraternities is drawn from Christian, *Local Religion*, 185–87. See also Sanchez Herrero, *Las Diocesis*, passim; and Llompart, "Desfile Iconográfico," 43–45.

28. Pinheiro de Veiga, *Fastiginia*, 10–11. See also Christian, *Local Religion*, 188–89.

29. Christian, "Provoked Religious Weeping," 97–114.

30. Wroth, *Christian Images*, pp. 17–18 and fig. 1.

31. In the late 1500s, "there seems little doubt that the many thousands of local confraternities and other religious groups served as an important bond of unity and cohesion for Spanish society . . ." (Payne, *Spanish Catholicism*, 50).

32. Christian, "Provoked Religious Weeping," 97 ff.

33. Llompart, "Desfile Iconográfico," 35, quoting from an anonymous account of 1765 first published in *Revue Hispanique* 30 (1914): 466–67.

34. Payne, *Spanish Catholicism*, 44.

35. Callahan, *Church, Politics and Society*, 58; and Farriss, *Crown and Clergy*, 93. On *autos sacramentales*, see *The Catholic Encyclopedia*, 2:143.

36. Cedula of Charles III (20 de Febrero de 1777), quoted by Llompart, "Desfile Iconográfico," 37. *Empalados* are penitents who march with a heavy log tied to their outstretched arms, giving them the form and appearance of the crucifixion. See Llompart, 34 and fig. 1. On Charles III's program of ecclesiastical reform, see Farriss, *Crown and Clergy*, 87–108 and passim.

37. Puyol, "Plática de Disciplinantes," 259. For a discussion of Spanish Catholicism in the late eighteenth century, see Callahan, *Church, Politics, and Society*, 38–72. Callahan notes: "Public flagellation [in the late 1700s] was seen as an example of excessive zeal that distracted onlookers from contemplating the sacred scenes passing before their eyes. Clerical pressure finally persuaded the state to forbid the practice in 1780 [actually 1777], although the prohibition was often ignored" (57). The "clerical pressure" here mentioned is the petition of the Bishop of Plasencia to Charles III, to which the king refers in his 1777 cedula. To what extent the clergy supported this prohibition is not known, but the fact that public penance continued in more isolated areas for many years suggests that clerical support was ambivalent at best.

CHAPTER 3

1. On the "spirituals" in New Spain, see Phelan, *The Millennial Kingdom*; and Wroth, *The Chapel of Our Lady of Talpa*, 53 and 70, n.5.

2. Alaman, *Disertaciones* 2:259–60. The year is incorrectly reported as 1521 by Woodward, *The Penitentes of New Mexico*, 176. The next earliest foundation of the confraternity of the Santa Veracruz that we have found in New Spain is that of Santiago de Guatemala (then part of New Spain), established by Bishop Don Francisco Marroquín, March 9, 1533. See Fuentes y Guzman, *Historia de Guatemala*, 1:237–38.

3. *Motolinia's History of the Indians of New Spain*, Foster, trans., 94–95.

4. Mendieta, *Historia Eclesiástica Indiana*, 2:73. See also the anonymous "Informe de la Provincia del Santo Evangelio al Visitador Lic. Juan de Ovando" (ca. 1570), in García Icazbalceta, ed., *Codice Franciscano. Siglo XVI*, 67–68.

5. Ibid, 90–91.

6. Ibid, 87.

7. Zorita, *Historia de la Nueva Espana*, 187. The extremely light statues made by the Indians were a New World innovation that continually evoked comment from the Spaniards. They were made of a paste called *tatzingueni* derived from corn pith (*caña de maíz*) and orchid bulbs. The Tarascan Indians were the most renowned makers of these famous "cristos de Michoacán." See Rea, *Crónica de la Orden*, 41; and Weismann, *Mexico in Sculpture*, 167, 217.

8. Dávila Padilla, *Historia de la Fundación*, 561. See also Franco, *Segunda Parte de la Historia de la Provincia de Santiago de México* (written 1637–1645).

9. The foregoing description of the ceremony of the Descent and Burial of Christ is based upon Dávila Padilla, *Historia de sa Fundación*, 563–68. See also Franco, *Segunda Parte*, 545. Franco notes that at the time of his writing (1645) the procession had become even more illustrious, "as much by the authority and pomp that has been added to it, as by the great number of people that it has attracted. The *penitentes* of the discipline of blood alone will be 3,000, without counting the other multitude of people who occupy themselves in carrying the insignias, standards, streamers, and the *an-*

das of the Most Holy Virgin and the glorious Magdalene, and those who carry tapers and flaming torches of wax, who are many."

For later descriptions of the Descendimiento, see, for the 1840s, Calderon de la Barca, *Life in Mexico*, 363–64, and for the 1940s in Michoacán, Toor, *A Treasury*, 215. A remarkable survival in the 1970s of the Descendimiento and other Holy Week ceremonies is to be found among the Mixe Indians of Oaxaca, who were Christianized by the Dominican friars in the 1500s. See Kuroda, *Under Mt. Zempoaltépetl*, 120–22 and plate 23. See also Kelemen, *Vanishing Art*, 72–73, for a description of the Descendimiento in the city of Oaxaca.

10. A colonial Mexican painting of Our Lady of Solitude with the insignias of the passion is on the altar screen of the Ranchos de Taos church (illustrated in Wroth, *The Chapel of Our Lady of Talpa*, plate 12a). The shrouded cross with the ladders and other insignia are in low relief at the top of a church altar in Yucatan, with a statue of Our Lady of Solitude holding the holy cloth (illustrated by Weismann, *Mexico in Sculpture*, plate 75; and Toussaint, *Colonial Art in Mexico*, plate 149). The shrouded cross by itself is discussed in Wroth, *Christian Images*, 183 and plate 173. It is apparent that the shrouded cross is a much more generalized and widely spread image than our commentary in *Christian Images* suggests. Toussaint, *Colonial Art in Mexico*, illustrates a stone carving of Our Lady of Solitude praying beside the shrouded cross (plate 182).

11. Wroth, *Christian Images*, 123, 124, 205, and plate 89. See also below, chap. 6, plates 12 and 15. The famous Holy Week procession in Taxco, Guerrero, perpetuated in the twentieth century much of the traditional imagery of Christ's passion. A statue of Santa Verónica dressed in black and holding the veil with the Holy Face on it is shown in a Taxco procession in Varona, *Tasco* (unnumbered plate: "Holy Week procession. The Veronica").

12. Dávila Padilla, *Historia de la Fundación*, 570. See also Torquemada, *Monarquía Indiana* 3:423–24.

13. Thomas A. Janvier, *The Mexican Guide*, 480–84.

14. Mota Padilla, *Historia de la Conquista*, 347. The founding of the *cofradía* is discussed on 274–75. See also Tello, *Libro Segundo de la Crónica Miscelánea*. The *mandatum* is the Latin name for the ceremony of the washing of the feet (English "maundy," hence Maundy Thursday). See chapter 1 above.

15. 347.

16. 309.

17. Amador, *Bosquejo Histórico de Zacatecas* 1:195. See also Bezanilla Mier y Campa, *Muralla Zacatecana*.

18. Ribera Bernardez, *Compendio de las Cosas mas notable*, 118, 123, 124.

19. Ribera Bernardez, *Descripción Breve*, 95–97.

20. *Archives of the Cathedral of Durango* (ACD), "Libro de la segunda visita del obispado por Dn. Pedro Tamarón y Romeral, 1765–1768" (Sombrerete, April 13, 1767), roll 7, fr. 83–93.

21. ACD, "Libro 53: Visita pastoral del Obispo Dn. Pedro Tamarón y Romeral . . . Sombrerete, March 19 and 20, 1761," roll 10. Although cast in the third person, this document is clearly Bishop Tamarón's personal journal of his 1760 to 1761 *visitas* and is quite different from his more formal and impersonal *Demostración del Vastísimo Obispado de la Nueva Vizcaya—1765*, for it gives his daily itinerary, his experiences, and often his feelings. In addition, the ACD holds the official records of Tamarón's visitations (roll 7), which often provide further information concerning the communities visited, supplementing both his diary and his *Demostración*, as well as the official records of his second *visita* in 1767 to 1768, also in roll 7.

22. This is an image of Christ in his suffering, depicted on His knees, bearing the cross on His back; it is used to enact the station of Christ's three falls in the Via Crucis.

23. Ecce Homo (Behold the Man) is another title for the suffering Christ, similar or often identical to Jesús Nazareno. The name and iconography of this image derive from the Gospel description of Christ's passion: "Then came Jesus forth, wearing the crown of thorns and the purple robe. And Pilate saith unto them, Behold the man!" (John 19:5).

24. Smaller images, usually careful copies of the confraternity's patron, were used by the members to carry through the streets soliciting alms (*limosnas*) to help fund the group's regular obligations or for special projects.

25. ACD, Libro de la segunda visita del obispado por Dn. Pedro Tamarón y Romeral (March 24–27, 1767), roll 7, fr. 55.

26. ACD, Libro II de la visita del Señor Pedro Tamarón y Romeral, 1760–1761 (San Sebastian de Sain Alto, February 19, 1761), roll 7, fr. 540.

27. In 1765 Bishop Tamarón described Parras as "the richest place in the bishopric because of the profitable products of wines and brandies that their many luxuriant vineyards produce . . ." (Tamarón y Romeral, *Demostración*, 110).

28. ACD (*Visita* to Santa María de Parras, June 4, 1767), roll 7, fr. 126.

29. Vásquez, *Crónica de la Provincia* 4:397 ff; and Iguíniz, *Breve Historia*, 13.

30. Fuentes y Guzman, *Historia de Guatemala . . .* (written ca. 1690), 1:213. The Third Order Regular which this quotation describes followed the strict practices of the friars, while the Third Order Secular members still lived in the world.

31. Iguíniz, *Breve Historia*, 54. Iguíniz notes that *las razas de color* were admitted to the Franciscan confraternity of Los Cordígeros, but not to the Third Order.

32. Vetancurt, *Teatro Mexicano* (first published in 1698) 3:136–37. It was not only the wealthy in Puebla who contributed to building the Via Crucis chapels: "the eleventh station which is the crucifixion . . . is called the chapel of the poor ones, because these built it, some working on it personally and others contributing with materials." (Fernández de Echeverría y Veytia, *Historia de la Fundación* 2:316, quoted by Iguíniz, *Breve Historia*, 96).

33. Vásquez, *Crónica de la Provincia* 4:425.

34. Ibid., 426–27.

35. Vetancurt, *Teatro Mexicano* 3:105. The penitents who "put themselves on the Cross" may have been *empalados*, those who following Spanish tradition tied their outstretched arms to a beam or log to give them the form of the Crucified. See above chapter 2. In Mexico this penance continued to be practiced in the twentieth century; a photograph of a procession in Taxco, Guerrero, in which three *empalados* have their outstretched arms bound to heavy bundles of sticks, is reproduced in Varona, *Tasco* (unnumbered plate: "Holy Week procession. The penitents").

A more passive form of this penance was simply to prostrate oneself on the ground with arms outstretched in the form of a cross; when the stations of the cross were performed indoors as a spiritual exercise, this was commonly done. See *Estaciones de la Passion del Señor*, (copy in possession of the author). In the tenth station, "one prays three Our Fathers and three Hail Marys, lying crucified on the ground [*en cruz sobre la tierra*] . . . and before getting up from the ground one prays a Credo." See also Nicolás de Espinola, *Diario Quadragesimal y Desagravios de Christo*, Mexico, 1728, 11 ff. (copy in the Lilly Library).

36. *Libro de las constituciones de Nuestra Sagrada Orden Tercera de Penitencia de Nuestro Seráphico P.S. Francisco . . .*, Mexico, 1760, 13 (copy in the Lilly Library). We have not translated *disciplina* here, for it appears to refer to other "disciplinas" in addition to self-scourging.

37. Ibid.

38. *Sumario de la Regla . . . los Hermanos Profesos del Sagrado Orden Llamado de los Terciarios de Penitencia de . . . N.S.P.S. Francisco*, Mexico, 1802 (copy in the Lilly Library).

39. Vásquez (*Crónica de la Provincia*, 432) notes that in the early 1700s in Santiago de Guatemala: "each chapel [of the Via Crucis] has its doors, which are closed all the year, and are only open for cleaning them and on the Fridays of the Lent for the stations."

40. Iguíniz, *Breve Historia*, 93.

41. The other three *colegios* were Nuestra Señora de Guadalupe de Zacatecas, San Fernando de México, and the Colegio de Pachuca. The Franciscan provinces responsible for the north were the Santo Evangelio de México (in Mexico City), San Pedro y San Pablo de Michoacán, Santiago de Xalisco, and San Francisco de Zacatecas. For a discussion of colonial religious administration of northern Mexico, see Gerhard, *The North Frontier*, 19–23 and passim.

42. Wroth, *Christian Images*, 204–205. See also note 45, below.

43. Sotomayor, *Historia del Apostólico Colegio*, 248.

44. Espinosa, *Crónica de los Colegios*, 189. On provoked religious weeping as a means of repentance, see above Chapter 2; and Christian, "Provoked Religious Weeping," 97–114.

45. Alcocer, *Bosquejo*, 189. In the 1770s and 1780s Alcocer and his fellow friars ranged widely over northern Mexico making *misiones de fieles* in a great many cities and towns. In 1775 among the towns in which they held missions were: Cuencamé, Peñon Blanco, Nazas, San Miguel de Mezquital, and Santa María de Nieves, all in the bishopric of Durango. The next year they made missions in the city of Guanajuato and surrounding towns; in 1777 to 1778 they were in three towns in Zacatecas and Jalisco. The next year they preached in the Villa of Jerez, the Hacienda of Jalpa, Zacatecas, and then the Villa of Aguascalientes. In 1780 they preached a large mission in Guadalajara in which at least seven friars took part, followed by a mission in the city of Durango. They continued to be just as active through the 1780s, preaching missions in among other cities, San Luis Potosí, Real de Catorce, Matehuala (all in San Luis Potosí), Durango again, Santiago Papasquiaro, San Juan del Rio, and Nombre de Dios (all in Durango), and Fresnillo in Zacatecas (Alcocer, *Bosquejo*, 19–22).

Thanks to these and all the other missions led by the Zacatecan friars, Our Lady of Refuge became one of the most popular advocations of the Virgin Mary in northern Mexico and New Mexico, for her banner led the preaching friars in all their missions after 1744. In a group of sixty-four mid-nineteenth-century paintings on tin (*retablos*) collected mostly in Guanajuato by William S. Stallings, Jr., of the Taylor Museum, Our Lady of Refuge was the single most represented image (17.1%). This was followed by the Holy Face of Christ (Veil of Veronica) (15.6%) and Our Lady of Sorrows (10.9%), both passion images. These results are reported by Carrillo y Gariel, *Imaginería Popular Novoespañola*, 23–24. See also Giffords, *Mexico Folk Retablos*, 143–44, who reports similar results from her 1966 survey of 351 pieces.

46. Fr. Diego de la Concepción Palomar, "Miscelánea de Documentos Históricos y Curiosos Perteneciente al Apco. Colegio de N.S. de Guadalupe de Zacatecas," unpublished manuscript (1852–1853) in the Mendel Collection, Lilly Library, Indiana University, 60.

47. Ibid., 59–60. The extent to which these friars renounced the world and its pleasures was by today's standards quite extreme. The following incident told of Fray Diego Alvares (Ibid., 61) is exemplary. When visiting a wealthy woman in Guadalajara, he sat down next to her on a hammock. This apparently forward gesture surprised her, but he immediately assured her by saying: "Yo a todas

las mugeres las miro como unas calaveras" (I see all women simply as some skeletons). For Fray Diego the world of the flesh no longer existed, and as the commentator notes, he lived in constant remembrance of death and its significance. Thus for him the world was as a heap of ashes: the eternal truth was not hidden by the veil of existence.

48. Alcocer, *Bosquejo*, 192. See also Sotomayor, *Historia del Apostólico Colegio*, 249, citing García Diego's *Método de misionar* (1841): "on the same day that [the friars] announce in the pulpit the first general communion they also announce the procession of penitence, so that they [the participants] have time to make their crosses. They are cautioned not to go out half-naked, nor to go whipping themselves. They are encharged to prepare their crowns of thorns and their ropes. And the women are advised not to take crowns nor ropes nor crosses, but that they may secretly endure some kind of hair shirt and they should keep a great deal of modesty and silence; and they should close their doors and windows where the procession passes by."

49. Arlegui, *Crónica de la Provincia*, 435.

50. Arlegui, *Crónica de la Provincia*, p. 462. This and the previous citation are from the continuation of Arlegui's chronicle of 1737, written by Fr. Antonio Galvez in 1827. However, at least as late as 1826 the friars were still practicing their private mortifications. A visitor to the Colegio de Guadalupe in that year noted: "[the friars] retire at seven in the evening to a darkened room having only one small taper burning before a crucifix: here for one hour they flog themselves with a small whip of twisted wires, called a *disciplina*, and sing the 'Miserere' during the penance" (Lyon, *Journal of a Residence* 1:217–18).

51. Martín de Ballarta, "Verdadero Camino del Espiritu" (1807), manuscript in the Lilly Library, 48.

52. Ibid.

53. Excesses commonly complained of by Church authorities included the profanation of the sacred mysteries through introduction of secular, impious, and pagan practices. Secular practices included gambling, drinking, and overly boisterous socializing during Church festival days, and pagan practices included in particular the introduction of native dances into Christian festivals. Also frowned upon by some were the elaborate passion plays known as *nixcuitiles* performed by the Indians in their native languages, which were thought to be full of burlesques and sacrileges (see "Las Representaciones Teatrales de la Pasión," *Boletín del Archivo General de la Nación*, 5, 3:332–56).

54. Pardo, *Efemérides*, 104. For a discussion of the Holy Christ of Esquipulas, which was also highly revered in New Mexico, see chapter 4. Data concerning the founding of the Santa Escuela de Cristo in Santiago de Guatemala are to be found in Vásquez, *Crónica de la Provincia*, 3:384–85.

55. Mota Padilla, *Historia de la Conquista*, 371. The term *escolapio* refers to a student or friar of the Escuelas Pías (Pious Schools) founded by Saint Joseph Calasanctius in Rome in 1597. These were the first free public schools in Europe intended for the poor; Mota Padilla is using the term here to describe the poor members of the Escuela de Cristo.

56. Ibid., p. 371. The Mercedarians also had established an Escuela de Cristo in Mexico City by 1723. An artist's contract for an altar that year notes that it will include an image of "Our Lord Ecce Homo [Christ in His suffering] like the one the Escuela de Cristo venerates in the Church of Our Lady of Mercy, Redemption of Captives, in this city" (Berlin, "Salvador de Ocampo," 419, n.11).

57. The practice of thirty-three-day retreats was of medieval European origin; it is notable that flagellant confraternities in the Middle Ages also observed thirty-three and one-half day periods of intensive discipline, followed by a public procession. See Cohn, *The Pursuit of the Millennium*, 133. The thirty-three-day *desagravios de Cristo* was still prac-

ticed within the confines of the church in Mexico at least until the 1840s, when it was observed in the church of San Francisco in Mexico City and described in detail by Mme. Calderon de la Barca. See Calderon de la Barca, *Life in Mexico*, 263–66.

58. Mota Padilla, *Historia de la Conquista*, 371.

59. Ibid., 371.

60. *Constituciones de la Santa Escuela de Christo Señor Nuestro . . .* , Reimpressa . . . Mexico, 1774, 1 (copy in the Latin American Collections, University of Texas Library, Austin). A later edition of this volume, with minor changes, was published in Mexico City in 1819 (copy in the Lilly Library).

61. This devotion to San Juan Nepomuceno may have derived from the practices of the congregation of the Escuela de Cristo of Santiago de Guatemala, who as we have seen were also under the direction of the Oratorians of San Felipe Neri. A document of December 3, 1731, of the Santiago de Guatemala city council notes that the council, at the request of the president of the congregation of San Felipe Neri, agreed to empower Fr. José de la Madre de Dios to solicit "his Holiness" (the pope) that he might concede "the same Mass and double office . . . for the best cult and veneration of Sr. Dr. Don Juan Nepumuceno, with indulgences on his day, the 16th of May, with *privilegio de ánima* at his altar . . ." (Pardo, *Efemérides*, 139). The fourteenth-century Saint John Nepomuk, whose devotion was particularly promoted by the Jesuits, was not canonized until 1729. This request to honor him is undoubtedly in response to his recent canonization.

62. *Constituciones*, 1774, 10 and 38.

63. *Constituciones*, 1774, unnumbered page. For an image of Jesús Nazareno and discussion of the significance of this devotion, see below chapter 6, plate 7.

64. Phelan, *Millennial Kingdom*, 109.

65. The exercises of San Felipe Neri's Congregation of the Oratory closely resembled and were probably the source of those we have described above for the Escuela de Cristo:

> On Monday, Wednesday and Friday these vocal prayers [of the Congregation of the Oratory] were replaced by the discipline, the lights were extinguished and nothing remained visible except the crucifix painted on the glass of a small lantern; some one recited a brief summary of the Passion, after which they scourged themselves for some moments. The exercise ended with the singing of the antiphon of Our Lady. (Ponnelle and Bordet, *Saint Philip Neri*, 396).

Virtually identical practices are described by Mme. Calderon de la Barca (*Life in Mexico*, 264–65) in the *desagravios de Cristo* which she witnessed in 1840.

66. *Constituciones*, 1819, 9. This later edition of the *Constituciones*, published in the last years of Spanish rule in Mexico, seems to display in its language some of the ideals of the revolutionists: "under the banner," "equality," "fraternal charity." It is curious, too, that the author inverts the meaning of the words of Christ, "many are called," for the point of this saying rests in its second formula, "but few are chosen," unmentioned in this text. In fact it seems that too many were called, for the policy of virtually open membership—candidates were expected only to be free of vices and of the "deceits and vanities of the century"—had led to disorders, and in a decree of December 18, 1811, the *Provisor* reduced the membership to one hundred brothers, which limit it was not to exceed.

67. ACD, roll 7, fr. 311.

68. ACD, roll 10, fr. 670, 671.

69. Ibid. fr. 673. The previous day Bishop Tamarón, not one to sit idle, visited the "beautiful chapel" in the nearby town of Aduana and celebrated mass "in honor of the very miraculous image [of Our Lady of Valvanera] which is located in said chapel. It is the loadstone (*imán*) of all these

regions" (fr. 672). On this sanctuary, see Fontana, "Nuestro Señora de Valvanera," 80–92.

70. ACD, roll 10, March 26, 1760.

71. *Constituciones*, 1819, no. 33.

72. Tamarón y Romeral, *Demostración*, 390.

73. Archives of the State of Durango (ASD), roll 63, March 27, 1768 (no frame numbers). See also the Decree for Holy Week enacted by Don José Yldefonso Diaz de Leon in San Luis Potosí, April 13, 1824 (ms. in the Lilly Library). This proclamation, in addition to forbidding billiards and cockfighting and ordering stores to close, prohibited the driving of coaches or riding of horses in the city and the entrance of mules and burros with or without cargo, all of which "even the pure-blooded castes are to cease during these days."

74. Although Church-State relations were increasingly strained during the second quarter of the nineteenth century, civil and ecclesiastical officials cooperated not only during Holy Week but also in times of civic calamity. During the severe cholera epidemic which hit northern Mexico, Church officials in Durango in July 1833 instituted a series of rogation days in which the miraculous image of Jesús Nazareno was carried through the streets in public processions, because "it is well known what great success this recourse has had in other similar circumstances." City officials were invited to participate in these processions.

In this time of public prayer and supplication, there is no suggestion in the records that any public penance took place, but the Church fathers granted "all possible faculties to priests giving confession to administer the sacrament of penance." While one city official complained that the Church fathers had neglected to apply for a license for public processions, the State Supreme Court later requested another procession of the miraculous image, along with a solemn mass.

By late August, with the epidemic unabated, the Church fathers decided to "carry the Patroness of Mexico, Most Holy Mary of Guadalupe in procession from her sanctuary to the parish church . . . asking her intercession to appease the anger of God and free us from this blow to humanity, the cruel cholera epidemic." This procession was to be preceded with a solemn mass which they would conduct in union with the Governor of Durango, the city council, and the religious communities, "if they are willing to take part" (ACD, Actas Capitulares, Libro 24. Roll 6, fr. 187–89).

75. Calderon de la Barca, *Life in Mexico*, 129. See also 352–66 for a description of Holy Week celebrations in a small town. For another firsthand description of Holy Week in Mexico City in the 1840s, see García Cubas, *El Libro de mis Recuerdos*, 323–36. Holy Week in the 1890s is described by Starr, "Holy Week in Mexico," 161–65. For early twentieth-century practices, see Toor, *A Treasury*, 210–23; and for the 1970s, see Kuroda, *Under Mt. Zempoaltépetl*, 116–23.

77. Warren, *Dust and Foam*, 192–93. See also Sartorius, *Mexico about 1850*, 154–60.

77. Evans, *Our Sister Republic*, 344–346.

78. On the significance of the *promesa* in twentieth-century Mexico, see Toor, *A Treasury*, 217 ff; Beals, *Cherán*, 130; and Foster, *Tzintzuntzan*, 235–41. For Spain, see Christian, *Local Religion*, 23–69, and Christian, *Person and God*, chap. 3.

CHAPTER 4

1. Pbto. Antonio José Martínez to Señor Obispo Don José Antonio de Zubiría, February 21, 1833, ACD (in possession of the Archivo de la Catedral). My thanks to Mary Taylor for sending me a copy of this letter, with Bishop Zubiría's reply of April 1, 1833.

2. Villagrá, *Historia de la Nueva México*, 91–93. The only published translation of Villagrá's *Historia, History of New*

Mexico, renders this passage incompletely and rather loosely. Woodward's paraphrase of it is closer to the original (*The Penitentes of New Mexico*, 193–94).

Following the custom of other Spanish explorations, Oñate's Franciscan friars gave names to the places they discovered, according to feast days in the Church calendar. Thus, on March 19, the day of Saint Joseph, the party camped at "Agua de San Joseph." On Holy Thursday, March 20, in honor of the Feast of the Blessed Sacrament, the friars named the river on which they camped, "Sacramento." On Good Friday, March 21, they camped at the "Descendi-miento de la Cruz y Sancto Sepulcro" (Descent from the Cross and Holy Burial). On the night of Holy Saturday, they named the oak grove in which they camped, "la Resurrección," and they spent Easter Sunday (Domingo de la Resurrección) in that place (Hammond and Rey, *Don Juan Oñate* 1:312). Thus the crucial events of Holy Week were enshrined in these place-names by the first settlers of New Mexico.

3. Hodge, *Fray Alonso de Benavides' Revised Memorial of 1634*, 66, 100.

4. Ibid., 68. In his *Memorial* of 1630 Benavides states that "all the soldiers [in Santa Fe] are unassuming, well instructed in their religious duties, and for the most part, a good example to the Indians. . . . They have about seven hundred persons in service; so that, counting Spaniards, Mestizos and Indians, the total is about a thousand." At the new Santa Fe church and convento built by Benavides, "the friars are already teaching the Spaniards and Indians to read, write, play musical instruments, sing, and to practice all the arts of the civilized society" (Lynch, *Benavides' Memorial of 1630*, 24). In this very early description of the beginnings of Hispanic culture in New Mexico, Santa Fe is already a rich cultural mixture of Spaniards, mestizos and Indians.

5. Greenleaf, "The Inquisition," 35.

6. Domínguez, *The Missions of New Mexico, 1776*, 15, 29.

7. Ibid., 122, 124. Ahlborn cites an unpublished 1777 document (Biblioteca Nacional de México, leg. 10, no. 43, p. 321), in which Domínguez again praises Fernández for the Via Crucis devotions and the "scourging by the resident missionary and some of the faithful" (*The Penitente Moradas of Abiquiú*, 126).

8. Archives of the Archdiocese of Santa Fe (AASF), Accounts, book 62. Translated from the transcription in Weigle, *Brothers of Light*, 245. The word *cadaveras* is used in this document, a Mexican usage meaning skulls (not bodies, which would be *cadaveres*). However, it is not clear from the context whether "skulls" or "bodies" (skeletons) is meant, for the text goes on to say that "no exhumations, either partial or total may be made of the *cadaveras*," which suggests that "bodies" is meant. Either meaning is applicable to the practices of the Escuela de Cristo; its *Constituciones* state that "at the foot of the altar should be placed two skulls, and bones of the dead and two bundles of scourges" (*Constituciones*, 1774, 10).

It is not obvious from the context that the "adjacent room" is the Chapel of the Third Order of St. Francis, as both Weigle (33) and Boyd suggest (Boyd, *Popular Arts*, 445–46). A recent historical discussion of the Castrense chapel is found in Kessell, *The Missions of New Mexico since 1776*, 44–48.

9. Tamarón, 1760. ACD, roll 7, fr. 351.

10. Guevara, 1818. AASF, Accounts, book 62, quoted by Kessell, *Missions of New Mexico since 1776*, 45.

11. Domínguez, *Missions of New Mexico, 1776*, passim.

12. Report of Rev. Custos Fray Cayetano José Bernal to Governor Fernando Chacón, October 1794. Archivo General de la Nación (AGN), Ramo de Historia, 313, f. 350. Translated from the transcription in Weigle, *Brothers of Light*,

197–98. Bernal also discusses the six confraternities, virtually the same as those listed by Domínguez in Santa Fe and Santa Cruz. His care to distinguish between the officially sanctioned Third Orders and the confraternities suggests the growing concern of Church and civic officials with the question of possibly unlicensed and hence unsupervised lay orders. The *Interrogatorio* (questionnaire) prepared for the visit of the Bishop Marqués de Castañiza to the northern provinces in 1816 includes among its detailed questions: ". . . are the confraternities legitimately founded with the necessary licenses? . . . Are there some others that call themselves confraternities although they do not have approval and were not formally established? If so, give information about them according to the preceding questions" (ACD, roll 16, fr. 65. Libro I. Visita del Obispo, Marquéz de Castañiza, 1816–1819).

13. Report of Rev. Custos Fray Cayetano José Bernal.

14. For a discussion of these points, see Wroth, "New Mexican Santos and the Preservation of Religious Traditions," 5–12.

15. Weigle, *Brothers of Light*, 37–47. See also Espinosa, "Penitentes, Los Hermanos" 635–36.

16. Chavez, "The Penitentes of New Mexico," 97–123. See also Chavez, *My Penitente Land*, 209, 218–22; and Steele and Rivera, *Penitente Self-Government*, 7–8.

17. Chavez, *But Time and Chance*, 47.

18. As suggested in Chavez's *My Penitente Land*, 237, 241.

19. Woodward (*The Penitentes of New Mexico*) also proposes a continuous tradition of penitentialism in New Mexico, deriving from the Spanish and Mexican confraternities, but she provides only scattered documentation for this theory, nor did she have available to her the Martínez-Zubiría correspondence of February and April 1833.

20. Chavez, *But Time and Chance*, 47. See also his "The Penitentes of New Mexico," 111. Zubiría's "Special Letter" of July 21, 1833, is transcribed by Weigle, *Brothers of Light*, 195–96.

21. ACD, roll 16, fr. 689. The entire passage is transcribed below in Appendix 2.

22. Yarrow, "General Itinerary," 143.

23. The Ritch interviews are found in the William G. Ritch Collection, Huntington Library, HM RI 2212 (vol. 4). Memo Book no. 4, 326. The 1861 "Rules . . . " are transcribed in Weigle, *Brothers of Light*, 235.

24. Wroth, *The Chapel of Our Lady of Talpa*, 21 ff.; and Wroth, *Christian Images*, 26 ff. and passim.

25. Chavez, "The Penitentes of New Mexico," passim; Woodward, *The Penitentes of New Mexico*, 105 ff.; Bunting, "Penitente Brotherhood Moradas and Their Architecture," 79.

26. AASF, Loose Documents 1870, no. 7. (My thanks to Father Steele and Dr. Rivera for sending me, prior to its publication, the draft version of their *Penitente Self-Government*, which included this unpublished document.) The earliest known document to have originated within the Brotherhood (1853) also states this primary emphasis upon penance:

"Do penance and believe in the Gospel," says the Lord, and he joins these two things to teach us that the rigors of penance are inseparable from the profession of Christianity. . . . His example instructs us to do penance, for if the holiest of the holy fasted and wept, what should we do, miserable sinners that we are? . . . Let us not lose the greater for the lesser but the main treasure is achieving the fruit of penance as the following saints teach and instruct us regarding the tender meditation upon [the passion] of Christ: Saint Albert, Saint Bernard, Saint Magdalen, all of whom tell us and instruct us to do penance . . . the saints tell or explain to us that if we do more penance God offers us glory [i.e., salvation], if we obey those commandments, those orders, and comply with what we hold for a burden with our free and spontaneous will, we will come to the reward of God" (AASF, Loose Documents 1870, no. 7, translated as "Docu-

ment 1: 1853 Cochití Rules" in Steele and Rivera, *Penitente Self-Government*, 77, 87).

27. Steele and Rivera, *Penitente Self-Government*, 85-86, 111-12.

28. Cohn, *The Pursuit of the Millennium*, 141-42. See also 65, 73, 103. At least one other aspect of the New Mexican Brotherhood (aside from flagellation itself) bears resemblance to the medieval European flagellants. These early flagellants wore a white skirt during their exercises, a practice which survived in Spain and Mexico. Spanish *disciplinantes* in the twentieth century wore these skirts while performing the mortification of *empalado*, a form of ritual crucifixion (Llompart, "Desfile Iconográfico," RDTP 25, fig. 1). Llompart also reproduces a sixteenth-century drawing of a Spanish penitent wearing a short white skirt and black *venda* or veil over his face (fig. 5). In New Mexico, following Mexican tradition, the long white skirt is often to be found upon nineteenth-century statues of Christ crucified. In medieval Europe, a flagellant bare chested and dressed only in this skirt (which they called "the robe of innocence") would lie in front of the church with arms outstretched in the form of a crucifix, while his brothers each in turn stepped over him, gently striking him with the *disciplina* as they passed (Cohn, *The Pursuit of the Millennium*, 130, 144). In New Mexico the mortification of lying down in front of the procession was practiced: "not unusual for one of the devotees to prostrate himself at the steps of the church so that all who enter must step on his body" (Yarrow, "General Itinerary," 143, quoting "an old resident of New Mexico").

29. On Franciscan devotion to the blood of Christ, see *Viva Jesús. Septenario Devotíssimo a la Preciosíssima Sangre de Jesus Nuestro Redemptor*, Mexico, reprinted in 1757. This devotional manual was published by Fr. Francisco de la Concepción Barbosa, an official of the Franciscan Colegio de la Santa Cruz in Querétaro, and was inspired by a letter written in 1687 by the founder of the Colegio, Fr. Antonio Linaz. The copy consulted by the present writer in the Spanish Colonial Arts Society collection at the Museum of International Folk Art (L.5.55-51) was said to have been collected in Tomé, New Mexico.

30. Martínez-Zubiría correspondence, ACD.

31. Chavez, *But Time and Chance*, 45-47, 133.

32. Christian, *Local Religion*, 185.

33. See chapter 3. Mota Padilla, *Historia de la Conquista*, 347.

34. ACD, roll 7, fr. 446, 452.

35. "Libro 2.º de Visita del Año de 1806," ACD, Roll 11, fr. 379. Other confraternities at Parral at this time were those of Nuestra Señora del Rosario, San Nicolás, la Purísima Concepción, Las Animas, Nuestra Señora de Guadalupe, and El Santo Entierro.

36. "With the important object of fomenting the commerce of New Mexico, it has been considered advantageous to establish an annual fair in the Valle de San Bartolomé, that should be carried on from the 18th to the 23rd of December inclusive, in which time all manufactures, and products from Europe and from the region that are here introduced for sale or trade will be free from duties." (José de Yturrigaray. *Bando*. "Con el importante" December 17, no year given. Manuscript copy in the Lilly Library.) This fair may well date prior to Yturrigaray's administration. On this fair, see also Moorhead, *New Mexico's Royal Road*, 43.

37. ACD, roll 7, fr. 458. The "pious men (*varones piadosos*) of the Descent" are statues of Joseph of Arimathea and Nicodemus, the followers of Christ who removed His body from the Cross.

38. Domínguez, *The Missions of New Mexico, 1776*, 18, 75, 104, 147. At Taos in 1776, Domínguez found near the altar on the right side of the church an articulated image of Christ which would be used in the descent from the cross: "a large hinged crucifixion with iron nails," and on the left side there was "a casket of painted wood for the Holy Sepulchre, which is completed with the hinged crucifixion mentioned just above." In 1760 Bishop Tamarón had also found at San Gerónimo de Taos the "sepulchre of wood with Our Lord" and at Santa Cruz de la Cañada, among other images, "a Jesús Nazareno of a *vara* [ca. thirty-three inches] and three-quarters; a Holy Sepulchre of two *varas* with its casket" (ACD, roll 7, fr. 351 ff.). An eighteenth-century Christ in the Holy Sepulchre is to be seen in this church today.

39. Wroth, *The Chapel of Our Lady of Talpa*, 33, 39-40, 64, and the firsthand accounts cited therein, 72, n.23. For a photograph, ca. 1894, of the procession of the descent and burial of Christ during Holy Week at Taos, see Steele and Rivera, *Penitente Self-Government*, 91.

40. Steele, "The Death Cart," 1-14. The medieval survival theory of the death cart is proposed by Wilder and Breitenbach, *Santos*, plates 30-32, and by Boyd, *Popular Arts of Spanish New Mexico*, 462-64. See also Weigle, *Brothers of Light*, 168-70.

41. Stark, "The Origin of the Penitente 'Death Cart,'" 304-10.

42. ACD, roll 7, December 13-14, 1767. The "holy sheet" (*savana santa*) is most likely the winding-sheet for the statue of Christ during the procession after the descent from the cross. The Confraternity of Blessed Souls traditionally cared for the dying and for the souls in purgatory, so it is appropriate that this group should have a death figure, and since Real de Rosario apparently lacked a confraternity of the Descent and Burial, it is also appropriate that they should be in charge of this funereal Holy Week ceremony.

43. For instance, Weigle, *Brothers of Light*, 169-70; and Henderson, *Brothers of Light*, 32-39, 43-44. The idea of death as a reminder of the fleeting nature of the things of this world is spelled out in the 1853 Brotherhood rules: "Brothers, I advise you to keep in mind the four last things of man and you will never sin. They are death, judgment, hell, and glory. . . . The memory of death helps to guide us from the sins committed for the love of wealth, as we ponder the truth that at the moment of death, all will be left behind, for it is all of this earth, and man will not be able to take anything with him" (Steele and Rivera, *Penitente Self-Government*, 85).

44. Borhegyi, "The Miraculous Shrines," 92-95. See also Borhegyi, "The Cult of Our Lord of Esquipulas," 387-401; and Paz Solorzano, *Historia del Santo Cristo de Esquipulas* (Guatemala, 1949). A northern Sonoran statue of Our Lord of Esquipulas was documented by the present writer in 1982. "Esquipulas" is pronounced in Guatemala as here written, but in New Mexico it is "Esquípulas."

45. Chavez, *But Time and Chance*, 47: "This Guatemalan image of the so-called miraculous Crucified Christ of Esquipulas, which gave the impetus to the now famous Santuario of Chimayó, appears intimately connected with the Penitente movement." See also Chavez, *My Penitente Land*, 216 ff.; and Steele and Rivera, *Penitente Self-Government*, 16-18. It is quite possible that there was in the early 1800s, as we have suggested, a revival or formalization of the Brotherhood (which could have included influence from northern Mexico), and in this revival the pious and active Don Bernardo would have played an important part.

46. Orozco, *Los Cristos de Caña*, 1:448-501. Borhegyi, "The Cult of Our Lord of Esquipulas," lists, among the ten Mexican shrines of Our Lord of Esquipulas he has documented, one in Jalisco at Totomilco, near Guadalajara. There was also an important image of Esquipulas in the city of Colima, just south of Jalisco; see *Novena del Milagroso SS.*

Christo de Esquipulas que se Venera en el Reyno de Guatemala, y por su Sagrada Copia, en la Iglesia de N.P.S. Juan de Dios de la Villa de Colima, reprinted in Mexico, 1784 (copy in the Lilly Library).

47. Borhegyi, "The Miraculous Shrines," 94.

48. In addition to the *Novena del Milagroso SS. Christo de Esquipulas* (cited in note 46), there is also Paz, *Novena y Bosquejo* (Medina 7251). Another edition was published in Guadalajara in 1817 (copy in the Lilly Library). Paz's work includes at the end a "Devoción a Santa Ludovina" connecting this popular Dutch saint of the early 1400s with the devotion to Our Lord of Esquipulas—perhaps because both were known for their miraculous cures of extreme diseases. The image of Our Lord of Esquipulas in the church of San Francisco in Ranchos de Taos, New Mexico—probably carved about 1815 to 1818—is accompanied by a statue of Santa Ludovina, carved by the same hand (see Boyd, *Popular Arts*, 353; and Espinosa, "A Little Dutch Girl far from Home," 70–73). This linking of the two images in remote New Mexico strongly suggests that Paz's *Novena*, perhaps the Guadalajara edition of 1817, was known and followed by the donor and the artist.

49. This document is mentioned by Chavez, *Archives of the Archdiocese of Santa Fe*, 120, but it was omitted from the AASF microfilm and has been translated for the first time by Steele and Rivera, *Penitente Self-Government*, 77–92.

50. The Abiquiú reference is in AASF, L.D. 1856, no. 12, and is cited by Ahlborn, *The Penitente Moradas of Abiquiú*, 129. Efforts by Bishop Lamy to control the Brotherhood are documented by Weigle, *Brothers of Light*, 53–55; Horgan, *Lamy of Santa Fe*; and Wroth, *The Chapel of Our Lady of Talpa*, 35–37. The 1860 rules are in Steele and Rivera, *Penitente Self-Government*, 952, originally appearing in Darley, *The Passionists of the Southwest*, 14. A late survival of the name "Sangre de Cristo" occurs in the Cochití rules of 1915 to 1916, which are titled "Rules and Regulations of the Brotherhood of Our Father Jesus Nazarene," in which the *hermano mayor* is called "the Principal and Central Brother of the Most Precious Blood of Our Lord Jesus Christ and of the Holy Brotherhood of Our Father Jesus Nazarene" (Steele and Rivera, *Penitente Self-Government*, 105, also 104 and 118).

51. Copy in the Padre Martínez Papers (item no. 80), New Mexico State University Library. This document is discussed by Chavez, *But Time and Chance*, 152. Miguel Griñe and Juan de la Cruz Medina were among the thirteen Brotherhood leaders whose names appear in "An Act to incorporate the 'Pious Fraternity of the County of Taos,' January 30, 1861" (transcribed by Weigle, *Brothers of Light*, 224–25), along with Nicolás Sandoval, founder of the Chapel of Our Lady of Talpa near Ranchos de Taos (Wroth, *The Chapel of Our Lady of Talpa*, 32).

52. The Ritch document is in the group numbered RI-1866 in the Ritch collection, Huntington Library, cited by Weigle, *Brothers of Light*, 43. José Guadalupe Vigil's will is in the Taos County Records, roll 4, fr. 1048 (State of New Mexico Records Center and Archives—SNMRCA), cited by Wroth, *The Chapel of Our Lady of Talpa*, 44, n.19.

53. For the Talpa prayers see Wroth, *The Chapel of Our Lady of Talpa*, 77, 65. The Brotherhood prayer of 1853 is found in Steele and Rivera, *Penitente Self-Government*, 86: "A Credo to the blood of Christ for the life and well-being of the soul of the Brother José Isidoro Martines . . ." (and repeated on 87). It should be noted that the image of the Cristo Entierro itself was known in Talpa and elsewhere as "La Sangre de Cristo" (*The Chapel of Our Lady of Talpa*, 65), and today many *moradas* have one particular image of Christ Crucified which they call "la Sangre de Cristo" (anonymous informant, personal communication). See also Chavez, *My Penitente Land*, 205–206. Thus these prayers

were not directed to some abstract notion of *sangre* but rather to the image of the crucified Christ Himself, who shed His Blood for the salvation of souls. An important variant of this image includes the angel bearing a cup to catch the blood of the crucified Christ (see plates 9–11). The *alabados* (hymns) of the Brotherhood also give reference to the blood of Christ. See the examples cited in Wroth, "La Sangre de Cristo," 289.

54. Martínez-Zubiría correspondence, ACD.

55. A similar change occurred in the life of Bishop Zubiría. As a well-regarded priest in the 1820s, he was complimented by liberal politician Carlos de Bustamente for his charity towards the poor (Alcalá Alvarado, *Una Pugna Diplomática*, 175). One of his first acts during his 1833 visitation to New Mexico was to prohibit the "very deformed" locally made images (Chavez, *But Time and Chance*, 41), and in 1840 he again expressed his "enlightened" view towards traditional imagery by completely destroying the Baroque altars and images of the Cathedral of Durango and replacing them with modern, rationalistic neoclassic designs, now to be found all over the bishopric of Durango (Gallegos, *Durango Colonial*, 399; Maza, *La Ciudad de Durango*, 21). However, beginning with the anticlerical political triumph in the 1830s, Zubiría became an outspoken foe of the liberal governments for the rest of his long life, seeking to protect the traditional rights and values of the Church. See Gallegos, *El Obispo Santo*.

56. On the influence of modern ideas in colonial New Mexico, see Greenleaf, "The Inquisition," 49–57; for the republican period, see the complaints registered in letters from priests to the Archdiocese of Durango, in ACD, roll 13, "Borrador de correspondencia del Obispado de Durango" (1823–1835), for instance, fr. 335 (Dec. 15, 1824): "The priest of Santa Fe, New Mexico [Don Juan Tomás Terrazas] is ordered to compose and send to this Secretary a summary of information concerning the possession and retention of prohibited books and concerning the irreligious and heretical propositions of which he spoke in his undated letter received yesterday." This letter goes on to say that Don Bartolomé Baca, the Governor of New Mexico, "following the latest determinations of our government and the laws regulating freedom of the press," is being asked to help "collect the corrupt books of which he [Terrazas] has spoken, and to restrain the citizens who are attacking Religion, Faith, the Church, and Morality."

57. 1853 Cochití Rules, Steele and Rivera, *Penitente Self-Government*, 78. The Brotherhood rules abound in moral prescriptions indicating the necessity for the Brothers to live an exemplary life both for the sake of their own salvation and for the good of the community.

58. 1871 Cochití Rules, AASF, Loose Documents 1870, no. 7 emphasis added).

59. 1853 Cochití Rules, Steele and Rivera, *Penitente Self-Government*, 78. Also repeated in later versions of the Brotherhood rules.

CHAPTER 5

1. Henderson, *Brothers of Light*, 86, 87. A slightly different version of the Spanish text is in Rael, *The New Mexican Alabado*, 33–34, 140.

2. This introduction is based on Weigle, *Brothers of Light*; its companion compilation of some 1,200 sources, *A Penitente Bibliography*; and various more recent sources cited in idem and Lyons, "Brothers and Neighbors," 231–51.

3. Martinez, "Early Settlements, Folkways of Northern Taos County," 29 February 1936, New Mexico Federal Writers' Project ms. in the History Library, Museum of New Mexico, Santa Fe. Hereafter, such manuscripts will be designated NMFWP-MNM. For a discussion of this 1935 to 1942 project, see Weigle, *New Mexicans in Cameo and Camera*.

Specific Penitente beliefs and rituals used as examples in this introduction are drawn from eyewitness descriptions and reminiscences by four writers who are for the most part accurate and sympathetic outsiders to the Brotherhood: Cleofas Martinez de Jaramillo (1878–1956); her brother, Reyes Nicanor Martinez (1885–1970); Santa Fe poet Alice Corbin Henderson (1881–1949), who, with her artist husband William Penhallow Henderson, witnessed Brotherhood rites at Abiquiú during the 1920s and 1930s; and Lorin William Brown (1900–1978), who was raised in Taos and lived in Santa Fe and Cordova during the 1920s and 1930s. The accounts by Jaramillo and Martinez, both of whom were born and raised in Arroyo Hondo, are especially important because the Taylor Museum collection assembled by Harry Garnett between May 1936 and May 1969 contains numerous pieces from the village's five religious structures—Our Lady of Sorrows Church, the two Penitente *moradas*, and the two private chapels of the prominent Martinez and Medina families (Shalkop, *Arroyo Hondo*).

4. Jaramillo, *Shadows of the Past*, 75–76.

5. Martinez, "Community Spirit Preserved by Some Religious and Social Customs," 23 January 1939, NMFWP-MNM.

6. Weigle, *Brothers of Light*, 146–48.

7. Martinez, "Sheep Herders Galore," 26 March 1937, NMFWP-MNM.

8. Steele and Rivera, *Penitente Self-Government*, 177–83.

9. Bunting, Lyons, and Lyons, "Penitente Brotherhood Moradas and Their Architecture," 31–79.

10. Martinez, "Oraciones/Prayers," 10 April 1940, NMFWP-MNM.

11. Steele and Rivera, *Penitente Self-Government*, 184.

12. Martinez, "Hondo Church," 13 May 1936, NMFWP-MNM.

13. Martinez, "Arroyo Hondo," 13 June 1936, NMFWP-MNM.

14. Jaramillo, *Shadows of the Past*, 67. See also the account by another Arroyo Hondo native, Juan B. Rael, "New Mexican Spanish Feasts," 83–87.

15. Martinez, "Odd Religious Practices," n.d., NMFWP-MNM.

16. Jaramillo, *Shadows of the Past*, 67. See also Gilbert, *The Good Life*, 37–43.

17. Brown, "Lent in Cordova," n.d., NMFWP, rpt. Lorenzo de Cordova [pseud. Brown], *Echoes of the Flute* (Santa Fe: Ancient City Press, 1972), 41–42. Brown's mother, Taos native Cassandra Martinez de Brown (later, Lopez), became a schoolteacher in Cordova, where it was her "custom to pay a personal visit to the *morada* during the evening of Holy Wednesday." After the prayer service, Brown and his mother stepped outside and passed by "three figures, masked and scourging themselves, [who] paid a remarkable tribute to a woman they revered and respected, and for whom they chose this supreme recognition of her worth as neighbor, mentor, and friend" (*Echoes*, 34). See also Brown with Briggs and Weigle, *Hispano Folklife of New Mexico*.

18. Martinez, "Odd Religious Practices."

19. Martinez, "Early Settlements."

20. Jaramillo, *Shadows of the Past*, 64.

21. Brown, *Echoes*, 32–33, 41. See also Weigle, "Ghostly Flagellants and Doña Sebastiana," 135–47.

22. Henderson, *Brothers of Light*, 32, 35.

23. Steele, *Santos and Saints*, 90.

24. Martinez, "Oraciones/Prayers." See also Fisher, *The Way of the Cross*.

25. Martinez, "Con Rendida Devocion/With Humble Devotion," n.d., NMFWP-MNM. At the time of his termination from the Writers' Project, Martinez was collecting ma-

terial for a volume on *alabados* and religious customs in Taos County.

26. Jaramillo, *Shadows of the Past*, 71–72.

27. Ibid., 70.

28. Ibid.

29. Ibid., 71.

30. Martinez, "Odd Religious Practices."

31. Brown, *Echoes*, 42.

32. Ibid., 42–43.

33. Henderson, *Brothers of Light*, 106, 107. A slightly different version of the Spanish text is in Rael, *New Mexican Alabado*, 135.

CHAPTER 6

1. Wilder and Breitenbach, *Santos*, 29–30, and plates 1, 7, 8, 20, and 39. As E. Boyd correctly notes (*Popular Arts*, 416), many works in this style were not executed from milled lumber and hence are not "flat figures," and also other *santeros* on occasion created flat figure pieces in decidedly different styles.

2. A typed copy of this baptism record is found in E. Boyd's files at the Museum of International Folk Art, upon which is noted: "As copied by C. D. Carroll from copy in possession of Morris—nephew of J B Ortega) 1962." In Boyd's handwriting on the margin is noted "copy by EB-10-2-62." Boyd later checked the original record in the Book of Baptisms at the church of Santa Gertrudis in Mora and reproduced this entry in her *Popular Arts*, 427. Boyd cites no evidence in *Popular Arts* to connect the Mora style pieces with José Benito Ortega.

Fortunately, a note by Boyd recently found by the present writer provides the evidence which she failed to mention in print. The accession record in the Museum of International Folk Art for an Ortega piece (A.9.54-4-B) has the following information added by Boyd, ca. 1963:

Ortega's sister married a soldier from Fort Union who settled in Mora county after his discharge. Their son, José L. Morris, and Ortega's nephew, was still living in 1963, aged 72, at Buena Vista, Mora county. He gave information on his uncle the santero, and said he had been taught to make bultos by Ortega when he was 12. *Morris, his son Pedro Morris, and the adjacent morada back of their home, all had santos made by Ortega* [emphasis added]. (The Muerte in cart by Ortega was bought by the Spanish Colonial Arts Society in 1963.)

Regarding this figure of Death in the cart, Boyd noted in *The New Mexican Santero*, that "LA MUERTE . . . It is the work of Jose Benito Ortega and was acquired by the Museum of New Mexico from the nephew of the *santero*." However, this death figure (as well as the one attributed to Ortega, illustrated in Boyd, *Popular Arts*, 412), is so different in conception from his human saints that one cannot be certain it is the work of the same artist. That Boyd saw *santos* made by Ortega in the possession of the Morrises virtually confirms the attribution of the Mora style to Ortega; had the Museum purchased some of these pieces, other than the Death cart, the case would be even stronger.

3. Prior to the 1870s when Ortega began working, images were brought over the mountains from the communities of the Rio Grande watershed, where most of the settlers of the Mora area themselves were born. A good example is the statue of Saint Gertrude by Rafael Aragón in the Taylor Museum, said to be the first statue of this patron saint in the church of Santa Gertrudis de Mora, founded about 1838. See Wroth, *Christian Images*, legend for plate 136.

4. On the requirements of traditional Christian art, see Wroth, *Christian Images*, chapters I–III). We disagree with Boyd's assessment that many of Ortega's *bultos* "resemble living people of Spanish descent in New Mexico, which suggests that he may have used a relative or neighbor for a

model" (*Popular Arts*, 420). Rather, they represent a highly stylized type conceived with little thought to naturalism, or indeed to the supernaturalism of the holy subjects he was portraying. Espinosa perhaps overstates the case somewhat when he says: "Generally speaking, Mora [i.e., Ortega] images are the least attractive of all New Mexican folk-made statuary" (*Saints in the Valleys*, 77).

5. The village of La Jara, in which one of these (TM 5666) was collected, is probably the village of that name ten miles east of Mora rather than the La Jara near Cuba in west central New Mexico.

6. Boyd, *Popular Arts*, 425.

7. Boyd, *Popular Arts*, p. 420, figs. 208 and 209, plate 40. Another Ortega *bulto* with the Holy Face painted on it is Our Lady of Solitude illustrated in *A Little World of the Saints*, Amarillo, 1975 (no plate or page number), and a School of Ortega I *Our Lady of Solitude* in the Taylor Museum (TM 5734, plate 15) also has the Holy Face in a slightly different but related style.

8. On the tree-ring dating of New Mexican *retablos* see Wroth, *Christian Images*, 198–200; and W. S. Stallings, Jr. (untitled ms. study of New Mexican *retablos*), ca. 1951, passim. The three pieces attributed to Ortega which Stallings dated are TM 1187, 528, and 505.

9. Boyd, "Comments on Taylor Museum *Santos—retablos*," 3.

10. Boyd, *Popular Arts*, 420.

11. See, for instance, Field, *Fifteenth Century Woodcuts and Metalcuts*, plates 125 and 126 (our plate 8).

12. For early woodcuts and paintings of this image, see Field, *Fifteenth Century Woodcuts and Metalcuts*, plates 136–42; and Souchal, *Gothic Painting*, plates 17, 139, and 142.

13. This painting is discussed and illustrated in *El Palacio*, Jan. 31, 1920. The Domínguez report has been translated as *The Missions of New Mexico, 1776*.

14. Boyd, *Popular Arts*, 122, 129; and Mather, *Colonial Frontiers*, 7 (legend for plate 9). On Captain Sebastián Martín Serrano, see Chavez, *Origins of New Mexico Families*, 223–24. Fernández San Vicente's visitation to San Juan is discussed in Kessell, *The Missions of New Mexico Since 1776*, 92, and the original report is in AASF, Accounts, Book LXIV (Box 5) (San Juan, Aug. 1–3, 1826).

15. *Bultos* of this subject are illustrated in Wilder and Breitenbach, plate 46 (by the Arroyo Hondo Carver, ca. 1830 to 1860); and in Stern, *The Cross and the Sword*, plate 29 (by Ortega). The Abiquiú *bultos* are in Ahlborn, *The Penitente Moradas of Abiquiu*, figs. 11, 12, 33, and 42. See also Wroth, *Christian Images*, plate 65, for a small *retablo* of this subject.

16. On the White Penitents and the Stabat Mater Dolorosa see *The Catholic Encyclopedia* 2:671, 6:91 and 14:239. For the transcription of "Estaba Junto al Madero" see Rael, *The New Mexican Alabado*, 52. My thanks to José María Prats for pointing out that the San Luis *alabado* was the Stabat in Spanish.

17. Horacio Valdez, personal communication, 1977. See also Weigle, *Brothers of Light*, 167–68.

18. The hollow-skirt method of constructing processional images derives from colonial Mexico and ultimately from Spain. Examples of Mexican Baroque statues constructed this way at Mission San Xavier del Bac are illustrated and discussed by Ahlborn, *The Sculpted Saints of a Borderland Mission*, 93, 104–105.

19. Boyd, "Comments on Taylor Museum *Santos—retablos*," 21. Similar renditions of this subject are published in Boyd, *Popular Arts*, fig. 209, and plate 21, above. The handwriting here is very similar to that on an Ortega *bulto* of Our Lady of Mt. Carmel in the McNay Art Institute collection.

20. "George Archuleta. May he rest in peace. a prayer and a credo for his soul." On the New Mexico usage of "sudario" to mean a prayer for the deceased, see Steele, and Rivera, *Penitente Self-Government*, 198–200.

CHAPTER 7

1. Bartlett, *Personal Narrative*, 1:191.

2. Stallings, (untitled manuscript study), 127. Gonzales may have lived in Sonora prior to coming to New Mexico, or the informant may have confused Chihuahua and Sonora.

The first to comment on his work was John Gregory Bourke, who visited Las Trampas in 1881. Like most Anglo-American observers, Bourke was condescending and negative about local folk art, though at the same time he was one of the earliest to recognize its "charm" and picturesque value. The church of San José de las Trampas "certainly was not lacking in the elements of simple beauty." The interior he found

> . . . neat and in good order, but thoroughly Mexican. . . . The paintings were on wood and were I disposed to be sarcastic, I would remark that they ought to be burned up. . . . This criticism, in all justice, would be apt and appropriate in our own day, but . . . the greatest charm of New Mexico will be lost when these relics of a by-gone day shall be superseded by brighter and better pictures framed in the cheap gilding of our own time. (Bourke, "Bourke on the Southwest," 272–74.)

3. As transcribed by Boyd, *Popular Arts*, 345; see also her fig. 193. This inscription, probably written by Gonzales, reads in English: "Jose de Gracia Gonzales painted this altar screen at the expense of Don Jose Dolores Duran. The said painting was completed today, July 20, 1864." To the immediate left of this inscription, noted by present writer in 1988, is this salutatory prayer, written in the same hand: "Los dulses nombres Jesus, Maria y Jose esten con vosotros" ("May the sweet names Jesus, Mary and Joseph be with thee").

4. On the original Talpa Chapel, see Wroth, *The Chapel of Our Lady of Talpa*, chap. I. Boyd, *Popular Arts*, 345, suggests the possibility that Gonzales painted an altar screen for Durán's Llano de Santa Bárbara chapel. In 1885 José Dolores Durán stated in his will that he was the son of Francisco Antonio Durán and Juana María Sandoval and asked that "his body be buried in the chapel of Our Lady of Talpa in my Residence, with Mass while lying in state [*con misa de cuerpo precente*], for which I leave a cow to pay for my funeral." He went on to note that his worldly goods included "the house of my residence and more than 446 *varas* of land situated in the limits of the Rio of Santa Barbara" (Taos County Probate Court Records, microfilm roll 4, fr. 1048–1051).

5. New Mexico Territorial Census, 1870, Taos County, Town of Cordovas, no. 45. Atochita Maestas's birthplace was given as Mora by Gonzales's granddaughters Belinda Gomez and Mercy Valerio (1989).

6. 1880 Federal Census, Las Animas County, Colorado, Precinct 17, E.D. Dist. 68, 22–23. I am grateful to Mark L. Gardner, who in 1989 conducted extensive research for me in the Trinidad area, and to the descendants of José de Gracia Gonzales who responded to a letter which we inserted in the Trinidad *Chronicle-News* (December 7, 1989), in particular, his daughter-in-law Mrs. Pedro Celestino (Rufinita) Gonzales; his granddaughters Juanita Martinez, Adeline Aragon, Belinda Gomez, and Mercy Valerio; and great-grandchildren, Joseph de Gracia Gonzales and Margaret Apodaca.

7. 1885 Las Animas County Census, Las Animas County Courthouse, Trinidad. "Galine" most likely is a mistake by the census taker for "Salome."

8. Whitney, *Directory of Trinidad, Colorado for 1888*, 85. 1900 Federal Census for Las Animas County (12th Census of the U.S.), E.D. 66, sheet #6, Precinct 24. Also listed as a "boarder" in the Gonzales home in 1900 is Agapito Maestas, age eighty-nine, born in New Mexico, probably Atochita's father. Atochita was said by her daughter-in-law, Rufinita Gonzales, to have been a *curandera* who visited sick people and cured them. She may have contributed significantly to the family finances through this activity. She died March 23, 1907 (*Record of Interments, 1874–1912*, Catholic Cemetery, Trinidad, Colorado), and her obituary notice appears in the Trinidad *Chronicle-News*, (March 25, 1907): 1.

9. Las Animas County Tax List for 1901, based on assessment rolls of May 1, 1901, which strongly suggests that Gonzales died prior to May 1, 1901. The Deed of Trust is found in Las Animas County Deed Record Book 107, p. 303 (Las Animas County Courthouse, Trinidad). The party of the second part is W. C. Pearce. The Gonzales family executed a promissory note with Pearce for $65.75 payable in six months, with their property in the Pleasant Homes addition as collateral. In June 1894 Gonzales traded his property on High Street, which he had purchased in 1887, for eight lots in Block #3 of the Pleasant Homes addition (Record Book 33, p. 526, December 29, 1887, and Record Book 87, pp. 191 and 564, June 19, 1894).

10. Boyd, *Popular Arts*, 334–35.

11. Adeline Aragon, Juanita Martinez, Belinda Gomez, and Mercy Valerio all agree that their grandfather was a sculptor who made images out of plaster of Paris in little molds which he also made. Mrs. Aragon remembers seeing the molds which were still in the family's possession when she was a child. Rufinita Gonzales (age ninety-nine in 1989) stated that people said her father-in-law José de Gracia Gonzales was a very good man and that he made *santos* out of paper (probably meaning papier-mâché) and plaster. They were very beautiful because he "covered them with colors." She also said that he made them to sell, in whatever sizes people wanted, working out of his home. We are grateful to Belinda Gomez for allowing us to photograph the one piece that has remained in the family (fig. 7.3).

12. Author's telephone interview with Mercy Valerio, February 1990. My thanks to Robin Farwell Gavin, Helen Lucero, and Barbara Mauldin for photographing the San Rafael statue for me in April 1990, and to Mrs. Valerio and the owner of the statue (who wishes to remain anonymous) for their help and cooperation. The tin and glass niche for this figure has floral motifs in Gonzales's style painted on the glass panels, which helps to affirm the original owner's statement that Gonzales made both the niche and the figure.

13. Another slightly different tradition is remembered by some family members: that Gonzales's parents were artists from Europe who were living together unmarried in Mexico; one was Jewish and the other Italian. At some point in his early childhood they returned to Europe, leaving him behind with the Gonzales family, who raised him. Both traditions take into account the memory of Gonzales as having a light complexion and hair; Juanita Martinez stated that he was remembered as a "towhead" (blonde), and Mercy Valerio recalls that her uncle Andalesio Gonzales (fig. 7.1) was often mistaken for an Anglo-American: "people who didn't know him would ask: why does that Anglo speak such good Spanish?"

Yet another version of the family tradition records that Gonzales's mother was Mexican and his father German or Jewish, and that he was adopted by the family (Gonzales) of the nana who had taken care of him as a baby. At the age of seven or eight he began to work as an errand boy for a German artist named Mr. Schmid (or Schmidt). Schmid recognized his artistic talents and taught him to paint. Later Gonzales accompanied Schmid to the United States and settled in New Mexico.

14. Robin Farwell Gavin kindly transcribed the original inscription in Truchas and supplied a photocopy of a photograph of this piece. The statue is a typical Mexican Baroque piece constructed by the hollow-skirt method and intended to be dressed (*un imagen de vestir*), a type frequently found on the northern frontier. See Ahlborn, *The Sculpted Saints of a Borderland Mission*, 104–105, for a similar example at San Xavier del Bac. Gonzales's inscription is written on the cloth covering the framework. It reads in the original:

se retocó esta Imagen por cuenta/
de Da. Ma. Ramona Archuleta . . . N . . . [Nativa?] de . . . /
San Antonio de Embudo . . . /
fué hecho por mi José de Gracia G< . . /
escultor del mismo punto de San Antonio. . . . Se co[nc]clullo/
esta retocacion el dia 24 de Mallo/De 1864.

The latter part of the inscription suggests that José de Gracia Gonzales may have lived in the village of San Antonio de Embudo, or else—and this is a more intriguing possibility—that he was listing his hometown, another San Antonio in Mexico. He inscribed this piece in Embudo or Truchas (where it is now) just two months before painting and inscribing the altar screen at Llano de San Juan.

15. It appears that José de Gracia Gonzales was not the only itinerant artist from Mexico working in northern New Mexico in the late 1800s. A large altar screen, now in a private collection, was purchased from the owner of a private chapel in Chimayó, New Mexico in the 1960s. It consists of ten large panels within a wooden framework, all painted in oil in a rough Mexican provincial style, considerably less competent than Gonzales's work. It is illustrated in *Imagenes Hispano Americanas*, plate 7, and incorrectly identified as the work of Gonzales.

In her *Popular Arts* (345), Boyd notes that an old photograph of the interior of the Church of Our Lady of Guadalupe in Santa Fe shows two pedestals in front of the altar, "recognizably painted with figures by Gonzales." Two fragments of an altar screen painted by him, probably from the church at El Cerrito in San Miguel County, are now in the Spanish Colonial Arts Society collection at the Museum of International Folk Art. In the record for one of these fragments (The Most Holy Trinity—L.5.71–21) Boyd states that this piece was "bought from Jay Stern of Las Vegas, New Mexico. . . . Stern says [this piece] was part payment for work on the church at El Cerrito, over 50 years ago [ca. 1920]. Presumably an altar screen by Gonzales was there and, in poor condition, discarded." The other fragment identified by Boyd is of San Pedro (A.71.28–2).

CHAPTER 8

1. Wilder and Breitenbach, *Santos*, 30. The four *bultos* no longer attributed to this stylistic group are their plates 24 and 36 (the Abiquiú Santero), plate 26 (Miguel Herrera), and plate 42 (Rafael Aragón).

2. Ahlborn, *The Penitente Moradas of Abiquiu*, 139 and figs. 42, 52, 53.

3. Ibid., 138 and fig. 33.

4. Boyd, *Popular Arts*, 436.

5. Jaramillo, *Shadows of the Past*, 61. On the celebration of the feast day of Saint John the Baptist in Arroyo Hondo, see "Festivals" in *El Palacio*, 89 (1975): 29–30.

6. Harry H. Garnett, "Report No. 1. Don Miguel Herrera, Santero, Arroyo Hondo, New Mexico," and "Report No. 2. Don Miguel Herrera, Santero" (unpublished reports in the Taylor Museum Archives). See also Shalkop, *The Folk Art of a New Mexican Village*, 12 ff.

7. Illustrated in situ by Shalkop, *The Folk Art of a New Mexican Village*, plates 8, 9, 10, and 19. Shalkop also attrib-

utes another Arroyo Hondo piece to Herrera, *San Juan Bautista* (his plate 11), but from the photograph, it is not clearly evident that this figure is by the same hand.

8. Wroth, *Christian Images*, 185–91.

9. Wilder and Breitenbach, *Santos*, plates 15, 16, and 52.

10. Espinosa, "The Discovery of the *Bulto*-maker Ramón Velázquez," 183–90.

11. Ibid., 187–88.

12. Boyd, "Addendum," 190–91. See also Espinosa, *Saints in the Valleys*, 61, 79–80; and Boyd, *Popular Arts*, 408–409.

13. Taylor Museum accession records, catalog number 1402.

14. Espinosa, "The Discovery," 189.

15. Ibid.

16. Boyd, Spanish Colonial Arts Society accession records, Museum of International Folk Art.

17. Ibid.

18. Boyd, *Popular Arts*, 409, 416.

19. This photograph is reproduced in Boyd, "Troubles at Ojo Caliente," 347–60.

20. Jaramillo, *Shadows of the Past*, 61. Garnett's "Background of the *Santos* in the Taylor Museum: The Santo Entierro" (unpublished report in the Taylor Museum Archives) describes his first inspection of the *Cristo Entierro* in the upper *morada*:

> Coiled under the head was a strong cord, attached to the back of the head. The head and jaws were articulated. I surmised that during the ceremony on Good Friday that the Hermano Mayor (Varges) would stand in dark corner back of the casket, bring the string up and over the lower part of the casket and when he pulled the cord the head would rise and the jaw fall open. I knew then why Varges' little granddaughter said, "On Good Friday, Christ raises his head and tries to talk to us."

21. Garnett, "Report #1."

22. Shalkop, *The Folk Art of a New Mexican Village*, 6 and 8. The altar panels are discussed by Shalkop, 8, and by Wroth, *Christian Images*, 115–19.

23. Harry H. Garnett, "Arroyo Hondo, New Mexico. The Medina Private Chapel. The Lower Hondo *Morada*" (unpublished report in the Taylor Museum Archives).

CHAPTER 9

1. See above, Preface, and Wroth, "The Flowering and Decline of the New Mexican *Santero*," 273–82.

2. See Stoller, "Traditional Hispanic Arts and Crafts," 81–96.

3. Boyd, "Addendum," 191. In her notes in the files of the Museum of International Folk Art, Boyd left a more complete record of this information given her by Elmer Shupe:

> Elmer Shupe at Canjilon . . . met old man Avelino Velasquez, younger son of J. R. V. who was born in 1884. . . . J. R. V. made living making santos—last year he made them was 1899, he died 1902.
>
> A. V. said father made them for all over the country—had so many orders he would take the whole family with him and stay in some village 2 or 3 or more months making them. "Vallecitos, Petaca, El Rito, Cebolla, etc." He made them where they were wanted—not at home to be peddled round, as has been said of "santeros—peddling saints." Said J. R. V. first used to make his own colors but in latter years used store paints (oil or enamels).
>
> Avelino says family sold all they had. He never made santos himself. Reported verbatim by Elmer Shupe to E. B., May 3, 1954.

See also Boyd, *Popular Arts*, 408.

4. Marianne L. Stoller, personal communication, May 30, 1985.

5. Wallrich, "The Santero Tradition," 158.

6. Ibid.

7. Accession card, TM 3590. Stoller, "Traditional Hispanic Arts and Crafts," 91, caption for plate 20, notes that Francisco Vigil "lived at La Valle, near San Luis." La Valle is southeast of San Luis, close to San Pablo. E. Boyd also recorded information on Vigil: "Elmer Shupe says his information on the santero who lived at LaValle was that his name was Francisco Vigil, and that he was the principal santero for the region around San Acacio but of course worked in other towns around San Luis also. Shupe said that Francisco's son, Modesto Vigil, was 70 years old when he died in 1945 and had been the hermano mayor of the local morada at San Acacio" (Accession record for L.5.70–14, Spanish Colonial Art Society collection, Museum of International Folk Art).

8. For a history of early settlement of the Front Range, see LeCompte, *Pueblo, Hardscrabble, Greenhorn*; and LeCompte, "Charles Autobees."

9. See Wroth, *Christian Images*, 67–68, comments for plates 23 and 24.

10. Boyd, "Comments On Taylor Museum Santos—*Bultos*," 4, comment for TM 3854.

11. Pursuant to the Museum's agreement with the Brotherhood, the name and location of this group is being held in confidence, until such time as the members decide that this information can be made public.

12. This woman, while not officially a member of the all-male Brotherhood, had been closely associated with the group all her life in taking care of the altar and the *santos*, including the provision of new clothes, when necessary, for the images. Her title was "la hermana del altar," which the Brothers translated as "the altar lady." The Brothers also stated that the image of Christ Crucified was known as *La Preciosa Sangre* (The Precious Blood), while Christ in the Holy Sepulchre (not represented in the *morada*) was, as is traditional in New Mexico and Mexico, *El Santo Entierro* (the Holy Burial). They also stated that neither the death cart nor the figure of Death without the cart were used or even known in the *moradas* in their area.

13. Information provided by Floyd Trujillo, December 1, 1989. On *cachana* (Blazing star, *Liatris punctata*), see Moore, *Los Remedios de la Gente*, 6. Another *dominita* can be seen around the neck of *Christ Crucified* by Juan Miguel Herrera (plate 71, TM 3951).

14. See Chavez, *My Penitente Land*, 205–206; and Wroth, *The Chapel of Our Lady of Talpa*, 65. Chavez recalls that in his childhood, the figure of *Jesus Nazarene* in the local *morada* was known as "la Sangre de Cristo."

CHAPTER 10

1. Wilder, "Religious Folk Art," 7–8.

2. Coomaraswamy, "*Samvega*: Aesthetic Shock," 179.

3. On the Dance of Death, see, for instance, Riguer and Valverde, "La Danza de la Muerte y el Teatro Medieval," 563–81. On colonial funeral monuments and their death figures, see Kelemen, "A Mexican Colonial Catafalque," in *Vanishing Art of the Americas*, 31–50.

4. Among Catholic institutions concerned with death, there is, for instance, the Jesuit Bona Mors confraternity, devoted to the proper preparing for a happy death (see *The Catholic Encyclopedia* 2:668). The Day of the Dead in Mexico has been extensively documented; for an account with good visual documentation, see Hernandez and Hernandez, *The Day of the Dead*. The Mexican caricature form known as the *calavera* ("skull") is a humorous, satirical, secular expression of death imagery, that often conveys a deeper reflection upon mortality. See Tyler, *Posada's Mexico*, 73–75 and plates 175–95.

5. Anonymous informant, personal communication, 1977. The large size of the death cart at the Las Trampas

church (fig. 10.1) and its generously proportioned seat suggest that it too may have been used for this election ceremony. It was first described by John G. Bourke in 1881 ("Bourke on the Southwest," 272–73).

6. Boyd, *Popular Arts*, 464; Weigle, "Ghostly Flagellants and Doña Sebastiana," 141.

7. Steele, "The Death Cart," 1–3.

8. Ahlborn, *The Penitente Moradas of Abiquiu*, figs. 10, 32, 55. For other illustrations of death figures, see Boyd, *Popular Arts*, figs. 210 and 215; Weigle, *Brothers of Light*, facing 102; Bunting, "Penitente Brotherhood Moradas," fig. 47; and Steele, "The Death Cart," cover illus. and 6.

9. Boyd, *Popular Arts*, 462. On the attribution of the Cordova death figure (Plate 94) to Nasario Lopez, see Briggs, *The Wood Carvers of Cordova*, 29.

10. *Santos of the Southwest*, 52–53.

11. Anonymous informant, personal communication, 1977.

CHAPTER 11

1. Héctor Gonzáles Martínez, *La Catedral de Durango*, Durango, 1982, 23, 31. See also Maza, *La Ciudad de Durango*, 24.

2. Transcribed in Weigle, *Brothers of Light*, 196. The term *madero* also occurs in Brotherhood *alabados*: "Bendito el santo madero/arbol de la santa cruz/en quien fuimos redimidos con sangre de mi Jesús (Blessed be the holy timber, tree of the holy cross in which we were redeemed with the blood of my Jesus), from Rael, *The New Mexican Alabado*, 36.

3. On the *guía*, see Steele and Rivera, *Penitente Self-Government*, 192. The use of these crosses in the initiation of new members was suggested to the writer by an *hermano mayor* who said that it would be appropriate for the initiate to hold a plain cross (rather than a crucifix) because Christ Crucified is the goal, not the beginning: he desires to bear the cross and to be crucified with Christ ("I am crucified with Christ: nevertheless I live; yet not I but Christ liveth in me." [Galatians 2: 20]).

Bibliography

BOOKS AND ARTICLES

Ahlborn, Richard E. *The Penitente Moradas of Abiquiú*. Washington, D.C., 1968.
———. *The Sculpted Saints of a Borderland Mission*. Tucson, 1974.
Alaman, Lucas. *Disertaciones*. Mexico, 1942.
Alcalá Alvarado, Alfonso. *Una Pugna Diplomática Ante la Santa Sede: El Restablecimiento del Episcopado en México, 1825–1831*. Mexico, 1967.
Alcocer, Fr. José Antonio. *Bosquejo de la Historia del Colegio de N.S. de Guadalupe y sus misiones, Año de 1788*. Edited by Rafael Cervantes. Mexico, 1958.
Amador, Elias. *Bosquejo Histórico de Zacatecas*. Zacatecas, 1906.
Arlegui, José. *Crónica de la Provincia de N.P.S. San Francisco de Zacatecas*. Mexico, 1851.
Bartlett, John R. *Personal Narrative of Explorations and Incidents. . . .* New York, 1854.
Beals, Ralph L. *Cherán: A Sierra Tarascan Village*. Washington, D.C., 1946.
Berlin, Heinrich. "Salvador de Ocampo, A Mexican Sculptor." *The Americas* 4, no.4 (1948): 415–428.
Bezanilla Mier y Campa, Joseph. *Muralla Zacatecana*. Mexico, 1788.
Borhegyi, Stephen F. de. "The Cult of Our Lord of Esquipulas in Middle America and New Mexico." *El Palacio* 61 (1954): 387–401.
———. "The Miraculous Shrines of Our Lord of Esquipulas in Guatemala and Chimayó, New Mexico." *El Palacio* 60 (1953): 83–111.
Bourke, John G. "Bourke on the Southwest, X." *New Mexico Historical Review* 11 (1936): 272–274.
Boyd, E. "Addendum to Paper on Jose E. Espinosa's Ramon Velasquez." *El Palacio* 61, 6 (1954): 190–91.
———. *The New Mexican Santero*. Santa Fe, 1969.
———. *Popular Arts of Spanish New Mexico*. Santa Fe, 1974.
———. "Troubles at Ojo Caliente, a Frontier Post," *El Palacio* 64, 11–12 (1957): 347–360.
Briggs, Charles L. *The Wood Carvers of Cordova, New Mexico*. Knoxville, 1980.
Brown, Lorin W., with Charles L. Briggs and Marta Weigle. *Hispano Folklife of New Mexico: The Lorin W. Brown Federal Writers' Project Manuscripts*. Albuquerque, 1978.
Bunting, Bainbridge et al. "Penitente Brotherhood Moradas and Their Architecture." In *Hispanic Arts and Ethnohistory in the Southwest*, edited by Marta Weigle. Santa Fe and Albuquerque, 1983.
Burckhardt, Titus. *Siena: The City of the Virgin*. London, 1960.
Calderon de la Barca, Mme. *Life in Mexico*. New York, 1931.
Callahan, William T. *Church, Politics and Society in Spain, 1750–1874*. Cambridge, Mass., 1984.
Carrillo y Gariel, Abelardo. *Imaginería Popular Novoespañola*. Mexico, 1950.

The Catholic Encyclopedia. New York, 1907–1914.
Chavez, Fr. Angelico. *Archives of the Archdiocese of Santa Fe*. Washington, 1957.
———. *But Time and Chance: The Story of Padre Martínez of Taos, 1793–1867*. Santa Fe, 1981.
———. *My Penitente Land*. Albuquerque, 1974.
———. *Origins of New Mexico Families*. Santa Fe, 1954.
———. "The Penitentes of New Mexico." *New Mexico Historical Review* 29 (1954): 97–123.
Christian, William A., Jr. *Local Religion in Sixteenth-Century Spain*. Princeton, 1981.
———. *Person and God in a Spanish Valley*. New York, 1972.
———. "Provoked Religious Weeping in Early Modern Spain." In *Religious Organization and Religious Experience* (Association of Social Anthropologists Series 21), edited by John Davis, 97–114. London, 1982.
The Chronicle-News. Trinidad, Colorado. March 25, 1907.
Cohn, Norman. *The Pursuit of the Millennium*. London, 1970.
Constituciones de la Santa Escuela de Christo Señor Nuestro. . . . Reimpressa, Mexico, 1774.
Constituciones de la Santa Escuela de Christo Señor Nuestro. . . . Mexico, 1819.
Coomaraswamy, Ananda K. "*Samvega*: Aesthetic Shock." In vol. 1 of *Coomaraswamy: Selected Papers*, edited by Roger Lipsey, 179–85. Princeton, 1977.
Damian, Saint Peter. *Opuscula varia*, In *The Portable Medieval Reader*, edited by James B. Ross and Mary M. McLaughlin, 49–55. New York, 1949.
Darley, Alexander. *The Passionists of the Southwest*. Pueblo, 1893.
Dávila Padilla, Fr. Agustín. *Historia de la Fundación y Discurso de la Provincia de Santiago de México, de la Orden de Predicadores*. 1596. Reprint. Mexico, 1955.
Domínguez, Fray Francisco Atanasio. *The Missions of New Mexico, 1776*, edited and translated by Eleanor Adams and Fray Angelico Chavez. Albuquerque, 1956.
Espinola, Nicolás de. *Diario Quadragesimal y Desagravios de Christo*. Mexico, 1728.
Espinosa, Aurelio M. "Penitentes, Los Hermanos (The Penitent Brothers)." In *The Catholic Encyclopedia* 11:635–36.
Espinosa, Fr. Isidro Felix de. *Crónica de los Colegios de Propaganda Fide de la Nueva España*. 1746. Reprint. Washington, D.C., 1964.
Espinosa, José E. "The Discovery of the *Bulto*-maker Ramon Velazquez of Canjilon." *El Palacio* 61, 6 (1954): 183–90.
———. "A Little Dutch Girl far from Home." *El Palacio* 61 (1954): 70–73.
———. *Saints in the Valleys*. Albuquerque, 1967.
Estaciones de la Passion del Señor, que Anduvo la Venerable Madre María de la Antigua. . . . Mexico, 1755.
Evagrius Ponticus. *The Praktikos. Chapters on Prayer*. Spencer, Mass., 1970.
Evans, Albert. *Our Sister Republic*. Hartford, 1870.
Farriss, N. M. *Crown and Clergy in Colonial Mexico, 1759–1821*. London, 1968.

Fernández de Echeverría y Veytia, Mariano. *Historia de la Fundación de la Ciudad de Puebla de los Angeles.* . . . Puebla, 1931.

"Festivals." *El Palacio* 89 (1975): 29–30.

Field, Richard S. *Fifteenth Century Woodcuts and Metalcuts.* Washington, D.C., n.d.

Fisher, Reginald. *The Way of the Cross: A New Mexico Version.* Santa Fe, 1958.

Fontana, Bernard L. "Nuestra Señora de Valvanera in the Southwest." *Hispanic Arts and Ethnohistory in the Southwest,* edited by Marta Weigle. Santa Fe and Albuquerque, 1983.

Foster, George M. *Tzintzuntzan.* Boston, 1967.

Franco, Fr. Alonso. *Segunda Parte de la Historia de la Provincia de Santiago de México.* . . . Mexico, 1900.

French, R. M., trans. *The Way of a Pilgrim.* New York, 1965.

Fuentes y Guzman, Francisco A. de. *Historia de Guatemala.* . . . Madrid, 1882.

Gallegos, José I. *Durango Colonial, 1563–1821.* Mexico, 1960.

——. *El Obispo Santo: Doctor Don José Antonio Laureano de Zubiría y Escalante.* . . . Mexico, 1965.

García Cubas, Antonio. *El Libro de mis Recuerdos.* Mexico, 1904.

García Diego, Fr. Francisco. *Método de misionar entre fieles.* 1841. Reprint. Guadalajara, 1931.

Garrigou-Lagrange, R. *The Three Ways of the Spiritual Life.* London, 1938.

Gerhard, Peter. *The North Frontier of New Spain.* Princeton, 1982.

Giffords, Gloria K. *Mexico Folk Retablos.* Tucson, 1974.

Gilbert, Fabiola Cabeza de Baca. *The Good Life: New Mexican Food.* Santa Fe, 1949.

Gonzáles Martínez, Héctor. *La Catedral de Durango.* Durango: 1982.

Greenleaf, Richard E. "The Inquisition in Eighteenth-Century Mexico." *New Mexico Historical Review* 60 (1985): 29–60.

Hammond, George P., and Agapito Rey. *Don Juan Oñate: Colonizer of New Mexico, 1595–1628.* Albuquerque, 1953.

Hay, Denys. *The Church in Italy in the Fifteenth Century.* Cambridge, 1977.

Henderson, Alice Corbin. *Brothers of Light, The Penitentes of the Southwest.* New York, 1937.

Hernandez, Joanne F., and Samuel R. Hernandez. *The Day of the Dead.* Santa Clara, Calif., 1979.

Hillgarth, J. N., and Giuli Silano, eds. and trans. *The Register Notule Communion 14 of the Diocese of Barcelona (1345–1348).* Toronto, 1983.

Hodge, Frederick W., et al. *Fray Alonso de Benavides' Revised Memorial of 1634.* Albuquerque, 1945.

Horgan, Paul. *Lamy of Santa Fe.* New York, 1975.

Iguíniz, Juan B. *Breve Historia de la Tercera Orden Franciscana en la Provincia del Santo Evangelio de México.* . . . Mexico, 1951.

Imágenes Hispano Americanas. Tucson, 1976.

"Informe de la Provincia del Santo Evangelio al Visitador Lic. Juan de Ovando." Ca. 1570. In *Codice Franciscano. Siglo XVI* . . . , edited by Joaquín García Icazbalceta, 67–68. Mexico, 1941.

Janvier, Thomas A. *The Mexican Guide.* New York, 1895.

Jaramillo, Cleofas. *Shadow of the Past.* 1941. Reprint. Santa Fe, 1981.

Kelemen, Pál. *Vanishing Art of the Americas.* New York, 1977.

Kessell, John L. *The Missions of New Mexico since 1776.* Albuquerque, 1980.

Kubler, George. *Santos: An Exhibition of the Religious Folk Art of New Mexico.* Fort Worth, 1964.

Kuroda, Etsuko. *Under Mt. Zempoaltépetl: Highland Mixe Society and Ritual.* Osaka, 1984.

Lecompte, Janet. "Charles Autobees." *Colorado Magazine* (1957–1959): 34–36, 163–79, 274–89; 51–70, 139–53, 219–25, 303–08; 58–66, 202–13.

——. *Pueblo, Hardscrabble, Greenhorn: The Upper Arkansas, 1832–1856.* Norman, 1978.

Liaño Gomez, Pedro. *Historia de los Cofradías Sevillanas.* Seville, n.d.

Libro de las constituciones de Nuestra Sagrada Orden Tercera de Penitencia de Nuestro Seráphico P.S. Francisco. . . . Mexico, 1760.

Little, Lester K. "The Latin Church: 1054 to 1305." In vol. 3 of *Dictionary of the Middle Ages,* edited by Joseph R. Strayer. New York, 1983.

Little World of the Saints. Amarillo: 1975.

Llompart, Gabriel. "Desfile Iconográfico de Penitentes Españoles." *Revista de Dialectologia y Tradiciones Populares* 25 (1969): 31–51.

——. "Penitencias y Penitentes en la Pintura y en la Piedad Catalanas Bajomedieveles." *Revista de Dialectologia y Tradiciones Populares* 28 (1971): 229–49.

Lynch, Cyprian T., ed. *Benavides' Memorial of 1630.* Washington, D.C., 1954.

Lyon, G. F. *Journal of a Residence and Tour in the Republic of Mexico.* London, 1828.

Lyons, Thomas R. "Brothers and Neighbors: The Celebration of Community in Penitente Villages." In *Celebration: Studies in Festivity and Ritual,* edited by Victor Turner, 231–51. Washington, D.C., 1982.

Mangravite, Peppino. "Saints and a Death Angel," *Magazine of Art* 33, 3 (1940): 160–65.

Mather, Christine, ed. *Colonial Frontiers.* Santa Fe, 1983.

Maza, Francisco de la. *La Ciudad de Durango: Notas de Arte.* Mexico, 1948.

Mendieta, Fray Gerónimo de. *Historia Eclesiástica Indiana.* Mexico, 1945.

Mills, George. *People of the Saints.* Colorado Springs, n.d.

Moore, Michael. *Los Remedios de la Gente.* Santa Fe, 1977.

Moorhead, Max. *New Mexico's Royal Road.* Norman, 1958.

Moorman, John. *A History of the Franciscan Order.* London, 1968.

Mota Padilla, Matías de la. *Historia de la Conquista del Reino de la Nueva Galicia.* 1742. Reprint. Guadalajara, 1924.

Motolinia, Fr. Toribio. *Historia de los Indios de la Nueva Espana.* Mexico, 1941.

Motolinia's History of the Indians of New Spain, translated by Elizabeth A. Foster. Westport, Conn., 1973.

Novena del Milagroso SS. Christo de Esquipulas que se Venera en el Reyno de Guatemala, y por su Sagrada Copia, en la Iglesia de N.P.S. Juan de Dios de la Villa de Colima. Reprint. Mexico, 1784.

Oakley, Francis. *The Western Church in the Later Middle Ages.* Ithaca, 1979.

Orozco, Luis F. *Los Cristos de Caña de Maiz y Otras Venerables Imagenes de Nuestro Señor Jesucristo.* Guadalajara, 1970.

Pardo, J. Joaquín. *Efemérides de la Antigua Guatemala, 1541–1775.* Guatemala City, 1944.

Pastor, Ludwig. *The History of the Popes From the Close of the Middle Ages.* London, 1923.

Payne, Stanley G. *Spanish Catholicism: An Historical Overview.* Madison, 1984.

Paz, Nicolás de. *Novena y Bosquejo de los Milagros y Maravillas, que Ha Obrado La Santísima Imagen de Christo Crucificado de Esquipulas.* Reprint. Mexico, 1781.

Paz Solorzano, Juan. *Historia del Santo Cristo de Esquipulas.* Guatemala City, 1949.

Phelan, John L. *The Millennial Kingdom of the Franciscans in the New World.* Revised edition. Berkeley, 1970.

Pinheiro de Veiga, Tomé. *Fastiginia.* Valladolid, 1916.

Ponnelle, Louis, and Louis Bordet. *Saint Philip Neri and the Roman Society of His Times (1515–1595).* London, 1979.

Principe, Walter H. "Christology." In vol. 3 of *Dictionary of the Middle Ages*, edited by Joseph R. Strayer, 319–24. New York, 1983.

Puyol, Julio. "Plática de Disciplinantes." In vol. 1 of *Estudios Eruditos in memoriam de Adolfo Bonilla y San Martín*, 241–66. Madrid, 1927.

Rael, Juan B. *The New Mexican Alabado*. Stanford, 1951.

———. "New Mexican Spanish Feasts." *California Folklore Quarterly* 1 (1942): 83–87.

Rea, Alonso de la. *Crónica de la Orden de N.S.P.S. Francisco, Prov. de San Pedro y San Pablo de Mechoacán. . . .* Mexico, 1882.

"Las Representaciones Teatrales de la Pasión." *Boletín del Archivo General de la Nación* 5, no. 3:332–56.

Ribera Bernardez, Joseph. *Compendio de las Cosas mas notable . . . en los Libros del Cabildo de esta Ciudad de Nuestra Señora de Los Zacatecas. . . .* In *Testimonios de Zacatecas*, edited by Gabriel Salinas de la Torre. Mexico, 1946.

———. *Descripción Breve de la muy Noble y Leal Ciudad de Nuestra Señora de Los Zacatecas. . . .* In *Testimonios de Zacatecas*, edited by Gabriel Salinas de la Torre. Mexico, 1946.

Ricard, Robert. *The Spiritual Conquest of Mexico*. Berkeley, 1974.

Riguer, Martin de, and José M. Valverde. "La Danza de la Muerte y el Teatro Medieval." In *Historia de la Literatura Universal*. Barcelona (1984) 2:563–81.

Sanchez Herrero, José. *Las Diocesis de Reino de Leon, Siglos XIV y XV*. Leon, 1978.

Santos of the Southwest. Denver, n.d.

Sartorius, Carl. *Mexico about 1850*. Reprint of *Mexico: Landscape and Popular Sketches*. 1858. Stuttgart, 1961.

Schuon, Frithjof. *Spiritual Perspectives and Human Facts*. Middlesex, 1987.

Shalkop, Robert L. *Arroyo Hondo: The Folk Art of a New Mexican Village*. Colorado Springs, 1969.

———. *Wooden Saints*. Colorado Springs, 1967.

Sotomayor, José Francisco. *Historia del Apostólico Colegio de Nuestra Señora de Guadalupe de Zacatecas*. Zacatecas, 1874.

Souchal, Genevieve et al., *Gothic Painting*. New York, 1965.

Stark, Louisa R. "The Origin of the Penitente 'Death Cart.'" *Journal of American Folklore* 84 (1971): 304–10.

Starr, Frederick. "Holy Week in Mexico." *Journal of American Folklore* 12, no. 46 (1899): 161–65.

Steele, Thomas J., S. J. "The Death Cart: Its Place among the Santos of New Mexico." *The Colorado Magazine* 55 (1978): 1–14.

———. *Santos and Saints: The Religious Folk Art of Hispanic New Mexico*. 1974. Reprint. Santa Fe, 1982.

Steele, Thomas J., S. J., and Rowena A. Rivera, *Penitente Self-Government: Brotherhoods and Councils, 1797–1947*. Santa Fe, 1985.

Stern, Jean, ed. *The Cross and the Sword*. San Diego, 1976.

Stoller, Marianne L. "Traditional Hispanic Arts and Crafts in the San Luis Valley of Colorado." In *Hispanic Crafts of the Southwest*, edited by William Wroth, 81–96. Colorado Springs, 1977.

Sumario de la Regla . . . los Hermanos Profesos del Sagrado Orden Llamado de los Terciarios de Penitencia de . . . N.S.P.S. Francisco. Mexico, 1802.

Sumption, Jonathan. *Pilgrimage: An Image of Medieval Religion*, London, 1975.

Tamarón y Romeral, Bishop Pedro. *Demostración del Vastísimo Obispado de la Nueva Vizcaya—1765*. Mexico, 1937.

Tanquerey, Adolphe. *The Spiritual Life: A Treatise on Ascetical and Mystical Theology*. Tournai, Belgium, 1930.

Tello, Antonio. *Libro Segundo de la Crónica Miscelánea en que se trata de la Conquista Espiritual y Temporal de la Santa Provincia de Xalisco*. Guadalajara, 1891.

Tixeront, Joseph. *History of the Dogmas*. 2d ed. St. Louis, 1923.

Toor, Frances. *A Treasury of Mexican Folkways*. New York, 1947.

Torquemada, Fr. Juan de. *Monarquía Indiana*. Mexico, 1944.

Toussaint, Manuel. *Colonial Art in Mexico*. Austin, 1967.

Tyler, Ron, ed. *Posada's Mexico*. Washington, D.C., 1979.

Varona, Esteban A. de. *Tasco*. Mexico, 1953.

Vásquez, Francisco. *Crónica de la Provincia del Santísimo Nombre de Jesús de Guatemala de la Orden de N. Seráfico Padre San Francisco en al Reino de la Nueva España*. Guatemala City, 1937.

Vetancurt, Fr. Agustín de. *Teatro Mexicano*. 1698. Reprint. Madrid, 1961.

Villagrá, Gaspar de. *Historia de la Nueva México*. Alcalá, Spain, 1610.

———. *History of New Mexico*. Translated by Gilberto Espinosa. Los Angeles, 1933.

Viva Jesús. Septenario Devotíssimo a la Preciosíssima Sangre de Jesus Nuestro Redemptor. Mexico, reprinted in 1757.

Wallrich, William J. "The Santero Tradition in the San Luis Valley." *Western Folklore*, 10, 2 (1951): 153–161.

Warren, T. Robinson. *Dust and Foam or Three Oceans and Two Continents*. New York, 1859.

Weigle, Marta. *Brothers of Light, Brothers of Blood: The Penitentes of the Southwest*. 1976. Reprint. Santa Fe, 1989.

———. "Ghostly Flagellants and Doña Sebastiana: Two Legends of the Penitente Brotherhood." *Western Folklore* 36, no. 2 (1977): 135–147.

———. *New Mexicans in Cameo and Camera: New Deal Documentation of Twentieth-Century Lives*. Albuquerque, 1985.

———. *A Penitente Bibliography*. Albuquerque, 1979.

Weismann, Elizabeth W. *Mexico in Sculpture 1521–1821*. Cambridge, Mass., 1950.

Whitney, W. H. *Directory of Trinidad, Colorado for 1888*. Trinidad, 1888.

Wilder, Mitchell A. "Religious Folk Art." *Ideales Panamericanos* 1, no. 5 (1945): 7–8.

Wilder, Mitchell A., and Edgar Breitenbach. *Santos: The Religious Folk Art of New Mexico*. Colorado Springs, 1943.

Woodward, Dorothy. *The Penitentes of New Mexico*. New York, 1974.

Wroth, William. *The Chapel of Our Lady of Talpa*. Colorado Springs, 1979.

———. *Christian Images in Hispanic New Mexico*. Colorado Springs, 1982.

———. "The Flowering and Decline of the New Mexican Santero: 1780–1900." In *New Spain's Far Northern Frontier*, edited by David J. Weber, 273–82. Albuquerque, 1979.

———. "New Mexican Santos and the Preservation of Religious Traditions." *El Palacio* 94, no. 1 (1988): 5–12.

———. "La Sangre de Cristo: History and Symbolism." In *Hispanic Arts and Ethnohistory*, edited by Marta Weigle, 283–92. Santa Fe and Albuquerque, 1983.

Yarrow, H. C. "General Itinerary." In George C. Wheeler, *Annual Report upon the Geographical Explorations and Surveys West of the 100th Meridian. . . .* Washington, D.C., 1875.

Zorita, Alonso de. *Historia de la Nueva Espana*. Madrid, 1909.

UNPUBLISHED DOCUMENTARY SOURCES

Archives of the Archdiocese of Santa Fe (AASF)

Accounts, Book 62.
Accounts, Book 64, Box 5. San Juan, Aug. 1–3, 1826.
Loose Documents 1870, no. 7. 1871 Cochití Rules, translated by Thomas J. Steele and Rowena Rivera.

Archives of the Cathedral of Durango (ACD)

Actas Capitulares. Libro 33. Libro de la Segunda Visita del obispado por Dn. Pedro Tamarón y Romeral, 1765–1768, Roll 7.
Actas Capitulares. Libro 53. Visita pastoral del Obispo Dn. Pedro Tamarón y Romeral, 1759–1761, Roll 10.
Actas Capitulares. Libro 60. Libro 2. Visita de Dn. Pedro Ignacio de Iturribarria, del Año de 1806, Roll 11.
Actas Capitulares. Libro 73, Borrador de correspondencia del Obispado de Durango, 1823–1835, Roll 13.
Actas Capitulares. Libro 85. Libro I. Visita del Obispo, Marquéz de Castañiza, 1816–1819, Roll 16.
Actas Capitulares. Libro 89, 1833–1839, Roll 16.
Actas Capitulares, Roll 6.
Pbto. Antonio José Martínez to Señor Obispo Don José Antonio de Zubiría, February 21, 1833. In possession of the Archivo de la Catedral.

Archives of the State of Durango

Act Prohibiting Activities during Holy Week. Joseph Carlos de Aguero, 27 March, 1768, Roll 63.

Federal Records Center, Denver, Colorado

New Mexico Territorial Census, 1870, Taos County.

Huntington Library

William G. Ritch Collection, HM RI 2212, vol. 4. Memo Book no. 4.
William G. Ritch Collection, RI-1866.

Las Animas County Courthouse

1880 Federal Census, Las Animas County, Colorado, Precinct 17, E.D. Dist. 68.
1885 Las Animas County Census.
1900 Federal Census for Las Animas County. 12th Census of the U.S., E.D. 66, sheet #6, Precinct 24.
Las Animas County Deed Record Book 107, p. 303; Book 33; Book 87. Las Animas County Courthouse, Trinidad.

Lilly Library, Indiana University

Decree for Holy Week enacted by Don José Yldefonso Diaz de Leon in San Luis Potosí, April 13, 1824.
Fr. Diego de la Concepción Palomar, "Miscelánea de Documentos Históricos y Curiosos Perteneciente al Apco.

Colegio de N.S. de Guadalupe de Zacatecas." Unpublished manuscript, 1852–1853.
José de Yturrigaray. *Bando.* "Con el importante. . . ." December 17, no year given.
Martín de Ballarta. "Verdadero Camino del Espiritu." 1807.

Museum of International Folk Art

Accession records.
Accession records, Spanish Colonial Arts Society Collection.
E. Boyd Files.

Museum of New Mexico History Library, New Mexico Federal Writers' Project Manuscripts

Lorin W. Brown. "Lent in Cordova." n.d. Reprint. Lorenzo de Cordova [pseud. Brown]. *Echoes of the Flute.* Santa Fe, 1972.
Reyes N. Martinez. "Arroyo Hondo." 13 June 1936.
———. "Community Spirit Preserved by Some Religious and Social Customs." 23 January 1939.
———. "Con Rendida Devocion/With Humble Devotion." n.d.
———. "Early Settlements, Folkways of Northern Taos County."
29 February 1936.
———."Hondo Church." 13 May 1936.
———. "Odd Religious Practices." n.d.
———. "Oraciones/Prayers." 10 April 1940.
———. "Sheep Herders Galore." 26 March 1937.

New Mexico State University, Rio Grande Historical Collections

Padre Martínez Papers.

Taos County Records, State of New Mexico Records Center and Archives

Taos County Probate Court Record Book of Guardianship B-6. 1877–1888, Roll 4.

Taylor Museum Archives

E. Boyd, "Comments on Taylor Museum *Santos—Bultos.*"
———. "Comments on Taylor Museum *Santos—Retablos.*"
Harry H. Garnett. "Arroyo Hondo, New Mexico. The Medina Private Chapel. The Lower Hondo *Morada.*"
———. "Background of Santos in the Taylor Museum: Death Angel of Cordova."
———. "Report No. 1. Don Miguel Herrera, Santero, Arroyo Hondo, New Mexico"; and "Report No. 2. Don Miguel Herrera, Santero."
W. S. Stallings, Jr. Untitled manuscript study of New Mexican *retablos.* Ca. 1951.
Taylor Museum accession records.

Trinidad, Colorado Catholic Cemetery Records

Record of Interments, 1874–1912.

Index

All plate numbers are in italic.